*The Vocation of the Artist* examines the historical role of the artist and presents a particular perspective, grounded in the author's experience as a practicing artist and scholar, on the contemporary function of the artist as prophetic critic and visionary. Using specific interpretations of the words "vocation," "prophetic," and "visionary," Deborah Haynes draws attention to the need for artists to assess critically the relationship of the past and present to the future. Bringing together a wide range of historical and theoretical sources in cultural history, art history and theory, and religion, this book is addressed to those interested in the complex interdisciplinary dialogue of the visual arts, religion, and ethics.

# The Vocation of the Artist

# The
# Vocation
## of the
# Artist

**DEBORAH J. HAYNES**

*Washington State University*

CAMBRIDGE
UNIVERSITY PRESS

PUBLISHED BY THE PRESS SYNDICATE OF THE UNIVERSITY OF CAMBRIDGE
The Pitt Building, Trumpington Street, Cambridge CB2 1RP, United Kingdom

CAMBRIDGE UNIVERSITY PRESS
The Edinburgh Building, Cambridge CB2 2RU, United Kingdom
40 West 20th Street, New York, NY 10011–4211, USA
10 Stamford Road, Oakleigh, Melbourne 3166, Australia

First published 1997

Printed in the United States of America

Typeset in Sabon

*Library of Congress Cataloging-in-Publication Data*
Haynes, Deborah J.
       The vocation of the artist / Deborah J. Haynes.
          p.   cm.
       Includes bibliographical references and index.
       ISBN 0–521–58040–4. – ISBN 0–521–58969–X (pbk.)
          1. Artists – [Artists –] History – Social conditions – and Community.   2. Arts and
       Society.   3. Arts and Religion.   I. Title.
   N8350.H39   1997
   702'.3—dc20                                                96–46114
                                                                CIP

*A catalog record for this book is available from
the British Library*

ISBN 0 521 58040 4 hardback
ISBN 0 521 58969 X paperback

This book is dedicated to those living artists whose work has inspired me.

# Contents

# CONTENTS

# Illustrations

# Preface

At the outset of this book, I invoke two mythological figures: the Hindu goddess Durga and the Jewish-Christian-Muslim angel Gabriel. Their stories relate to the polemical core of *The Vocation of the Artist;* their images provide powerful metaphoric points of reference. Durga conquers destruction and makes possible a future. Gabriel announces new beginnings; Gabriel's story comes at the end of the book.

In India, Durga is a complex goddess. In ancient times she was related to crops and fertility. The earliest Hindu texts tend to speak of discrete goddesses, such as Parvati, Sita, and others, but in the medieval period, the tendency to think of all the goddesses as related to one another developed. The earliest example of this trend is the *Devimahatmya,* which dates from the sixth century. In this text Durga is identified with the Devi, or primal goddess, and many stories are told about her. Perhaps the most famous story and most popular epithet is of her incarnation as Mahisa-mardini, the slayer of Mahisa (Figure 1).

In the story the cosmos is embroiled in a crisis. A battle between the gods and demons for control of the world has been underway for one hundred years, and it appears to have been won by Mahisa, chief of the Asuras. Indra, leader of the beleaguered gods, gathers over thirty other deities to tell Visnu and Siva of their trouble. In order to conquer Mahisa, they decide to concentrate their energies and to produce a goddess. Durga is created. Each male god gives her a weapon: Siva – his trident, Yama – a staff, Visnu – a discus, Indra – a thunderbolt and a bell, Agni – a spear, the wind – a bow and arrows, and so forth. She rides off with their cries urging victory in the background. The army of demons fights hard, but she is able to move through them like fire in a forest. Durga destroys demons until blood runs in rivers. However, she must also confront Mahisa himself, who has terrorized the troops that have joined the goddess. At last Durga becomes so enraged that from her fury she creates the black goddess Kali. When Kali throws her noose, Mahisa changes shape and becomes a lion. As she cuts off his

head, he becomes a man. She cuts the man down, but he becomes a huge elephant that drags the goddess's lion from under her. When she cuts off the elephant's trunk with her sword, Mahisa becomes a buffalo. Guzzling her liquor, the goddess gathers her strength and flies at him. Finally, she pierces him with her spear, cuts off his head, and stands on him. All the other creatures – human, divine, and animal – praise her victory. The world is saved from destruction; there will be a future.

This story, and the many manuscript paintings and sculptures that depict it, engages my already-developed apocalyptic imagination. Indeed, one could say that an apocalyptic sensibility informs *The Vocation of the Artist.* I think regularly about death. Born in the post–World War II years, I have experienced, like others of my generation, enormous changes. How can one characterize these changes? In terms of war and countries torn asunder by strife on every continent? Korea, Vietnam, the Middle East, Rwanda, the former Yugoslavia, Northern Ireland, Haiti. The list is seemingly endless, and it changes with each year. Ecological destruction on a scale previously inconceivable is underway, with Love Canal, Chernobyl, Three Mile Island, and the *Exxon Valdez* disaster among the most publicized examples. A sad legacy for me, having been born in the state of Washington (the "Evergreen State"), is the disappearance of once-majestic fir and pine forests in the Cascade Mountains. Farther away, in Russia, Lake Baikal is rapidly dying from industrial waste and pollution; and the oceans themselves are now full of dead zones where nothing discernible lives. During my lifetime we are witnessing the "end of nature," as the title of Bill McKibben's book put it.

But an even more potent image and devastating reality is The Bomb. It is, in fact, the major cultural icon that has shaped my thinking and experience. I grew up in its shadow, and, like all schoolchildren of my generation, hid under my desk during air-raid drills. From early adolescence my consciousness was formed by a keen sense of the proximity and possibility of death. I knew that personal death could be chosen – my mother's suicide attempt was a constant reminder that death always offered a ready escape from the vicissitudes of life. But I also understood, as much as anyone can, the finality of the nuclear solution. As a member of my high school debate team, I had researched nuclear proliferation. I knew the statistics about how many warheads each nuclear power had in its stockpile, and I knew what nuclear conflagration would mean. Long before cultural artifacts such as the New Zealand film *The Quiet Earth,* or the made-for-TV drama "The Day After," I could describe the consequences of detonating a single megaton bomb.

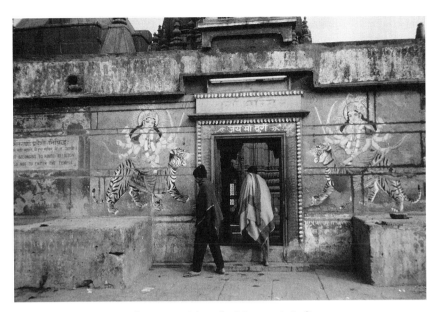

**Figure 1.** Entrance to the Durga Temple, Varanasi, India, 1992

Luckily, life, as well as the polymorphous imagination that helps to shape one's experience and perception, is a process, never fixed and finalized, until death. Even then, the interpretive possibilities for those who view a person's life are endless – unfinalizable, as Mikhail Bakhtin would say. My process, my story, provides the logic for the ideas contained in this book.

Very often at the beginning of a book one finds a biographical note, which sets a broad personal context for what will follow. With this Preface I too frame my agenda in a personal manner. It is by now almost commonplace to acknowledge that one's particularity and situatedness define one's hermeneutics, or interpretive standpoint. But even beyond issues of interpretation, the very questions I ask can be linked to my personal story.

In reflecting about my work as an artist and a scholar and about the vocation of the artist more generally, I have been aided by recent feminist theoretical writing on autobiography.[1] A number of questions have insinuated themselves into the process; I am not the first to think about them. Who is writing? What is the role of personal memory and my own past life in a project like this? Is there an "appropriate" limit to personal reflection? How does my present feminist consciousness shape my memory of the past and my imagination of the future? And how does the act of writing inform who I am becoming? I cannot answer these questions simply. I could say that I experience the self who writes

the present, the self who was, and the self who also continues to grow and age as one creates into the future.[2] But this way of describing the process is ideologically and axiologically neutral, and it belies the fact that writing, and the memory and imagination on which writing relies, is thoroughly value laden. It is never ideologically or axiologically neutral. My values – social, political, religious, and moral – pervade these pages.

Beyond these general questions and concerns related to writing, there is yet another consideration: I am determined to challenge some of the conventions of art historical and theoretical forms in order to make the act of reading more active. For instance, Liz Stanley has identified several innovations of feminist auto/biography (her neologism to name the breakdown of the traditional categories of autobiography and biography) that encourage such active reading. The self-conscious traversing of boundaries between different genres of writing, such as fiction and nonfiction, prose and poetry; the articulation of a social focus, with a "contingent and engaged authorial voice"; and a conscious focus on textual practice and the vicissitudes of the act of writing itself all encourage and even demand active reading.[3] That the book is presented in a format of relatively short chapters should make it accessible, even if the ideas are challenging. But this book is not simply my quirky response to personal desire or to theory construction for its own sake.

If all writing is in some sense autobiography, then *The Vocation of the Artist* is about my own struggles to define my vocation as an artist and a theorist in the world. I feel a personal calling to write this book, a sense of calling that has grown over at least the last fifteen years. The commitment that informs my point of view is neither trendy nor driven by market-based enthusiasm, but it is born of a lived life, full of experience and reflection about that experience.

At age six I wanted to be a teacher or a nurse, ideas that were shaped by cultural and gender stereotypes. I read vociferously and continued to develop my grandfather's and father's stamp collection. I wanted to be a veterinarian; later, I was drawn to psychiatry. I played the flute from age ten, and thought I could be a musician. I loved drawing architectural diagrams on the kitchen table. Still later, my desire to be a Russian translator or to do international work conflicted with a new aspiration to become an artist.

Few of my many jobs have had anything to do with those early aspirations: clerk in a cleaning plant, sales in all departments of a large store, conveyor belt worker in a cannery, waitress, bartender, typist,

elementary school teacher, go-go dancer. But in the past twenty years my work has centered in education.

My search for my own vocation has everything to do with the teachers I have sought: artists such as David Stannard, Bob James, George Kokis, and M. C. Richards; yogis such as B. K. S. Iyengar and Angela Farmer; theologians such as Gordon Kaufman and Margaret Miles. My acknowledgments really begin with these teachers; here, I want to say more about David Stannard and M. C. Richards in particular.

In this book I am seeking the most appropriate vehicle for the expression of certain ideas. This notion, that every idea has its most elegant and appropriate form, was one of the key lessons I learned from David Stannard, my first ceramics teacher. Stannard's teaching was governed by his love of clay, stone, and ceramic processes, by his unflagging curiosity (how our universe was formed, how the microcosm reflects the macrocosm), and by his conviction that each person has ideas unique to her or his position in the world that must be explored and developed. As far as I know, Stannard was not a poststructuralist or new historicist; these terms were not in wide circulation in the late 1960s. My earliest art training was modeled on learning *to wonder*, to ask what, why, and how things came to be, and what could be done, rather than on issues concerning historical tradition or contemporary style. We did not learn enough history or art history, but I developed a commitment to finding out what I think.

Educators and activists such as Paolo Friere advocate learning to question as a pedagogical tool for developing linguistic, social, and political consciousness. Ivan Illich has written that schools teach students the need to be taught, which prepares them for the alienation and institutionalization of life that awaits once schooling has been completed. Students are "schooled" to confuse teaching with learning, grade advancement with education, a diploma with competence, fluency with the ability to say something. By inculcating the idea that there is only one main authority and one right answer (the teacher's), schools thus destroy the desire to learn. This is a devastating critique of public school education, and although Stannard did not articulate it in this way, he practiced another pedagogy. Long before I knew Friere's or Illich's ideas, I had already learned that following the meandering way of questioning led me not necessarily on the quickest route from here to there, but on an authentic quest. I learned from Stannard that every question is valid and that every content carries its own most elegant form and material.

Once a small group of us traveled with him to visit an observatory in the central Oregon desert. We stayed up all night looking through the large telescope at the Crab Nebula and the moons of Jupiter, and watching the campfire – that mysterious and magical element with which we danced at home. I have always loved fire. As a child, I was transfixed by the sight of a neighbor's house in flames. As a ceramics student, I savored every opportunity to light the burners of the Alpine kiln, adjust the air, and create just the right admixture of air and fuel for optimum combustion. Ceramic processes were indeed tied to the *Music of the Spheres,* as the title of Guy Murchie's book suggested. Our teachers were committed to providing an environment that would allow us to engage with those materials. Clay and the other earth elements, fire, water, and air: Suddenly the cosmos seemed alive. In a 1970 journal entry, I wrote that Stannard seemed to me about "twenty years ahead of himself." Perhaps he was one of the first people I knew that I might now call visionary.

In this context, where the emphasis was on our direct experience with the materials, a few texts were also called to our attention. David Green's *Understanding Pottery Glazes* and Daniel Rhodes's *Clay and Glazes for the Potter* were consulted on technical questions. D'arcy Thompson's *Growth and Form,* Christopher Alexander's *Synthesis of Form,* Gaston Bachelard's *Psychoanalysis of Fire,* and Guy Murchie's books were consulted for aesthetic and philosophical guidance.

But, in the winter of 1971, another book was urged on us: *Centering in Pottery, Poetry, and the Person,* by Mary Caroline Richards. Originally published in 1964, the first paperback edition appeared in 1969. Our teachers read it with excitement and invited us to read it too. Here, in a book written by a poet and potter, a woman whose first book was a translation of Antonin Artaud's *Theatre of the Absurd,* was a philosophy of creativity and a philosophy of life. If books such as those by Green and Rhodes might be said to provide the body of ceramics, and by Bachelard and Murchie the intellect, then *Centering* was an attempt to articulate its soul.

In her book, Richards talked in a poetic language about the connections between our work as potters who center clay – who create pots that must withstand the ordeal by fire – and the hard work of bringing into being – through our speech, our gestures, our acts – a self capable of responding, in life as well as in art, to other persons. Here, for the first time, I encountered a vision and articulation of the moral dimension of artistic work. "How do we do it," she wrote, "how do we center in the moral sphere? How do we love our enemies? How do we perform

the CRAFT of life, *kraft, potentia?*"4 "*Kraft*" means power or strength; and we must use that power to form not just the pot, but ourselves. Art, Richards insisted, is a "Moral Eye" that opens and closes, helping us to see truly and to live ourselves into the questions. At the center of her vision there was no product to sell, no "specific object" such as artist Donald Judd touted in the 1960s, but instead a process of becoming, of evolution.

Richards's writing appealed to me because it was vivid, personal. This was no disembodied abstract philosophy, but writing that stimulated the senses. Richards told jokes, describing how we tear and swat and push and pinch and squeeze and caress and scratch and model and beat the clay. She related philosophical ideas to her life as a poet, a potter, a teacher, an "odd bird" in both academic and craft worlds. She talked of the paradox of human longing for union and for separation and of the pain, suffering, and joy that accompany our attempts to live and love. And at the center of all our yearning and urgent activity was mystery and paradox. Richards came to my university art department for just one week, and my friendship with M. C. began then.

Following my completion of a bachelor of fine arts degree in ceramics and of a master of fine arts degree that involved experiments in mixed-media writing and drawing, I began to create installations and performances around the Pacific Northwest. All of my work between 1977 and 1984 dealt with themes of initiation, environmental destruction, death, and regeneration as aspects of both inner and outer life.

In my *Gaia* installation of 1979, for example, I sought to express my pain about the destruction of the earth. Extinction of species; depletion of nonrenewable resources; pollution of the environment – the rivers, lakes, streams, the oceans, the land, the air – through individual and industrial carelessness; nuclear proliferation and problems of nuclear waste disposal; global warming (what I then called "thermal pollution"); decreasing genetic diversity of plants; overpopulation; changes in the structure of the earth's crust due to removal of oil, gas, and other deposits: all of these seemed urgent then. They seem even more urgent now.

In Greek myth, Gaia is one of the names given to the goddess of the earth. It was once believed that she was the creator of all the deities, earth mother and bestower of abundance. Details in the myths of earth goddesses differ in various cultures, but they share the idea that the earth is not a dead body. Rather, the earth is inhabited by a spirit that gives it life and soul. All agree that the earth spirit is female and will give nourishment to those who shelter in her womb.

As with the theorists of the Gaia Hypothesis,[5] I used the name Gaia not to propose a female deity, but to suggest that the entire living pelt of our planet, its thin green rind of life, is actually a single life-form with its own senses, intelligence, and power to act. But just as the body is mortal, so also may the earth be. Confronting the literal destruction of life on the planet, I wanted to create an environment that evoked a counterimage, affirming life and reestablishing a connection with and reverence for the earth. In addition, *Gaia* was my first full-scale attempt to create a work of art that sidestepped the habitual production-consumption cycle, that resisted the commodity market, that neither polluted nor used nonrenewable natural resources.

In 1980, some time after this installation and nearly a decade after our first meeting, I went to visit M. C. in Portland, Oregon. We retired early that night. When we awoke before seven, we lay talking from twin beds on opposite sides of the room. As I complained about the state of the arts, M. C. said that perhaps my task was to teach artists. Their consciousness is no higher than that of "corporate workers," I said. "Few artists seem to embody 'higher' values like community or ecological awareness. Much work seems, sadly, to follow in some kind of artistic tradition, but cut off from the era in which we live." I hear now the youthful judgment of that statement, but I still hold the sentiment. M. C. spoke of her recent experience teaching at an institute where the students seemed especially frivolous and irresponsible in their use of precious materials and nonrenewable resources. "But," I said, "what should artists be doing if they are capable of a visionary potential? What does the culture require?" We mulled this over before getting up. A very specific sense of my vocation as an artist and a theorist was born in this formative conversation.

I was, at the time I visited M. C. in Portland, already scheduled to create an installation at a gallery in LaGrande, Oregon. I chose then, as I still choose, to live mostly in the Pacific Northwest, already a marginalized location vis-à-vis the art world. Expanding on comments by Martha Rosler in "Place, Position, Power, Politics," I observe that in the 1960s and 1970s not only did many artists seek to liberate themselves from consumerist and materialist values by developing art forms such as mail art, installation, and performance, but they also chose to live outside of New York.[6] Moreover, alternative artists' spaces were developed to counteract the power of galleries and museums in the art world. Unfortunately, these strategies for both the production and exhibition of art were not successful in changing dominant art-world val-

ues. It is now rare that major art magazines devote any space to art or artists or even theorists not well anchored in the gallery-museum-magazine network of the country's major cultural centers. But such marginalization, "life in the provinces," as the printmaker LaVerne Krause insisted, does not preclude conversation with others located more centrally in the art world. In addition to the plan I had developed for the LaGrande installation, I decided to solicit contributions from various artists in the United States and Europe concerning the following propositions and questions.

Proposition A: Much contemporary artwork seems to lack spirit and soul. Proposition B: Artists tend to ignore the survival problems facing our species: nuclear proliferation, overpopulation and famine, air, food, water and land pollution by toxins, depletion of natural resources, and so forth. Proposition C: Artists tend to follow an artistic "tradition" and produce objects. This activity fits into cycles of production/consumption responsible for the destruction of life on this planet. Therefore, Question 1: If artists are the cultural visionaries (and I think that the best artists have been), what should they be doing? Question 2: What values need to be either implicit or explicit in the work (aesthetic, spiritual, intellectual values, etc.)? I put the letters and visual responses from artists such as Richard Long, Carolee Schneemann, David Stannard, and Nancy Pobanz on one wall of the gallery during the *Temenos I* exhibition.

The museum, from the Greek *mouseion* (home of the Muses), was once a place for the sacred band of scholars to work and to share their work in tangible communicable form. In two *Temenos* installations, I tried to create such a *mouseion,* a temple for contemplation. For, I thought, in the temple the world is resanctified. Like *Gaia, Temenos* was based on a particular understanding of the title. The word *temenos* meant, literally, the share of land apportioned to the deity. This sacred precinct was the center of worship and the only indispensable cult structure. As both the physical and metaphoric center, its function was to create a space in which problems could be met and the personality protected during change. In Celtic and Druidic worship, the word *nemeton* meant a sacred grove with a spring. In the *Temenos* installations, I sought to reestablish a sense of connection with the body/earth and to rediscover the holy.

During the opening of *Temenos II* in Boise, Idaho, I made my first short performance piece: a ritual of initiation for those who were present at the opening. Between 1982 and 1984 I created four other per-

formance pieces: *Faer/Fear* (1982), *Initiation into the Mysteries of the Goddess* (1983), *Gloomy Monday* (1983), and *The Twelve Stations* (1984).

In 1984, having recently completed a tour of *Initiation* and having returned from a sojourn in India, I decided that I wanted to learn more about how European-American culture had gotten into its (our) current ecological and spiritual predicaments. Among the most pressing of the problems, I thought, were environmental destruction, fundamentalism, nihilism, cynicism, and apathy. How could one understand the broad cultural problems that we face on both individual and institutional levels? Further, my will-to-understand my own creative activity led me to ask questions such as the following: Are there moral imperatives to which art must attend? What is the relationship of human creativity to divine creativity? How can the insights of art historical and theological study be appropriated and used as vehicles for change?

With that ambition to know, I set out across the continent on an intellectual quest that lasted seven years and brought me back to the Northwest in 1991. To acknowledge the time and space traversed is easy; it is harder to describe the expansion of my knowledge and consciousness through those years. This book reflects the evolution of my ideas during the course of my journey.

# Acknowledgments

I want to acknowledge those people who have contributed to the development of my perspective and who have directly supported this project. There are, of course, others besides David Stannard and M. C. Richards who were formative along the way. I have already mentioned others of my teachers: Bob James, George Kokis, B. K. S. Iyengar, Angela Farmer, Gordon Kaufman, and Margaret R. Miles. C. A. Bowers was the first to propose some of the questions about education that have become so central to my thinking.

My colleagues at Washington State University expressed genuine interest and support, especially Christopher Watts, Rita Robillard, Jack Dollhausen, Ross Coates, Sandra Deutchman, Carol Ivory, Ann Christenson, Mike Mandel, Shelli Fowler, Noël Sturgeon, T. V. Reed, Val Jenness, Birgitta Ingemanson, Bonnie Frederick, Don Bushaw, Paul Lee, Francis Ho, Patrick Siler, Patricia Watkinson, and Margaret Sherve, who provided outstanding research assistance. I especially thank Interim Provost Geoffrey Gamble, who, upon hearing a talk that I gave as I was working out the shape of the book, suggested the phrase "reclamation of the future." Washington State University also provided a Completion Grant that covered the costs of obtaining reproductions and permissions.

Although the sources of the ideas that (in)form this book go back many years, my students at Washington State, both undergraduates and graduate artists, gave me the opportunity to test ideas. The first such opportunity was with a group of undergraduates in the fall 1992, when we read Edmund Feldman's book *The Artist*. The students insisted that they needed a more complex account of the evolution of ideas about the artist. I doubt that many would have found the present text easy, but it certainly moves in the direction of complexity! Then, during the fall 1995, a group of graduate artists read the manuscript with me and queried many of its premises and arguments. This latter process was especially useful, as it provided a gauge of the level and persuasiveness of the book.

During the period I was preparing to write, I met a number of Russian artists and curators in Vladivostok, Russia. Among these, Alexander Doluda, Andrei Kamalov, Alexander Pyrkov, Ryurik Tushkin, Victor Serov, Nataliia Yanchenko, Victor Fedorov, Margarita Snitko, and Marina Kulikova expressed enthusiasm as well as disagreement about my ideas on *prizvanie khudozhnika,* "the vocation of the artist." I hope to make the ideas here available in translation for them at some point.

After years of preparation, I began actually writing the book during the Coolidge Colloquium in Cambridge, Massachusetts, in June 1994. Individuals from that diverse group of scholars in several disciplines – especially John Downey, Laurence L. Edwards, Mary Phil Korsak, Suzanne Stewart, Emilie Townes, and Carol White – asked many hard questions that helped to shape what I subsequently wrote. The support of a Senior Fellowship at the Center for the Study of World Religions, Harvard University, provided me with an intellectually stimulating context in which to spend my 1994–95 year on leave and complete the book. I thank Director Lawrence Sullivan and my fellow Fellows, especially Bathula Sree Padma, Emily Lyle, Katharine Tehranian, Immanuel Etkes, and Kimmerer LeMothe, for many vivid conversations. I also thank Duncan Williams and Barbara Ambros, Zen priests with whom I practiced *zazen* during the year. A number of friends and colleagues read chapters and versions of the book and offered constructive criticism. To thank Lynn Randolph, Virginia Abblitt, David Thorndike, Robert Littlewood, Edward Robinson, Rita Robillard, Margot Thompson, Michelle Ross, Laurence L. Edwards, David Michael Levin, Bonnie Frederick, X Bonnie Woods, and Frank Burch Brown for reading various chapters while the text was evolving is not enough, but it is a start. Lynn Randolph, in particular, argued vehemently with me about some of the book's major premises. To her I owe the idea of works of art as chapter epigraphs, or *epi-eikons.* I am especially grateful for our letters and conversations.

Writing, while a solitary task, is never the result of a monologic voice. I learned (again) that work is sustained by intimacy. Friends such as Virginia Abblitt, Louise Dunlap, Rosemary Gordon, Dorrie King, Betty Sawyer, and Zoya Slive have been especially significant. At Cambridge University Press, the enthusiasm, criticism, and support of Beatrice Rehl, Margot Lovejoy, Camilla T. K. Palmer, and Susan Greenberg have helped to make this a better book. For all of the dialogues, personal and professional, I thank my friends, colleagues, and students.

# Preliminary Issues

# Introduction

The androgenous figure in Remedios Varo's 1955 *The Flutist* (Figure 2), let us say the artist, stands beside a mysterious vegetal mountain. In the crevices, and even across the top of the mountain, plants are growing. The flutist is part of and connected to the hill, yet s/he creates the structure on the left by playing the flute. Constructed of stones and fossils and based on an intricate three-dimensional technical drawing, the structure is octagonal at the top, though it is hard to tell how many sides it has at the base. Stairs ascend through the building's three levels, through three arches. High mountains recede in the distance; they seem to be volcanoes. The background is blown and blotted paint; the hillside is built up through this process, a technique that Varo and other Surrealist artists used to emphasize chance and the work and play of the unconscious. Hidden amid the blown lines are tiny scratched marks and painted plants. Colors vary: greens, golden browns, and earth tones, except for the flutist's face, which is inlaid mother-of-pearl. The gender-ambiguous flutist creates using sound. The chord becomes the cord of creation.

From the earliest Greek mysteries to the twentieth century, philosophers and artists have explored the relationship of music, sound, and form. Goethe once declared that "architecture is crystalized music."[1] It is just this notion that we see in Varo's painting. Here the vibrations created by sound are powerful enough to construct the three-tiered temple from fossils and stones. Here the artist linked the human to natural cosmological processes.

This painting is a meditation on creation. It literally demonstrates the power of the music of the spheres. Through sound, the flutist constructs an edifice. Who will live there? We can only imagine. Varo's *Flutist* illustrates the profound relationship between creativity and hope for the future. But toward what does this creative process lead? What kind of world will it be? What future will unfold?

\*    \*    \*    \*    \*

The vocation of the artist is the reclamation of the future. What does this bold statement mean? Who is an artist? To which artists does this statement refer? Why use a seemingly old-fashioned word like "vocation" to describe what artists should be doing? What gives me the right to say what artists "should" be doing in the first place? Why the concern about the future, and why does the future need reclaiming? Such issues and questions form the ground against which I see the figure of the artist at work and play.

The problem I am setting out to explore concerns our situatedness in a largely pluralistic, postmodern, and nuclear era. This complex phrase indicates, first, that there are few shared religious and moral values, and in fact, in some quarters, no clear values at all; second, that there is no consensus within the cultural arena about what art is or should be and little attempt to articulate its purposes; and third, that the stakes in this highly ambiguous and uncertain context are high. Ecological destruction and nuclear annihilation remain distinct possibilities. In my view, our social, political, and ecological situation on the planet lends a vividness and an urgency to both the artistic and the religious spheres of culture, because it is through artistic and religious imagination that we envision the future.

Along with cultural critics such as Fredric Jameson, I bemoan the loss of the ability to imagine possible futures other than total devastation. Many people, including artists, are presently unable to envision the future at all. In the past, people talked about, and visualized, their lives extending forward into the future. Now, most of us feel as though the only future we can see is very close in time to the present. We plan for today and tomorrow, maybe next year, or two years hence. In this context, there is a genuine need for both theoretical and practical discussions about the cultural function of the artist in contemporary society. We must regain the capacity to act and to struggle, a capacity that is rooted in prophetic criticism and visionary imagination and is in many respects presently neutralized.

In particular, in this book I articulate a vocation for the artist as prophetic critic and visionary. Using a specific interpretation of these words, I bring attention to the need for artists to assess critically the relationship of the past and present to the future. Indeed, we need to reclaim the possibility of a viable future in order to create it.

"Reclamation" is a noun that suggests land-use planning or land previously used for garbage dumps. As a child, I regularly accompanied my father to a site near Kent, Washington, where we would literally dump our family waste into a huge pit. Later, the pits were replaced by

giant containers that would be wheeled away to some distant unseen site. Later still, the city of Kent commissioned artists to help in the reclamation of the site by designing a park. Reclamation in this sense suggests a shady, grimy, disorderly, *messy* past that needs to be cleaned up. "Ecology," "recycling," "ecofeminism": Such words beckon us toward the future, for we reclaim something to make use of it in the present, as that present extends forward in time.

The prefix "re" normally indicates three possibilities when attached to verbs. It means backwards or back, as in re-act. We "act back" at another person or at an event. Life is indeed a series of interwoven reactions. "Re" also means to intensify, as in re-fine. I refine the language of my ideas in order to clarify and hone their meaning – to refine, to take out the dross. Finally, "re" often means to do something again, anew. We continually re-define the questions and re-evaluate decisions that determine reflection and action.

My assertion that the vocation of the artist is the reclamation of the future carries all of these prefixal connotations or inferred meanings. To reclaim, we look back at the past, surveying it for insight into the

Figure 2. Remedios Varo, *The Flutist*, 1955

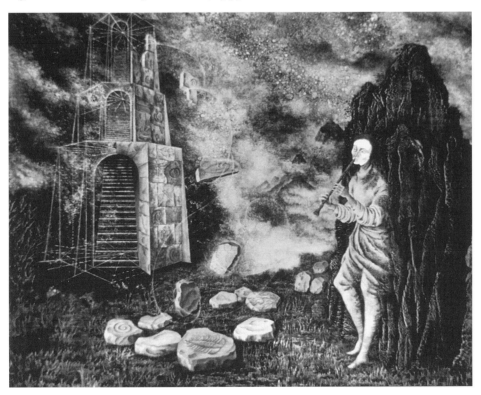

present. This is not a mild act, for to reclaim is also to intensify the act of claiming. We reclaim, again and again making clear the commitment to this act.

Reclamation, in this sense, is a benign, even (re)constructive act. But it also has a more sinister implication, for reclamation can also imply colonization. To reclaim in this sense is a magisterial act, an attempt to impose upon the unknown future the relative values of a particular present. The artist Lynn Randolph said to me, "You can't reclaim what you don't own! To try to do so is an imperialist act."[2] With this language, she asserts, we would colonize the unknown, an act that has already been tested in history with perverse and horrific consequences. Can we reclaim what we have never known? Or can we reclaim what we can never really own? Of course not. But the power of the language lies in the metanoia it hopes to accomplish.

The reclamation of the future is an imaginative act. If you, the reader, imagine one future, I another, she or he still another, we begin to create the possibility of envisioning multiple futures. And this could have profound results. The very multiplicity of possible futures means that we would create nonstatic utopias – heterotopias – ever-changing fluid visions of what could be. Reclamation founded on such ground, if it can be called ground at all, can never colonize, for it is open to change and imaginative transformation at every point. Furthermore, attempts to imagine and reclaim the future must always be grounded in the awareness that history has not been, and will not be, a linear process. As Wittgenstein put it, "When we think of the world's future, we always mean the destination it will reach if it keeps going in the direction we can see it going in now; it does not occur to us that its path is not a straight line but a curve, constantly changing direction."[3]

The reclamation of the future implies critique of, subversion of, and strategic intervention in the present, based on what we understand as the possible consequences of that present. Yes, there is a sense in which the future is already in the present, implied, as that-which-is-not-yet-but-will-be-soon. The technoscientific future we envisioned only yesterday is upon us today.

Perhaps it would be more accurate to say that the future is already making its claims on us. The future penetrates the present; it penetrates our very existence. The future hurtles toward us, no "slouching toward Bethlehem," no "sailing toward Byzantium." Slouching and sailing are slow processes, implying time to take in one's surroundings in a leisurely way. But our technofuture in cyberspace, "manned" by cyborgs of every

(in)conceivable variety, is constantly forcing itself into our present. This new future claims *us,* at least those of us who notice.

Nevertheless, we have largely abandoned the future. Consider water for a moment. Water tables are dropping. Water that is no longer fit for human consumption without purification flows down the drain while we wash the dishes or brush our teeth. I boil the water not only in Bombay, India, or Vladivostok, Russia, but in Cambridge, Massachusetts, and Pullman, Washington. If growing populations are sure to make extraordinary demands on energy production and distribution, then potable water is and will be among the most pressing problems. This abandonment of the future through our collective refusal to face the consequences of our present acts will haunt us.

In this context, to urge the reclamation of the future seems a modest exercise. Is the future at risk? I believe that it is. Can it be reclaimed? Time will tell.

## METHODOLOGY

Drawing primarily on the resources of cultural history, especially art history and theory and the study of religion, *The Vocation of the Artist* is addressed to artists, to scholars in cultural studies, and to those interested in the complex interdisciplinary dialogue of the visual arts and religion. The use of resources from art history and art theory is obvious for a project dealing with the cultural function of the artist.

Against earlier formalist art historical methods, Linda Nochlin has described three of the major challenges and revisions to art history that have been useful: the social history of art; the supplementary, revivalist, or "they-also-ran" approach; and the pluralist, or "let-a-thousand-flowers-bloom," model.[4] Each of these approaches, while it has merit, also is problematic. The social history of art, for instance, does not address the issue of the artistic canon itself, the so-called great artists and major movements of the history of art. It also does not question the status of history, but accepts history as a given, a foundation against which visual representations may be understood. The supplementary and pluralist approaches run the risk of another kind of distortion: failing to read the past critically or to deal with the ideological nature of the work in a particular context. In the enthusiastic attempt to include Others, much is left out. Nochlin's own answer to these dilemmas is "thinking art history Otherly": to use her feminism, her personal

vantage point of Otherness, to examine how politics and ideology are implicated in representational practices. I am also committed to such a point of view. Analogously, issues of difference and representation thoroughly inform my teaching of art theory and history.

But Nochlin's comments leave out yet another alternative open to the new art history. Art, left alone in its self-imposed ghetto, has preyed on its own past long enough. By entering into new dialogues with other disciplines, by righting the Enlightenment wrong turn whereby aesthetics was separated from science and morality, the arts and their practitioners – artists, historians, theorists, critics – may gain new and vitalizing energy. I believe that we need to develop *ethical aesthetics*, which, unlike other varieties of lofty and skeptical criticism, will be flexible and helpful, combining care with judgment.[5] The goal of this ethical aesthetics will be to allay the sense that (to paraphrase a song by David Byrne's band, the Talking Heads) we don't know just where we're going and we don't know just where we've been. But to attempt such a synthesis of aesthetics and ethics also necessitates reexamination of complex and tangled values, philosophical constructs, and art historical dicta.

In another example, Ellen Dissanayake has tried to reclaim the arts from postmodernist dissolution with the help of a biological and evolutionary perspective – what she calls "species-centrism."[6] From this point of view, art and art making are normal and necessary parts of human activity in all cultures and all times. I agree with her that if, with our hyperverbal and deconstructionist postmodern aspirations, we succeed in erasing and eviscerating art, we are only impoverishing ourselves.

The new art history and art theory are especially comfortable with the diverse methodologies of literary theory and psychoanalysis. Frequently, new historians and theorists invest their scholarly work with the currencies of these disciplines. But religion remains a suspicious partner, its "currency" thoroughly implicated in all kinds of patriarchal and hierarchical disasters. In academic quarters, the institutions of religion are often regarded with skepticism, if not contempt. If God is dead, as many since Nietzsche have proclaimed, then shouldn't we let "him" lie?

Art historians are willing to use the discourses of religion to explicate the past, but few find its vocabulary useful for understanding contemporary art and for explaining contemporary artistic practice. This book aims to create a new dialogue that will be accessible to scholars and practitioners in both arenas. The relationship between art and religion

can be described as a somewhat one-sided affair. Art history and theory have largely rejected religion, whereas religion – as an academic enterprise at least – has embraced the arts.[7] I hope a few further comments about the role of religion in the conversation will aid the reader, especially the skeptical secular reader who might resist, in understanding my use of resources from the study of religion.

In recent years numerous attempts have been made to bring religion back from its marginalized position within the academy to a more central position in both academic circles and public discourse. These efforts continue today. Scholars are working on such diverse issues as the role of theology in public policy debates; the religious issues surrounding women's reproductive health care, including abortion; liberation theology and political life in Latin America, Asia, and elsewhere; religious themes in literature; and the role of faith development in psychological growth. Such projects bespeak a multifaceted attempt to bring religion into dialogue with other fields of inquiry. Not the least of these has been work in the interstice between religious studies and the visual arts.

Interdisciplinary work in the arts and religion is proceeding with theoretical, analytical, and practical goals.[8] The theoretical focus is primarily concerned with issues such as how their visual and verbal languages are similar and how they are different, or the dilemmas of the two disciplines. The analytical focus is concerned with the use of the arts as sources and documents for both historical and contemporary analyses of faith and culture. The practical focus is concerned with the role of the arts in education, worship, and ministry. Perhaps the least attention in this new dialogue of disciplines has been given to questions of theory and method, which include the relationship of theology and the arts.

How, for instance, does *theology in the arts* – the analysis of theological content in specific paintings of Caspar David Friedrich or Vasily Kandinsky, for example – differ from *theological interpretation of the arts* – how various artistic media such as literature, music, or painting reveal religious insights, a topic that Susanne K. Langer explored in *Feeling and Form*. Of more direct interest to me, however, is the difficult-to-describe area sometimes called *theology of the arts*.

A theology of the arts delineates the role of the arts in addressing the religious and moral dimensions of culture, and it also sets forth the limits of what the arts can and cannot do for theological understanding. As a theoretical enterprise it addresses many questions: the revelatory, prophetic, and sacramental potential of the arts; how the arts aid in our understanding of religious doctrines concerning issues such as creation

and death, as well as post-Christian ideas and values concerning the sacred; the role of the churches and of secular institutions in supporting the arts; the religious and moral dimensions of creativity, including the development of religious aesthetics; and the vocation of the artist, which is my central concern here. Although I will not emphasize that this book may be read as one aspect of a theology of the arts, *The Vocation of the Artist* is part of this new area of inquiry.

The Romanticism of the early nineteenth century was concerned with the artist as tortured bohemian or prophetic genius. The late-nineteenth- and early-twentieth-century avant-garde (at least one strand of it) was concerned with the work of art, the art-for-art's-sake object that could be best analyzed using formalist vocabulary. Mid-twentieth-century and early postmodernists opened a way for the viewer/reader of the art/text. Perhaps we are now ready to reconsider the creator in the creator-object-viewer triad – not from the point of view of the biography of this exemplary human specimen (usually conceptualized as male), not as an avant-garde luminary, but as a person, a human being with a particular calling and vocation. For help in this process, I turn to the study of religion, with its theological and ethical discourses and many cultural traditions.

In the process of writing, I have encountered various subdisciplines within the study of religion. For instance, the study of prophecy and apocalypticism continues to engage scholars, some working across traditions, others working within one tradition. Still other scholars look at prophecy from the perspective of another academic discipline altogether, such as anthropology. But the reader should be clear in advance that at no point have I attempted to read, assess, and "master" all of the scholarly literature in these diverse fields of inquiry.

This is also true more generally. My methodology goes against the tide of discipline-specific inquiries by traversing the grounds of cultural studies, philosophical aesthetics, and especially, art history and the study of religion. My inquiry itself ranges from general philosophical principles to history to a polemical stance that is deeply informed by a particular assessment of the present. I have, to paraphrase Barbara Stafford, deliberately chosen breadth, without, I hope, sacrificing depth. The scope and significance of our cultural predicament necessitate such a comprehensive approach. I have tried to deal with complex material "complexly," without reducing it to false simplicities.[9]

*The Vocation of the Artist* was neither conceived nor written as an explication of a particular philosopher's, writer's, historian's, or artist's point of view. As Arthur Schopenhauer once put it, thinking never

happens in isolation, but there is virtue in "thinking for oneself."[10] Here I seek to clarify ideas of my own that have been evolving for many years. In the process, I inevitably draw on the ideas of many others. For instance, I found in Herbert Marcuse's and Hannah Arendt's work, respectively, supportive and provocative points of view regarding the relationship of art to social change, and a useful set of distinctions concerning labor, work, and action. Or, in discussing the denigration of vision in twentieth-century thought, I have drawn on the ideas of Maurice Merleau-Ponty and Mikhail Bakhtin. However, I did not seek to evaluate all of the secondary writing on any of these writer's ideas.

There are other inescapable tensions that accompany the writing of a book like this. The book originated in convictions born of my experience as a practicing artist and scholar, as I indicated in the Preface. It is also a thoroughly postmodern enterprise, in that it draws from a wide range of historical and theoretical materials. Postmodernism offers new approaches to issues surrounding discourse, knowledge, truth(s), and validity. For me, postmodernism must be linked to feminist theory and practice, which can help to counter totalizing perspectives. Together they constitute a "rejection of epistemic arrogance for an endorsement of epistemic humility."[11] This humility means specifically that I acknowledge the way my particularity grounds my perception and action. Also, postmodernism offers a perspective from which to see discourse itself as a process of interaction rather than as a structure that articulates truth or falsehood. The interaction of my own with others' ideas is apparent at every point.

From the outset, however, I have maintained a particular point of view. I aim not for simplicity, but to hold complexity in view, not for universality of meaning, but to acknowledge particularity, not for a totalizing unity, but to articulate a singular vision, placing my perspective within our thoroughly pluralistic cultural context. In the process of working out this complex and particular point of view, I have repeatedly asked what will help to clarify this perspective and make it more persuasive? Where do I find compatible or challenging ideas, as well as images that illustrate my ideas?

My remarks on these pages constitute a plea for a religiously and morally grounded artistic practice, an *ethical* aesthetics. I am aware that for traditional religious people my generalized language will be perceived as totally inadequate, as depriving religious and theological discourse of all its power. For these readers, a religious aesthetics, as it has been articulated by Frank Burch Brown, may be more meaningful.[12]

Paradoxically, what I say may also be unsatisfactory to a secularist or an atheist. From a deeply secular perspective, my attempt to articulate a religious and moral understanding of the vocation of the artist may seem misguided or even futile. I accept that some readers will find this emphasis alien. To these persons I can only counter that mine is one point of view in a diverse and thoroughly pluralistic culture. I would argue, however, that the point of view articulated here makes more sense during the last few years of the twentieth century than one focusing on short-term monetary gain or fame.

The nature of art itself is changing, especially with the accessibility of newer electronic media and other time-based genres such as installation art, performance art, and video art. Just as modernist aesthetics can be linked to the invention of photography and its ramifications for the perception of the world (and to nineteenth-century processes of imperialism and colonialism), so postmodernist aesthetics can be linked to the evolution of television, video, and the computer (and to the wider process of decolonization and to new opportunities to hear the voices of those on the margins). All of these developments change what art is and what it will become in complex ways, and they offer new possibilities for the role of the artist, as we shall see.

## GOALS

My goals for *The Vocation of the Artist* are personal, historical, and polemical; the overall structure of the book reflects this. Readers interested in one or another part of the book are invited to start or focus their reading there. The Preface already presented some of the personal experiences that inform the book. Part I deals with preliminary issues about the artist, vocation, and the efficacy and power of art. Part II is broadly historical: It provides historical context for my interpretation of the vocation of the artist through an examination of premodern, modern, and postmodern roles of the artist. Finally, Part III contains the polemical core of the book. Most of the book is concerned with what it means to speak of reclamation of the future, but here the reader will find my argument about the nature and significance of prophetic criticism and visionary imagination.

While this terse summary describes the structure of the book by topic, a few further remarks about my goals will help to ground what follows. I write, first, from a personal perspective, although surely many others share similar standpoints. My desire to speak of the vocation of the

artist is grounded in my training and experience as a practicing artist and as a scholar who has stepped outside the boundaries of the studio and into the worlds of cultural history and theory.

If the narration of my own quest were the main goal of *The Vocation of the Artist,* however, I would not write this book. None of the issues I address here are new; there are historical precedents for my proposal that artists (can) have prophetic and visionary functions. Indeed, a history of how the cultural role of the artist has evolved will help to set the stage for understanding why the prophetic and visionary functions have fallen into disfavor, or at least are often met with skepticism and indifference. I will show why it is important to consider the vocation of the artist now, in the final years of the twentieth century at the end of the (Christian-based) second millenium. Perhaps every *fin de siècle* is inherently oriented toward the future – some would argue that these periods are even apocalyptic[13] – and this was true of certain movements of the late nineteenth century. Our time is no exception.

History has both personal and cultural (social-political-economic) dimensions. In Part II of the book I turn to broad cultural developments, especially a narrative about the roles of the artist within modernism, the avant-garde, and postmodernism. Since the appearance of the now famous essays by Roland Barthes and Michel Foucault in 1968 and 1969, respectively, we have heard much about the death or disappearance of the author or artist. Walter Benjamin's essay on the author as producer brought attention to the fact that since the development of photography, authors and artists have had new opportunities to extend their work into the public sphere; but this is a mixed blessing. So far, however, there has been no comprehensive history of the modern and postmodern that concentrates on the changing roles of the artist in culture. The chapters of this section, although perhaps not comprehensive enough, move in that direction.

Beyond this particular focus, I have another agenda for Part II. I am interested in the categories of the modern and modernism, the avant-garde, and postmodernism not only in aesthetic terms, for what they tell us about art movements, but also in broad historical and cultural terms. It is hard to "grasp" history and historical developments, for history is notoriously slippery. As new historicists in particular have shown, what history is depends upon interpretation, which is determined by many factors, including the interpreter's standpoint.

For a number of years, I have attempted to make sense of both modern history and the postmodern present. Hegel was the first modern philosopher to assert that no civilization, and certainly no individual

within a civilization, is capable of identifying itself completely. Only after its demise and in retrospect can an age be fully comprehended. R. G. Collingwood put this insight slightly differently: Every era has absolute presuppositions that cannot be clearly articulated, but which provide the inspiration for more explicit values. Strictly speaking, from this perspective, it is folly to try to conceptualize the present. Discussing the nature of any era is controversial and ideological: All kinds of aesthetic and political value judgments and diverse meanings are attached to every point of view. I acknowledge the difficulty that Hegel points to, and agree with Collingwood that we cannot articulate all of the presuppositions that ground contemporary life. Honest self-reflection is notoriously difficult; the task is compounded when one wants to understand one's present cultural context.

On one level, and there are many levels here, this book is about the language that (in)forms our conceptions of artistic creativity. Against the claim that originality and artistic creativity are dead (or at least dead issues), that all we have are irony, parody, and pastiche, I hold that creativity is intrinsic to the life process and to the artistic vocation. Things degrade and decay, are made and remade. People are continuously being born and dying. Creativity is unstoppable. But the book is full of "vocabulary problems," as one friend put it, for much of the language I use is thoroughly contested. Words like "modern," "avant-garde," "postmodern," "prophetic," "imagination," and "visionary" are ever-shifting signifiers; there are, for instance, many incommensurable ideas about what constitutes modernism, the avant-garde, and postmodernism. Confronted with such complexities, I am reminded of a much-used word in Mikhail Bakhtin's early essays: *zadannost'*.[14] Difficult to translate, the word means "that-which-is-set-as-a-task-to-be-accomplished." The aforementioned problems notwithstanding, my task is set in the sense of *zadannost'*. Thus, the chapters in Part II outline parameters and clarify definitions, especially those defining past and present roles of the artist in order to better understand possibilities for the future.

My effort to do this may itself be understood as part of an intense longing – though perhaps "longing" is too ethereal a word – to understand how we human beings, living in the United States in the late twentieth century, arrived here, "to know the place for the first time," as the line from T. S. Eliot's *Four Quartets* suggests. There is, of course, the old adage, articulated so well by George Santayana: Those who do not know the past are condemned to repeat it. How we interpret the recent past, especially the last two centuries, bears on how we under-

stand the present. I do not hold naive hopes that my writing will somehow free me or the reader from repeating either aesthetic or actual historical acts of the past. But I do have utopian aspirations: that our understanding in new ways where we have come from will enable us to make new assessments of and to initiate action regarding where we are headed.

Certainly it is arguable that earlier utopian and spiritual aims for art have been thoroughly subverted and that in the cynical circumstances of our postmodern condition, to speak of utopian aspirations is folly. But postmodernity is a complex cultural construct, with at least two contradictory trajectories. One of these is indeed cynical, even nihilistic; but the other, although perhaps less highly visible and less sensational, is critical, reconstructive, and passionate. I will have more to say about these issues in Part II.

The relationship of history to memory is complex. In contemporary society, with the loss of notions of the self constituted by religious identity (self as soul) or communal identity, memory has become a private psychological faculty. This privatizing and psychologizing of memory makes it very difficult for people to believe that they share the past or have a collective connection to what has happened in history. Obsessed with our private pasts, we lose track of shared histories of people.[15]

William Olander, curator of a 1985 exhibition titled "The Art of Memory, The Loss of History," has described memory and history in stark terms that emphasize their instability and fragility: "Memory. It is unstable, fragile, problematized. At present, it is not a matter of remembering, but of what is remembered and its relation . . . to its 'reality'. History. It is no longer constituted by the facts, but by just so many memories, informed not by events, but by their [electronic] representations. It is as elusive as anything else in today's society."[16] That elusiveness has everything to do with one's situatedness. As a person of European-American descent whose ancestors chose to emigrate here in the seventeenth and eighteenth centuries, my past is different from that of an African American whose ancestors were forcibly brought to the United States as slaves, or that of a Chinese American whose ancestors were lured here to build railroads throughout the west and suffered the indignities of white suprematist attitudes. All of these experiences are clearly different from those of the many newer immigrants to the United States, who bring perhaps closer links to traditional cultures elsewhere.

Given this set of contexts, what does it mean to recall the past? Whose past? Can "we" assume a common or shared past? No, I cannot make this assumption; but I can at least set out consciously to examine

some of the dominant mythologies surrounding the artist. Some of these mythologies are transcultural and transnational: They cross cultural and national boundaries. Artists have been in diverse cultures heroes, magicians, healers, shamans, revolutionaries, and commodity producers. Artistic creativity can be defined around other myths, usually identified with men and masculinity: alienated and marginal recluse, madman, starving bohemian, martyr, wealthy cultural hero, businessperson, eternal child, near-divine creator, or imitator of God.[17] These certainly relate to the myths of the past, but some are modern and postmodern inventions.

The history I set forth here does not pretend to be universal or global. I am interested in the forces that have shaped contemporary culture in the United States, and that means certain questions weigh more heavily than others. How does gender influence our interpretation of the roles of the artist? The presence and contributions of women have had significant, and differing, impacts at various historical moments. How does one account for the diverse cultural influences that have led to the main governing paradigms for artistic production today? What insights do we glean from other cultural contexts? In contemporary Australia, for instance, aboriginal artists work out of a strong indigenous background but also embrace western modernism. In parts of Oceania, women are the primary artists.[18] In Tibet thangka painters and in Russia icon writers have evolved specific, and compelling, creative processes that I describe in more detail later.

Cultural pluralism, including my encounter with world religions and the effects of changing demographics in the United States today, enters this narrative at various points. Indeed, pluralism is perhaps one of the most challenging issues that confront me as a writer. The increasing fragmentation of all the categories of analysis, such as gender, class, race, sexuality, ethnicity, and even religion, makes it nearly impossible for me to make generalizations. This fragmentation challenges the privileging of a particular political or ideological identity (including my own), as well as easy coalitions.[19]

Still, much is elided or glossed over in my descriptions. I take heart from Richard Rorty's radical ideas about the history of philosophy. Rorty insists that philosophers should give up trying to write books (or chapters, we might infer) called "A History of Philosophy" that claim either objectivity or comprehensive coverage. Rather, the writers should be free to seek their own intellectual ancestors or even to say that they have no ancestors at all, to pick out bits of the past or to ignore it completely.[20] Whereas this describes quite well my approach to the range of materials I have studied, it is especially pertinent to the his-

torical chapters. I do not ignore history, but as the reader will see, I am selective about what I include in the narrative.

This leads directly to the polemical goals that inform the book. The word "polemical" comes from the Greek *polemikos*, meaning warlike. In more common usage it implies controversy and controversial argument; my ideas may confront the reader. *The Vocation of the Artist* is related to the discourse during the past few decades about contemporary art, as well as to the emerging discussion about the relationship of the visual arts to the study of religion in modern and postmodern culture. Ever since the Renaissance and Vasari's *Lives of the most excellent Painters, Sculptors and Architects*, there has been a great deal of interest in the person and personality of the artist. The idea of the (male) artistic genius was clearly articulated by Kant in his *Critique of Judgment*, and art historians have for centuries found much material for analysis in an artist's biography. More recently, Rudolf and Margot Wittkower's *Born under Saturn* documented changes in the character and conduct of male artists from the ancient world up to the French Revolution. Their work, however, like Vasari's, remained focused on biography.

In art history, as in literary criticism, there has also been a concurrent focus on the object – sometimes on the object as a reflection of the artist's biography, or, as in traditional connoisseurship, on the stylistic and symbolic language of the object. From this standpoint, the social, political, and economic setting of a work of art would be less important than its stylistic uniqueness and connection to other objects. One of the main contributions of Marxist and Neo-Marxist analysis has been to bring the full context of an artwork to the fore.

As I described in *Bakhtin and the Visual Arts*, since the late 1960s attention has largely shifted to concern with either the object or the viewer.[21] Formalist, structuralist, semiotic, and deconstructive analyses center on the object. Poststructuralist writings, including reader-or viewer-response criticism, have focused on the formative role of the receiver in the creative process. These interpretive strategies have involved a healthy breakdown of standard stereotypes of the artist as genius, divine imitator, or hero. But much of value has also been lost with this realignment of interests. There are (at least) three major problems with the emphasis on the viewer/receiver.

First, feminists argue that white male theorists such as Roland Barthes and Michel Foucault concentrated on the "death of the author" precisely as women of all races and men of color entered the public sphere in increasing numbers.[22] Second, this reorientation toward the viewer/receiver turns attention away from questions regarding the pro-

duction of art to those concerning the consumption of art. This is not surprising given that late-twentieth-century American culture is thoroughly caught up in, we might say strangled by, a consumerist ethos. Art history and theory are analogously enamored of the object (the consumable product) or the viewer (customer or commodity buyer), or more recently, of its own historical foundations (thus consuming itself like an uroboros). Many contemporary critical theories are theories of and about consumption, seeking to understand objects so that they can be "profitably and correctly consumed."[23] Another approach is to consider art, including its objects, as a practice and to analyze conditions of that practice, such as the pressures and limits governing social production or the way ideology shapes representation and thus influences perception. Many artists, both aspiring and established, are also caught in patterns of production for consumption, with a quick buck and fifteen minutes of fame in mind. But I am after something else here. When we begin to ask about the cultural function of the artist, we move beyond consumable products and toward larger questions that have political, economic, and moral consequences.

My third objection to a viewer-centered criticism is that it tends to negate any sense that the artist has a vocation or calling to do artistic work of moral and religious significance. This is the main idea that undergirds the book as a whole. My use of the word "religious" throughout this book highlights the way human beings create order and meaning in life and in relation to death.

I am dismayed by the pervasive fragmentation, commercialism, and nihilism of much current artwork, as artists strive to succeed in the art market. Yet I do not hold a naive optimism that simply articulating a persuasive argument for considering the prophetic and visionary dimensions of artistic creativity will change dominant artistic practices. The art world, with its exclusive market and hierarchical museum and gallery system, all too easily participates in the worst forms of greed and materialistic acquisitiveness. The political and economic pressures on artists to conform within this system are too pervasive and, sadly, often too compelling to resist. In this context, there is a need for an exploration of alternatives.

If we need to create and attend to images that help us to stretch imaginatively into the future, then it may be crucial to depict the human body. Of course, related to the depiction of the human body are many complex problems around gender, race, and representation, and especially concerning ways in which the female body is already overly objectified and fetishized in the traditions of European and American art.

In this context, what might be the role of androgyny? Alongside the many other issues raised by Remedios Varo's *Flutist*, the gender ambiguity of the figure is notable.

And what about abstract art? In the twentieth century, the early abstract art of Kandinsky, Malevich, and Mondrian has been linked to both spiritual and utopian visions. Contemporary artists such as Porfirio DiDonna, Joan Snyder, and Margot Thompson remain committed to an abstract vocabulary. I do not mean to deny the personal transformative power of color, line, and abstract form; but I find myself wondering about its larger accessibility, and hence, its efficacy. Although I cannot fully answer such general questions here, these are two of the many subthemes that will surface from time to time.

The creativity of both well-known and lesser-known artists provides a concrete point of reference throughout *The Vocation of the Artist,* but I do not to offer an apologia for their work or develop lengthy critical responses to it. In order to illustrate various ideas, I describe works of art that provoke more than the usual five-second consideration in a gallery or museum. We are now in the process of forming the canon of artists whose names will be associated with the last few decades of the twentieth century. I purposely have chosen to include some artists who probably will not be in textbooks and overviews of the 1980s and 1990s, to emphasize that the ideas presented here are not unique to well-known artists, but are accessible to, indeed sometimes best articulated by, artists marginal to the New York art world.

Instead of traditional epigraphs to the chapters, I open each chapter with an image that can be viewed as a meditation on the themes of that chapter. I also attend to the diversity of art forms – from painting and sculpture to performance and electronic or digital imagery – that demonstrates the radical pluralism of contemporary American culture. Of course, choices had to be made about the works of art I would consider; regrettably, I was not able to deal at all with public art, such as Maya Lin's fine monuments, or with others of the plastic arts such as ceramics.

Some of the most innovative and generative expressions of resistance to our present cultural situation are coming from postmodernist artists, such as Kim Abeles, James Acord, Judy Baca, Suzanne Bloom, Erik Bulatov, Mary Beth Edelson, Ed Hill, Jenny Holzer, Suzanne Lacy, Louise Lawler, Richard Long, Bruce Nauman, Lynn Randolph, Miriam Schapiro, Joan Snyder, James Turrell, Bill Viola, Carrie Mae Weems, and Fred Wilson. What is missing in public discourse is a broad theoretical foundation for these artists and others to interpret their work, and indeed, their vocation.

# A Proposition

**A** life-size, *child-size,* puppet dangles from unseen strings (Figure 3). Its body covered by maps of the earth, the puppet is on fire. Flames spring from its arms, back, legs. Still, it strides ahead, as if compelled by the forces of history to continue its forward march. Will it die? Will the flames engulf the figure? David Wojnarowicz's 1984 *Untitled (Burning Child)* is a potent metaphor for our present moment.

* * * * *

As a whole, *The Vocation of the Artist* develops a sustained argument about the prophetic and visionary function of the artist in contemporary culture. The book's personal, historical, and polemical chapters are meant to forward this point of view. But here, early in the book, I want to state succinctly some of the values that ground my argument about art and the cultural role of the artist. Although this chapter is not personal in an autobiographical sense, it is personal in that it articulates my convictions. Along with Chapter 11, this chapter directly represents my own contingent and engaged authorial voice.

With the questioning of avant-garde values, it is by now commonplace to say that the artist can no longer be seen as either a privileged or an idiosyncratic visionary with special access to the prophetic sphere. This had been the view held by German Romantics such as Caspar David Friedrich and Philipp Otto Runge (Figure 14), the French and Russian Symbolists (Figures 28 and 15), and members of the Russian avant-garde such as Kasimir Malevich (Figure 16) and Mikhail Matiushin. Instead, I propose that *the artist is a self-critically engaged agent in particular situations, calling for reclamation of the sacred and the future in a world that seems in many ways to be dying.*

My proposition is declarative, but it bears acknowledging that this is not the only work that an artist can undertake. I will return to this important theme in the chapter on vocation. This book is addressed to visual artists and others engaged with the visual arts, but I hope it will

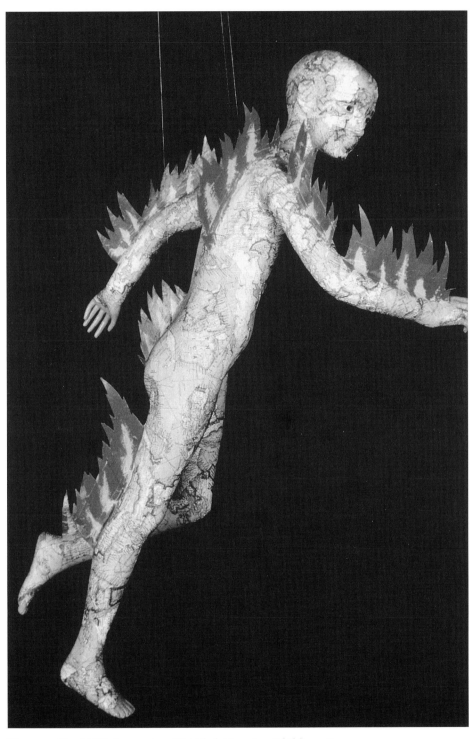

Figure 3. David Wojnarowicz, *Untitled (Burning Child)*, 1984

also be relevant to other cultural workers – to writers, musicians, actors, and dancers – who are concerned with the larger questions of their responsibility as artists. Before considering the language of my statement, however, I believe a few remarks are called for about how I arrived at my judgment regarding the role of the artist in contemporary culture.

My judgment regarding the role of the artist is related to two aspects of aesthetic judgment more generally: the judgment of quality and the judgment of value when evaluating works of art. First, neither quality nor value is a monolithic category, applicable transhistorically or transculturally. Both are specific to time – historical moment – and to place – physical location. Thus every work carries its own chronotope, in Bakhtin's sense, and must be pragmatically evaluated based on its specificity.[1] Issues such as craftsmanship and competence, complexity and/ or simplicity, inventiveness and innovation, the sphere of influence, how the work engages the viewer, the nature of authorship, scale and ambition as reflected in the work: all of these help to guide pragmatic judgments. None is absolute in itself.

Analogously, I have already been at pains to show that the perspective developed here is indeed time and place specific. I am not saying that this is the only possible perspective that might guide artistic creativity or that it has dominated in other historical moments. We (I, the writer, and you, the reader) live near the end of the twentieth century, in a time of growing disparities between nations and even between the citizens of this country. Our present moment in the United States is characterized by relative economic decline for the majority of people, unprecedented public and private debt, short-term profiteering by powerful individuals and corporations, inadequate education, a stubborn refusal to use resources in the public sphere, and the erosion of civil society, which means the inability to transmit values concerning the meaning and purpose of life in general. Market values (what I want and how I can get it) triumph over human values of love, community, and justice. I agree with Cornel West that if this situation continues, we "will enter a long and dark tunnel of increasing disorder, cultural anarchy, and communal chaos."[2] This book is addressed to readers who find such a description compelling.

Second, neither quality nor value is simply an aesthetic category, although modernist expressivist aesthetics in particular tried to isolate quality and value from the larger nexus of ethical and social consequences. Similarly, the roles we define for the artist have moral and ethical consequences. When the artist is primarily an entertainer, atti-

tudes of complacency, satisfaction, and acceptance of the status quo tend to be inculcated in the audience or viewer. The ramifications of the artist as prophetic critic and visionary move out in quite another direction.

To claim, as I do here, a particular identity for the artist entails having a perspective on creativity. Some see creativity as essentially an aesthetic act, separated from the other dimensions of human experience and existing, like quality and value, through its own immanent logic. Much of modernist aesthetics is based on this view. But for me, creativity is at once aesthetic, ethical, *and* cognitive – a form of ethical aesthetics, as I already mentioned. Hence, the reader will find here considerable reflection linking aesthetic values, the moral imagination, and intellectual analysis. True creativity combines these faculties.

\*   \*   \*   \*   \*

*The artist is a self-critically engaged agent* in particular situations, calling for reclamation of the sacred and the future in a world that seems in many ways to be dying. Who or what is an artist? Carl Sandburg once said that "artist" is a praise word, not to be taken as a self-appellation, but offered by a community to the one who creates. Such an interpretation is very far indeed from any contemporary understanding of how an artist is identified. Our cultural milieu is pluralistic (some would say nihilistic) to the core. No consensus exists about who may be an artist. Nor is there consensus about what art is. In our postmodern era, everything about art is "up for grabs." "Art" is whatever anyone wants it to be at a given moment.

I take a middle path between these extremes, between Sandburg's conservative stance and the excessive open-endedness of some definitions in our postmodern moment. Art can be defined as a process of making "objects" (even if they are conceptual or transitory) that transpose or translate a function, a program, or an impulse (either emotional, aesthetic, or economic) into another form.[3] An artist, then, is one who engages in this process. To be an artist does not, in my view, necessitate a specific kind or length of training or background; it does require, however, a commitment to engage in the creative process.

Common lore often posits the visual artist as verbally inarticulate, as unable to express ideas coherently. The artist in this view often simply points to the work, maintaining a relative silence about its intention and meaning. Although I recognize that it is often difficult to know exactly where a creative work is headed, especially while engaged in the process, for the artist to valorize silence or inarticulateness is an

abdication of responsibility, a form of unconsciousness difficult to justify in our world. "Our world" has become a code for me, a shorthand meant to alert the reader to the reality that we live in a precarious and contingent state – existentially, ecologically, politically.

To be self-critical is to ask oneself what the point of a work is, to wrestle with its content because one knows there is a viewer in the world, an answering consciousness who will respond. The artist is, in this sense, *engaged*. The artist perceives herself or himself as an agent or an actor in the world, as one whose actions make a difference.

The question of agency is, of course, complex. To be an engaged agent presumes a freedom and self-consciousness that is not accessible to everyone because of individual experiences of interlocking oppressions based on gender, class location, race or ethnic background, age, ideological and political values, or other factors. In other words, because of the way privilege operates in society, it is not possible to say unequivocally that everyone is free to be an active, self-critical agent of change. But to choose to become an artist in the first place implies at least a degree of ego strength and determination, both of which are necessary for action in the world.

In later chapters I will link this idea of critical engagement to the prophets of the Hebrew Bible. These historical figures – Amos, Hosea, Isaiah, Micah, Jeremiah, and others – were passionate participants in their own milieux. Artists today may learn by considering how the prophetic process was understood and exercised. Their perspectives, and the one I am developing here, are diametrically opposed to all forms of nihilism and world denial.

\*   \*   \*   \*   \*

The artist is a self-critically engaged agent *in particular situations*, calling for reclamation of the sacred and the future in a world that seems in many ways to be dying. Against every claim for universals – a universal human nature, a universal human condition, or a universal truth (Truth) – I, like other postmodernists, acknowledge the power of the particular. As individual human beings, we are situated. We live in particular space-time configurations that cannot be inhabited, or really even fully comprehended, by another person. We act in singular and unique situations that call forth specific responses.

To recognize that all insight is perspectival – that there is no Archimedean point, no God's eye view – is to take the first step toward the self-consciousness and awakening of conscience that will orient one's actions. We do not need universal norms or values to accomplish this

orientation in life, but universal accountability is essential.⁴ Universal accountability means that we are answerable and responsible for all our specific actions in particular situations.

＊　＊　＊　＊　＊

The artist is a self-critically engaged agent in particular situations, *calling for reclamation of the sacred and the future* in a world that seems in many ways to be dying. To speak of reclamation implies that something has been lost, as I described in Chapter 1. Assessments of what has been lost in contemporary society vary tremendously depending upon one's political and religious orientation. As should be obvious from the language of my proposition, I am especially concerned with the loss of the awareness of the sacred and the loss of the ability to imagine the future, rather than with the loss of "family values" or other such notions. For many in our largely secular context, especially those for whom the sacred is associated with the exercise of ecclesiastical power and a patriarchal God, to speak of the reclamation of the sacred and the future is a controversial claim. What is sacred for one culture or one individual may remain profane for another. With this phrase I mean to call attention to a profound sense of the mystery and creativity that pervades life (and death) and all things organic and inorganic. To reclaim the sacred is to recover that sense of mystery and awareness of the creativity and productivity that characterize all living processes.

What is mystery? The word derives from the Latin *mysterium*, from the Greek *musterion* (secret rite), and from *muein* (to be closed, or, to close the mouth). Mystery is harder to talk about than are other ideas about the sacred, for here one runs into the intrinsic limitations of human language. Mystery grounds us and surrounds us; in this sense, it is both the horizon and the environment of life. We live in a context filled with mystery; our futures, both personal and collective, are mysterious. Even our past, the past that extends back in time before birth, is mysterious. Death is mysterious. To use the word "mystery" is therefore to say that we do not know much about why we are here and where we are going.

The word "sacred" is derived from Middle English, *sacren* (to consecrate) and from the Latin *sacer* (sacred). This term is ambiguous. The word has broad religious connotations, but it is rooted in early human attempts to create meaning through myths and mythic consciousness. The sacred names that which is worthy of human veneration yet is ultimately beyond human comprehension. The sacred is often opposed to the profane: Sacred space (for example, church or temple) is opposed

to profane space (the home or market); sacred time (a festival) is opposed to profane time (daily chores). Rudolf Otto called the sacred the *mysterium tremendum,* the numinous: the all-powerful, awe-full, and "wholly other" mystery that surrounds us.

But to those who hold the concept of the sacred as wholly other, I would ask, what about the fragile or the precarious? What about the earth's ecosystem? What about humans, as individuals and as a species? Both are fragile. Any definition of the sacred that creates a bifurcation between the earth and humans and that which is beyond human comprehension is dangerous. We are reaping the benefit, if it can be called a benefit, of reverence for the sacred as remote from human life and from the environment in which it could flourish.

The sacred can also be linked to ideas of the divine. "Divine" comes from the Latin *divinus* or *divus,* "a god." In offering a provisional definition, I could trace a history of understandings of the divine within the Jewish, Christian, or other traditions, but a few personal comments will suffice. For many years I identified myself as an atheist and existentialist. I began using the phrase "the divine" to acknowledge that I felt the presence of something mysterious over which I had no control, but that seemed to influence my life and enable me to interpret events. For some who are more traditionally religious, the idea of the divine takes the form of a personal agential God, a God who acts in time. But for a number of reasons I never found this understanding and articulation of the idea of God appealing. At the least, this "God" seemed too male: As philosopher Mary Daly put it, when God is male, then the male is God.[5] And the idea of a God that "acts," either in predetermined ways, as a Calvinist would assert, or as a deist God who just set the world moving and stepped back, never made sense to me. Actually, my critique of traditional understandings of God is more complex than this, but I mention these ideas just to give a flavor of the concerns I bring to "the divine."

I have consistently explored the nature and experience of spirituality and how it is translated through the senses. "Spirituality," like "the sacred," is a vague term. It conjures the ineffable and mysterious; it points to the beyond (however we conceive it) or to the deepest inner core. It transcends denomination and religious tradition, for there are many diverse expressions of spirituality in different traditions and cultures. Communities share forms of spiritual practice. Prayer and meditation are both public/collective/shared and private/individual/solitary. Through spiritual disciplines, we reach into the greater world and into the self. Spirituality is visionary: It sees what is there, and it sees what

could be and should be, but probably will not be because of our greed. Through the visual arts, I have sought to express my own spiritual vision, with both a critical and visionary intent.

To me the concepts of the sacred and the divine name a process of activity in the world, the mysterious process of creativity that encompasses both birth and death. This process is ongoing; humans participate in it, and we strive to give it meaning. This creativity happens, and is expressed, in matrices of relationship, in interconnected networks of people loving and engaging with one another. Artistic creativity is a special case of this ongoing creativity in the world; and I believe that artists have a vocation to take their work seriously as an expression of this sacred dimension of existence.

How does one gain any idea about what constitutes the sacred, or even become aware that there is something sacred? Religious education and the academic study of history and of other cultures are means for discovering and understanding the sacred in the present. Social norms are usually passed on to each succeeding generation by parents. But in contemporary culture, where such systems of transmission have broken down, many young people do not gain their orientation in that context. In traditional cultures, the church or temple was another focus of moral education. But ours is a largely secular culture where there is little sense of shared values and no universally accepted way of transmitting those values. The rise of religious fundamentalisms all over the planet can be interpreted as one response to this condition.[6] The loss of a sense of the sacred in our culture is apparent in the slight value attached to human and other forms of planetary life.

So far I have been talking about the reclamation of the sacred. What of *the future?* I suggest, though I cannot prove, that moral imagination and conscience, as well as moral action in the world, are linked to our sense that life is ongoing. What happens when people no longer think that there will be a future? Once I heard on National Public Radio interviews with high school students in Washington, D.C. The students said that there is nothing worth living, or dying, for. One young woman also said that she did not expect to live a long life. When such attitudes are widespread, then, as Dostoevsky put it so succinctly in *The Brothers Karamazov,* everything is permitted. All forms of exploitation and violence can be committed if nothing is sacred and the future is unlikely.

The imagination always provides pictures of the world, of human life, and of the significant cultural symbols that help to orient life in the world.[7] How is our imagination of the future shaped in and by popular culture, especially through film, since the formative 1982 *Blade Runner*

and up to the latest violent cyborgian nightmares? Or, what would a visionary imagination, committed to imagining alternative – less dystopic – futures, conjure? Artists committed to the reclamation of the future will address such questions. This, finally, is related to the last phrase of my earlier proposition.

\* \* \* \* \*

The artist is a self-critically engaged agent in particular situations, calling for reclamation of the sacred and the future in *a world that seems in many ways to be dying.* The understanding of the vocation of the artist that I sketch here is based on a particular assessment of our historical moment: that ours is a situation of chronic global crises vying for attention. These crises – ranging from ubiquitous contamination of the earth, air, and water by toxic pollutants and radiation, destruction of tropical rain forests, global warming, and extinctions on a massive scale, to overpopulation and ongoing war and violence on every continent – are well documented, and I do not wish to reiterate them in detail here.

As Hélène Cixous put it, "[L]ife is fragile and death holds the power. That life, occupied as it is with loving, hatching, watching, caressing, singing, is threatened by hatred and death, and must defend itself."[8] This statement is related to my convictions about the importance of the prophetic function. Life – all of life, species, forests – is threatened with death, but not a "natural" death. The death that we face is the annihilation caused by human activity gone awry. As Buddhists have always understood, human ignorance, greed, and hatred lead on a spiraling course toward death. In the face of this pervasive power of death, we need to affirm life, to affirm the possibilities of the future. The point of even this brief acknowledgment is that change, fundamental change in human values and life, is needed for both human and planetary survival. How artists might participate in that change is the larger agenda of this book.

I share the perception with Mikhail Bakhtin and other "prosaic" thinkers that we live and act in a contingent world. This means that profound uncertainty about the results of our actions is unavoidable. Despair and nihilism could and often do result from both our individual and collective confrontations with contingency. As Wojnarowicz's puppet depicts, fire rages around us; our bodies and souls are threatened. We do not know if we can extinguish the flames before we are ourselves extinguished. But even in the face of contingency and uncertainty, creativity – both in life and in art – does not end. Creativity is an ongoing,

everyday, ubiquitous activity. Metaphors of birth and regeneration, of decay and death, describe both physical and cultural processes of creativity. Thus, *The Vocation of the Artist* is shaped by a sense of urgency about the future and of profound faith in the ongoingness of life in the cosmos.

# Vocation

The idea of a calling is illustrated in Remedios Varo's 1961 painting, *The Call* (Figure 4). The central figure, luminous with radiating filaments of light, wearing and carrying alchemical vessels, her hand in a gesture similar to a Buddhist mudra, leaves behind those half-awake, half-conscious, people who frame her. They remain caught in and part of an otherworldly sanctum, whose windows seem to open into nothingness. Labial walls simultaneously hold the figures in and seem to imply the possibility of their emergence. The figures' feet and heads, in dull shades of brown, seem ready to emerge. Bright orange, the main figure has fully emerged from the dark alcove behind her. Her hair is connected to a planetary orb; her feet seem to illuminate the patterns on the floor over which she walks. This figure leaves behind the state of sleep that mystics such as Gurdjieff thought was our normal human condition. The sense of a "call" is clearly depicted, but toward what is this figure called? Perhaps she is making a personal journey toward wholeness and enlightenment. She is initiated into the process of spiritual becoming, although how or why is unclear. Who calls? We cannot know.

\*   \*   \*   \*   \*

A major tension – between fear and hope, between death and ongoingness, between the past-present and the future – runs through *The Vocation of the Artist*. On the one hand, I have painted a rather bleak picture of the future. In this sense, my concerns here are eschatological. Eschatology is a branch of theology that deals with our ideas about last things, our ideas of death. When personal death seems imminent, one's concerns are eschatological. When the death of cultures and species is proceeding at an alarming rate, when the possibility of the death of most life forms as we know them, including human life, looms on the horizon, then our concerns must be eschatological. On the other hand, I have simultaneously asserted the hope that regeneration and renewal remain possibilities for the future. For instance, many critics read post-

**Figure 4.** Remedios Varo, *The Call*, 1961

modernism(s) as the last gasp of art and even of modern culture more generally. But I see, in art by Joan Snyder, Richard Long, James Acord, Lynn Randolph, Guillermo Gómez-Peña, and Coco Fusco, new forms of resistance to the necrophilia of European-American culture.

As I turn now to the concept of vocation, these eschatological concerns take another form. *Our work matters.* If the ecological crisis is a crisis of the whole life system of our planet – and I think that it is – then it calls into question all of our work in the world. "The ecological crisis today suggests to many observers that there is no future for our species on this planet and no future for the planet so long as our species refuses to change its ways. But this is where vocation enters – a voice from the future calling persons to believe in a future."[1] Belief in the future is not about dogmas, but it means acting *as if* there will be a future. A primary mode in which most of us act is by working in the world. Thus, my claim: our work matters.

This chapter is not an attempt to define work transhistorically or as a universal category of human experience. This would be extremely difficult, because work is so diverse. Work is also so ordinary, so close to us, so interwoven with our ideas about who we are and what we might become, that to try to generalize about it would be folly. The nature of work is changing drastically with the development and application of newer technologies.[2] There are also presently many crises concerning work around the world, crises of child labor, unemployment, discrimination, dehumanization, the exploitation of workers, and the destruction of the environment, to list but a few.

We work because we are human, but the meaning we attach to that work varies tremendously. The idea of work evokes a series of terms and related concepts. "Work" is similar to and sometimes synonymous with "vocation," "labor," "toil," "drudgery," "chore," "job," "gainful employment," "action," and even with the idea of an "opus." Each of these terms has its own valence. Vocation is perhaps the most complex term, as I discuss in what follows. Toil, drudgery, and chore all identify negative demanding activities that most of us would rather not do. Job and gainful employment are more positive and life sustaining, though often viewed as a necessary unpleasantness. Opus, in the sense either of a creative work or of a lifework, as Carl Jung used the term, also has a positive meaning. A further significant distinction separates labor, work, and action. We labor to meet our everyday needs. We work to create the world of things. But action, as we shall see, is born of another set of values more related to my ideas about vocation.

Artists, like other cultural workers, seldom think of their work or

describe it in terms of vocation, although I suspect that many feel "called" to do it in some general way, like the figure in Varo's *Call*. My purpose here is to provide a background or foundation for reconsideration of what it might mean to speak of the *vocation* of the artist. To this end, the chapter has a specific philosophical goal: to trace historical notions about vocation and work in influential writers such as Martin Luther, Adam Smith, Karl Marx, and Hannah Arendt, describing how the process of increasing secularization has affected views of work in the world, the purpose of work, and problems such as alienation. Beyond this, I want to reclaim a sense of vocation as action in the world, a calling that must be chosen with a sense of determination and commitment.

## A HISTORY OF "VOCATION"

In its root meaning the Latin *vocatio* (a call) had a distinctly Christian tenor. Tertullian was evidently the first to translate the Greek *klesis* as *vocatio* in the third century.[3] *Klesis,* in the Pauline and Johannine biblical literature, was interpreted as giving the Christian a special hope and destiny and would have contributed to developing a sense of new communal identity within the Greco-Roman and Hebrew contexts. If the Christian alone was called to his or her vocation, this calling set the group apart from others. Later, when Christianity became more popular and was not just one small sect among others, and especially with the institution of infant baptism, the idea of a calling largely disappeared. If one could be born into a Christian community, then personal decision or calling was not such an important factor.

Although he did not use the term, Clement of Alexandria contributed to the reevaluation of work by criticizing the classical philosophers for their low estimation of manual labor. He did not stop there, however, but also attacked the indolent who did not work, whether they were rich or poor. Augustine's classic treatise *On the Work of Monks,* written in 401, describes the place of work in monastic life. Thus, in its early usage, in both the eastern and western traditions, *vocatio* meant not only renunciation but also grace from God, and it was blended with the idea of a special profession based on aptitude and right intention.

The history of the word's use has evolved since its appearance in these and other early Christian texts, including the New Testament and church fathers such as Basil and Cassian, up to Erasmus and Luther. John Cassian, for instance, distinguished three stages in the *vocatio* of

a monk: the direct call from God; a secondary call by the human community; and the actual entrance into a monastic order. Cassian's stages were interpreted by later monks such as Benedict as a formal promise before God and, then, as a written vow. In fact, monasticism played a fundamental role in articulating the idea of a special calling, but scholars disagree about the relative importance of that role. On the one hand, through its high evaluation of productive work, monasticism prepared the way for later secular usage of the term vocation; on the other hand, the secular occupations themselves helped to strengthen the idea of a special calling.[4] German mystics such as Meister Eckhart articulated a notion of a call from God that was completely independent of monasticism or entrance into an order. Instead, a call could be related to secular work through which one could "experience the highest ideal of the nearness of God."[5] Eckhart had said that "if one were in an ecstasy, even if it were as high as that of Paul, and knew that beside him there was an infirm man who needed a bowl of soup from him, it would be better for him to abandon his ecstasy and serve the needy man."[6]

By the late sixteenth century a complete reversal of the meaning of the word had occurred. Initially, the word had meant that the monk alone has a special calling. However, Martin Luther's conception of a calling, *Beruf,* especially his assertion that only through work in the world could one genuinely realize the calling of God, reflects this reversal. In the first decade of his work as a reformer, Luther began to reassess the relationship between worldly activity and monastic asceticism. Perhaps because of his involvement in public life, in work, and in marriage after an earlier monastic experience, Luther began to value work in the world in a new way.[7]

In his translations of the Bible and in many of his other writings, Luther used *Beruf* for two different concepts: *spiritual vocation,* the call to eternal salvation in the kingdom of God, and *external vocation,* the call from God to serve one another and the world, in short, one's profession or fate in the world. As I have suggested, there were two important consequences of Luther's ideas about vocation: first, that greater value was now attributed to work in the world; and second, that the hierarchy of the contemplative over the active life was reversed.

Luther's vocational interpretation of work may also be criticized, however.[8] First, Luther's notion of vocation was indifferent to alienation; Luther thought that any work could be a vocation, even work that is dehumanizing. This criticism is not surprising, because the clearest articulations of alienation evolved in Hegel, Feuerbach, and Marx, all of whom wrote several centuries after Luther. Second, the two senses

of vocation are ambiguous, and there is no clear way to solve the conflict between them. How can one really differentiate, and then justify the differentiation, between spiritual and external vocations? Third, the vocational interpretation of work can be misused ideologically, which is related to the first point I mentioned. Alienating work can be ennobled by seeing it as vocation, and thereby necessary structural changes can be avoided. Fourth, the concept of vocation, which was originally based on the assumption that a person would have only one vocation, is not applicable in a postindustrial information age when, for many people, employment may change over the course of a lifetime. Fifth, earlier interpretations of vocation were based on single occupations, whereas in the modern and postmodern world many people have more than one job simultaneously. Sixth, the reduction of vocation to secular employment has led to a curious elevation of work to the status of religion. In a workaholic atmosphere, we are driven to work "religiously" to be able to buy and consume more and more.

Such problems notwithstanding, Luther's interpretation of work has been extremely influential. New evaluations of the artist's labor were roughly synchronous with these developments, as we shall see in Chapters 5 and 6, though they may not be causally related in a direct way. In its contemporary usage, the word "vocation" has been even more thoroughly secularized, so that it is virtually synonymous with "profession," "occupation," or "work." Work today is based more on a striving for self-realization than for fulfillment of the values of the Protestant work ethic as Luther and other early Protestants defined it.[9] In our postmodern secularized world, people commonly use the word "vocation" in a shallow sense; but we can still hear an echo of its meaning as calling, even though it may be just a search for a calling.[10]

Martin Luther, of course, worked and wrote from his position as a minister and theologian who was speaking to particular communities in sixteenth-century Germany. In the years to follow, the interpretation of work would be significantly developed by writers and philosophers with other disciplinary backgrounds: Adam Smith and Karl Marx from economics, Sigmund Freud from the new field of psychology, and Hannah Arendt from political philosophy.[11]

Adam Smith's ideas have had a tremendous impact both on the development of American capitalism and on economic theories more generally. He was responsible for articulating the ideas that personal identity is largely determined by one's work and that the fundamental mode of production influences how societies are organized. Karl Marx is also associated with these ideas, and he developed his own interpre-

tation of the nature of work in the world.[12] I emphasize these two economists because their ideas have been so influential.

Smith's major work, *The Wealth of Nations* (1776), is divided into five parts. Book I explains how a capitalist (competitive, private enterprise) economy functions, with chapters on topics such as the division of labor and the origin and use of money. Book II discusses the nature of capital, how it accumulates and can be employed. Book III is a history of economic "progress" from agriculture to commerce. Book IV concerns the dangers of mercantile policies and constitutes an appeal for free international trade. Book V is a series of reflections about social institutions such as the military, schools, and churches. Smith thought that human work provides the basic structure of society and is the main source of economic wealth.

These ideas greatly affected Marx, who read Smith's *Wealth of Nations* carefully during the 1840s while working on his *Economic and Philosophical Manuscripts* (1844). Although Smith was only one of Marx's conversation partners, references to Smith's ideas pervade this manuscript. Marx also engaged in a polemic with Smith in 1857–8 in *Grundrisse*, and again, in the early 1860s, in *Theories of Surplus Value*. They differed in their interpretations of the purpose of work, the effects of the division of labor, and the role of alienation in societies.[13]

Concerning the purpose of work, Smith thought that human beings were created for work in the sense that work is a means of achieving happiness. Happiness is achieved through consumption. Thus people work to satisfy their basic needs rather than to express their humanity and potential. Work is useful, but it is not a source of dignity. The accumulation of wealth through work makes possible greater leisure, but not necessarily greater meaning. This is a central tension in Smith writing: that work is socially productive, but personally negative. The most persistent and universal motive for work is self-interest. In fact, it may be argued that Smith constructed all of his theories about economic activity on this foundation.[14]

Marx defined a person essentially through his or her work: A person is primarily *homo creator*. Marx characterized work as having four main features. First, it is purposeful; second, there must be an object, either natural or manufactured, on which work can be performed; third, it requires tools; and fourth, it involves the use of nature by the individual. Thus, "work is a purposeful, social activity through which people, helped by tools, manipulate nature."[15] Especially in his late writings, Marx saw work both as a means to maintain existence – as the way humans create a world and humanize nature – *and* as an end

in itself that should be enjoyed, as the way humans realize their potential. (Although he was not a Marxist, Mikhail Bakhtin, in his early essays of the 1920s, similarly emphasized the act or deed that essentially defines a person's singularity in the world. Bakhtin developed Marx's insight, insisting that aesthetic activity – work in its most creative form – both humanizes nature *and* naturalizes the human being.[16])

In his *Economic and Philosophical Manuscripts,* Marx had articulated an important relationship of the human body and nature. "Nature is man's *inorganic* body. . . . Man *lives* on nature – means that nature is his *body,* with which he must remain in continuous interchange if he is not to die. That man's physical and spiritual life is linked to nature means simply that nature is linked to itself, for man is part of nature."[17] A person leaves imprints on nature; nature thus is an extension of the self, which is also part of nature. If Marx's assessment is accurate, then we must pause and consider what we are doing in the massive exploitation and destruction of the natural world in the late twentieth century. We have yet to understand the consequences for us as embodied beings of the despoliation of nature and its replacement by virtual worlds.

Marx also saw work as the way human beings as subjects interact with nature as object. "Labor is . . . a process in which both man and Nature participate, and in which man of his own accord starts, regulates, and controls the material re-actions between himself and Nature. . . . By thus acting on the external world and changing it, he at the same time changes his own nature."[18] Nature, therefore, is not just an object that a person changes through work, nature also changes the person.

Labor, for Marx as for Hegel, is an act of self-creation, not a commodity. As the expression of an individual's physical and mental abilities, labor or work is therefore not just a means to an end, such as the development of a product, but it is an end in itself, "the meaningful expression of human energy; hence work is enjoyable."[19] Through work a person reproduces herself or himself and sees a reflection of that self in the world that has been created. Finally, for Marx, human freedom and creativity are expressed through work.

Unfortunately, work is also often alienating. There are certainly many ways of interpreting alienation. The idea arose among early Jewish and Christian thinkers, who saw humans as fallen from grace, alienated from God. Adam Smith accepted alienation as inevitable; it helped form the basis of his economic system. Hegel made the overcoming of alienation through religion central to his theory of individual and social progress. And Feuerbach stood this notion on its head, saying that religion, instead of saving us from alienation, is itself the vehicle

and expression of how we are divided from the real world. For Marx, alienated labor is the key to understanding alienation. From a feminist perspective, even more fundamental than economics and class in causing alienation are the patriarchal, androcentric, and even misogynist biases that characterize most historical civilizations.

Both Smith and Marx understood that the division of labor, because it turns the worker and the work into means, is alienating. For Smith, the division of labor is decisive in three main ways. First, rather than saying that who we are shapes what we do, Smith asserted that human nature *is shaped by* the division of labor. Second, the division of labor is solely responsible for economic progress in societies; and third, the division of labor provides the structure for and helps to maintain modern societies. At the root of the division of labor lies a fundamental self-interest that drives the process. Even our helping others, according to Smith, evolves in relation to our self-interest. Yet this alienation is unavoidable if a society wants to thrive and progress. It is expressed in the fact that workers are powerless, exploited, and inevitably estranged from themselves.[20] Sadly, Smith did not provide any suggestions about how alienation could be alleviated.

Differing sharply from Smith concerning the division of labor, Marx asserted that it must end. The inversion of means and ends that marks the division of labor also extends to the goals of production. The primary goal within the capitalist mode of production is not the use of a product by the producer or by other persons, but that product's exchange value as a commodity. "A product that a worker makes has no value for her as a product, but only as a means to acquire another needed product or service."[21]

Marx insisted that, under capitalism, work and even existence itself are characterized by profound alienation.[22] This alienation grows because the person as subject experiences himself or herself as estranged from the world of nature, from other persons, and even from the self. For the majority of the population in the modern and postmodern worlds, the alienation of much work is symbolized by the image of the treadmill, a device formerly used in torture or for animal labor.[23]

Following Hegel's explanation, in *Phenomenology of Spirit* (1807), of the way in which alienation from work operates in the master-slave relationship, Marx analyzed how persons objectify themselves through their work and other activities. Although it should be possible for a person to enjoy the process of work – a process that involves seeing one's personality objectified in the objects created for use and satisfaction – under capitalism this process is alienating in at least four ways.

A worker can experience alienation from the product of work, from the work process itself, from the worker's "species being" (a term Marx used to indicate a person's relationship to nature and the external world), and from other workers. Humans have lost their "true" needs; they have reduced all their needs to the need to have money and to own property.

Work becomes even more alienating when machine production is introduced. When workers are forced to engage in the mechanical repetition of a single operation, their physical and mental well-being is put in jeopardy. They lose skills, putting them at the mercy of the managers who control their work.[24] Marx shared Smith's assessment of alienation but insisted that changes must be made in the capitalist system toward a communist model to end worker alienation.

Alienation is not foreign to art practice, given the exigencies of the art world and gallery and museum system. In fact, one could say that alienated labor is intrinsic to the contemporary art world, as it successfully molds aspiring artists into laborers within a capitalist market system. Marx wrote that alienation "is apparent not only in the fact that my means of life belong to someone else, that my desires are the unattainable possession of someone else, but that everything is something different from itself, that my activity is something else, and finally . . . that an inhuman power rules over everything."[25] In the art world, many artists do indeed believe that their means of life are owned by galleries, that their desires are governed by others (including what the market will support), and that inhuman powers decide the artist's fate. The consequences of this kind of alienation are profound, and, for the individual working artist, the effort to avoid it is arduous.

There are multiple paths toward becoming an artist, some highly individualized, others more collective. Nearly all involve alienation. Hustling may be one of the most basic survival skills in major art centers such as New York and Los Angeles, and even in smaller regional centers such as Seattle, Minneapolis, or Atlanta. One of the disturbing realities of the contemporary art world is that dealers often control an artist's fate: Artists become pawns in dealers' "games." If one becomes too discontented with how things are going, there are many other artists who would gladly be more docile, more willing to play by the given rules. It is very hard to be true to oneself in this world. The few artists who remain so often work from predominantly internal motives and are able to resist the "allure of capital" and its various trappings.[26]

Freud, like Marx and Nietzsche, is considered one of the "masters of suspicion," who succeeded in throwing into question many of the

assumptions of western European–based civilization. For Freud, love and work are the foundation of civilization and communal life. Eros provides the power that drives Ananke, the external necessities that govern what we do in order to live. But because humans are basically aggressive, instinctual beings, civilization can proceed only by seeking to control aggression. Hence, the "carceral continuum," Foucault's name for the systems of control that are built into all social institutions from the family to the government. At the end of *Civilization and Its Discontents,* Freud suggested that the most fateful question for the human species – and in light of recent environmental awareness, for all living beings and the earth itself – is the extent to which civilization and its institutions can control human aggression and destruction.

Questions about the meaning of life are usually answered by saying that one wishes either to obtain happiness or to eliminate suffering. Freud identified three sources of suffering: the superior power of nature, the feebleness of the body, and the external world of human relations. Happiness and avoidance of these sources of suffering are usually sought in a variety of ways – through love, enjoyment of beauty, intoxication, religion, and retreat from the world, among others. Being happy is an illusive goal, and work is not usually considered part of what makes a person happy.[27] Freud mentioned pleasure in relation to work only when he spoke of the artist's joy in creating art and the scientist's joy in solving problems. Otherwise, human beings tend to express resistance to work, and to work only under conditions of the "stress of necessity."[28]

Given the critique of work and alienation by writers such as Marx and Freud, I do not want to exalt work uncritically, to write a postmodern paean to work in the manner of nineteenth- and early-twentieth-century writers such as Thomas Carlyle and Eric Gill. But the ideas of Carlyle and Gill merit at least brief acknowledgment in this survey of attitudes about work and vocation because they bear on my assessment of our contemporary situation.

Carlyle wrote his *Past and Present* in the early 1840s, in response to economic conditions in England, which included abolition of the previous system of relief for the poor and the introduction of workhouses with their wretched living conditions. He detested the "get-rich-quick, dog-eat-dog, devil-take-the-hindmost" ethos that dominated economic life in Britain at the time. Work, in this context, consisted of the exchange of money for labor or material goods, conducted in an atmosphere of anonymity and heartlessness.[29] Carlyle wanted to reclaim an interpretation of work that had inspired monastic life: *Laborare est*

**Figure 5.** Ford Madox Brown, *Work*, 1852–65

*Orare,* "Work is Worship."[30] For him, destiny cultivates and shapes us through our work, just as the potter shapes lumps of clay. "For there is a perennial nobleness, and even sacredness, in Work. . . . The latest Gospel in this world is, Know thy work and do it." In contrast to the dictum "Know thyself," which has been attributed to Solon, Socrates, Thales, and others, and which Carlyle thought spurious because the self is ultimately unknowable, he insisted that we should concentrate on work. "Blessed is he who has found his work; let him ask no other blessedness. He has a work, a life-purpose; he has found it, and will follow it!"[31]

A visual representation of these ideas can be seen in Ford Madox Brown's *Work,* painted between 1852 and 1865 (Figure 5).[32] The paint-ing is a visual allegory depicting the ethic of labor that loomed large in nineteenth-century Britain. On a hot summer day on a main street in Hampstead, we see a spectrum of workers. All persons labor at the work that marks their station in life, and hence, their class. At the center are the ditchdiggers. To the right are their counterparts, "intellectual" workers, including Carlyle himself and the Reverend Frederick Denison Maurice, who had founded colleges for women and working-class men. Members of the wealthy leisure class are on horseback in the distance; middle-class Victorian women distribute temperance tracts to the left. In the foreground, a group of unruly children play. A young girl with

a torn dress looks after her siblings. Even the dogs are allegorical: The scruffy bull pup belongs to the ditchdiggers; the mongrel to the children, who may be orphans; the red-jacketed whippet struts along with the ladies. Finally, the painting's rather bluntly expressed moral purpose is summed up by the biblical quotation inscribed on the frame: "In the sweat of thy face shalt thou eat bread." Brown did not offer here a hidden critique of the way work and class interact, only the sense that, as Carlyle insisted, our destiny is formed through work.

Eric Gill inherited Carlyle's passion, and his prodigious production may be seen as an embodiment of the values expressed in Brown's *Work*. During his lifetime, between 1882 and 1940, Gill wrote twelve books and many essays; he produced over one thousand wood engravings; nine typeface designs; many sculptures in stone and wood, inscriptions, and nude studies; and designs for stamps, coins, books, a clock, and a church. He was a prodigious worker, and he saw all of these products as but the beginning of "a reasonable, decent, holy tradition of work."[33]

For Gill, the separation of art from this tradition of work and the separation of beauty from use, as goods that were both meaningless and unaesthetic were produced, were perhaps the greatest sins of modern art. Both were the result of industrialization. Gill's language about work was thoroughly religious, but it reflected the reversal of values that Luther and other Reformation thinkers had earlier helped to effect regarding active and contemplative lives. "Action is for the sake of contemplation, the active for the sake of the contemplative. To labor is to pray." Or, "The artist is concerned with God. As the priest brings God to the marriage, the artist brings God to the work. All free workmen are artists. All workmen who are not artists are slaves."[34] Although we might question the theology that underlies such statements, Gill, like Carlyle, was trying, through his artwork and his writing, to reinvest work with a sense of the holy – what I here am calling vocation.

Gill also articulated a strident critique of industrialism. By divorcing the material and spiritual, industrialism recommitted the original sin. This separation of matter and spirit, which is analogous to the separation of art from work and of beauty from use, is a kind of death: "[I]ndustrialism leads so clearly towards that separation that we may say death is the actual aim . . . its diabolical direction."[35] More recent writers, such as Erich Fromm and Mary Daly, from Marxist-Freudian and radical feminist perspectives, have also denounced the necrophilia of modern culture.

Industrialism takes dignity, initiative, imagination, creativity, and ho-

liness out of labor, replacing these values with crude materialism and crass consumerism. In its place, Gill envisioned a society based on holy work, charity, and an attitude of poverty: "To go without, to give up, to lose rather than gain, to have little rather than much."[36] For both Carlyle and Gill, work was a holy act; its purpose, to link the human and the divine. Or, as I would say, using more secular language, to link the human to that which is greater than the human: the mystery at the boundaries of our knowing about the larger world, the universe, the all-that-is.

Are such ideas meaningful to a late-twentieth-century artist grappling with the meaning of artistic production in an increasingly commodified external environment? I think that they are. The assessments of work set forth by Carlyle and Gill – especially the way industrialization and capitalism have affected the values surrounding art – are still relevant. Nowhere are more sobering evaluations of the contemporary meaning of work as secularized job offered than in Studs Terkel's *Working*.[37] Full of stories of discontent and monotony, of fantasies that make work bearable, and only occasionally of delight, *Working* tells how status has become more important than craftsmanship and planned obsolescence more important than committed service. Terkel's findings are consistent with the more grim assessments about work that I have just outlined. Sadly, they apply equally to many artists, whose own work is indeed driven by values related to status and fashion.

The "get-rich-quick" attitude that Carlyle detested; the proliferation of unaesthetic goods and the crass consumerism that Gill identified as great sins: These are very much with us still. In fact, such values are even more prevalent now, 50 to 150 years after these men wrote. The esteem they both granted to work as a holy act is an important counter to our contemporary work ethos that sees work as something to be gotten through so that we may enjoy life and leisure. The "holy tradition of working" exalted by Gill is not an uncritical acceptance of alienating work in an industrial (or, now, postindustrial) environment. Rather, it provides us with a way of thinking again about work as a calling or vocation.

Clearly, neither Carlyle nor Gill could have anticipated the momentous changes that make Terkel's conclusions about work so sobering, or perhaps, so inevitable. A painting like Brown's, with its implicit lack of criticism about the disparities between rich and poor, could not be painted now. The various distinctions between work, a chore, a job, and a calling are important in our secular context, because we are used to thinking of vocation in terms of work or a job rather than a calling.

It is therefore worth considering what a holy tradition of working might mean today.

## LABOR, WORK, AND ACTION

To reclaim an interpretation of work as vocation – as a calling with its own distinctive character – we must ask, why do we work? What, besides having to meet our basic needs for food, shelter, and the like, makes us work? What motivates an artist, driven by the same economic imperatives as everyone else, to turn to a concept such as vocation for sustenance? Are there fundamental differences between types of work that might inflect an understanding of vocation?

In *The Human Condition,* Hannah Arendt introduced a useful set of distinctions concerning work by analyzing human activities in the world in terms of labor, work, and action. Arendt believed that the task of human beings is to produce things that transcend human mortality. In short, we create in order not to die.[38] *Labor* is cyclical and repetitive. *Work* is teleological: It has a beginning and an end, is instrumental, and is often violent. *Action* is unpredictable, irreversible, and anonymous. As defined by Arendt, each of these three forms of work has its own characteristics; and I think they suggest specific ideas about the vocation of the artist.

Labor is connected to the processes of life, growth, and death.[39] Materials produced through labor are consumed. Labor has been divided into productive and unproductive labor, skilled and unskilled labor, and manual and intellectual labor, but only the first distinction is actually necessary. Labor and laboring leave nothing behind, because the objects of labor are consumed as soon as they are produced. Labor, like the biological processes of life, is cyclical and repetitive and in this sense has no end. (Examples include food preparation, caring for children, gardening, cleaning, and other basic subsistence activities.) Labor is seldom heroic; it requires endurance, and its main drawback comes from endless repetition. In a consumer society, we are supposed to labor to make a living. We are *animal laborans,* laboring animals.

Many traditional artisans in medieval culture – cobblers, dressmakers, masons, and so on – fit within this description. With the emergence of the artist as such, which I discuss in more detail in Chapter 6, labor gives way to work. According to Arendt, the artist is the only true worker in a laboring society.

Work moves us into the realm of material goods, for through work

we produce the world of artificial things that we live with and use, but these things outlast human life. Ironically, efforts to give people greater free time from work have resulted in a situation where that free time is spent in increased and more sophisticated forms of consumption of created goods.[40] Through fabrication, *homo faber,* the human being as toolmaker, engages in processes of reification, whereby the things created take on a life of their own.

Unlike labor, which supports everyday life and thus is inherently constructive, work has a violent and destructive dimension. Fabrication has a definite beginning and predictable end. The larger question is whether the end of the process will also be the end of life as we know it. Human beings invented tools not only to support life but also, and especially, to build the world. In Arendt's words, "The question therefore is not so much whether we are the masters or the slaves of our machine, but whether machines still serve the world and its things, or if, on the contrary, they and the automatic motion of their processes have begun to rule and even destroy the world and things."[41]

In this utilitarian world of things made through work, works of art are also intensely worldly, because they are often fairly useless and often permanent. Simultaneously, works of art imply immortality. Unlike in religious traditions, where immortality can refer either to the soul or to life itself, in the arts, the work of art produced by a mortal artist has a degree of immortality insofar as it may survive after the artist dies. Such artwork is the product of thought and cognition (both of which are different from logical reasoning). Thought (for instance, musing about the meaning of life) has no particular goal or end and is as relentless and repetitive as are life and labor. Cognition, however, is always goal oriented; it is the process by which we acquire and use knowledge for particular aims. The usefulness of cognition is evaluated based on what it produces.

These ideas, of course, presume that works of art are not transitory processes, but exist as objects in time and space. Art created using newer media, including performance, installation, video, and electronic imaging, challenge this assumption, for many such works of art exist, like music, in nonobject form – in transcripts and tapes and in cyberspace. But in this, they partake of the qualities associated with action rather than with labor or work.

In contrast to both labor and work, action does not necessarily produce or use goods. Instead, it names the transactions that take place among people, in webs of relationships based on human plurality. Human plurality, which is the basic condition of all speech and action, is

characterized by both the equality of human beings and their distinctness from one another.

Through action we assert ourselves in the world – we take the initiative; we set something in motion that was not there before. Action expresses our interests, "*inter-est*": that which both lies between people and connects them. Although we begin our lives by inserting ourselves into the human world through actions and speech, nobody is the sole author or producer of his or her own life story.[42] This is because action always takes place in a complex context of already existing relationships.

For Arendt, as for Bakhtin, action is never possible in isolation, because it requires the presence of another person. Just as work depends upon the materials of nature and a physical world in which to place the completed object, action is contingent upon the other; it needs other persons. Further, action cannot be confined to only two partners; it is boundless. It tends to break free of definitions, limitations, and boundaries. This boundlessness is also apparent in that action is inherently unpredictable: One cannot foretell its consequences. Unlike either labor or work, action is also irreversible and anonymous. These difficulties in defining action and confining its results have led people, including artists, to substitute making for acting.

Arendt's differentiation of work into labor, work, and action are intriguing for reconceptualizing the vocation of the artist. I do not interpret them here as a judgment, a hierarchy of value, where work is better than labor and action is better than work. Both labor and work are useful categories for understanding the role of traditional artists and artisans, as well as for certain kinds of art practice, such as production pottery, where consumable goods are made for everyday life. Arendt's concept of work is useful for describing historical art of earlier times and object-centered art of the present. But just as there are books after radio and television, so there will continue to be art objects as the process of dematerialization of the art object continues. Our time calls for a new conceptualization of the art-making process and for a new understanding of the vocation of the artist. Arendt's concept of action – with its emphasis on unpredictability, open-endedness, and unfinalizability and with its implicit acknowledgment that work is a process of self–other interaction – provides a fine starting point for reconceptualizing the artist's work.

I have thus far avoided discussing directly what it would mean to interpret vocation as a calling from God, as writers until Luther had done. The difficulties in defining a "calling from God" are compounded

by the ambiguities around "God," as I noted in the last chapter. If artists are "called," then by whom or by what? I could at this point rely on evocative or poetic language and simply say that an artist may be called by his intuition or her sense of social commitment. But this is really an inadequate way out of the dilemma. An artist's vocation is a calling to live and act in the world *as if* work matters. The source of that call must remain one of life's mysteries, open to interpretation by the artist either alone or in community.

To return once again to the question posed earlier, what motivates an artist, driven by the same imperatives as everyone else, to turn to a concept such as vocation for sustenance? Work, reconceptualized as action, can be undertaken for self-expression, to establish and express one's sense of social relatedness, and to help effect reconciliation with(in) the larger natural world in which we live.[43] For some artists, developing a sense of vocation may mean moving away from the immortal artifact and toward transient processes. To understand art as a form of action that establishes new self–other relationships in the world (that mysterious context that we inhabit) and to see the artist as committed to this process is what it means to speak of the *vocation* of the artist.

One last idea may be linked to vocation, before we move on to consider the relationship of art to social change. Work, especially creative action, can also be seen as a defiance of death; it limits the finalizability of life in death. As the poet Donald Hall put it, "If work is no antidote to death, nor a denial of it, death is a powerful stimulus to work. *Get done what you can.*"[44] If we face global destruction and annihilation of species, maybe even our own, then the imperative to work, and to rethink work as vocation, is part of what will give meaning to the present as we seek to live into the future. The most important thing, to paraphrase Hannah Arendt, is to think what we are doing.[45]

# The Efficacy of Art

Fifty women shrouded in black arrive in a motorcade at the Los Angeles City Hall. Arraying themselves on the steps of the building, carrying two banners that say "In Memory of Our Sisters" and "Women Fight Back," they address representatives of the media, community activists, and politicians about pervasive violence against women, ranging from rape and incest to abhorrent advertising images. They have come in response to the sensationalist newspaper coverage of the Hillside Strangler's tenth murder in the Los Angeles area.

Planned as a performance that would also be a media event, Suzanne Lacy and Leslie Labowitz's 1977 *In Mourning and In Rage* (Figure 6) was an attempt to, as Lacy put it, "use the media conventions to subvert media messages, and to introduce a more complicated feminist analysis into the coverage of the case."[1] The efficacy of the performance can be marked in a series of subsequent events. For instance, the telephone company, which had previously been unwilling to list rape hotline numbers with other emergency phone numbers, affirmed its willingness to change this practice. A city councilwoman committed herself to helping create self-defense classes for employees of the city. Another person pledged one hundred thousand dollars – the amount of the reward offered for information leading to the strangler's arrest – for free self-defense classes for women around the city.[2] The performance exemplified the important feminist dictum that "the personal is political"; and it demonstrated that, especially when created in collaboration and with both aesthetic and political savvy, art is a powerful tool for changing consciousness and creating social change.

\*   \*   \*   \*   \*

A fundamental presupposition supporting my project of articulating a vocation for the artist as prophetic critic and visionary, and barely acknowledged thus far, is that images have power. They are efficacious; that is, they provoke emotional response and action. This has been true

of historical images and will be true of art produced by artists in the future.

I am in sympathy with Hans Belting's distinction between "images" and "art," between the era of images and the era of art,[3] even though I do not make extensive use of it here. An image, for Belting, is essentially a holy image, worshipped, despised, and/or used in rituals. A work of art is a modern invention, created by an (often famous) artist and justified by art theory rather than religious ideology. When I speak of the power of images in what follows, my main concern is the evolution of ideas about the function of the artist's production in modern and postmodern European-based cultures. From this perspective, all art is a form of "image," though not all images are "art." This will become clearer in the next chapter, when I examine premodern roles of the artist, the craftsperson or artisan who worked prior to the development of mythologies about the artist as a special or privileged personality.

I do not intend to set forth a full theory of representation and of the power of images; this work has been done, and continues to be done, by contemporary theorists of the image and art historians.[4] In this chapter, I address two specific aspects of the efficacy of art. First, in briefly describing a theory of images on which my claims about the transfor-

Figure 6. Suzanne Lacy and Leslie Labowitz, *In Mourning and In Rage*, 1977

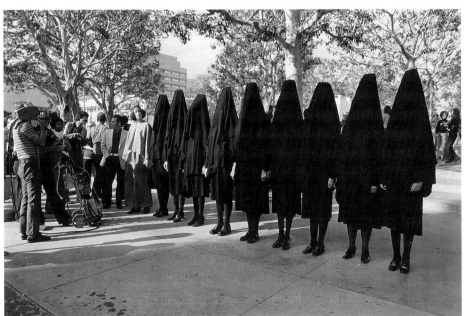

mative power of art are based, I address three interrelated issues: (1) the nature of our responses to images, as this offers evidence of their power; (2) tensions between theories that focus on why images are repressed and how they are productive; and (3) the questions of how and why images are used to express human understanding of the sacred. Second, I examine the claim that art can contribute to social change.

## TOWARD A THEORY OF REPRESENTATION

What does it mean to say that images have the power to provoke response? Images arouse (Jacques Louis David's *Death of Marat*), and they pacify (John Copley's portraits of early Americans, and portraiture in general). Some images arouse sexual feeling and behavior (pornography), whereas others evoke tears (Luis Cruz Azaceta's *AIDS Count* series). Some images provoke violence (Oliver Stone's film, *Natural Born Killers*), and others soothe (Barnett Newman's *Stations of the Cross* at the National Gallery in Washington, D.C.). Images are used to persuade, to urge us to follow causes (the 1977 performances *Three Weeks in May* and *In Mourning and In Rage* by Suzanne Lacy and Leslie Labowitz, or Spike Lee's film *Malcolm X*). Images may spur us to make religious pilgrimages (Robert Gardner's film *River of Bliss*) or to remain passive while changes take place around us (many television series and video and computer games). Their power may be the reason that we destroy those images that disturb us, whereas other images are copied and circulated widely because of their popular appeal. In short, the response provoked by images means the active, outward, and traceable deeds of viewers, as well as the beliefs that stimulate specific action.[5]

Second, the power of images can be seen by examining efforts to repress some images – the "repression" hypothesis – as well as by studying how images produce reaction more positively. David Freedberg has suggested that we may best see the history of response to images through looking for the evidence of the fear and repression they provoke. The many strictures against image making and image worship are testimony to the human propensity to create and worship images. In particular, the repeated and pervasive occurrences of iconoclasm in the west – recorded in the Hebrew Bible, in pagan antiquity, in patristic writers, in the eighth century, and in texts of the sixteenth-century reformations – offer ample evidence of suspicion and fear of images.[6]

Such suspicion and fear is related to the ways in which our senses

are mobilized and activated through images, in short, to their potential for arousal. Medieval writers such as Thomas Aquinas and St. Bonaventure justified images in several ways: because images function as forms of instruction for the unlettered, because images are more effective than words for exciting devotion to Christ, because through images the mystery of incarnation may be understood, and because images showing the exemplary deeds of the saints might thereby urge viewers to follow in their footsteps.[7] Iconoclasts acknowledged some of the same powers of images; they, however, emphasized the potential for dangerous idolatry.

The iconoclasts' interpretation of what constituted an idol was not (and is not) a neutral process. Typically, an idol is an image that has power over an individual or a group: It may be worshipped, and specific powers may be attributed to it. But the very definition of an idol is usually based on distinguishing between that which is valued by *someone else,* and that which is valued by the self or by the group to which one belongs.[8] Many Christians, for instance, distinguish between their own devotional images (crucifixions and so forth) and the images of non-Christians, which would be called "idols." John Calvin's early Protestant writings, however, expressed this rejection of *all* attempts to give material form to the uncircumscribable all-creating Creator, which would be a form of idol worship:

> If it is not right to represent God by a physical likeness, much less will we be allowed to worship by a physical likeness, or God in it. Therefore it remains that only those things are to be sculptured or painted which the eyes are capable of seeing: let not God's majesty, which is far above the perception of the eyes, be debased through unseemly representations.[9]

I do not mean here to rehearse the arguments of iconoclast/iconodule controversies of the past few millennia or of the sixteenth-century reformations. My point is that the power of images to provoke complex responses has been repeatedly acknowledged and debated.

However, as contemporary viewers and theorists of images, we tend to look at and talk about images in ways that neglect their impact and significance. But, says Freedberg, "it would do no harm to think and speak more openly about the life in the image, and sometimes, even to consider reclaiming the body."[10] For it is through the depiction of bodies, especially bodies in pain, that viewers are conditioned to empathize with an image. Although this was true of historical viewers seeing paintings such as the *Grünewald Altarpiece,* one must question whether this

process is still applicable today. Because viewers of television and film see so much real and staged violence and suffering on the screen, they (we) may have become less sensitive to the pain of others. As we shall see, the efficacy of art, its power to provoke strong response and action, is weakened if it has too high an entertainment value.

Without an image before us, we are thrown back on memory and imagination based on what we have previously seen or known. Everything but the ecstatic, syllogistic, and arithmetic must be grasped through images.[11] An elaborately articulated psychology of perception and of the image would be needed to demonstrate fully this claim, but historical texts show that the power of images has been perceived as sufficiently threatening to warrant censorship and legislation.

Because there is a lack of adequate terminology for analyzing the cognitive processes involved in our responses to images, we often fall back on affective language to describe those responses.[12] Words that refer to feeling, such as "spontaneity," "instantaneity," or "helplessness," are used to identify our complex reactions. Much sophisticated talk about art thus evades the issue of the power of art to evoke intense emotional responses. This is true both of critical discourse and of art historical analysis.

But how is the repression hypothesis related to a more productive understanding of the role of images? In her books on visual understanding and religious meaning, Margaret R. Miles has similarly acknowledged the power of images to provoke repression; moreover, she has set forth a nuanced perspective on the productive role of feeling, emotion, and the body in our responses to art works. Central to her work is the conviction that an accurate understanding of the power of representation must also include a "social theory of the subject," that is, a theory of how socialization, subjectification, and sexualization are inculcated and developed using both verbal and visual languages.[13]

Building on the work of Michel Foucault and Frigga Haug, Miles argues that the repression hypothesis alone is insufficient, especially in trying to fathom the construction of women's subjectivity. It is not only through an examination of what is repressed, or who is oppressed, that we gain insight into how subjectivity is constructed. We also need to analyze the productive power of images. People actualize themselves through complex processes that involve selecting among cultural offerings, accepting some and rejecting others. The productivity hypothesis is based on the idea that individuation takes place as a process in which an individual learns socially accepted theories of the self and practices

**52**

the skills of self-representation, a discipline that is itself "invested with pleasure."[14]

Thus, constraint and repression, together with more productive forces of attraction and regulated desire, help individuals develop a self. As Miles has written, "[F]ormation by attraction, or the creation and direction of the individual's desire, is effective, economical, and problematic because particular forms of socialization appear to be chosen and pursued rather than imposed as external requirements."[15] Using Foucault's categories of weak and strong power, she emphasizes that whereas weak power uses threats and physical force, strong power stimulates and attracts the individual and is often invisible. Certainly the history of the use of visual images presents numerous examples of the exercise of both weak and strong power. The distance between Hans Baldung Grien's prints and drawings of witches, with their implied violence against women who would trespass into this domain, and Lacy and Labowitz's performance piece, which indicts violence against women and murder, demonstrates these categories.

Miles further differs from Freedberg in asserting that images help constitute selves primarily through strong power, the force of attraction. We are in myriad ways socialized to become "docile bodies," to use Foucault's phrase. Through complex social processes in our carceral society, bodies are disciplined, organized, and trained to perform in predictable and controllable ways. Foucault's concept of the carceral is based on the continuity of punitive criteria and mechanisms within institutions of supervision and restraint (the family, schools, medical clinics, mental hospitals, and prisons), as well as on discreet surveillance and insistent coercion within society at large.[16] In short, the forces that urge us toward uniformity and conformity – through advertising and various reward structures – are extremely powerful. Although appearing to be free of violent excess, this carceral network actually is based on constant observation and constraint of the body. Seemingly benign, these processes have had disastrous consequences for women and, many would argue, for all of life on the earth.

At least until the rise of abstract imagery in the twentieth century, visual images provided a means of understanding and conditioning the life of the body and of emotion. "Visual images . . . are primarily addressed to comprehending physical existence, the great, lonely, yet universal preverbal experience of birth, growth, maturation, pain, illness, ecstasy, weakness, age, sex, death."[17] As suggested earlier, in seeing images of suffering, we may experience pain. Or, from images of celebration, we may experience vicarious joy.

Not only do images quite literally show the variety of embodied human experience, but visual language is also a mode of formulating and expressing feeling. As Susanne Langer has written: "Art objectifies the sentience and desire, the self-consciousness and world-consciousness, emotions and moods, that are generally regarded as irrational because words cannot give us clear ideas of them."[18] Langer's theory of language differentiates between verbal language and the multiple languages of the arts. Verbal or discursive language helps us to give form to our sensory experience. We group our impressions around those things that have been named, thus fitting our sensations to those qualities with adjectival names. In contrast, Langer argues, the presentational languages of the arts, especially the visual and theater arts and music, actually form our emotional experience.[19] Just as discursive language is capable of most directly communicating ideas, presentational languages most effectively communicate feeling.

Such expressivist interpretations of art, however, can be criticized in several ways. Because expressive aesthetics takes the human being as its primary object, it is decidedly anthropocentric in that all representation, even inanimate objects and forms such as color and line, are given human attributes. But more importantly, it is limited because expressive aesthetics usually posits only one coexperiencing consciousness, rather than the relationship of an "I" to "the other" that characterizes uniquely aesthetic experiences. Further, Langer's expressivist interpretation of art does not offer an adequate perspective from which to analyze form and the relationship of form to content in visual representation.[20]

"Representation" is a complex term that allows us to understand at least three significant aspects of art practice. First, representation highlights the fact that images are not mirrors of the world, but are always refashioned and coded in distinct ways. In this sense, representation follows conventions established for each medium – painting, photography, video, and so forth. Second, representation articulates or demonstrates the social practices and forces that are difficult to actually see, but which condition our lives. In this sense, representation both can show what is and can alter our experience of those conditions. Third, representation always signifies that a viewer or consumer is being addressed. In other words, theories of representation inevitably express ideology. More than just a collection of ideas or beliefs, an ideology is a systematically ordered hierarchy of meanings, which also prescribes how these meanings are to be assimilated.[21] Material practices within specific social institutions are governed by ideology. Cultural practices,

such as artistic creativity, can help us to make clear, and to make sense of, the ideological nature of representation.

In art history, representation has usually been interpreted around the figure of the individual artist, who follows the ideals of bourgeois masculinity, a "universal, classless Man [sic]."[22] One of the consequences of the analysis of the social production of art, especially as it combined with the poststructuralist analysis of the death of the author and birth of the viewer, is that the centrality of this male-artist-genius has been questioned in art historical discourse. As I will show in Part II, a reemphasis on the cultural function of the artist can have a significant impact on our interpretation and understanding of representation.

From my perspective, both of the major issues discussed thus far – the nature of our responses to images and the repression and productivity theses – are essential to understanding why and how images have had power in history and can be powerful in the present and into the future. These are two basic assumptions on which any theory of the arts must be constructed.

However, a third, more debatable, issue also informs my writing here: that images are an especially efficacious means for expressing human understanding of the sacred and the divine, that which is invisible and must remain unseen.[23] A critic could argue against this by pointing to the motif that a deity cannot be represented in material form or anthropomorphically, a motif that has been present since early Greek thought.[24] Indeed, from the time of Philo the most common argument against images is that the divine cannot be depicted in material form precisely because it is immaterial and cannot be circumscribed. The fear that base matter would somehow contaminate the divine is implicit in such ideas. Nevertheless, people in all times and all cultures have made material objects to represent what they considered divine.

This idea is nowhere more vividly depicted than in the eighth-century writings of John of Damascus.[25] John exploited the multiple meanings of the Greek *eikon:* as in English, the word can mean both a concrete and a conceptual representation. For John, an image can be an analogy or an imitation, a symbol or an expression of a plan. However, from Pseudo-Dionysius he took yet another meaning: that the *eikon* refers to objects in the visible world of the senses that act as reflections of the invisible world of the spirit.[26] As Pseudo-Dionysius had written, "[T]hrough the veiled language of Scripture and . . . tradition, intellectual things are understood through sensible ones, and the superexistent things through the things that exist. Forms are given to what is intangible and without shape and immaterial perfection clothed and multi-

plied in a variety of different symbols."[27] In other words, the "intellectual," the "superexistent," and the "intangible" can best be manifested through existing symbols and objects.

Images, from this perspective, are material prototypes of the divine archetype, which is invisible. Yet an image is not merely a symbol of the archetype; the represented actually becomes present through the icon or prototype. This whole idea is related to and made possible by the doctrine of the incarnation. As John wrote: "When the Invisible One becomes visible to flesh, you may then draw his likeness . . . [because] visible things are corporeal models which provide a vague understanding of intangible things."[28] John cited vivid examples such as the sun, light, burning rays, a fountain, an overflowing river, a rose tree, a flower, a sweet fragrance, as well as more abstract images such as the mind, speech, and the spirit. The natural world, material and corporeal, expresses the invisible God. Certainly his analysis of the nature and function of images is more complex than this short summary indicates, but John's central point is that in the icon the holy is made present. Icons serve as channels of grace because of the persons and events they represent, and yet they are also basically mysterious vehicles of divine power.[29] Later, I will discuss the training of Russian icon and Tibetan thangka painters, as these two traditional cultural forms exemplify some of the ideas I am developing here.

I have already alluded to the justification for the use of images in writers such as Aquinas and Bonaventure. Although the idea that all created things are symbols of God had existed earlier in the common era, only from the time of Bonaventure (1221–74) was a general theory of signs articulated.[30] Following an extraordinary mystical vision in 1259, Bonaventure wrote *The Soul's Journey to God*. In this text, he traced the seven stages through which the soul or mind (*mens*) passes in contemplating God. In this process the soul uses many dimensions of being: the senses, imagination, reason, understanding, intelligence, and conscience.[31] Most significant for our purposes is Bonaventure's assertion that we contemplate the material world with our senses and thereby know at least one aspect of God.

> [W]e can gather that all the creatures of the sense world lead the mind of the contemplative and wise man to the eternal God. For these creatures are shadows, echoes and pictures of that first, most powerful, most wise and most perfect Principle, of that eternal Source, Light and Fullness, of that efficient, exemplary and ordering Art. They are vestiges, representations, spectacles proposed to us and signs di-

vinely given so that we can see God. These creatures, I say, are ex-
emplars or rather exemplifications presented to souls still untrained
and immersed in sensible things so that *through sensible things which
they see they will be carried over to intelligible things which they do
not see as through signs to what is signified.*[32] (italics mine)

Bonaventure is saying here that things, including works of art, are the
shadows, resonances, tracks, simulacra, spectacles, exemplars, and signs
of the signified, in short, of God. Bonaventure's language had a for-
mative impact on our understanding of how created objects could lead
the mind of the contemplator toward God.

But another idea is implicit in Bonaventure's writing and relates di-
rectly to the significance of the role of the artist. Alluding to Romans
1:20, Bonaventure wrote: "[F]rom the creation of the world the invisible
attributes of God are clearly seen, being understood through the things
that are made."[33] In short, divine creativity is to be understood as anal-
ogous to the creative activity of the artist; thus, paintings and sculptures
provide us a means of contemplating God. Bonaventure essentially wid-
ened the anagogical or mystical interpretation of images by making the
equation between divine creation and artistic production clear.[34] In his
work, the idea that images move from being merely traces of God to
being simulacra, divinely given real signs, gained currency. Of course,
this idea was not unique to Bonaventure. Throughout many medieval
treaties, and implicit in the devotional manuals, handbooks, and other
aids to meditation of the fourteenth- and fifteenth-century *devotio mod-
erna,* is the assumption that the human mind is capable of grasping the
invisible only through the use of the visible.

Later in the history of theorizing about images, Gotthold Lessing
acted as an important apologist for the secularization of images. In fact,
he was hostile to religious images, suggesting that any work with ob-
vious religious content should not be called art. In such religious images,
"Art was not working for her own sake, but was simply the tool of
Religion, having symbolic representations forced upon her with more
regard to their significance than their beauty."[35] In thus proclaiming
art-for-art's-sake, Lessing may have been trying to offer validation for
museums and for commercial art, both of which were relatively new in
his time. By asserting that only nonreligious images should be called
art, he reinforced an opposition that has been pervasive ever since. Art
and beauty have stood together on one side; religion and symbolic sig-
nificance on the other. This separation can be seen in the early-
twentieth-century formalist theories against which Mikhail Bakhtin

polemicized, as well as in more recent critical writing, such as Clement Greenberg's many essays on modernist art.[36]

Ultimately, however, such oppositions are spurious, because all images resemble religious images in the sense that they have the potential to involve the beholder.[37] Although this ability to engage the viewer obviously depends to some degree upon the willingness of that viewer to be affected, still, the power of images has been sufficient in various historical contexts to cause people to claim that *all* visual representations must be subject to controls. Contemporary evidence of this can be seen in the vehemently conservative responses of the United States Congress to the National Endowment for the Arts and to individual artists such as Karen Finley, Tim Miller, David Wojnarowicz, and Bob Flanagan. Indeed, the censorship wars of the 1980s and 1990s, and even the dismantling of the NEA itself, offer ample evidence that though an image may be inanimate, it seems to come alive. For some critics of contemporary art that aliveness, which includes both veracity and verisimilitude, can be threatening.

The main function of this long excursus has been to articulate some of the presuppositions underlying my approach to the art discussed in the following chapters, as well as to justify my claim that art has power to change consciousness and ultimately to affect change in the world. Against the iconoclast position, I hold that images, even abstract ones, can powerfully express the sacred. Further, images have both a repressive and a productive function. They communicate what we must not do or be and help to shape what we positively become. This is part of how images are efficacious. Finally, images not only express feeling, but they also stimulate and influence our affective experience of other persons and the world. Images can take hold of the viewer's imagination and provoke fantasy as well as action. I will return to this theme many times in what follows, but especially in discussing the advent and impact of electronic media and digital imagery in the visual arts. No theory of representation would be adequate if it failed to acknowledge the powerful formative influence of interactive media today, which has radically changed the nature of spectatorship and participation in art making. Indeed, one could say that these new media are changing the nature of art itself. As these changes transpire, the self-understanding and the larger role of the artist must come under investigation as well.

## ART AND SOCIAL CHANGE

Is art an efficacious way to create change? No, and yes. No, because change is a dynamic process, hard to define causally, and hard to predict. Social transformation is a process that cannot be measured by standards such as immediate gratification that so characterize contemporary American culture. To imagine that visual art could directly affect social institutions, even with newer media like computers and imaging technology, would be wishful thinking. But art has undeniable power: power to name, to criticize, to heal, and ultimately to change consciousness. The experience of this power of the image starts with the creator and radiates outward into the world from that initial encounter of artist and object in the creative process. So, yes, art can change the way people perceive, think, and act in the world.

Nowhere has a more terse and clear account of the efficacy of art been offered than in Herbert Marcuse's small book *The Aesthetic Dimension,* a detailed examination of which will help to substantiate the idea that art has power, though perhaps not always directly.[38] Three aspects of Marcuse's ideas are relevant here: his views on the role of the individual, on the relationship of form and content, and on time.

Marcuse's perspective on the role of the individual as an agent of change arose in direct opposition to Marxist aesthetics, which is traditionally based on a series of suppositions: that there are necessary connections between art and the totality of the relations of production and between art and social class; that revolutionary content and the quality of art usually coincide; that the artist should express the interests of the proletariat, or struggling class, in works of art, and, related to this, that a declining class can produce only decadent art; and finally, that realism is the most effective and "correct" form of art. For Marcuse, the primary problem of these aesthetic dicta is that they do not acknowledge the power of individual consciousness and subjectivity in the world. The possibility of radical change is rooted in individual subjectivity – in intelligence, passion, imagination, and conscience. In order both to indict established reality and to invoke the image or possibility of liberation, which are the two primary functions of art, the artist must be able to transcend social conditions, if only in the process of creativity. This is very close to Mikhail Bakhtin's idea of outsideness: that to be effective, an artist must stand outside of lived life, at least in the process of creating.[39] Reality – social-political-economic-personal – must be sublimated, that is, stylized and reshaped, to reveal the actual nature of reality and to affect a change in the perception of the viewer.

The relative truth and power of art lies in its potential for helping us to see the ideological nature of what is defined as real.[40] And this power to break the monopoly of the reality principle lies in the individual consciousness.

What can it mean to speak of the "actual nature of reality" or of a "reality principle" in a world of virtual realities, cyberspace, and crowded information highways? Or to phrase this another way, when much of the world in which we live is constructed of simulacra, what is "real"? Clearly, these are questions that Marcuse never conceptualized, but I think his perspective remains relevant. Artists still need to wrestle with questions about what reality is, that is, about how our sense of reality is shaped by subtle principles designed to socialize and control desire, especially by capitalist values concerning materialism and consumerism. Such values certainly pervade cyberspace, as well as the physical space of shopping malls. Perhaps one could say optimistically that artists can help us to see and comprehend the symbolic order that governs desire and even possibly to change that order.

In general, art can be critical and "negative" (in the sense of negating the status quo) in two ways: either by affirming an alternative to established values or by denouncing establishment values and reality.[41] Art can give us images of a freer society and of more human and humane relationships, but its ability to affect change remains limited to individual consciousness. How it can become effective in the larger social arena is impossible to say. Marcuse did not think that absolute prescriptions for change can be defined. If people are complacent, then they are condemned to the established reality.[42] If they interrogate (from the Latin, *inter-rogare*, "to ask between") social customs and practices, then change is possible.

Art, however, does not affect reality directly. "Art cannot change the world, but it can contribute to changing the consciousness and drives of the men and women who could change the world."[43] By making the discrepancies between reality and possibility plain to the viewer, art has a subversive function within the individual. But this function, and the power it implies, can change into its opposite, especially when art becomes popular and fits too easily within the capitalist system of commodity exchange that assuages the viewer's and the public's sense of injustice. For instance, the films *Schindler's List* and *Malcolm X* were criticized as too easily assuaging the audience's sense of discomfiture and outrage about the Holocaust and anti-Semitism and about racism and racial injustice (after all, Oscar Schindler and Malcolm X both did *something*).

This leads to the second aspect of Marcuse's ideas: the relationship of form and content. Because of the complex relationship of entertainment, mass appeal, and the commodity status of art, for Marcuse the political potential of art lies in its aesthetic form, not in overtly political content. Because of aesthetic form, art is autonomous from social relations, and this allows both protest and transcendence of these relations in the public sphere.

Art can be revolutionary in several ways. It can represent a radical change in style or technique. Marcuse's examples were Expressionism and Surrealism, as these arts were developed in his time. We might locate new possibilities in artistic genres such as performance and electronic technology, which sidestep some of the problems of the commodification and co-optation of art. Such art can represent social reality, with its lack of freedom, and also show possible resistance that allows for change, as in Suzanne Lacy's and Leslie Labowitz's performances since *In Mourning and In Rage*. But new styles and new techniques are not the only means by which art expresses its revolutionary impulse. A contemporary example of such work would be Sue Coe's *Porkopolis* series of drawings on animal rights, widely circulated not only through exhibitions but through magazines and journals as well.

Marcuse insisted, however, that the process of representation is most effective when not directly didactic. "The more immediately political the work of art, the more it reduces the power of estrangement and the radical, transcendent goals of change."[44] This "power of estrangement" sounds like Victor Shklovsky's formalist notion of defamiliarization, but whereas many formalists eschewed both overt and covert political aims, Marcuse saw the radical potential in formal innovation. This is especially pertinent when considering Coe's work, for its power resides precisely in its didacticism. Against Marcuse's point of view on this, I would suggest that we cannot know the direct impact of didactic art in the public sphere, especially when, like Coe's, it is circulated in the mass media.

Marcuse valorized form over the representation of realistic content for another reason. For example, there is a problem in representing suffering directly, because by subjecting suffering to aesthetic form, art mitigates catharsis and arouses enjoyment. How else can one make sense of the response of the public to widely distributed images of suffering and pain (in Somalia or Rwanda, in the former Yugoslavia, even in the video of Rodney King), if not to acknowledge their entertainment value? Art based on such imagery – as in George Holliday's video of Rodney King's beating by the Los Angeles police, which was part of

the 1993 Whitney Biennial – may challenge definitions of what art is, but it does not necessarily cause a change of the viewer's consciousness. In short, the power of art is weakened to the extent that it popularizes itself, because this means that it appeals too much to mass consciousness. Possessed of high entertainment value and mass appeal, art becomes pure commodity.

"How can art speak the language of a radically different experience? . . . How can art invoke images and needs of liberation which reach into the depth dimension of human existence . . . ?"[45] With such questions, Marcuse highlighted significant issues about content and form for further discussion. In contrast to more moderate assessments of the power of form by theorists such as Bakhtin, Marcuse emphasized that content must become form. He placed much emphasis on the subversive possibilities of form itself; for instance, the poetry of Mallarmé is capable of shattering everyday perception and experience. He did not, however, foresee the problems with an aestheticized art-for-art's-sake, which has also been one of the consequences of esteeming form over content.

The third aspect of Marcuse's ideas worth considering here concerns time: the relationship of the past and future to the present in which we stand. The world of art establishes another reality that contrasts with the dominant reality principle governing the world in which we live. By contradicting given realities, art thus can communicate new possibilities and new truths.

Marcuse stated this in several different ways. Art has both a negative and an affirmative character: It negates reality, saying that "things must change," but it also affirms the possibility of reconciliation and hope. Art thus witnesses to the limits of freedom and to the ways we are embedded in nature. By art's intensifying perception, the otherwise invisible becomes visible and the otherwise unspeakable is spoken.[46] Marcuse also framed these ideas in terms of four "true" functions of art: "(1) to negate our present society, (2) to anticipate the trends of future society, (3) to criticize destructive or alienating trends, and (4) to suggest 'images' of creative and unalienating ones [trends]."[47] In the process of fulfilling these functions, art is not a mirror of reality, because it can never imitate reality. It leads beyond the present, allowing us to remember the past and preserve what was best in it, and points to a possible future society in which these values may yet be realized.

Memory of the past must live with imaginative possibilities for the future. In fact, memory, and the images of possible other realities, form the essential ground from which art is created. But this does not imply

**Figure 7.** Louise Lawler, *Connections*, 1990–1

that the future will be positive, that good will triumph over evil. Authentic works of art do not promise such glib happy endings either. There are, in fact, no promises; there is only the chance that change can occur.

A utopian dimension in art exists where and when artists free themselves from the pressures and contingencies of economic reality, a reality that has driven many artists to participate unquestioningly in the politics of the art market. Or, it may exist when artists can make their art out of commentary and questioning of that system. Examples here include Louise Lawler and Fred Wilson, whose interventions in museums bring attention directly to the politics of representation.[48]

In her 1990–1 "Connections" exhibition at Boston's Museum of Fine Arts, Louise Lawler installed the museum's thimble collection for a rare viewing, with individual photographs of many of the thimbles (Figure 7). In so doing, Lawler brought attention to the distinction between what is usually deemed worthy of exhibition and what is not. As the wall lettering intoned: "Does it matter who owns it? Who chooses the details?" (The thimbles were actually exquisite.)

Analogously, Fred Wilson's "The Museum: Mixed Metaphors" representation of artifacts at the Seattle Art Museum in 1993 (Figure 8) was both humorous and startling, as his discriminating placement of objects in relation to one another forced viewers to confront some of their own stereotypes. He worked throughout the entire museum, trying to demonstrate cultural and historical connections between art created in different times and in different places, art that we tend to conceptualize as distinct. For instance, in the hall of African Art, dashikis, wall-hung fabrics, and a life-size figurative sculpture were juxtaposed with a

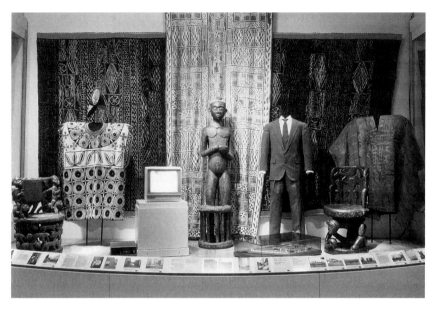

**Figure 8.** Fred Wilson, *Mixed Metaphors*, 1993

computer and a mannequin wearing a European-style gray business suit, also "traditions" in Africa. The label text for the suit parodied museum writing: "Certain elements of dress were used to designate one's rank in Africa's status-conscious capitols. A gray suit with conservatively patterned tie denotes a businessman or member of government. Costumes such as this are designed and tailored in Africa and worn throughout the continent."[49] The suit remains in the gallery long after Wilson has left; his intervention has had an effect. In an earlier statement for the 1993 Whitney Museum Biennial, Wilson had articulated the values that guide his work in museums: "I attempt to give new meanings to information and environments that are familiar and seductive. . . . I am interested in bringing historical information to the aesthetic experience in order to reveal the imperialist reality of how museums obtain or interpret the objects they display. I believe doing so makes clear the complexity of the things on display."[50] Both Lawler and Wilson have successfully criticized and subverted standard conventions within museums and the art world.

My enthusiastic description of Marcuse's ideas is not meant to imply that there are no problems with them. As Carol Becker has pointed out, there are several aspects of his thought that bear criticism.[51] He believed that art should envision a universal humanity beyond class and the specificity of one's social location, implying that art, or at least certain aesthetic forms, can transcend all categories of difference. Postmodern

discussions of the politics of identity and difference have made such claims highly suspect. He also placed an inordinate faith in the possibilities of form to create a sense of estrangement, a faith that must certainly be challenged by the historical development of an aestheticized art-for-art's-sake in the twentieth century.

Marcuse's notion of beauty is also interesting, but incomplete. Against the Marxist rejection of the idea of the Beautiful, Marcuse affirmed that beauty is an important goal of art. "Striving for beauty is simply an essential part of human sensibility."[52] He did not claim that he or anyone could say exactly what that is, because beauty is neither absolute nor unchanging. The Beautiful represents the pleasure principle (Eros) and is always oblivious to changing canons of taste. Marcuse's notion of beauty and the Beautiful is nuanced, insofar as he linked it to liberation. To the extent that beauty opposes its own nonrepressive order to that of reality, the Beautiful belongs to the imagery of liberation.[53] Unfortunately, Marcuse's notion of beauty and the Beautiful not only elides the presence of the acting consciousness of the artist, but it also is too morally neutral. For instance, Leni Riefenstahl's films representing Nazism are also compelling and "beautiful." Discussions about beauty, therefore, should not be separated from moral and ethical values.

Marcuse thought that the Beautiful resonates with originality, with strong formal qualities, and that it allows complex meanings to evolve, rather than be obvious. This is certainly in keeping with the ideas of artists such as William Blake or Vasily Kandinsky, who believed that only through struggling to understand their poetry and art could consciousness be transformed.[54] Many critics have not understood the subversive potential of the concept of beauty, especially when it is linked to social and political goals, as in Lynn Randolph's paintings (Figures 31 and 32). But what of the ugly? Some activist artists, such as Nancy Spero and Leon Golub, consistently give prominence to the ugly. A major problem with much aesthetic theory is that it values only one half of the beauty–ugliness dialectic. In so doing, this theory and its supporters miss the subversive potential of the ugly as well.[55]

Perhaps less problematic, but also provoking careful consideration, is Marcuse's belief that there is some part of the human psyche invulnerable to repression. One of the most powerful examples I know that supports such a premise is the play *Pedro y el Capitan* by the Uruguayan writer Mario Benedetto.[56] If the victim of torture unto death retains the ability to say "No!," as the main character Pedro is able to do, then hope for the future is still possible. This same power of the will to

endure is depicted in Ariel Dorfman's *Death and the Maiden,* made into a film by Roman Polanski in 1994. But this brings to mind again my earlier comments about the entertainment value of suffering.

Even the most radical and potentially transformative art cannot dispense with the element of entertainment, and this is one of the most difficult dilemmas of art.[57] Entertainment, and the pleasure that it implies, is essential if one wants an audience to be willing to consider seriously a work of art. But questions remain: How can an artist provide both entertainment and pleasure, while refusing the commodity world? How is this possible, when the market and art world are so deft at co-opting various strategies of resistance? I cannot answer them categorically here, but I think that serious artists must wrangle with such questions.

In the process, artists may take very different standpoints. The artist and critic Ronald Jones has articulated the pessimistic view: "If art actually had the capacity to create revolutionary change . . . it would be excused from view; at this point, change only exists by permission of the culture industry, which likes to create the illusion that the culture is transforming itself, but which has not been engaged in turning itself over in any fundamental way for a long time."[58] Mary Beth Edelson presents a view more in line with the argument I am developing here: "It doesn't make a difference in my behavior whether there is a chance that this will succeed or not [in changing things]. I will still behave as if these goals were a possibility, regardless of what my doubts are. . . . The opposite of not hoping is what we have – extraordinarily paralyzing, cynical alienation."[59] Her gallery installations of the 1980s testify to her conviction.

Art can function as a regulative ideal in the struggles to change the world, insofar as it preserves the memory of goals that have failed in human experience and history and the hope for freedom and happiness.[60] Marcuse was not here extolling an individualistic ethos, but emphasizing that art has radical potential to the extent that it indicts established reality, invokes beauty, and shows possibilities for transcending given social positions and constructs. Art, for Marcuse, is a particular kind of imaginative space in which freedom is experienced. This location can be physical or psychic, but it offers the larger possibility of freedom from given reality. By breaking open our perception of the world, by contradicting established reality, by showing another better reality, art preserves hope for a better future – indeed, it helps to create a vision of the future. A utopian dimension in art means developing a sense of these possibilities.[61]

All of this can be linked to Marcuse's understanding of thought itself. Marcuse claimed that he learned about the nature of thinking from Martin Heidegger, one of his teachers. "Real phenomenological thinking" is not just a matter of representing what already is, but it also involves "recalling" what has been forgotten and "projecting" what might be in the future. Real thinking involves not just the present but also the ability to think of the present in relation to the past and the possible future.[62] Although the actual future is unknowable, this does not obviate the necessity for thinking about and creating possibilities for the future. In so doing, art has important functions as education and self-criticism for the artist and for society.

Perhaps, finally, we need a certain modesty here, to counter any tendency to believe that art can change the world. In her diaries, Anaïs Nin told a story about the Hindu sage Ramakrishna that expresses this modesty. Traveling through India, Ramakrishna preached ecstatically. Once, someone cried out to him: "Do something for the suffering of the people." He answered: "I can do nothing." As Nin noted, perhaps this is also the position of the artist in society in the largest sense.[63] The action of the artist, like that of the sage, does not "save the world" or assuage the suffering of the people. Neither artists nor anyone else can change the world alone. But regardless, the whole point of this review of Marcuse's work is that art can be a powerful and subversive tool for changing personal consciousness and social conscience.[64]

Human creative and imaginative faculties can never be redundant, for as long as human beings wish to change, we can never cease to imagine. A book on the vocation of the artist is an admittedly small step toward the kind of change that will make human survival possible. Still, *The Vocation of the Artist* is based on the conviction that artists can play an active role in cultural transformation. That process of change starts with an individual consciousness and moves out into a particular cultural context from there. Education is crucial. Verbal language, the written word, and visual images are vital educational tools.

In his sermon on the twenty-fifth anniversary of Bertolt Brecht's death, Martin Walsor quoted the writer's words; these provide a fitting meditation for the end of Part I.

> To whom do you speak? Who finds what you say useful? And by the way:
> Is it sobering? Can it be read in the morning?
> Is it also linked to what is already there? Are the sentences that were
> Spoken before you made use of, or at least refuted? Is everything
> verifiable?

By experience? By which one? But above all
Always above all else: How does one act
If one believes what you say? Above all: How does one act?[65]

To whom does the artist speak? Who finds the artist's images most useful? Are they sobering, and can they be viewed in the morning? Are they linked to what was done before? Do they acknowledge, refute, or verify the past? And whose experience is esteemed? But above all else, how does one act if we believe what we see? The most important question is, how will we act?

# Roles of the Artist

## CHAPTER 5

# Premodern Theocentric Mimetic Craftsperson

The Buddhist *Wheel of Life,* or more properly, *The Wheel of Existence,* is a complex diagram depicting fundamental Buddhist teachings about the origins, causes, and alleviation of suffering (Figure 9). To "read" the diagram, start at the center, where a red cock or pigeon, a green snake, and a black pig symbolize the three basic causes of rebirth: desire, attachment, and greed (the cock); hatred and aversion (the snake); and ignorance and delusion (the pig). Around these animals is a second wheel: On one side is the so-called Dark Path, which leads to hells and bad rebirths for those who are caught in greed, hatred, or ignorance. On the other side is the Path of Bliss, which leads to better rebirths and finally, to liberation.

Around this circle are the six conditions of rebirth, or the symbolic worlds. These can be read clockwise: the realm of the gods, of titans, of *pretas* or hungry ghosts, of hell dwellers, of animals, and of humans. The realm of the gods is mirrored by the cold and hot hells. To the upper right, the world of the titans, the *asuras,* or anti-gods, is mirrored by the realm of animals, who are subject to instinct. To the upper left, the world of humans is mirrored by the realm of *pretas.* In each realm a manifestation of the Buddha appears, depicting the possibility of and way to nirvana.

The outer rim of the wheel depicts the twelve interdependent causes of rebirth. Clockwise from the top right, a blind person symbolizes delusion or ignorance; a potter shapes pots as we shape our karma or fate; a monkey plucks fruit from a tree, much as consciousness roams from this to that; two people rowing a boat symbolize personality; an empty house with five windows and a door symbolizes the senses and thought; an embracing couple demonstrate contact and sensuality; an arrow entering a man's eye represents feeling and emotion; desire, the thirst or hunger for life, is shown by a man who is being served food

71

and drink; a man plucking fruit from a tree symbolizes clinging to objects of the world; a pregnant woman depicts procreation, the process of becoming; a newborn child symbolizes birth; and a corpse being carried to a cemetery in the last picture symbolizes old age, death, and the next rebirth in one of the six symbolic worlds.

The wheel itself is held in the jaws and claws of Yama (Sanskrit) or Shinje (Tibetan), the Lord of Death, symbol of the transitory nature of all phenomena. Outside the wheel are Shakyamuni, the Buddha as teacher of freedom, and Avalokiteshvara, who helps humans to become free, and who is reincarnated as the Dalai Lama within the Tibetan tradition.

This type of thangka is usually placed in the vestibule of Tibetan temples or is carried around as a means of illustrating Buddhist teachings. Although its pictorial origins lie in Indian Buddhism, the form of the thangka itself evolved in Tibet.[1]

\*     \*     \*     \*     \*

Within western European cultures, the secularization of the artist's vocation took place through complex ideological processes and over many centuries. In Asia, the process is more recent and can be related to larger processes of colonization and modernization. Just what are these ideological processes that have shaped and reshaped the role of the artist, and why did they take place? How can we take account of changes from the premodern era and Renaissance through the sixteenth-century reformations and the eighteenth-century Enlightenment, to the rise and fall of the modernist paradigms in the late nineteenth and twentieth centuries and the emergence of various postmodernist options in the second half of the twentieth century? How are we to make sense of the encounter with, transformation of, and current interest in the traditions of Asia? A full account of such changes is obviously beyond the scope of this book, but we can examine some of the major paradigms that have governed artistic practice for the artist. If a sense of vocation as calling has largely been lost, what then governs the way artists and others have thought and now think about the artist's cultural function?

To answer these questions, I have made the structure of Part II both chronological and thematic. These are actually arbitrary cognitive divisions, as chronology and paradigm shifts are not always easy to separate. Four main concepts of the artist organize this part of the book: as theocentric mimetic craftsperson who copies God in premodern times (Chapter 5); as anthropocentric original productive inventor who replaces God in modern times (Chapter 6); (as a subset of the modern

artist), as prophet within avant-garde circles (Chapter 7); and as parodic ex-centric bricoleur who plays with already created bits and pieces of past culture in the postmodern present (Chapter 8).² The interpretation of the vocation of the artist that I am developing in the book is not homologous to any of these, but draws on themes within each paradigm.

Figure 9. Anonymous, *The Wheel of Existence*, 18th–early 19th century

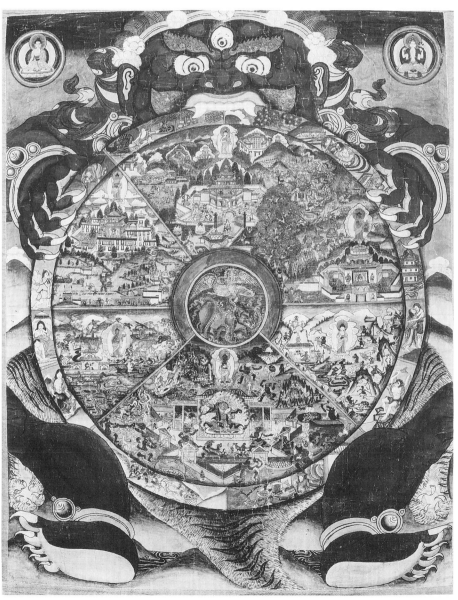

One of these themes is the problematic relationship of memory and history that I described in the Introduction. The absence of memory marks the agenda of many modern and postmodern artists. Barnett Newman, perhaps the most articulate philosopher of the Abstract Expressionists, wrote, "We are freeing ourselves of the impediments of memory, association, nostalgia, legend, myth. . . . "[3] Of course, Newman's agenda, and that of many American modernists of his generation, can also be interpreted positively, as an attempt to recenter creative activity in the natural human desire for what he called "the exalted." Nevertheless, my point is that much modern art effaces memory and history. The inability to remember a shared past not only makes collective action to create political change in the present quite difficult, but it also makes imagination of a collective future nearly impossible.

This statement of the problem – as the secularization of the artist's vocation within western European–based cultures and a corollary effacement of memory, history, and the future – raises an obvious question concerning the category "artist." Within the larger structure of Part II, my goal in this chapter is to examine ideas around the traditional artist or artisan, with considerable attention to two particular traditions, the Russian Orthodox icon writer and the Tibetan Buddhist thangka painter. Then, I will examine the usefulness of these two traditions, by asking what they have to teach us about the practice of art and the education of artists today. The evolution and use of the word "artist" are fairly recent phenomena in world history, but all cultures have had folk or traditional artists; and it is therefore with this category that I shall begin.

## TRADITIONAL ARTIST/ARTISAN

Following the direction of social historians, I would distinguish between folk, naive, and traditional artists or artisans. The origins of folk artists can be traced back to early neolithic cultures, but folk artists can also include artists working today in every culture in the world. Folk artists usually do not have formal training in art, and they follow cultural traditions that have been handed down. They are often highly skilled artisans and craftspeople whose work served and serves communal functions. Many women have been able to work as folk artists.

Although it is impossible to say exactly when naive art arose, the first noted exhibition was probably mounted by William Hogarth in 1762. He and Bonnell Thornton organized an exhibition of the "Sign Painters' Society," in which signs as well as portraits, landscapes, and

Figure 10. Harriet Powers, *Pictorial Quilt*, 1895–8

genre paintings by unknown painters were shown. Like folk artists, a naive artist generally has no formal academic training. Such artists make use of many stylistic devices: nonrepresentational color, exaggerated proportions, mixing of disparate elements, disregard for the rules of perspective.[4] Although the techniques may be naive, often the outlook and ideas that inform an artist's work is not.

Harriet Powers's magnificent quilts, for instance, made in the late nineteenth century as tools for teaching others, are notable. A freed slave who had no formal art training but worked out of ancient African traditions of stitchery and appliqué, Powers created pictorial biblical quilts, two of which are now in major U.S. museums, that demonstrate an extraordinary creative range.

The *Pictorial Quilt* (Figure 10), made between 1895 and 1898, contains fifteen squares. Ten are devoted to biblical stories, such as the threat of judgment, the Fall, Moses in the wilderness, the stories of Job, Jonah and the whale, and Christ's baptism and crucifixion. Powers herself provided detailed descriptions. In the top row, second from the right: "Adam and Eve in the garden. Eve tempted by the serpent. Adam's rib by which Eve was made. The sun and moon. God's all seeing eye and God's merciful hand." But the quilt also contains five squares depicting astronomical and current events. For instance, in the center of the bottom row: "Rich people who were taught nothing of

God. Bob Johnson and Kate Bell of Virginia. They told their parents to stop the clock at one and tomorrow it would strike one and so it did. This was the signal that they had entered everlasting punishment. The independent hog which ran 500 miles from Ga. to Va. her name was Betts." Although the image of the hog in Powers's rendition is literal, the word was also a code for escaped slaves. Thus, Powers's images are complex, combining visual and narrative elements that we would not necessarily associate with one another. They reveal the depth of her understanding of the events of her own lifetime and the redemptive vision of Christianity, combined with appliqué techniques that probably originated in West Africa.[5]

In common parlance, an artisan is any craftsperson who is employed in the industrial arts. More technically, an artisan is one who owns his or her own tools and sells the commodities produced through labor.[6] In the ancient world, a hierarchical social structure placed artisans and craftspeople below traders and merchants, but above slaves. In this system, occupations and the status they represented were hereditary. The earliest specialized craftspeople were probably itinerant, but as market demands grew, they became more stationary and specializations developed. In the making of weapons and tools, for instance, artisans included metalworkers, patternmakers, smelters, turners, metal chasers, gilders, goldsmiths, and silversmiths.

As associations of skilled male and female artisans in this latter sense, guilds developed in Europe between 1200 and 1900. All the people within a given town who produced a particular item were part of that guild. Potters and masons, saddlers and armorers, worked at their crafts. Masons, marble workers, and tomb makers were engaged in sculpture. Illuminators and mosaicists plied their trades. Most of these artisans had to follow the ordinances of their guilds, which were organized to include masters, journeymen, and apprentices. Guilds regulated all aspects of the working conditions of their members and of the production process by defining wages, hours, tools and techniques, quality, and prices. In this way, they functioned to preserve traditions; but beyond that, they also carried a certain mystique that may have contributed to the developing status of the artist.

Significant changes in the guilds recurred during three major overlapping periods. From the twelfth to the eighteenth centuries, in the first, primarily precapitalist, period, the guilds were preindustrial. The fourteenth century was the most prosperous period for these guilds; specialization had evolved so that there might be as many as one hundred guilds in large towns. Women were permitted to join some guilds,

but they could not hold office. There were also exclusively female guilds, but these often had lower legal and social status.

A countermovement to bring various crafts together for marketing and trade began, marking the beginning of the second period, from the sixteenth to the nineteenth centuries. Markets expanded, and a stronger separation developed between the master and other workers, resulting in a relationship that became more like one of employer to employee. Thus, large-scale capital investment in production began: Work was "put out" to be made by others outside the guild. Sometimes called the "putting-out" period, this was also when cottage industries developed. With the slow dissolution of the guild system, protofactories arose, and free laborers also practiced their crafts for wages. In a third period, from the eighteenth century to the present, the development of industrialization has dramatically affected the existence of guilds. Artisans still exist in many cultures, often better paid than industrial workers, but guilds as such had disappeared by 1900.

Perhaps the primary value of this model of the folk artist or artisan is the inextricability of the artist from his or her community or, specially, the role of the community in supporting the creative process. In the contemporary context, where artists work independently and often in isolation from one another, such communally based art may provide another alternative or at least an inspiration for reconsidering the nature of collective interdependence.

Much more could be said about the premodern artist, but speculation about the role of the artist in these earlier periods is largely conjectural; consequently, I have chosen not to inquire about what it meant to be an artist-shaman in early tribal societies, to be a producer of artifacts in early agricultural settlements or in the Greek and Roman worlds, or to work for the Byzantine church or medieval courts where art and artist were instruments of ecclesiastical or courtly devotion.[7] Instead, I now look more closely at two premodern traditions that survive up to the present: the training and practice of Russian icon "writers," or painters, and of Tibetan thangka painters. Although "vocation" may not have been part of how these "artists" considered their work, many of the issues addressed in Chapter 3 may be related to these two traditions.

In considering the models of the icon painter in the Russian Orthodox Church and the thangka painter in Tibetan Buddhism more carefully, my goal is not to compare the Russian Orthodox and Tibetan Buddhist traditions nor to extoll uncritically these premodern paradigms concerning the artist. Many important questions must be put aside: questions about the history of Rus', Russia, the Soviet Union, and

the presently evolving Commonwealth of Independent States, and about the history of Tibet, and including questions about possible connections between these two regions in the medieval period; questions about the history of religious and artistic traditions in these areas – about Russian Orthodoxy and about Tibetan Buddhism, including the development of its four orders (Nynigma, Sakya, Kagyu, and Geluk); and questions about the specifically aesthetic dimensions of these traditions. Although fascinating, these larger issues cannot be dealt with adequately in a book such as *The Vocation of the Artist,* where the agenda is much more specific.

What do we know about when and how icons and thangkas were first made? How do contemporary practices reflect the traditional patterns, and how are they changing under the pressures of commercialization? After briefly describing the historical contexts for these traditions, I will examine how they are relevant to our broadly pluralistic culture.

## THE RUSSIAN ICON WRITER

Orthodox Christianity was brought to ancient Russia by Byzantine missionaries. Following earlier unsuccessful forays into the region by some of these missionaries, Vladimir, then the imperial leader of Russia, married the sister of the Byzantine emperor around 988, converted to Orthodoxy, and began the process of Christianizing the country. Russia remained primarily an Orthodox country until 1917. The tradition of icon painting can be traced back to Hellenistic and Roman imperial portraits, busts on sarcophagi, and Egyptian mummy portraits, among other early forms.[8] When such images were placed in early churches, they were copied as wall frescoes and mosaics. Slowly, as the use of holy portraits, or icons, developed, the images were made from other materials and the rectangular form became more popular. In the western church, artists were free to interpret religious doctrine and stories according to their own wishes, whereas in eastern Orthodox churches, strict guidelines were developed for painters to follow. This became essential because, as outlined earlier, the power of images needed to be controlled and directed.

The first icons were apparently brought to Russia from Greece in the eleventh century, but few paintings survive prior to the 1230s and the Mongolian invasions. In thirteenth- and fourteenth-century Novgorod and Pskov, a so-called National Style and Golden Age developed. These two centers not only were isolated from Byzantium, but they were the

only two cities not conquered by the Mongols. Theophanes the Greek, later called "the father of the Russian icon," worked in Novgorod from the 1370s until 1405. In the mid-fourteenth century, Pskov gained independence from Novgorod and developed its own culture and painting style; but by 1500 the center of icon painting had begun to shift to Moscow.

During the seventeenth century, western influence prevailed, and the use of western perspective is especially evident in icons from this period. The split in the Russian Orthodox Church between the "True Believers," supporters of the state church, and the "Old Believers," or heretics, led to further developments in icon painting. In the first half of the century, portrait icons were made, and later the painters began to portray life realistically. A decline in aesthetic standards and quality during the eighteenth and nineteenth centuries was marked by the motto, "We paint according to the price," and by a so-called saccharine style.[9]

Although icons were not meant as objects of aesthetic appreciation, at least until the 1600s, they do embody general aesthetic principles. Prior to the strong influence of western ideas, perspective tended to be of three types: (1) an aerial view, where all persons and objects are visible; (2) a relative or ranking perspective, where size concurs with the figure's importance; or (3) a reverse perspective, represented as if seen from those within the icon. A combination of these forms of perspective can be seen in the icon of Sophia, or *Divine Wisdom* (Figure 11).

Generally, as is also apparent in *Divine Wisdom,* early icons have shallow spatial depth, which helps to differentiate the space of the icon from realistic space. Images are presented frontally, with centric composition; light seems to come from within the painting rather than from the outside world. For this reason, traditional icons do not use chiaroscuro. The use of colors is based on polychromy rather than colorism: Colors are independent of their use in the natural world and most often have both moral and spiritual significance. Russian icons also often contain titles, phrases, and inscriptions that are essential to the icon.

Icons served and continue to serve a variety of functions in the Orthodox church.[10] They enhance the beauty of a church, but more importantly, they are the focus of church ritual and are used as teaching tools. They are also objects of devotion. Because the theory of icons is based on the idea that the icon is a channel of grace, such a holy image is believed to enable the person who venerates or worships it to change identity. *Theosis,* divination or deification, is the final goal of an Orthodox Christian. Based on the idea that redemption, salvation, and

**Figure 11.** Anonymous, *Divine Wisdom*, 18th–19th century

transformation of the individual are possible, *theosis* is available to all Orthodox practitioners through the practices of daily religious life, such as going to church, receiving the sacraments, reading scriptures, and venerating icons. This is a social process that must be conducted within a community; icons are integral to the process.

Given this context, the role of the traditional Russian icon painter was very carefully prescribed. Initially, icon painters were anonymous, and even today many icon painters do not sign their icons. As Ananda Coomaraswamy has written, a culture and philosophy that support anonymity of the artist tend to be "directed against the delusion 'I am the doer'. 'I' am not in fact the doer, but the instrument; human individuality is not an end but only a means."[11] This is analogous to the understanding of the priest: "Similar to the way in which the priest constitutes the Lord's Body 'through the Divine Word', the icon-painter 'in place of the Word, paints and depicts and gives life to the body'."[12] The creation of an icon by a painter was compared in some Russian texts with the transubstantiation practiced by a priest offering the eu-

charistic bread and wine. Like the eight-century text of John of Damascus, the *podlinnik* used in Russia affirmed the correspondence between the word/ear and the icon/eye: "[W]hat the word recalls to the ear, the icon presents to the eye: the icon and the verbal memory are equal."[13]

Icon painters usually followed *podlinniki,* or pattern books, for painting their subjects. The act of painting an icon is described with the linguistic metaphor of translation: The painter quite literally creates a *perevod,* or translation. Though the form and iconography of the image were carefully prescribed, painters often added individual stylistic touches. The aesthetic act of the painter thus enlivened the image for generations of subsequent viewers of the icon. However, just as the icons became marketable objects in later centuries, so the painter's role changed radically from priest-figure to producer for a consumer market. The earlier anonymity of the icon painter was replaced by painters who signed each icon.[14] Thus the painter's primary patron shifted from the church to the consumer market.

In contrast to our present understanding of the artist, not anyone could pick up the materials and claim the identity of icon painter. Values of obedience (to God, the tradition, and the church), patience, and faith all combined with a strong anti-individualistic ethos. Prescribed content, form, material, and technique then became the outer framework or matrix for inner experience and inner freedom. The intention of all icon painters, whatever their relative skill, has generally been the same: to give form to the sacred tradition of the church, thus enabling the viewer to see, indeed to enter into, the invisible world of the spirit that coexists within and throughout the material world. The icon painter traditionally served three major aspects within Orthodoxy: the dogmas, expressed through the Bible, creeds, and other texts that are central to the life of the church; the liturgy or worship practices; and the prayer that lies at the heart of both the sacred texts and the liturgical tradition. In this sense one could say that because icon painting depicts the gospel in line, form, and color, the icon painter functions as a minister.[15]

The Orthodox tradition, like other forms of Christianity, assumes that human beings are fallen, sinful, and in need of redemption. (In contrast, traditions such as Tibetan Buddhism see humans not in terms of sin, but as blinded by desire and hence unable to achieve liberation from the wheel of life.) In Orthodoxy there are two main paths out of this state of fallenness. The first involves ordinary church life; the second is a more rigorous path generally associated with the training and spir-

ituality of icon painters, as well as of those wishing to be monks and nuns. The monastic life traditionally took three basic forms: hermits who lived isolated from routine activity; monasteries based on a strong communal life; and so-called semieremetic communities, which were loosely organized settlements under the guidance of an elder, who was sometimes a priest. Prior to the nineteenth century, icon painters most often worked in a workshop or studio under a master painter.[16]

In this context, the icon painter had to be a "transformed person in order to be able to present in his work a transfigured being and a trans-figured universe."[17] The artist does not design images, but unveils what is already there. As Pavel Florenskii wrote, "You [the icon painter] help us to remove the scales that cover our spiritual eyes. With your help we now contemplate, not your skill and mastery, but the very real ex-istence of the countenances themselves [for instance, the Mother of God]."[18] Consequently, the character and deportment of the painter were extremely significant.

Two existing historical texts give information about the qualities and values that were central not only to the lives of monks and nuns but also to the training and practice of icon painters.[19] St. John Climacus (c. 570–649) wrote the *Ladder of Divine Ascent,* which details thirty stages in the transformation of consciousness from the material to the spiritual. *The Philokalia,* collected in 1782 by St. Nicodemus of the Holy Mountain (1749–1809) and St. Makarios of Corinth (1731–1805), contains diverse writings from the fourth to the fifteenth centu-ries. Based on a way of praying called "hesychasm," from the Greek *hesychia,* meaning stillness, tranquility, and concentrated attentiveness, *The Philokalia* places great stress on wakefulness, alertness, and the prayer of the heart ("Lord Jesus Christ, Son of God, have mercy on me").

Values taught in *The Philokalia* include attentiveness and watchful-ness, the desire to travel this path, the abandonment of passion, atten-tion to memory and fantasy so as not get caught in either the past or the future, purification of the heart through prayer, detachment from desire and the attractions of the world, patience, humility, silence, and stillness. In contrast to wisdom, which is acquired through meditation on scriptures and grace from God, spiritual knowledge is developed especially through silence and inner stillness. As the text tells the seeker, "Continuity of attention produces inner stability; inner stability pro-duces a natural intensification of watchfulness; and this intensification gradually . . . gives contemplative insight into spiritual warfare."[20] Such characteristics clearly would also affect the way an icon painter worked.

Originally, the icon was seen as a medium for expressing ideas rather than conveying reality: It was a "living metaphysics," concrete, not abstract.[21] The power of the image or symbol was that it could actually convey several ideas simultaneously. The spiritual dimension of the icon painter's work was the attempt to understand and express the essence of life. For the Orthodox believer, the themes of incarnation, life-in-Christ, and human deification were the most important. The icon was thought to be a mysterious vehicle of divine power and grace and a means of knowledge for the person who venerates it. Similar values can be seen in the training of thangka painters and in the use of thangka paintings within Tibetan Buddhism.

## THE TIBETAN THANGKA PAINTER

As a major religious tradition, Buddhism was founded in India by Shakyamuni Buddha in the sixth century B.C.E., at around the same time as the Greek pre-Socratics, the Hebrew prophet Isaiah, Zoroaster in Persia, and Confucius and Lao-Tzu in China. From India, Buddhist traditions traveled throughout Asia, finally arriving in Tibet in the seventh century C.E., when a Buddhist teacher, Shantarakshita, was invited to the country. Shortly afterward, Padma Sambhava, a famous Tantric teacher and exorcist, joined Shantarakshita to help construct Tibet's first monastic complex. The first small group of monks were ordained, and textual translation began.[22]

It is probable that the first Buddhist missionaries brought sacred images with them that immediately helped to shape the artistic developments in Tibet. The origins of movable paintings on cloth or paper may date to pre-Christian times, when caravan traders carried signs for safety, protection, and general auspiciousness.[23] Buddhist texts explicitly detailing the practice of painting deities date from the common era. A diverse set of Indian and Chinese influences may be noted. Indian Buddhist Mauryan, Gandharan, and later Gupta and Pala styles, developed in Buddhist universities, traveled into Tibet via Kashmir. Even the early Ajanta frescoes (100–500 C.E.) may have had an influence on the painting traditions. For example, one of the representations of the Buddhist wheel of life has been seen as a precursor to the Tibetan thangkas on this theme. From the fourteenth century there was also frequent contact between Chinese monks and Tibetan lamas. But even earlier, from the construction of the Dunhuang caves (366 C.E.), Chinese influences on Tibetan styles were notable.[24] Printed pounces, or transfers,

for Buddhist designs, as well as Buddhist diagrams, were found at Dunhuang from the ninth to tenth centuries. In addition, the introduction of landscape elements, softening in the drawing, and elaboration of detail, and even the addition of red and yellow borders (originally made of Chinese patterned silk from ceremonial robes), came from China. Generally, four traditions contributed to the creation of Tibetan Buddhist art: Indo-Nepali, Central Asian, Chinese, and indigenous Tibetan art. Buddhism has proven remarkably adaptable in new and changing environments, as can be seen in the diversity of Buddhist art in those national settings.

After a period of decline, Buddhism was revived in the tenth and eleventh centuries; and its evolution continued with succeeding "waves" of Sakya, Kagyu, and Geluk influence. The full sacralization of Tibetan society was completed, and the tradition of the Dalai Lama instituted, by the Geluk order in the fourteenth century. As Robert Thurman has astutely observed, "the Tibetan worldview dating from this period can be understood as a kind of alternative modernity, a spiritualistic or interior modernity in contrast with the Western materialistic or exterior modernity we are familiar with. It is this different kind of modern quality that makes Tibetan civilization and its arts so fascinating to us, and so worthy of our study and emulation."[25] Just as the European west was developing a thoroughly secular and rationalized modernity, Tibet was moving in the opposite direction. Its arts reflect this most vividly, for the traditions of bronze and clay sculpture, painted thangkas, temple banners, rolled wall hangings, wall frescoes, and mandalas, as well as the creation of other objects for ritual use, testify to the richness of the Tibetan Buddhist worldview.

Of the many arts from Tibet, thangka painting has an especially well-developed set of values concerning production and the role of the artist. The earliest surviving thangkas probably date from the ninth to tenth centuries C.E., although the earliest thangka with an inscribed date comes from the fifteenth century.[26] In general, thangkas were made for various purposes: as a donation that might result in immediate benefits to the donor, such as material success in one's endeavors, longevity, good fortune, and so on; for commemoration of the dead; for teaching; and to invoke certain deities as an act of piety or devotion. Like mandala paintings, thangkas are aids to meditation and can become abodes of the divine. More recently, they are also made for commercial markets in Asia and the rest of the world.

The complexity of the Buddhist pantheon discourages systematic classification, but two forms of imagery are unique to thangka paint-

ings: apotheosized or deified lamas and saints (arhats) and a range of terrifying deities. Technical aids to painting these and other images include fixed patterns, spray stencils, imprints, illustrations in manuscripts, block prints, certain texts (especially when a life history is to be portrayed), and painter's manuals containing further data about color and other details.

Very little is known about the social background of individual Tibetan thangka artists of the past, except for the Newari artists from the Kathmandu Valley in Nepal who work in Tibet.[27] In general, these artists could be of two basic types. Most of them were ordinary artisans, pious laypeople who came from families whose primary occupation was painting. Some Chinese and Kashmiri artists probably also worked in Tibet. A smaller group of painters can be called yogis, Tantric initiates whose work follows set ritual steps and visualizations. This group has included lamas and monks, as well as karmapas, the black-hat abbots of the Kagyu order. Organized into guilds, some of these painters moved around among monasteries and temples. As members of specific ateliers or guilds, their work may also be seen as "the product of collective will and collective effort."[28]

But regardless of their background, all traditional painters worked under canonical authority and strong artistic tradition. Hence there was little place for the kind of individual artistic expression that has characterized post-Renaissance western art. Nevertheless, as with Russian icons, opportunities for individual expression in thangka painting can still be found in decorative details such as landscape and ornamentation.

Also as in traditional Russian Orthodoxy, the qualities or values to be expressed by the thangka painter are very carefully prescribed in terms of technical skill and personal conduct. Technically, the thangka painter needs to be skilled in drawing and depicting correct proportion. In fact, all of the elements of composition – ornaments, gestures, and so on – are to be depicted following canonical guidelines so that the lineage of artistic transmission is maintained. The thangka painter uses a manual, not unlike the *podlinnik*, that illustrates and explains traditional iconography and iconometry. The strictness of these guidelines is emphasized by a description in an early-fifteenth-century treatise by the lama sMan-bla don-grub rgya-mtsho.[29] He defined the seven religious aspects of painting and sculpture as follows: (1) defining correct dimensions and measurements; (2) correcting the errors in other written works; (3) detailing the consequences of wrong measurements; (4) tracing the books of reference; (5) naming the virtues of accurate execution; (6) defining the spiritual prerequisites of the artist and patron;

and (7) describing the method of painting. Five of these seven guidelines deal with the accuracy and consistency of reproduction from and within the tradition.

Related to such concerns, the traditional artist also must be able to discriminate between the content of higher (inner) and lower (outer) tantras, as well as understand all of the characteristics of both peaceful and wrathful deities. Specifically, to depict the deities of the inner tantras, the artist must have received the appropriate training and empowerment and must perform daily rituals, such as meditation and mantra recitation, related to the deities depicted. The performance of appropriate rituals is especially important at the outset of a project, when the artist's meditation and visualization are essential for purifying the canvas and consecrating the pigments and brushes.

Beyond these technical issues, the thangka painter should also embody certain personal qualities.[30] This person should be restrained, compassionate, patient, without vanity, slow to anger, and not concerned with wealth. Traditionally, thangka painters were well paid for their work, with patron and artist negotiating the amount of gold and other special materials as well as the payment for the artist. The painter should also be clean, scrupulous in conduct, and able to work in a sustained manner without procrastinating. Finally, when the thangka is completed, the painter must be able to explain it convincingly to the patron.

It was rare for thangka artists to sign their works, although their names are sometimes found in texts, on wall inscriptions, and on some individual thangkas and bronzes.[31] There were two interrelated reasons for this anonymity. First, because the artist served as an instrument of the divine, that person's individual identity was insignificant. Second, a major precept of Buddhism is to destroy the ego;[32] in this context, signing one's name would be an egotistical act. Because images created were used for Buddhist rituals and meditation, the artistic process was also considered to be a form of yoga, and the artist, a yogi. This is analogous to the idea that the icon painter was a priest or minister.

By emphasizing four aspects of the roles of thangka painters and icon writers – anonymity and the contrast to contemporary glorification of the artist over the process and the work itself, long training, sense of spiritual mission and calling that informs the work, and practices of inner purification – I suggest that these traditions may provide inspiration and insight for artists working today who are seeking an alternative to the materialist and commercial values that drive the

contemporary art world. How can such models of the artist be reappropriated or "reaccented" in our time?

## REACCENTING PREMODERN TRADITIONS

"Reaccentuation" is a term Mikhail Bakhtin used to describe the way ideas can never be limited by their past use or expression. "Every age re-accentuates in its own way the works of its most immediate past, [thus] their semantic content literally continues to grow, to further create out of itself."[33] In his last published writings from 1974, Bakhtin reaffirmed this idea even more vividly: "There is neither a first nor a last word and there are no limits to the dialogic context (it extends into the boundless past and the boundless future). Even past meanings . . . can never be stable (finalized, ended once and for all) – they will always change (be renewed) in the process of subsequent, future development of the dialogue."[34] This radical view of the ongoing openness of words, art, and ideas is intrinsic to my consideration of various models for the artist in this part of the book, as well as in Part III, where I address prophetic criticism and visionary imagination.

I take as my starting point in this process of reaccentuation the two premodern traditions, Russian Orthodox icons and Tibetan Buddhist thangkas, which I have just considered. Traditions change and evolve through time, and this is certainly true of both of these. For instance, contemporary thangka painters, now working in Kathmandu, Nepal, as a result of the forced exile of Tibetans from Chinese-occupied Tibet, learn their trade as artisans from many different tribal and professional backgrounds in schools for the commercial market. Coexisting with this type of school are more traditional settings, where lay painters and monks paint thangkas for both commercial and temple patrons in a traditional master-apprentice system, and where monastically trained lamas work in the most traditional manner for temples only. In Russia, the resurgence of Orthodoxy in the 1990s has led to the renovation and reconstruction of churches that were destroyed during the Soviet period. Alongside traditionally trained icon writers are others, such as Alexander Kharitonov and Otto Novikov, whose contemporary icons may well constitute a new type. Adherents of both Russian Orthodoxy and Tibetan Buddhism might bemoan the inevitable shifts that occur through the migration of and assimilation of western cultural and commercial values, but these changes cannot be halted.[35]

My discussion here is not meant to idealize the traditions of the icon and thangka painters. Perhaps, working from a postmodern western secular perspective, artists might be able to aid in the conservation of significant values in these two traditions. This possibility can best be described through consideration of how the education of artists might be affected by these traditions.

At the risk of oversimplifying and reducing cultural differences, I suggest that certain values were highly esteemed in the training of both Russian icon and Tibetan thangka painters and have been lost under modernist, avant-garde, and postmodern aesthetics. Even in their own cultural contexts, under commercial pressure in the late twentieth century many of these values are no longer rigorously practiced. Consequently, the fact that I describe them in the present tense is less related to present practice than to past reality and future possibility.

These values include, first, a recognition that one is part of a tradition whose methods and techniques should be honored and conserved, as evidenced in the pattern books that were used by both Russian and Tibetan artists. Second, the artist's ego (although the word "ego" might not have been employed) is insignificant. Coomaraswamy's " 'I' am not in fact the doer, but the instrument," summarizes this idea succinctly. Third, both traditions clearly see the act of painting, and the necessary training that precedes painting, as part of a spiritual practice, with both inner and outer dimensions. Fourth, technical skill should be cultivated through long apprenticeship.

Although there are undoubtedly other areas of overlap, let us consider each of these further, as they pertain to the education of contemporary artists. First, one's relationship to a sustaining tradition. The nature of what constitutes "one's own" tradition has changed rapidly in the postmodern world, as I will discuss later. The fact that the history of world cultures, and the artistic traditions that have both sustained cultures and nurtured their change over time, is available to us in the late twentieth century means that a broad, well-grounded study of these traditions is now possible. In contrast to some modernist or avant-garde aesthetics that rejected the past with its particular histories and traditions, a resistant postmodernism actively engages with the multiple pasts that have contributed to the formation of the present.

In a small way, *The Vocation of the Artist* attempts to model a dialogue between contemporary concerns, from a European-American background, and objects and practices from other cultural chronotopes, or constellations of space and time. For instance, to enrich one's study of the art of the past by looking closely at two particular traditions such

as the Russian icon and Tibetan thangka presents intriguing possibilities for the contemporary practice of art. What might an artist, interested in these forms of art, do with that knowledge? Appropriation is a powerful aesthetic strategy, especially when used with some understanding of what one is appropriating. Parody, unlike satire or empty pastiche, involves a special form of dialogue with the past that grasps its value but is also critical and transgressive. It may move in contrary or unexpected directions, crossing previously established boundaries to create new forms.

Second, the artist's selfhood: anonymity versus self-aggrandizement. It is unlikely that artists in contemporary culture will adopt an ideal based on anonymity. The modern artist-hero, the semidivine creator, the avant-garde prophet, and the postmodern bricoleur were and are all devoted to art as a form of ego gratification, with the attendant financial and psychological rewards that accrue with it. Such values will probably remain the major motivating factor for many artists, as they are so central to what drives American life.

However, there are alternatives to a practice of art based on self-promotion and self-aggrandizement. Here I am thinking of the idea that the work of art is a gift rather than a commodity to be sold. Lewis Hyde has eloquently articulated the idea of a gift economy versus a market economy in the arts; he suggests that art and the imagination die to the extent that art aspires to enter the market as commodity.[36] In giving a gift the artist is not necessarily anonymous, but the presence of a second person, and a second consciousness, radically transforms the work of art into a full aesthetic and moral event. Placed within a system that primarily values it as an exchangeable commodity, an artwork loses its aesthetic and moral power.[37]

Hyde's notion of the gift suggests several interrelated questions. If art is a gift, how can artists survive in a market economy? How do artists live in the world? Many must have a second job, their first being the creation of art and the second for financial support. Others subsist with the support of patrons – in our time, an ever-diminishing store of grants and stipends – and rarely, the support of friends. Others live by selling their work or by making art to sell. For many artists, the academy functions as a patron of sorts, providing considerable autonomy and a modest livelihood.

What is the source of an artist's work? Many artists and writers have acknowledged that inspiration itself often comes as a mysterious gift, and in this sense it cannot be taught or learned. "The imagination," as Hyde put it, "is not subject to the will of the artist."[38] The word "mys-

tery," as I mentioned earlier, comes from the Greek *muein,* "to close the mouth." This meaning may have originated in the practices of ancient mystery rites, after which initiates were sworn to silence. But perhaps this image of closing the mouth has another meaning: What has been learned cannot be shown or described; it can only be experienced directly. Creative imagination, too, can be experienced but is very difficult to describe. Analogously, what would happen in the practice of art if this sense of the mysterious *gift* – a metaphor that found particularly vivid use in Bakhtin's early essays – were to replace, even partially, the sense that art practice is supposed to be a profit-making activity? Such questions cannot be answered didactically or theoretically, but must find their way into the cognitive framework and art practice of aspiring, and experienced, artists.

Third, the nature of art as spiritual practice, with both inner and outer dimensions. On the one hand, the icon or thangka artist was engaged in a practice of inner purification through the work. In this regard, the artist had either to be a transformed person or at least be engaged in transforming the self through the cultivation of values such as attentiveness, detachment, patience, humility, and silence. On the other hand, the artist was giving form to religious and moral teachings. As such, the artist's work can be seen as expressing a sense of calling – a vocation – to make spiritual teachings available to various publics. For artists already interested in or committed to a particular spirituality or religious practice, such as Christian prayer, Hindu yoga, or Zen Buddhist meditation, this second dimension might be easily incorporated into the working process.

A different set of problems, however, is encountered by modern and postmodern secular artists, many of whom may actively repudiate any form of organized religion. In contrast, the inner dimension of art as spiritual practice is more readily accessible to all artists. What if, as a regular part of studio education, artists were taught how to mediate or were trained in the techniques of visualization? What about the role of silence? In the howl of contemporary life, where do we have the time or the space for silence, except for the artist's or writer's studio, the religious community, and the scientist's laboratory?[39] Silence allows one to experience life at a different level, to listen not only to the self but also to the many other audible (and inaudible) voices that surround us.

What of other values such as attentiveness, acceptance, or contentment? Contentment, like full attention, is paradoxical in two senses. It happens best when it includes no self-consciousness. Full attention means no notion of attention, no-self-to-attend, as a Buddhist would

say. Contentment and attention are paradoxical in another sense: Both can lead to loss of ego, but they can also mean working in the most ego-bound manner to please others – parents, family, church, university, or other institutions.[40] My point here is that even the inner dimension of artistic practice is related to external demands.

Fourth, the nature of training and the attainment of technical skill. Here I do not mean to look back at an idealized past, whether European, Tibetan, or Russian, when to be an artist meant that one's technical skills were highly developed. But I am in favor of rigorous technical training in the arts that might include, depending upon one's orientation and focus, drawing from life; learning how to move, speak, and sing so that one's performances are not mundane; or acquiring a full range of computer-based skills.

Related to this is the urgent need for artists to become cognizant of, and even enter into dialogue with, contemporary postmodern theory. The "problems" that I will discuss in Chapter 8 – cultural pluralism, ecological issues, and the role of Others, especially women – are part of the present cultural situation in the United States. There is no better way for artists to deepen their understanding of these issues than by reading postmodern theorists and cultural critics. At the least, artists should read and engage in these theoretical discussions during their academic training. Working artists can always learn independently.

In particular, the world of images requires informed and trained designers, artists, and architects, for each of these persons brings a unique perspective to the task of interpreting and reshaping that world. Various forms of electronic communication play an increasingly major role in our environment; understanding how to use new technologies is essential. As Barbara Stafford put it so vividly,

> In the face of an amplifying and diluting pan-"Image-World" – polluted by the proliferation of electric signs, flashing billboards, video, high definition television, and doctored rephotographs – manipulated by cynical advertisers, the visually skilled and trained person has a special advocating role. Who else will demonstrate that one does not necessarily become dumb watching? Who else will show the need for visual aptitude, not just reading literacy? Who else will teach the difference between empty merchandizing or narcotic, plasmic propaganda and the constitutive imaging arts, encouraging and persuading the actively engaged beholder to think?[41]

With such a perspective on the contemporary image-world in which we live, we are already much ahead of the historical narrative I am con-

structing here. But Stafford's questions have everything to do with the values I wish to affirm. In order not to be "dumb watchers" of commercial images, in order to cultivate visual aptitudes and visual literacy, in order to learn to think critically rather than accept visual propaganda blindly, artists must be educated in ways that take such issues and questions into account.

# Modern Anthropocentric Original Inventor

**H**e looks at us as we contemplate him. We see a full frontal view of the artist's head and shoulders, with a date, monogram, and Latin inscription. Having appropriated the tradition of the *vera eikon,* the true image of God, Albrecht Dürer's Munich *Self-Portrait,* painted in 1500, might be read as an emblem of the divine creativity of the artist, the artist in the image of God (Figure 12).[1] Here the artist no longer imitates God; the artist replaces God as the original creator and inventor.

This painting helped to establish some of the categories on which later understanding of the self, history, art, and "man" would be based. In self-portraiture, the sovereignty of the self and the nature of cultural epochs were reified, celebrated, and questioned. In the moment of depicting the self, the artist is both the viewing subject and the object put forward for viewing by others. This "moment" of the emergence of self-portraiture, represented in Dürer's painting with the artist as both subject and object, foreshadows the Romantic cult of genius. The artist turns into a sad, frail, introverted individual, distanced from life, the environment, society, and even the times in which the artist lives.[2]

Dürer's work established what viewers would mean by self-portraiture, as he increasingly worked on images of himself. His paintings function as "quintessential epoch-making works," identified with the origin of the German character and the modern self, the end of Gothic and the beginning of Renaissance painting, and the transformation of the sacred into the secular.[3]

\*　\*　\*　\*　\*

Dürer's self-portrait marks a decisive change in the art of early modern Europe. In the move from a guild-supported culture of artisans to a more individualistic model of the artist, new cultural myths became prominent, especially the artist as hero, as semidivine creator, as mystic visionary, and as prophet. In this chapter and the next, I will examine each of these models of the artist's activity. Much could be said about

such myths and models in relation to the lives and works of particular individual artists (Michelangelo, Dürer, Blake, Kandinsky, etc.), but my purpose here is to provide an overview of how the myths evolved. The modern artist, focused on the human rather than on the divine, the self rather than the other, was committed to following an original and inventive path.

These myths about the artist evolved in contexts that assumed and valued artistic creativity as a masculine, and distinctly male, perogative. This is certainly not a novel insight, as the past twenty years of feminist scholarship has repeatedly stressed its historical veracity. Not only were women artists dismissed or excised from history, but the very theoretical categories used to define creativity were patterned on attributes perceived as uniquely male. Because to be an artist presumed possibilities of autonomy, originality, inventiveness, and genius that were thought to be accessible to men alone, women were habitually excluded from the category "artist." My goal, in describing formative modernist myths regarding the artist's cultural function, is not primarily to claim that women should have been included as actors on the artistic stage (though of course I assume that they should have been) or to claim that previous writers simply overlooked the fact that women *were* heroes (or heroines), semidivine creators, mystic visionaries, and prophets. Clearly, the opportunities for women to assume such roles were extremely limited in the modern period. One of the insights to be gleaned from surveying modern models of the artist is to see the thoroughly gendered nature of their articulation and expression in cultural life. A corollary conviction is that new possibilities are alive within late-twentieth-century culture.

## FROM THE PREMODERN TO THE MODERN

To begin a discussion of the mythologies that formed around the modern artist and under a modernist aesthetic, one needs to define notions of the modern, differentiating the modern era from aesthetic modernism and modernist art that developed in the mid to late nineteenth century. These are European-based categories, although "modernization" is a term used to describe world-historical processes of technological development wherever they occur.

"The modern era" is a historical phrase; it refers to a broad range of historical and cultural events, much as "the premodern world," "the ancient world," or "the medieval world" does. How one defines the modern era varies greatly depending upon the lens one uses. For in-

Figure 12. Albrecht Dürer, *Self-Portrait*, 1500

stance, if we read race relations, imperialism, and colonialism as major categories in defining the modern era, then it extended from about 1492 until 1945.[4] The year 1492 marks the time of wars in Europe and of the expulsion of Jews and Muslims from Spain; of Christopher Columbus and European expansionism; of the publication of the first grammar book in Spanish, which highlighted the way language functions as the foundation of culture. The years between 1945 and 1974 mark the end of the Age of Europe and the rise of the United States as a world power. This time included decolonization of third world: India, China, Ghana, Cuba, Guinea, Angola, and, later, South Africa. In the United States the years since 1974 have been generally a period of national economic and social decline marked by increased inflation, increased unemployment, and lower levels of productivity. Disparities continue to grow between the very rich and the poor. The commodification of culture continues unabated in the United States and abroad.

Or, we may locate the beginnings of the modern era in the Age of Enlightenment, circumscribed by revolutions in England in 1688 and France in 1789. These beginnings may be pushed back as far as the Renaissance and the sixteenth-century reformations.[5] The Renaissance shift from the medieval God-centered universe to a human-oriented vision of the cosmos, as well as the Copernican revolution, were central to this changing perspective; the sixteenth-century reformations on the European continent and in England accelerated it. As already discussed, reformers such as Martin Luther altered the way Christians understood the role of their will and work in the world and, ultimately, the way work was understood in European-based cultures more generally. In a human-centered universe, issues such as free will and grace through good works took on new significance.

The so-called Golden Age of the modern period extended from 1789 to the unification of the German empire in 1871. Romantic ideas about tradition, nature, and God challenged the authority of science.[6] During this part of the modern era in the European-influenced world, several major myths of artistic activity existed side by side – artist as hero, as semidivine creator, and as Romantic visionary.

But what was the broader historical and intellectual context for changes in the artist's cultural function? The Enlightenment philosophes esteemed reason, the idea of progress, and the individual subject, ego, or self, which formed the basis for promulgating values of equality, toleration, and freedom. However, this period was also marked by an increasing alienation of the individual, as bourgeois capitalism began to grow, as religious struggles arose between Christianity and neoclassical

paganism, and as science, morality, and art were separated from one another.[7] Each of these developments bears more discussion.

First, in social-historical terms, the eighteenth and nineteenth centuries were periods of increasing industrialization, urbanization, and secularization. People's lives radically changed in the shift from country to city.[8] The phrase "bourgeois capitalism" carries a particular view of the unfolding of European history that is linked to these processes. The evolution of the bourgeoisie – the middle class – only became possible because of the shift from an agrarian feudal society to an urban industrial one with its deeper class divisions than had existed in medieval societies. Writers from Bernard Smith to Ernest Mandel have argued that changes in art's content and forms can be linked to these broader cultural shifts in production and, especially, to changes in technology.

One of the functions of art is to help us to see the world in new ways, and this applies to landscape painting in particular. When are certain visions of reality presented? What world do we see? In market capitalism after around 1848, the technology of steam-driven motors was used for industrial production, which changed styles of life and work. In the visual arts, artists gave new attention to genre and landscape painting, depicting everyday scenes differently than they had before. Space was desacralized, and forms of naturalism and realism dominated.[9] But what does this really mean?

Although separated by decades and by differences resulting from national context, nineteenth-century landscape painting in England (rustic painters such as John Constable), in France (Barbizon school artists such as Theodore Rousseau), in Russia (Wanderers such as Isaac Levitan), and in the United States (Hudson River school artists such as Thomas Cole) can be interpreted against this background of the impact of industrialization, urbanization, and secularization. The art of John Constable, for instance, was an extended meditation on the virtues of the English landscape precisely at the moment the countryside was being radically transformed by the forces of bourgeois capitalism and industrialization.[10] Landscape traditions valorized human engagement in history as well as mystical vision. Creative imagination was venerated, and the idea that artists have privileged access to the sacred or spiritual dimension prevailed.

Of the artists mentioned here, the least well-known is the Russian Isaac Levitan (1860–1900). In Russia, industrialization was initiated by Peter the Great in the early eighteenth century and furthered by Catherine the Great later in that century, but it did not really develop until the 1890s. During this period, the government channeled two-thirds of

**Figure 13.** Isaac Levitan, *The Lake (Russia)*, 1900

its revenues into economic development. For example, the iron and steel industries boomed, as more than nineteen hundred miles of railroad were constructed each year between 1898 and 1901.[11] Levitan's work can be interpreted as one response to this broad social and historical context.

Artistically, Levitan was an intermediate link between the *Peredvizhniki* (Wanderers) and the *Mir Iskusstva* (World of Art) groups and their respective art exhibitions. From his *March* of 1890 to *The Lake (Russia)* of 1900 (Figure 13), his work foreshadowed a new kind of landscape painting based, not on realism, but on "profound poetical feeling," not on abstract nature, but on the contemporary landscape as a source of vitality, freshness, and feeling.[12] Levitan humanized nature by showing human surroundings and architecture, but he rarely depicted people in those environments. In many of his paintings of the 1890s he visualized both the beauty and the magnificence of nature.

In *The Lake,* Levitan tried to create an image that symbolized "Mother Russia": a sweeping landscape inspiring a sense of freedom. Much earlier, he had written to his friend Anton Chekhov, "Can anything be more tragic than to feel the infinite beauty of your surrounding, to read nature's innermost secrets and, conscious of your own helplessness, to be incapable of expressing these powerful emotions?"[13] He wanted to show the spiritual *and* human content of nature. Like artists

such as Constable and Rousseau, however, his vision was benign. Levitan depicted neither nature's harshness and indifference to human or other life nor the direct impact of industrial development.

Five concepts of nature are discernible in such landscape painting.[14] Nature may be, first, a static setting for human activity – an idea that resembles older classical ideas about nature and that is visible in much landscape painting. Second, nature may be an impetus for poetic reverie; or third, a mirror of the human soul. Fourth, nature may be seen as a partner in the metaphysical universe. These last three concepts are especially applicable to Levitan's painting *The Lake*. At a time of impinging industrialism, it is not surprising that artists would esteem the poetic and metaphysical aspects of nature. Artists such as Constable and Levitan thus functioned as indirect barometers of technological change, and they exemplified the new emerging modern paradigms.

Finally, in some landscape painting nature may be synonymous with the Absolute, as the source, measure, and end of all phenomena in the universe. Beyond these attributes of Nature itself, another more subtle presupposition undergirds much of the landscape art alluded to here. The new, uniquely modern, artist did not simply reflect religious dogmas. Instead, this artist mirrored Nature and improved it, making it even more perfect than God "Himself" had when "He" created it. Thus, the way was paved for the myth of the artist as semidivine creator.[15]

What was the fate of the individual in this developing context of bourgeois capitalism, or, as in Russia, in the shift from a feudal to a modern state? Many historians, philosophers, and theologians such as Paul Tillich have argued that alienation became a more common existential problem. Characterized by a loss of connection to one's deepest feelings and manifested in qualities such as meaninglessness, powerlessness, isolation, and estrangement, alienation could be interpreted as an individual psychological process. Modern society, in this view, is more alienating than previous societies because modern forms of work, education, and community (or lack thereof) foster these qualities. However, all such assertions must be carefully grounded not in an essentialist interpretation of the human psyche, as if alienation were a "natural" state, but in the social-economic-political realities brought about by changing technology and cultural institutions. In the nineteenth century, Hegel, Feuerbach, and Marx already understood alienation as a cumulative historical process.[16] From a feminist perspective, the alienation of the individual may also be seen as the predictable

consequence of the patriarchal world views that have dominated European-based traditions for centuries. Religion, of course, has been and continues to be the major propagator of patriarchal ideology; and this brings us to the second issue mentioned earlier: conflicts between Christianity and neoclassical paganism, as well as other religious traditions of the world.

When, in his two-volume history of the eighteenth-century Enlightenment, Peter Gay spoke of the conflicts between Christianity and a modern (or neoclassical) paganism, he was pointing to the way the Enlightenment philosophes – thinkers like Voltaire in France, Gotthold Lessing in Germany, and David Hume in England – turned away from contemporary Christianity and back to classical post-Aristotelian Roman sources such as the Stoics (Zeno, Chrysippus, Cicero, and later, Marcus Aurelius) and the Epicureans (Epicurus, Dionysius, and Lucretius). In these writers, the philosophes found congenial sources for their thinking about rationality, skepticism, and eclecticism; and especially, they found a secular alternative to Christianity.[17]

But modern world views were not formed only by philosophers seeking an alternative to Christianity. This period of the Enlightenment also reflected the many attempts to reform Christianity from within that had begun during the reformations of the sixteenth century. Newly formed Protestant groups (for instance, Lutherans, Calvinists, and Anabaptists) tried, from their differing points of view, to create churches and new doctrines consistent with modern life. Catholic counterreformers such as St. Ignatius tried to make Catholicism more accessible to Catholics. In England, reforms led to the creation of the Anglican Church, with its own episcopacy, doctrines, and rituals. By the 1893 World Parliament of Religions in Chicago, the ever-increasing encounters of radically different religious world views would take on new significance. The poetic, metaphysical, and spiritual aspirations of artists must also be seen against this background.

Turning now to the third point about the beginnings of the modern era: What of the gaps that began to develop between various spheres of life, especially science, morality, and art? The project of modernity was essentially determined by and during the Enlightenment: to develop each of these spheres according to their inner logic, with an emphasis on the development of rationality. The extent to which this Enlightenment project was completed or perfected continues to spur discussion in contemporary cultural theory. This "project," if it can be so called, was first of all an attempt to compartmentalize experience and knowledge. Science developed as the sphere of truth and knowledge; morality

was the sphere of justice, of normative rightness (the "correct"); and art, or aesthetics, became the domain of beauty and the cultivation of good taste.

Each sphere was regulated by its own experts. Science was freed to develop according to its own inner logic. Technicians free of ethical restraints or aesthetic considerations could develop nuclear weapons, other weapons for biological and chemical and warfare, and sophisticated torture devices, as well as undertake less sinister research. Artists, poets, and others in the visual and literary arts were also free of constraints, in their case coming from the spheres of science and ethics, and could develop an aestheticized art-for-art's-sake. From Alfred Barr to Clement Greenberg, art critics thus understood art as having developed by its own immanent logic and its autonomy from all other spheres of culture. But perhaps, I submit, the project of modernity thus conceived represents an ill-fated development: Science, morality, and art should never have been separated from each other in the first place. The strongest lesson to be taken from examining premodern models and roles of the artist may be precisely the fact that this separation had not yet occurred.

## ARTIST AS HERO

One of the major images or myths that developed around the premodern artist, but that also carried over into modern mythologies, concerned the artist as hero. Such heroes tend to be male. Here my intention is not to glorify this masculine paradigm further, but to describe its etiology and development.

A hero is a paradoxical character: "[H]is exploits act out contradictions which his society is unable to resolve in real life."[18] For instance, a hero may be separated in early life from his family, tribe, or community in order to embark upon a series of adventures involving physical, emotional, or spiritual challenges. These challenges are met and overcome; and the hero returns to the community. Admirers may establish a cult, later centered around the hero's tomb or gravesite. The paradox of the hero's identity lies in the fact that he may act out social contradictions that bring about self-destruction, and which may result in the hero later being venerated in myth. Communities tend to produce heroes at times of cultural change, especially in relation to changing technologies.[19]

On at least three occasions the artist has been esteemed as just such

a cultural hero: in Greek culture, in the early Renaissance, and in modern Europe, synchronous with the Industrial Revolution.[20] The first coincided with the birth of technology, symbolized in the Greek myths of Prometheus and Daedalus. Because he gave us fire and the arts, Prometheus, the Greek god who created human beings, was chained to a mountain by Zeus. Thomas Cole's painting, *Prometheus,* vividly visualizes this myth, which represents the time when art was not separated into fine arts and applied crafts, but was a skill, *techne* or *ars.* The promethean impulse, however, has lived into the present – in movements such as the Russian avant-garde and in individual artists such as Joseph Beuys – in their belief that human beings are able to transform the world when they are aware of their powers.

Daedalus, a skilled artist who was a member of an Athenian royal family, was to be punished after murdering one of his assistants. When sentenced to exile, he fled to Crete where he became the architect and sculptor for King Minos. There he constructed the Labyrinth, as well as an artificial cow with which Pasiphae, the wife of Minos, copulated, giving birth to the Minotaur. Later imprisoned for helping Ariadne and Theseus to escape, Daedalus also escaped, with his son Icarus, by making them wings of wax. Icarus, of course, died by flying too close to the sun. Daedalus survived by hiding in Sicily. Daedalus's heroic feats were a powerful model for artists like Jacques-Louis David; but unlike Prometheus, whose work was a gift to humankind, Daedulus (and David) produced art for the aristocratic court.

The second period during which artists were associated with the role of hero involved the separation of the fine arts from the crafts in the late medieval period and early Renaissance. The thirteenth and fourteenth centuries were years of transition in Europe. Artists – as painters, designers, manuscript illuminators, palace decorators – worked in royal courts across the European continent. Simultaneously, they worked in cloistered religious communities, and they worked as architects, or, more properly, as masons who designed and built palaces, castles, churches, and military structures. Many, though not all, of these artists and designers were anonymous. Little evidence exists that any *mystique* surrounded them. As Andrew Martindale has observed, "There is, in fact, little evidence for an informed interest in the arts by non-artists at all. Nothing is, indeed, more striking than the apparent apathy towards art. . . . In fact, stories involving artists [even in monastic settings where their sculpture and illuminated books were essential] are very rare and seldom complimentary."[21] In general, the main purpose of medieval

artists was to instruct and to please by creating objects of beauty. Therefore, that there are so few extant representations of squalor, pain, mutilation, and death, which were prominent aspects of the medieval world, should also not surprise us.[22]

In the 1300s the word *artiste*, from the Latin *artista*, meant a member of a university faculty.[23] Before about 1500 there were no artists as we know them today, and there was no distinction between artist and artisan. Giotto was the first bourgeois painter, although it was not as an artist or a painter that he was most honored. In 1334, because it had at that time no category of City Painter, the Italian city of Florence designated Giotto its City Architect. Vasari, writing about Giotto's fame in the mid 1500s, nearly two hundred years after Giotto lived, told stories about the artist that must be taken as largely apocryphal.[24]

In fourteenth- and fifteenth-century free Italian cities, commissions were given not only by the church but also by other wealthy private patrons. Indeed, this shift from the patronage of mendicant orders and city communes to merchant families and princely courts provided fertile ground for the professionalization of the artist.[25] Although it is difficult to disentangle the actual beginnings of this process, the development of systematic collectors at about this time is also synchronous with the artist working independently of either patron or client.

One of the earliest examples of this new kind of private patronage is Lorenzo Ghiberti's commission for the design of the second door to the Florence Baptistry in 1425. Ghiberti had won, over his rival Filippo Brunelleschi, a competition organized by the Arte de Calimala. The design was left completely up to the artist, and Ghiberti put his own portrait on the Baptistry doors. As he was later to write, in a voice that echoed the self-assertiveness of his design: "There were six of us in the contest which was in great part a demonstration of the art of sculpture. The palm of victory was awarded to me – by all the experts and all those who competed with me. The honour was conceded to me universally and without exception." Even though the dome of the building was later completed by Brunelleschi, Ghiberti claimed that "few important works executed in our territory were not designed or supervised by me."[26]

In this period, the artist began to be recognized as separate both from the guilds and from the masses, which led to subsequent hero worship and imitation. A clear division of labor developed between craft skill, exemplified in the goods produced within guilds, and inventive creativity. (Brunelleschi was thrown into prison for refusing to pay guild dues.)

Also in this period, some artists saw their work not in terms of economic gain (or loss) but as a calling.[27] The artist qua artist began to emerge.

Ghiberti's *Commentarii* (c. 1430–50) suggested that the first-rate artist, like other learned men, would be versed in Grammar, Geometry, Philosophy, Medicine, Astrology, History, Anatomy, and Arithmetic; and the *Commentarii* is the first direct testimony of an artist from his own time.[28] Leonbattista Alberti was more modest. In his 1435 treatise, *Della pittura*, he placed painting and sculpture on a level with the Liberal Arts (as in Ghiberti's list); but he also emphasized that the artist should be an educated "gentleman" (of course, women were excluded from this category), who is reasonable and likeable and gets on well with other poets, orators, and especially, princes.

This relationship to the institutions of power was crucial to an artist's upward mobility. The examples of Giotto, Simone Martini, and Jan van Eyck follow this model.[29] In this context it is perhaps not surprising that artists in the late fifteenth century such as Andrea Mantegna, Carlo Crivelli, and Gentile Bellini were all knighted. As Hans Belting put it very succinctly, "The celebrated social rise of the Renaissance artist took place on the public stage of civic life."[30]

The impact of the courts on the status and lives of artists cannot be underestimated. Princes and rulers who needed visual representation hired artists, and when established in their courts, artists could then be exempt from the affiliations and regulations of guilds. A variety of other organizational changes were instituted that have had long-term consequences: Bursaries were formed for artists' training; procedures were established for procuring works of art and artists' services; state responsibility for the building and oversight of public projects was begun; visual media were used for new forms of secular propaganda; and perhaps most significantly, the courts promoted the aesthetic appreciation of the arts.[31] There were, of course, attendant problems such as the relative lack of freedom for the artist ensconced in a particular court. Vasari noted these as early as 1568. But this affiliation with the courts of late medieval and early modern Europe also benefited artists. Artists began to be viewed, and to view themselves, as irreplaceable, which was supported by the notion that artistic genius was unmistakably individual.[32] Thus, by the sixteenth century, the artist as individual learned "man" had appeared.

In 1563 Vasari founded the first academy of art, the Accademia del Disegno, which provided an institutional framework for artists, offering them security and social prestige. Today, this function has been largely,

but problematically, taken over by university and college art departments. Artists at the academia were given an education that was both theoretical and practical according to the stylistic ideals Vasari had developed in his *Lives*[33] His artist-hero myth was modeled on the stories of Hercules and Launcelot; it was primarily internalized to support male artists such as Michelangelo and Leonardo. Vasari articulated the fundamental idea that artists alone were responsible for the aesthetic sphere.[34]

This emergence of the idea of the artist evolved in various parts of Europe slightly differently, according to the way secularization and mercantile interests developed. In Italy the artist's separation from the church that earlier had provided the sole patronage for the arts and from the medieval craft guilds that fashioned artifacts for daily use took place between the fourteenth and sixteenth centuries. Even in Italy, however, the professionalization of the artist occurred differently in Sienna, in Florence, and later, around the courts of Urbino and Rome.[35]

New humanist ideas developed in Renaissance Italy spread to northern Europe, helping to free people, including artists, from religious orthodoxy. It may be argued that medieval artists prior to this time were just as individual as artists of the Renaissance, but we have no records, so they are not known as individuals. To be a good artist could raise one's status as an individual; the status of one's occupation, however, did not necessarily change. It is possible too that the development of perspective, and proficiency in other aspects of the visual arts considered as learned, contributed to increasing respect for the artist more generally.

The sixteenth and seventeenth centuries were periods of consolidation of the artist's new status. Admired and hired by princes, courts, nobility, and gentry, the artist also sought during this period to create new institutions, in lieu of the earlier guilds, to support that changing status. Not only were academies of art founded, but artists also developed large ateliers, where a master painter might be supported by framers, gilders, drapery painters, engravers, and other apprentices.

It can also be argued that the artist as a distinctly modern character (in contrast to the artisan or craftsperson) appeared in the eighteenth century. Specifically, in the 1762 edition of the *Dictionary* of the French Academy, the first modern definition of the artist was given: "*Artiste*: Celui qui travaille dans un art ou le génie et la main doivent concourir. Un peintre, un architecte sont des artistes."[36] Whereas previous definitions had emphasized the artist's proficiency and learned qualities, suddenly artists, like architects, were possessed of special inventive genius.

Although such individual genius had been recognized earlier, here it was articulated directly.

The third major shift in attitudes about the artist as hero occurred during the Industrial Revolution of the late eighteenth century, but this change was different from the previous two. Cast earlier as a technologist who made good use of the latest tools and materials, as industrialization proceeded, the artist took on an increasing estranged, even revolutionary, role. With changes in the modes of production, artists' output was no longer viewed as exceptional "work," but rather as exceptional "play." Artists were no longer needed to fulfill roles as craftspeople; they were freed to develop new points of view, which included sustaining "an old-fashioned, but human, mode of production in an increasingly inhuman, increasingly inorganic situation."[37] Especially in the context where Adam Smith's ideas about the division of labor were promulgated, the artist became one of the countermodels, supposedly less alienated in an alienating society or at least able to point out the dangers of industrialized labor. Artists such as Francisco Goya, Jacques-Louis David, William Blake, Gustave Courbet: In different ways these artists exemplified this new heroic attitude, which was acted out when artists chose to be revolutionaries rather than technicians. The notion of revolutionary art that functions as a kind of propaganda has been present at least since David's paintings of the late eighteenth century, works such as *Oath of the Horatii, Tennis Court Oath,* and *Death of Marat.* I will return to this theme later in discussing the modern artist as prophet.

In the nineteenth century, the heroic attitude led to two interconnected, albeit contradictory, roles: on the one hand, artist as realist observer of the world, as spectator and documentor, and as illustrator and cultural critic; on the other, artist as bohemian, often self-destructive. In contrast to the Romantics, the realists were not so concerned about the artist as a person, but about the social function of art in society.

Chief among those who theorized an interpretation of the artist as critic was Pierre Proudhon (1809–65). Our sense of familiarity with his writing belies its nineteenth-century origins, because what he says about the importance of the artist expressing a position or commitment is similar to what is said by contemporary critics. Realism, for Proudhon, was not an end in itself, but a means of improving, even saving, society. The artist does not invent anything new, but is able to "penetrate the surface of life, to discover the primary forms, and to present them to the spectator's eye. The artist thus shows us the inner structure of the

world."[38] Proudhon was one of the few who denounced the French Romantics; and he followed Saint-Simon in positing art as a vehicle for the moral and social improvement of humanity. Daumier, Courbet, Thomas Couture, and Millet are among the best-known artists whose work fit this model.

Linked to this idea of the artist as realist observer, but often moving in another ideological direction, was the artist as civil servant. As a worker for a monarch, the artist had to provide "effective means of propaganda, vehicles for the display of [imperial] power, and varied entertainment."[39] In seventeenth-century France, artists became civil servants to the government of Louis XIV; and in 1648 the Royal Academy of Painting and Sculpture was formed. Academy artists painted contemporary history and modern events using themes from antiquity. In Spain, artists such as Velázquez and Goya worked as both servants and skillful critics of the court, as already indicated.

Decisive changes in the artist's social status took place as patronage was transferred from the aristocracy to the bourgeoisie. The artists working for the aristocracy and in the courts of Europe were instruments of and for propaganda, decoration, and entertainment. But artists were also beginning to work as producers of commodities for the new mercantile classes. For instance, during the seventeenth and eighteenth centuries in Holland, artists worked with dealers and merchants in an open market. When middle-class collectors began to see works of art as highly desirable, the status of the artist began to rise, whereupon artists became freer to express the ideology of the social group to which they belonged.[40]

With the development of an art market, art criticism also came of age. In his 1766 *Réflexions sur quelques causes de l'état présent de la peinture en France,* Lafont de Saint-Yenne wrote about paintings that had been exhibited in that year's Paris salon. But it was the writing of Diderot from 1759 to 1781 that really initiated art criticism. Diderot's essays on the Salons of 1759, 1761, and 1763 are typical of this genre. Having written *L'Encyclopédie* article on art, Diderot continued to write other such essays. Although friendly with many artists, he wanted them to serve a cause, "to have a human content, to speak for the misery of the humble against the pride of the mighty, to inspire virtue and purify morals."[41] He found his exemplars in Jean-Baptiste Greuze and later in Jacques-Louis David.

The myth of the bohemian artist is also synchronous with these developments, although its origins go back at least to Michelangelo. The image of Michelangelo, "brooding alone in magnificent solitude," as

well as his own self-description – "I have never been a painter or sculptor such as those who make a business of it" – suggest an artist set apart from society.[42] At his most mythic (for this artist was also decidedly male), the bohemian artist defied customs, used drugs and alcohol, was sexually promiscuous, had no family or major personal loyalties, was self-absorbed, and often died young from illness or suicide.[43] Numerous artists of the nineteenth and twentieth centuries, from Van Gogh to Mapplethorpe, have cultivated this myth.

## ARTIST AS SEMIDIVINE CREATOR AND MYSTIC VISIONARY

Directly related to the idea of the artist-hero was the artist as semidivine creator. This notion of a person endowed with semidivine powers emerged in fifteenth-century Florence in the writing of Neoplatonist humanists such as Marsilio Ficino. Supported by the Medicis, Ficino wrote that the human mind functions analogously to God's when a person creates: "It expresses this in audible speech, writes it with pen on paper, represents it in the matter of the world by what it makes. . . . Man is god over all the material elements, for he uses, modifies and forms them all."[44]

This equation of the human creator with God, and the birth of the artist as a semidivine creator, further stimulated the movement of art-for-art's-sake. What then mattered was not the content, but the signature of a particular artist – Leonardo, Michelangelo, or Bellini. The birth of the artist and the work of art as independent entities also mark the beginning of the commercialization of and speculation in art as a commodity for profit. Earlier, artists had worked under specific patronage of the church or government, but a significant reversal occurred. Patrons, kings or merchants, sought particular artists to paint their portraits or for other work. Artists like Raphael and Titian succeeded in this atmosphere.

A literary critic, Fortoul, coined the term "art-for-art's-sake" in 1835. Philosophically based in the writings of Kant, Schiller, Goethe, Schelling, and Friedrich Schlegel, the idea had adherents in France, England, and Germany. Among its primary tenets are five interrelated ideas: (1) that the artist is sovereign in the sphere of art; (2) that artistic freedom, rather than adherence to a school or tradition, is essential; (3) that the true artist is concerned with aesthetic issues over the social or political effects of art; (4) that aesthetic perfection is achieved through

expressing inner vision rather than outer appearance in form; and (5) that creative imagination dominates over cognitive or affective processes of reflection. These ideas were expressed in literature and the visual arts in a variety of ways, but for some philosophers and critics the idea of art-for-art's-sake constituted a fundamental crisis within culture. Nineteenth-century aestheticians such as Jean Marie Guyau, critics such as Pierre Proudhon, and moral philosophers such as Mikhail Bakhtin were convinced that art must be deeply connected to life.[45]

Models of the artist's activity, however, have never been monolithic, and alongside the ideas I have been describing, others also developed. In the late eighteenth century, for example, the image of the artist as a rationalist academician, exemplified by Joshua Reynolds in England and William-Adolphe Bouguereau in France, was challenged by the development of ideas about the artist as mystic Romantic visionary. How are ideas about the artist as semidivine creator linked to the artist as mystic visionary? This is a crucial question, because later I will use the vocabulary of the visionary imagination but with significant differences from its earlier meaning. In the art associated with Romanticism, we see especially pertinent ideas about the artist as mystic visionary.

I cannot here summarize the enormous literature on Romanticism(s), but I must note that "it" has been linked to issues of national identity, nationalism, and other diverse themes. Depending upon whether one examines early or late Romantic developments – from the 1790s in England and Germany to the late nineteenth century in Russia – various elements can be discerned. Ideas about pantheism (God equals the world, and the world equals God) and panentheism (God includes, but is greater than the world) as well as special notions about imagination, love, beauty, organic nature, and artistic creativity may be emphasized.

Fascination with the artist's creativity and imagination is an old concern of philosophers and teachers of poetry, but Romantic philosophers added important new themes.[46] For example, although he died in 1798 at age twenty-five, before he could develop his ideas in depth, Wilhelm Heinrich Wackenroder emphasized the conflict between the artist and the society in which the artist lives. This became a major theme in Romanticism and, even later, in avant-garde art. The idea that the artist is completely on "his" own is one of the legacies of Romanticism, and one that has finally been challenged by some collaborative forms of postmodern art. "From the romantic period on, art is the language of the lonely man, alienated from the world, seeking and never finding sympathy. He expresses himself in the form of art because – tragically or blessedly – he is not to be confused with his fellow beings."[47]

Pantheistic and panentheistic ideas, whereby the act of artistic creativity was linked to divine power, further dramatized this sense of the artist's separation from others. The artist was seen as a kind of demiurge who creates the world.[48] But if there was no God, if God was dead as Nietzsche had proclaimed in his 1882 *The Gay Science*,[49] then human creativity had to develop new rationales. The ideology of art-for-art's-sake, a countermovement within Romanticism that sought to articulate a new basis for art, can be understood as one of these.

The image of the Romantic artist as creator-genius thus developed. This artist was characterized by an emotional hypersensitivity that made "him" superior to others; by a need for withdrawal from society; by a conviction that an artist was destined to suffer, especially in a hostile society; and by a special genius that allowed the artist to express all this through creative forms. Though clearly not a Romantic painter, Jacques-Louis David had told the students in his atelier that the high calling of the painter, demonstrated by his "unteachable invention," separated him from the cobbler's *métier*.[50]

Christine Battersby has ably traced the genealogy of the concept of genius and has described the ways in which historical notions of genius are inextricable from masculine identity. Her goal, to reclaim "genius" for women artists of the past and present, is not mine, but the passion of her argument reminds us that images of the Romantic artist are not neutral. "When Johan Georg Hamann wrote to Johann Gottfried Herder in 1760, 'My coarse imagination has never been able to imagine a creative genius without genitals', we can be sure that it was male genitals that he was imagining."[51] Romanticism depended upon the vocabulary of masculinity to justify its visions of creativity; we can now examine the movement with a certain historical distance and dispassionate criticism. But it remains somewhat disconcerting that even today works of art may be labeled "seminal" or artists and writers described as "virile" or "masterly."[52]

German Romantics such as Wackenroder and Karl Friedrich Wilhelm Solger developed other important ideas about the relationship of religion to art, about creativity, and about the artistic imagination. Wackenroder was interested in the mysterious quality of the process of artistic creativity. Creation begins with a "half-conscious probing," which is developed through both inspiration and the activity of the creative imagination and finally comes to fruition through the use of skills and techniques.[53] He articulated the Romantic idea that, although art is an inadequate representation or revelation of the divine, it does affect our emotions.

**Figure 14.** Philipp Otto Runge, *Morning*, 1808

Solger saw imagination as the mirror image of divine creativity. "The power within us that corresponds to the divine creative power, or rather in which the divine powers come to real existence in the world of appearances, is imagination."[54] But, imagination actually moves in two directions, toward God (as religious consciousness) and away from God (as artistic consciousness). Thus, for Solger, the artist could be an interpreter and prophet of God.

William Blake and Caspar David Friedrich fit this model, but in Philipp Otto Runge we find an especially relevant example of such tendencies in German Romanticism (Figure 14). Runge's art, and his theories about it, were anchored in his Lutheranism, but they were also deeply informed by his interest in the ideas of the seventeenth-century mystic Jacob Böhme. In his ten-point manifesto, Runge sought to relate the modern artist to the mainstream of life, as he saw it. Thus, the artist should express: (1) "presentiment of God," or "consciousness of ourselves and our eternity"; (2) "perception of ourselves in connection with the whole"; (3) the "highest feelings through words, tones or pictures"

that demonstrate the link between art and religious ideas, which (4) give rise to the subject of art. Runge then elaborated on the use of composition, drawing, and various aspects of color through which the artist accomplishes this task.[55] In *Morning,* Runge offered his complex religious vision, replete with angels, angelic children, a holy landscape, and symbolic flowers, all using light and color to communicate the "highest feelings." Romantics such as Runge – and Isaac Levitan – focused on the artist's unique experience and ability to give expression to the divine. They fulfilled the image of the artist as mystic visionary and original creator that I have described.

Related to the older Renaissance ideal of the artist as a semidivine figure, critics like Théophile Gautier, a poet and novelist, developed his Romantic art-for-art's-sake theories in a manifesto, published as the Preface to *Mademoiselle de Maupin* in 1835. With Charles Baudelaire, however, attempts to link art to society and to life more generally were overthrown. Baudelaire ardently believed that art is autonomous and that its primary value and service to society result from that autonomy. Although the earlier art-for-art's-sake movement did affect him, Baudelaire was more directly influenced by the philosopher Victor Cousin, who asserted that religion, morality, and art should be separated. For Baudelaire, simply to copy the world is to provide a duplication of what already exists. Using the imagination, the artist instead "decomposes all creation, and with the raw materials accumulated and disposed in accordance with rules whose origins one cannot find save in the furthest depths of the soul, it creates a world, it produces a sensation of newness."[56] Whereas Gautier had celebrated Ingres, Baudelaire celebrated Delacroix. The latter artist's statement, that imagination "is the primary faculty of the artist,"[57] was part of Delacroix's attempt to see the artist as free to develop independent of any social concerns. In France, the artists Corot, Manet, and Cezanne were also part of this lineage.

The relationship of the Romantic artist to society was contradictory, or at least highly ambiguous. Many artists were of bourgeois origin, but déclassé. If not literally of the lower classes, some artists voluntarily displaced themselves.[58] Some of these, as well as later nineteenth-century artists such as Van Gogh and Gauguin, preferred to live out an Orphic myth, seeing themselves as outlaw or pariah: like the mythological Orpheus, a religious leader, preserver of tradition, celebrant of the mysteries, leading society into the future.[59]

None of the characteristics described here are meant to define a single unified vision of the artist, but they represent some of the dominant, and conflicting, themes that artists and critics alike have found persua-

sive. By the end of the nineteenth century, the transition from the pre-modern theocentric craftsperson was complete: The artist had become an anthropocentric inventor, imitating God and creating the new world.

Finally, the models and myths of the artist just described are not the only way to understand the modern. The terms "aesthetic modernism" and "avant-garde" bring different issues to the fore. Many scholars have investigated just what caused changes in the arts. The foregoing broad sketch of historical and cultural developments should confirm that changes in representational practices, pictorial rhetoric, and even in the role and function of the arts themselves are intricately linked to events in other spheres of culture. Using the categories of aesthetic modernism and the avant-garde in the next chapter, my purpose is to discuss further ways in which the function of art and the role of the artist were understood in the period from the second half of the nineteenth century to about 1950.[60]

The period between 1871 and 1950 has been interpreted as the decline of modernity. To quote Walter Benjamin, we might say that "there is no document of [modern] civilization which is not at the same time a document of human barbarism."[61] A radical questioning of modern ideals resulted from complex historical and cultural developments: revolutions, devastating world wars, struggles against oppression and for national sovereignty; the proliferation of mass culture; paradigm shifts in many academic disciplines; and the rise of psychoanalysis, which contributed to the decentering of the subject in a range of cultural discourses. These developments can be linked to the rise of monopoly capitalism in the 1890s, which relied on electric and combustion motors, and to aesthetic modernism and the avant-garde[62] – movements such as Cubism, Futurism, Dada, Surrealism, and the various "isms" of the Russian avant-garde, Neoprimitivism, Cubofuturism, Rayonism, Suprematism, and Constructivism. Both market and monopoly capitalism also coincided with and spurred increasing colonialism and imperialism in the "two-thirds" (non-European) world. In the visual arts, the Orientalism of painters like Jean-Léon Gérôme dealing with north Africa and the art done in India during the mid-nineteenth century typify this stage.[63]

The consequences of these developments for the role of the artist were palpable. Aesthetic modernism and the various avant-gardes were particular responses to new social and scientific worlds that artists inhabited in the late nineteenth century, worlds that included new technologies such as photography, the x-ray, the telegraph, and the airplane. Added to older tools such as the microscope and telescope, all of these

changed the experience of space and time. Artists, along with others, were offered the possibility to see more of both the macrocosm and the microcosm, to learn that reality is more than what we can perceive with our senses. Among the responses of artists to these changes was the emergence of new definitions of the artist as seer or prophet.

# Avant-Garde Prophet

ikhail Vrubel's 1904 *Six-winged Seraph* (Figure 15) is a literal visualization of Aleksandr Pushkin's 1826 poem "The Prophet":

Possessed by spirit-thirst
I shuffled in the dreary waste
And a six-winged seraph
Appeared to me at the crossroad.
With fingers light as sleep
He touched my eyes:
Prophetic eyes were opened,
Like those of an alerted eagle.
He touched my ears
And hum and clang did fill them:
And I did attend heaven's shudder
And the mountain-flight of angels,
And the passage of serpents under-sea,
And the sprouting of the vine in far valleys,
And he pressed close to my lips
And tore out my sinful, my idle
And too clever tongue,
And placed with bloody hand in my benumbed mouth
The sting and wisdom of the snake.
And he cleaved my breast with a sword
And pulled out my quivering heart
And put a coal alive with flame
Into my opened chest.
I lay like a corpse in the desert,
And the voice of God called out to me:
"Rise, O Prophet, look and attend,
Perform my will
And travelling over sea and land,
With my word set fire to the hearts of men."[1]

Pushkin's poem, as well as another of the same name by Mikhail Lermontov, put into verse the narrative of the biblical prophet Isaiah's call by God in Isaiah 6. In fact, Vrubel's work on the image of the prophet may have been connected to an order given him for illustrations for an 1899 centennial edition of Pushkin's work.[2] To the viewer his rendition of the poems and biblical verse are as literal as one can imagine.

This painting, like his earlier *The Prophet,* is visually fascinating because of the hidden and obscured forms that inhabit the image, but more significant to my argument is the rhetoric that developed around Vrubel. The theme of the seer or prophet was prominent in both French and Russian Symbolism.[3] Vrubel believed that the messianic and regenerative role of the artist could help to transform life spiritually. Not surprisingly, the poet Alexander Blok, himself an important theorist of Symbolism, referred to Vrubel as a seer living in eternal time, rather than in the present, a Symbolist by birth rather than by choice.[4] Whether or not Vrubel was indeed a prophetic artist is not the point here. This was part of his self-conception and part of how others interpreted his work.

\* \* \* \* \*

A major paradigm for the artist that developed in the modern context, and to which I have only alluded thus far, is the artist as prophet. This had particular relevance for avant-garde artists. In this chapter, I will discuss the history of the term, and some of its conflicting definitions, and the major characteristics of the avant-garde, especially the function of avant-garde art and the avant-garde artist as prophet.[5] An important tension in avant-garde art, as well as in writing about it, has been between attempts to erase the past in order to promote a vision of changing the world for the future and attempts to create new aesthetic forms for their own sake. Other problems related to gender and the exclusion of women also dominated much of the rhetoric around the prophetic role of the artist, as had been the case with earlier modern paradigms for the artist. Nevertheless, among the various avant-gardes, especially in Russia and in Germany, women did play major roles as innovators and leaders.

I believe that the avant-garde remains a valuable and useful concept, but we need new genealogical narratives that both complicate our understanding of its past and pluralize its present.[6] The problem with earlier influential narratives is that they were based on the premise that *one* theory could comprehend *the* avant-garde. To pluralize means to recognize that many theories are actually necessary to comprehend var-

ious avant-gardes. Other problems of the avant-garde will become clear: its ideology of progress, its presumption of originality, its elitist hermeticism, its historical exclusivity, and its appropriation by the culture industries.[7] These tensions notwithstanding, the question of the continued viability of avant-garde aspirations is crucial to the themes I will develop in Part III.

## THE AVANT-GARDE

The formula and concept of the avant-garde are French. From the start, the use of the term both implied and invoked military resonances. The French humanist Etienne Pasquier (1529–1615) used "avant-garde" to extol the virtues of modern writers against the so-called ancients. In the early nineteenth century, Charles Fourier, Henri Saint-Simon, and the latter's colleague Olinde Rodrigues, used the term to speak of the role of the artist.

**Figure 15.** Mikhail Vrubel, *Six-winged Seraph*, 1904

Saint-Simon's vision of social organization included a social-political vanguard and an artistic avant-garde in which art should be functional, utilitarian, didactic, and easy to understand. His vision was unique, in that he placed artists in the vanguard, followed by scientists and industrialists. "To Saint-Simon the artist is the 'man of imagination' and, as such, he is capable not only of foreseeing the future but also of creating it."[8] Rodrigues, whose writings are often mistaken for Saint-Simon's, insisted that with their "weapons" of marble, paint on canvas, poetry, music, the novel, and even the theater, artists would serve as the avant-garde. Their power to influence the public is immediate, electric, victorious. "We address ourselves to man's imagination and sentiments; consequently we are always bound to have the sharpest and most decisive effect."[9] But although such rhetoric may be inspiring, Rodrigues also noted the seeming lack of influence of the artist in society because the arts did not have "a common drive and a general idea, which are essential to their energy and success."[10] Thus, the avant-garde was stuck with a central paradox: on the one hand, to be free enough to resist authority, what we might now call the cultural hegemony of the times, but on the other, to be compelled to fulfill a social program defined by others.

In 1845 Gabriel-Désiré Laverdant, a follower of Fourier, published *De la mission de l'art et du rôle des artistes*, in which he wrote, "Art, the expression of society, manifests, in its highest soaring, the most advanced social tendencies: it is the forerunner and the revealer. Therefore, to know whether the artist is truly of the avant-garde, one must know where Humanity is going, know what the destiny of the human race is."[11] In its earliest usages, the avant-garde was thus linked to political ideals. For this group of theorists, and for the artists whose work exemplified their ideas, perhaps the military metaphor implicit in the name is justifiable.

It may also be argued, however, that the dilemmas of the avant-garde – especially the ways in which various factions articulated political or aesthetic goals – can also be linked to Saint-Simon's legacy.[12] From this perspective, his intellectual legacy was not limited to France, where artists such as Courbet and Manet inherited his ideas, but also extended to other European countries. In England, Thomas Carlyle, among others, was deeply affected by his ideas. As discussed earlier, Ford Madox Brown's *Work* (Figure 5) depicts Carlyle standing beside the Reverend Frederick Maurice, the man who founded the Working Men's College in London in 1854. A friend of Maurice, John Ruskin, influenced the ideas of designer William Morris.

With increasing industrialization, mass production had a tremendous impact on art and the role of the artist. Morris, a founder of the Arts and Crafts movement, wrote many essays analyzing the class structure by which the few (rich) live on the labor of the many (poor).[13] According to Morris, for labor to be worth performing it must be directed toward a useful end, of short duration, various in activity, and conducted in pleasant surroundings. The artist then could work with an attitude based on hope: hope of rest, hope of using what was produced, and hope of pleasure in the work process itself, which expressed the person's creative skill. Hope makes work worth doing. Without hope, work would be, in his words, "useless toil."

Morris's convictions were endorsed and developed by Henry Van de Velde (1863–1957) in Belgium and, later, in Germany, and by De Stijl artists in Holland. Van de Velde copied Morris insofar as he turned from working as a painter to designing useful objects. He designed his own houses, as Morris had; but more importantly, he founded the Société anonyme van de Velde near Brussels, where he and other craftspeople produced tapestries and interior objects for daily use in the home. Van de Velde wanted to redeem "the modern world from its own ugliness" by creating objects of beauty that could be manufactured for everyday use.[14] Though the effectiveness of his ideas as a designer and an architect is still subject to debate, he was an example of a "bourgeois revolutionary," an avant-garde artist whose revolutionary ideals were directed toward the middle class.[15]

The young Karl Marx was also deeply influenced by Saint-Simon, and that influence was further transmitted by other Marxists. Piotr Kropotkin, for instance, a Russian-born anarchist, coedited a Swiss magazine titled L'Avant-garde in the late 1870s. Kropotkin considered realism an inadequate form for expressing revolutionary anarchist ideas. His ideas affected Seurat, Signac, and Pissarro, as well as later Symbolists such as Mallarmé, and the Cubists and Futurists.[16]

Many of the ideas about the avant-garde, developed in a politically progressive socialist context, were also related to earlier Romantic notions of the artist or poet as prophet.[17] In his 1821 "Defence of Poetry," the English poet Percy Bysshe Shelley, for instance, called poets "heralds," their minds "mirrors of futurity," the poet, "the unacknowledged legislator of the world." But whereas Saint-Simon and his followers articulated a program for the imagination – the "common drive" and "general idea" identified earlier – Shelley and other Romantics saw the imagination as a moral sphere. However, they disdained general attempts to define a program for it. This tension between nonconformism

and submission to external disciplines defined by others would haunt the future of the avant-garde.[18]

Before 1848, art had avant-garde status because of its overtly political themes, its commitment to social criticism and progress. For a time the two senses of the avant-garde (political-prophetic and aesthetic) had coincided. But a shift in the meaning of avant-garde, from the political toward the aesthetic, occurred in France between 1848 and 1870. One expression of this shift was the response of Pierre Proudhon to writers such as Théophile Gautier. In his manifesto, of 1835, Gautier had insisted, contra Saint-Simon, that artists constituted an elite and therefore should never be forced to devote their art to social goals. Proudhon, a friend of Courbet after 1848, had nearly completed *Du principe de l'art et de sa destination sociale* when he died. Here he attacked ideas about art-for-art's-sake as they had been expounded by Gautier.

By the 1870s, the term was increasingly used to designate a cultural-artistic avant-garde, producing art that was aesthetically progressive, formally ahead of its time.[19] A transformation of the meanings of the avant-garde began. Although they were not lived out in a wild life, the Symbolist poet Arthur Rimbaud's *Lettres du voyant* demonstrated these avant-garde aspirations.

> The first task of the man who wants to be a poet is to study his own awareness of himself, in its entirety; he seeks out his soul, he inspects it, he tests it, he learns it. . . . A Poet makes himself a visionary through a long, boundless, and systematized *disorganization of all the senses*. All forms of love, of suffering, of madness; he searches himself, he exhausts within himself all poisons, and preserves their quintessences. . . . He attains the unknown, and if, demented, he finally loses the understanding of his visions, he will at least have seen them![20]

Rimbaud's values are part of the myth of the bohemian artist alluded to earlier. He glorified writers like Gautier and Baudelaire as visionaries for the way they "examine the invisible and hear the unheard," inventing new forms to express these "inventions of the unknown."[21]

After 1870, formal aesthetic innovation became the most significant marker of the avant-garde. Not surprisingly, therefore, later art historical and critical narratives that sought to justify the avant-garde focused on the reduction and purification of art to its essence. In numerous essays dating back to his 1939 "Avant-Garde and Kitsch," Clement Greenberg was one of the major proponents of this point of view. He insisted that the task of the avant-garde artist was to imitate God by

creating a work of art valid on its own terms.[22] Content should be dissolved into form; the artist should attend to the properties of the medium itself. In other words, instead of concerning itself with and imitating literature (by telling the stories of mythology, history, or novels), painting should seek to preserve itself through a rigorous process of purification. By such "purity" Greenberg meant acceptance of the limitations of the medium. For instance, painting should abandon chiaroscuro and shaded modeling. The picture plane should be made shallower and flattened, thereby destroying realistic pictorial space and the depiction of the actual object. In these ways, Greenberg thought, avant-garde art would call attention to the medium of painting itself: the flat surface, the shape of the canvas and its support, the properties of pigment.

By the 1910s and 1920s the avant-garde became identified with a rejection of the past and the cult of the new. Many of the artistic movements we identify with the avant-garde, Futurism and Dada especially, embody these values. But the practice of avant-garde artists was governed by a countertendency that belied their expressed wish to reject tradition and give birth to the new: that tendency was repetition.[23] In the grid, for instance, many avant-garde artists (among them Malevich, Mondrian, Leger, Picasso, and Schwitters and more recent artists such as Carl Andre, Sol LeWitt, Eva Hesse, and Agnes Martin) found a powerful image. The grid refuses language, hierarchy, and center; it is non-referential, and, in this sense, it refuses nature and narrative traditions. In that massive refusal, artists, as well as their critics, sought and found "an aesthetic purity and freedom," a new beginning, and ultimately, the origins of art.[24] Art-for-art's-sake thus was reborn in another guise. Although the avant-garde artist has claimed a variety of roles and guises – revolutionary, dandy, anarchist, aesthete, technologist, mystic – one theme has been consistent: the originality of the artist. The avant-garde artist, whatever cultural role he or she identified with, could claim the self as the origin of the work's uniqueness and signature style.

There are many further conflicting definitions of the avant-garde. For instance, in Renato Poggioli's 1968 *The Theory of the Avant-Garde*, which provided the basis for many subsequent discussions, aesthetic modernism and the avant-garde are synonymous. Although his book has been criticized by some as atheoretical and historically ungrounded, it has been taken seriously by other contemporary theorists.[25] Poggioli asserted that the avant-garde did not hold to any political ideology, except perhaps to libertarianism and anarchism, the least political of all

ideologies. Consequently, avant-garde art oscillates between various forms of alienation: psychological, social, economic, historical, aesthetic, stylistic, ethical.[26]

In stark contrast to this perspective, Peter Bürger urged that the avant-garde should be distinguished from aesthetic modernism, especially aestheticism.[27] Whereas aestheticism sought to emancipate the work of art fully from connection to the praxis of life (exemplified in Greenberg's theories), the "true" avant-garde wanted to reestablish that connection. Modernism attacked tradition and traditional techniques but stayed within the bounds of bourgeois economic structures, especially commerce. The avant-garde saw itself as expressing a radically different social role. Specifically, for Bürger the term must be limited to the art movements of Futurism, Dadaism, Surrealism, and the left-wing avant-garde in Russia and in Germany.[28] Implicit in his point of view is the idea that art has a socially significant role only when it sees itself as related to the norms and values of society. However, Bürger's attempt to conflate all the forms of Dada (in Berlin, Zurich, and New York), Russian Constructivism and Soviet Productivism, and French Surrealism under one avant-garde umbrella is too simplistic, failing to acknowledge significant differences in avant-garde contexts and practices.[29]

Another response to the problems of defining the avant-garde has been to say that there have always been and will always be those artists who are ahead of their peers.[30] Such artists transcend traditional aesthetic conventions; they have a small audience, encountering initial lack of public acceptance; and they inspire others who follow them. But although this type of general definition may help in discriminating avant-garde artists of the past, it seems completely nonsensical in the 1990s, when artists are working in so many divergent forms, genres, and media.

How, for instance, can one compare the relative avant-garde-ness of performances by Meredith Monk and Karen Finley, both of whom work alone, using minimal accoutrements, and of performances by Suzanne Lacy or Robert Wilson, whose public spectacles involve the supervision, in Lacy's case, of hundreds of other artists and nonartist participants? Or, how might one compare the more private visionary video-based art of Bill Viola to the public and widely known art of Jenny Holzer? Or, how, using avant-garde models, can we account for the burgeoning public awareness of art by African Americans, including, for instance, Robert Colescott's paintings, Lorna Simpson's and Carrie Mae Weems's photography, Glenn Ligon's installations, and Fred Wilson's museum interventions? All of these works, and the artists

that create them, might be interpreted in avant-garde terms with this broad definition. But ultimately, relying on such nonnuanced definitions for understanding the avant-garde fails to bring clarity.

In general, it is necessary to separate the historical avant-gardes of the twentieth century, pre- and post-1945, from their nineteenth-century modernist predecessors.[31] Many writers identify two distinctive avant-gardes of the twentieth century. The first, during the 1910s and 1920s, had overtly political goals. Among the artists who must be acknowledged here are those from many countries – Germany, Russia, Rumania, Italy, England, Scandanavia, and the United States, to name but a few – who strove to depict both the immediate horrors and the aftermath of World War I. Max Beckmann, George Grosz, Otto Dix, Nataliia Goncharova, Olga Rozanova, Constantin Brancusi, Giacomo Balla, Paul Nash, Stanley Spencer, and George Bellows are among the best known. Many, though not all, of these artists turned away from the then-developing abstraction and towards figuration as the best means of expressing what Paul Nash had called the "unspeakable, godless, hopeless . . . bitter truth" of the war.[32] Although it would be a mistake to assume a common motive for these artists, they all tried to represent as powerfully as possible their experiences of death, devastation, and hope for the future. The second neo-avant-garde, in the 1950s and 1960s, was more aesthetically revolutionary. Because this period marks the transition to the postmodern, I will describe it in more detail shortly.

Beyond the historical categorization I have just been discussing, are there other identifiable characteristics of the avant-garde? Poggioli listed several main characteristics of the various avant-gardes as he understood them: activist-agonistic, antagonistic-nihilistic, futuristic-experimental, but more than anything else, alienated. He saw some of these traits in dialectical relationship. Activism refers to a sense of dynamism and fascination with action and adventure, often for its own sake, which contrasts with an antagonistic spirit of hostility toward the public and toward artistic traditions. Antagonism is linked to attitudes of eccentricity and exhibitionism. Similarly, the nihilism-agonism dialectic contains an outer and inner aspect, although neither is particularly constructive. The French Orientalist Eugène Burnouf coined the term "nihilism" to translate *nirvana*, "attaining nonaction by acting," but nihilism does not contain the positive valence of nirvana in Buddhist doctrine and practice. Here it is destructive and sadistic rather than constructive.[33] From the Greek noun *agon*, "struggle," and the verb *agein*, "to drive," agonism aims at self-ruin and sacrifice and is a form

of masochism. Futurism (with a small *f*) represents a utopian attitude and preparation for revolution. In Poggioli's view, participants in avant-garde movements were conscious of being precursors of the art of the future.[34] As such, they were also interested in experimentalism for its own sake. Rimbaud's claims about the poet and artist fit this model. But none of these categories – agonism, futurism, purity, the new, originality – is alone adequate for understanding the complexity of the modern and the avant-garde. Clearly, interpreting modernism and the avant-garde in terms of only one theme or major paradox is too constricting.

A more politically astute, although still limited, definition was offered by Peter Bürger.[35] From his point of view, in a bourgeois society governed by the laws of commerce, art functions to neutralize critique. Because art is mostly detached from daily life, experiencing it remains without any tangible effect. The avant-garde becomes the self-criticism of art in the sense that it seeks to develop what has been neglected. This is similar to Greenberg's idea that modernist art evolved as a form of self-purification and self-criticism of the medium. Or, put differently, in bourgeois society art has contradictory aims: it projects an image of a better social order, which implies critique, *but,* by bringing forth this "better" image, it relieves the necessity for actually creating change. According to Bürger, the twentieth-century avant-garde did not demand that the content of art be socially significant, as the French social realists of the mid-nineteenth century had done, but rather they insisted that artists should look at the way art functions in society.

This is an important distinction, for it suggests that one should not define too narrowly the connections of art to the praxis of life. By criticizing the practice of art itself, artists do perform an important cultural function. Although I have been largely arguing against the ideology of art-for-art's-sake, it can be seen more positively as a kind of defense against the threats of modern science and technology, which seem to deprive art of its realistic functions. By attributing almost mystical properties to artistic media, art-for-art's-sake attitudes can give the artist a sense of purpose.[36]

The avant-garde can be further described by two related characteristics: its attack on the bourgeois institutions of art, and the development of a new interpretation of the "work." Bourgeois institutions of art, especially those related to commerce, have allowed the autonomy of art to take on a quite specific meaning. Art has increasingly been defined as a special sphere of human activity, detached from the nexus of life.[37] To succeed in a commercial market, artists usually must

comply with what bourgeois institutions demand. To the extent that they initiate critiques of such institutions, artists, such as Hans Haacke, Louise Lawler, and Fred Wilson, express avant-garde aspirations.

One of the most generative contributions of the avant-garde has been a new definition of the work separated from the tradition, inherited from the Renaissance, of the individual creation of unique works of art.[38] This new concept of the work was based on four ideas: chance, allegory, and montage (in various forms), and the inorganic. In their art, the Dadaists and Surrealists and their inheritors extolled chance, accident, and serendipity over rational creative processes. Jean Arp's collages, made by randomly dropping cut or torn pieces of paper onto a surface, and Remedios Varo's experiments with decalcomania and blown paint are two examples. In her exquisitely rendered images of gender-ambiguous figures, most of which were painted in the decade before her death in 1963, Varo built up the background by blowing the paint to form irregular and accidental patterns from which she drew forth other organic forms (Figures 2 and 4).[39]

Whereas the role of chance in artistic production is fairly self-explanatory, the idea of allegory is more abstract and was described by Walter Benjamin. An allegorical procedure removes material elements from their usual context, thus isolating them. The work is then constituted by joining these isolated fragments together and positing a new meaning for them. The producer of such an allegorical work must be in a state of melancholy, and the receiver would have a pessimistic view of history. I find such a concept of allegory, which emphasizes a melancholy artist and pessimistic viewer, sobering. As I will insist later, we need instead to foster a kind of hope or "tragic optimism" to survive into and create a viable future.[40]

The new concept of the work also was based in the techniques of montage–collage, photomontage, film, and, more recently, assemblage and installation art. From early Cubist and Suprematist collages by Picasso, Braque, and Olga Rozanova, to more recent environmental installations by Christian Boltanski, Ilya Kabakov, and Mary Beth Edelson, montage presupposes the fragmentation of reality that characterizes modern and postmodern life.[41] It makes that quality of fragmentation into a major characteristic of the work.

Finally, an avant-garde work of art should be inorganic. In an organic work all the parts function together to form a unified whole; in an inorganic work the parts have greater autonomy in relation to the whole. This autonomy of parts is visible in many works that I have already mentioned. But even the generative aspects of these ideas could

not prevent many artists, historians, and theorists from using these same categories to posit and discuss the death of the avant-garde, as we shall see shortly. First, however, let us consider one of the most influential models for the avant-garde artist.

## ARTIST AS PROPHET

We need to begin by noting the way artists of the late nineteenth and early twentieth centuries articulated their roles as prophets and their interpretation of prophecy. Earlier articulations of such roles have rightfully been deconstructed or even debunked, because they were based on untenable notions of the artist's privilege, on prophecy as foretelling the future, and on the artist as oracle.[42] The artist could act as a prophet in two main ways: either by consciously using his or her intuition to show, through content or form, what the future might be; or more generally, by simply being part of a historical moment and historical processes, which were related less to the artist's individual vision and more to the dominant cultural currents at a given time.[43] The latter view has had wide circulation by Neo-Hegelians such as Ernst Gombrich. Although I see major problems with such ideas, I am convinced that possibilities still exist today for reinterpreting and reaccenting the ideas of prophecy and prophetic criticism, but these must be understood against the backdrop of avant-garde aspirations, goals, and values.

In Germany, in the late eighteenth and early nineteenth centuries, the idea arose that "artists of all kinds were blessed with a prophetic insight that was denied not merely to ordinary people, but even to men of learning."[44] Schiller's *Die Kunstler,* in which he claimed that art prepares the way for the speculative and scientific intellect, exemplifies this view, which gained general acceptance in German aesthetics, spreading throughout the rest of Europe.

Like other left-wing thinkers in France in the early nineteenth century, Saint-Simon was especially concerned with the role of the artist in society, as I have already discussed. Later in the century the view that the artist had a special prophetic function became widespread in Europe. For instance, in 1834, writers like Balzac would claim that the artist is greater than a king, because a king rules only for a limited time, whereas artists rule over centuries.[45] In Britain, Thomas Carlyle, John Ruskin, William Morris, and the Anglo-Irish historian W. H. Lecky shared some of these notions. Whereas the Saint-Simonians explained the artist's role using quasi-mystical language, Lecky linked his expla-

nation to the rise of rationalism: "[A]rtists did not literally anticipate the future, they merely appeared to be doing so because they could communicate ideas more immediately through the medium of architecture or painting or verse than moralists or philosophers or scientists could do through that of complex language."[46]

In Europe prior to World War I, many artists saw themselves as creating prophetic art that sought to influence attitudes toward the present and to foresee another, different, future world.[47] Of course, their visions varied widely. French and German Expressionist artists pushed in nearly opposite directions – subjectifying the objective world and objectifying the subjective world respectively, as some historians have put it. Artists of the Russian avant-garde and Dutch De Stijl set forth spiritual and mystical objectives.

Many scholars and historians have wrestled with the question of whether or not art can indeed portend economic or social revolution – Michael Sadler in England in the 1920s and 1930s and Germain Bazin in France in the 1940s, to name but two.[48] Bazin had written that "the artist is like a kind of magus gifted with second sight who from the palimpsest of an epoch can unravel its destiny and express it in the language of forms. For the artist is often a prophet whose vision is not so much the product of its own time as the augur of time to come. A work of art . . . is an anticipation or a correspondence rather than a consequence."[49] From this perspective, because artists are not restrained by the logic of verbal language, they are able to anticipate the future and foresee more clearly than writers, who are constrained by words.

This view found particularly vivid expression in Russia. In the Russian context, Bakhtin inherited such ideas and asserted that the outsideness of the artist from the events of life and the world allowed the artist to share in "divinity": "In doing this the artist and art as a whole create a completely new vision of the world . . . unknown to any of the other culturally creative activities. . . . The aesthetic act gives birth to being on a new axiological plane of the world: a new human being is born and a new axiological context – a new plane of thinking about the human world."[50] The artist's prophetic vision results in new values, new ways of seeing and comprehending the world, and even in a new kind of person.

The so-called Silver Age of the Russian avant-garde (1895–1925) was a period of considerable flowering of the prophetic impulse in Russia, in literature (both poetry and prose), in the visual arts, and in the theater.[51] A specific example of this impulse can be seen in Mikhail Vrubel's paintings *The Prophet* (1898 or 1899) and *Six-winged Seraph*

(1904), both of which were linked to Pushkin's 1826 poem titled "The Prophet."

Of the artists who worked at the Abramtsevo estate, Mikhail Vrubel is perhaps the best known. He was a painter, sculptor, and designer, but, arguably, his best works were monumental convases that dealt with historical and mythological themes such as angels and demons. Vrubel was indebted to Art Nouveau and the neonationalist style that had evolved with the work of the Wanderers. However, he cultivated his own idiosyncratic approach, which is not solely identifiable with either of these. Later critics described him as the first cubist, because of the faceting in his paintings. Two years after completing *Six-winged Seraph*, Vrubel went blind, and he spent the last four years of his life in a hospital.

Other artists in Russia – among the most well known are Vasily Kandinsky, Mikhail Matiushin, and Kasimir Malevich – also saw their work in prophetic terms. Their ideas can be related to the larger apocalyptic context of pre- and postrevolutionary Russia. Such a prophetic, indeed apocalpytic, impulse can be found in Kandinsky's repeated use of themes of the Deluge and Last Judgment, as in *Small Pleasures, Resurrection,* and his *Composition* series from the 1910s. In *Composition IV,* for instance, there are traces of his apocalyptic and eschatological imagery: a boat with oars, the horns of angels' trumpets, the city on a hill under siege.[52] Kandinsky, at least while he was painting the *Composition* series, believed that only by working to unravel and reveal the hidden content could the viewer be initiated into higher levels of meaning and consciousness.

Mikhail Matiushin, with Malevich and others at the new Petrograd State Free Art-Teaching Studios (the former Imperial Academy of Arts), was similarly committed to the idea that the artist would be the agent of a new transcendent and prophetic consciousness. Matiushin had written, "Artists have always been knights, poets, and prophets of space in all eras, sacrificing to everyone, perishing, they opened eyes and taught the crowd to see the great beauty of the world which was hidden from it."[53] His paintings of this period reflect his experimentation with color, form, and consciousness.

Malevich's voluminous writings also demonstrate his belief in the prophetic potential of his art. In his short 1915 essay, "The Artist," he attempted to sketch out a view of the role of the artist: "The artist of color, the artist of sound and the artist of volume – these are the people who open the hidden world and reincarnate it into the real. The mystery remains – an open reality and each reality is endlessly multifaceted and

**Figure 16.** Kasimir Malevich, *Head of a Peasant*, ca. 1928

polyhedral. . . . The artist discovers the world and shows it to man."[54]
As expressed in many of his essays of this period, Malevich seemed to
believe that he was different from people of the past and that in his era
the past was being radically transformed. "It is necessary," he wrote,
"to consciously place creativity as the aim of life, as the perfection of
oneself, and therefore current views of art must be changed: art is not
a picture of pleasures, decoration, mood, experience or the conveyance
of beautiful nature. . . . We are entering a new paradise and creating
our new image, throwing off the mask of the old deity."[55]

I have argued elsewhere that this theme is central to Malevich's paint-
ings of the 1910s, such as *Black Square* of 1915. But even in late images,
such as *Head of a Peasant* (Figure 16) and *Sportsmen* of 1928–32,
Malevich offered a meditation on the nature of worship and idolatry.
*Head of a Peasant* becomes a contemporary icon of sorts, whereas the

revolutionary athletes in *Sportsmen* resemble the saints in traditional icons painted for particular months or days.[56]

Radical new thinking was called for, and these artists attempted to provide it. Such values, however, were widely held outside of Russia, in post–World War I Europe and the Americas. Even the work of Constantin Brancusi, the first distinctly modern abstract sculptor of the twentieth century, expressed a prophetic impulse.[57] Although a link to the theosophical spirituality of Kandinsky and to Malevich's broader spiritual aims can be discerned in Brancusi's magnificent abstract sculptures, they also express a prophetic quality – a sense at the beginning of the century, and at the close of World War I, that we were entering a new phase of art and, indeed, of human history.

For instance, in his many versions and variations of the *Beginning of the World* (including *Sleeping Muse*, *Prometheus*, *Newborn*, and *Sculpture for the Blind*), Brancusi used the image of the head or egg to create an extended meditation on creativity. That "meditation" had at least two aspects: First, it concerned "the fantasy of self-engendering that is in a sense characteristic of avant-garde artists."[58] Second, many of Brancusi's sculptures on this theme were undertaken during and after the devastation of World War I. The French government waged a pronatalist campaign to urge women to have more babies, but women resisted, calling for a "strike of the wombs" in 1919. Although the government imposed draconian laws against birth control and abortion, both persisted. In this context, the head or egg may be read as having to do with birth and regeneration – not only with procreation but also with the (re)birth of art itself. As Brancusi said in 1927, "There still hasn't been any art; art is just beginning."[59] Because of the ways Brancusi's work is open to multiple interpretations, we can also now see its prophetic dimension: For women, this century has opened up new possibilities for control of their bodies.

In general, the avant-garde prophetic artist has been seen both as more spontaneously expressive than most people and as able to experience in ways less mediated by the culture. Historically, this artist has been viewed in two basic ways: the first ascribes special perceptual power to the artist; the second regards the artist as "uniquely authentic in an inauthentic society."[60] Nietzsche's Overman is the model of the self-rejuvenating, self-transmutating, and self-transfiguring powers of the avant-garde artist; it was with this model that Mikhail Vrubel consciously aligned himself. An additional benefit of these powers is that the artist is able to heal, or at least hopes to heal, both the audience

and society itself. Therefore, in addition to being a prophet, the artist becomes a kind of therapist or "existential conscience."[61]

Like many categories of historical and art historical analysis, aesthetic modernism and the avant-garde are not stable, agreed-upon terms, but they are interpreted differently depending upon a scholar's context and point of view. As I have shown, the avant-garde artist has been understood variously as a cultural hero and a cultural vampire, an innovator and a prophet. But under emerging postmodern aesthetics, this model of the artist was not to remain convincing.

## THE DEATH OF THE AVANT-GARDE AND THE BIRTH OF THE POSTMODERN

Synchronous with the birth of the postmodern, critics and theorists began to speculate about the death of the avant-garde or at least about major contradictions and inadequacies of the concept. These contradictions became apparent when the audience, whose values had been rejected by avant-garde artists, enthusiastically embraced their art. When the offensive rhetoric of Dada, for instance, is regarded as amusing, and when its apocalypticism becomes a cliché, then the concept of the avant-garde is no longer useful or adequate.[62] Absorbed into bourgeois culture, accepted and sought-after, avant-garde art no longer possesses either a political or an aesthetic edge. The avant-garde had been premised on the ideas that artists were ahead of their time and that they faced a formidable enemy, the tradition and tyranny of the past. As a cultural success, the avant-garde could no longer keep its authentic name.

This reading of the process of the rise and fall of the avant-garde is not the only possible one.[63] Such assessments of the so-called death of the avant-garde fail to consider the ways in which the neo-avant-garde of the early postmodern 1950s and 1960s has actually, finally, been able to develop its investigation into the media and institutions of art, which had been one of the goals of the first avant-garde. Whereas the first avant-garde had initiated processes and devices such as montage, collage, and assemblage, the readymade and grid, monochrome painting and constructed sculpture, only in the neo-avant-garde were these given their full development and form. Analogously, whereas Dada and Constructivist artists especially had initiated a critique of the institutions, such as the art museum, that govern the art world, only with neo-avant-

garde artists such as Daniel Buren, Hans Haacke, Louise Lawler, the Guerrilla Girls, and Fred Wilson have these criticisms found a compelling public expression.[64]

Any interpretation of the neo-avant-garde as simply a repetition of the first avant-garde depends upon a historicist interpretation of history: that every cause–effect relationship must be in a before-after sequence. Such historicism fails to understand that history itself is neither finished nor necessarily linear. History always remains unfinished, unfinalizable in Bakhtin's terms. The neo-avant-garde (at least some strands of it) has "produced new aesthetic experiences, cognitive connections, and political interventions" that may be among the most vital in contemporary art.[65] In this way, the neo-avant-garde actually helps us to comprehend the first avant-garde more thoroughly.

I have tried to describe some of the internal tensions and contradictions that accompany theories of the avant-garde: its progressivist ideology, its presumption of originality, its hermetic and elite attitudes, its historical exclusivity, and its appropriation by commercial interests and institutions. This last problem underlies the nihilism and cynicism of theorists of the death of the avant-garde, such as Paul Mann.

> Imagine artists for whom every hope for the future of art has been purged in the apotheosis of the economy; artists sick of the constant parade of recuperations, of being caught in all the double binds of opposition (the anti is mandatory, the anti is impossible). . . . Without exception art that calls itself art, that is registered as art, that circulates within art contexts can never again pose as anything but systems-maintenance.[66]

Certainly, the recognition of the seriousness of the relationship between the individual artist and the culture industry – especially the way economic values (including wealth and fame) determine aesthetic judgments by both artists and the public – demands response. Sandro Chia articulated one possible response: "If you're out, you're out – you simply don't count. . . . Anything that happens must happen within the system. . . . I work for a few months, then I go to a gallery and show the dealer my work. The work is accepted, the dealer makes a selection, then an installation. People come and say you're good or not so good, then they pay for these paintings and we all go to restaurants and meet girls. I think this is the weirdest scene in the world."[67] Unfortunately, this type of response illustrates the worst kind of complacent participation in the art world.

Yet more is at stake than artists such as Chia acknowledge. Although

the lives of most of us, including most readers of this book, are not constantly threatened by dissolution, we live, as Guillermo Gómez-Peña put it, in a "state of emergency."[68] The crises to which I have already referred may seem distant, but how distant are they actually, and for how long?

I believe that there is a need to understand the genealogy of the avant-garde and to define neo-avant-garde and postmodern aspirations. To see the history of the various avant-gardes as an ongoing struggle over the very categories that constitute culture would be more useful than some of the definitions posited by Poggioli, Bürger, Greenberg, or other well-known theorists. Especially, the development of new audiences and of new strategies to resist the control of the culture industry over practices and spaces of representation is a worthy goal for artists.[69] But this is not the goal that dominates the late twentieth century. Other diverse and contradictory values about the artist have developed: outsider artist, clown, entertainer, healer, "primitive," celebrity, illustrator.

Consider, for example, the distance (both temporal and axiological) between Bruce Nauman's 1967 pink-and-blue neon spiral *The True Artist Helps the World by Revealing Mystic Truths* and his 1987 video installation *Clown Torture*. *The True Artist*, originally placed in the large window of Nauman's storefront studio in San Francisco, reflects the contradictions of his youthful values. "I could see that the statement . . . was on the one hand a totally silly idea and yet, on the other hand, I believed it. It's true and it's not true at the same time."[70] This statement reflects the core ideology of much Romantic art, thoroughly criticized and rejected under the "rigid aesthetic atheism"[71] of postmodernism. In the 1960s context of civil rights struggles and Vietnam War resistance, what counted as "mystic truth"? The phrase traditionally referred to ideas such as the ineffability of the divine, a sense of oneness in the universe, and the dissolution of polarities such as body/mind or body/spirit. Nauman's piece, and many subsequent works, might be read as a meditation on this third "mystic truth," as an attempt to break down fundamental dualisms that govern our thinking. His simple declaration, then, could be interpreted as providing the raison d'être of his work for many years after 1967. Perhaps to rediscover the hidden truth in worn clichés is to ask, even implicitly, what is worth doing.

Twenty years later, in *Clown Torture*, we see another representation of the artist. As stated in the gallery notes for his 1994–5 retrospective, for Nauman the clown symbolizes the artist's role in society. Artists, like clowns, fulfill collective social fantasies; they are able to say things

and to act in ways that would normally not be tolerated. But *Clown Torture,* as the title illustrates, is about torture. The viewer enters a room, on three sides of which are video images. On the two side walls, large projected images show a clown using a public toilet and a clown in the untenable position of balancing a bucket of water on a broomstick, which occasionally spills, creating a mess. Directly ahead, four monitors display a variety of images of the clown. To add to the overall sense of disorientation, one monitor is upside down and another on its side. The room is dominated by the sound of "NO!, NO!, NO!, NO!" repeatedly yelled at an invisible assailant or unknown source. The strident "NO!" assaults the viewer. What is it that so affronts or threatens the clown that he is forced to react with such vehemence? This, after all, is "clown" "torture." The clown is not, indeed cannot be, tortured, because he is not really a clown; he is acting and we know this. Analogously, the torture is only pretend torture. This double unreality notwithstanding, the piece is extremely difficult to watch.

Perhaps the artist, like the clown, not only "reveals mystic truths" but also can tell us something about the proper attitude toward our present dilemmas. "NO!" may be the most adequate response to at least some of what we see in the world every day. Such a clown does not entertain, but shows us what a postmodernism of resistance looks and sounds like. Both of these examples embody the tensions between irony and parody.

In many ways, irony and satire, long recognized as effective critical strategies, have been replaced by parody and pastiche.[72] In its most positive definition, parody does not mean simply repeating and ridiculing images, ideas, and so forth from the past, but it is a special form of dialogue with the past. Parody can be a form of critical awareness *and* love of history – a dialogical relationship between identification and continuity with the past, on the one hand, and distance from the past and transgression against it, on the other. Pastiche, however, does not carry this positive and critical valence. Rather, it is based on the random imitation, or even cannibalization, of styles of the past, wherein traditions are treated as products for consumption in the new shopping mall of art history. This grim interpretation of postmodern art fits well within what Ernest Mandel identified as the third stage of multinational capitalism. This stage, with its electronic and nuclear-powered technologies, including television and the computer, supports reproduction and consumption rather than older forms of productive creativity.

I do not think, however, that such developments signal the end of art. Many factors will influence the future of the visual arts. For in-

stance, in recent decades there has been increasing diversity in the arts as women have gained access to artistic training and as people of color have been recognized. Furthermore, the breakdown of genres is allowing the emergence of newer interart media that resist easy commodification, as we shall see. The birth of the postmodern signals many changes, including new myths and models for the artist.

# Postmodern Parodic Ex-centric Bricoleur

Jenny Holzer's *Truisms* was the first of many series to use language, series that have included *Inflammatory Essays, Living, Survival, Under a Rock, Laments,* and *Mother and Child.* The *Truisms* have taken diverse forms since her initial commercially printed broadsides, made in 1977–8 while she was in the Whitney Museum Independent Study Program. Printed posters and LED displays in many languages, T-shirts, bronze wall plaques, billboards (including the spectacolor board in Times Square, New York), and marble benches (Figure 17): This diversity of forms has made it possible to circulate Holzer's work widely.

Unlike other works, such as the *Inflammatory Essays,* which had identifiable sources ranging from Mao, Marx, and Emma Goldman to the John Birch Society, the *Truisms* are original. Consisting of over two hundred fifty different viewpoints, the *Truisms* represent both common sense statements as well as politically and psychologically controversial opinions. As Holzer has commented, she sometimes used the ideas of people she knew and ideas from books as sources for the truisms: "Abuse of power comes as no surprise." "Killing is unavoidable. . . ." "Much was decided before you were born." Unfortunately, by outlining so many points of view, the truisms themselves may advocate tolerance of the intolerable.

The *Truisms* marble bench carries additional resonances. Related to Holzer's series *Under a Rock,* the use of stone underlines her apocalyptic preoccupations. As she has said, "Well, if everyone dies, this writing will stay on the rock."[1]

\* \* \* \* \*

At the outset of this chapter at least a few words need to be said about its title: postmodern artist as "parodic ex-centric bricoleur." Although this chapter is not meant as a long discourse on definitions of the postmodern, one of its main goals is to elucidate some of the directions postmodern artists are exploring and the roles they assume in the pro-

cess. The end of the last chapter, as well as the following section, "Characterizing the Present," explicitly describe and illustrate what "postmodern" and "artist" mean today. But "parodic," "ex-centric," and "bricoleur" deserve more immediate attention.

How do contemporary artists enter into dialogue with artists of the past? Parody is one strategy employed by many artists working today. Some, like Sherrie Levine and Mike Bidlo, have practiced blank parody, simply copying the images of other artists. Levine's well-known "stealing" of Edward Weston's photographs of his son Neil and her appropriation of art by Malevich, Rodchenko, and Schiele are but a few of many possible examples. Others use techniques of pastiche, the random cannibalization of past styles, to accomplish their artistic goals. Still others enter into genuine dialogue with work of the past. As Linda Hutcheon has observed, parody's *para* means not only "counter" or "against" but also "near" and "beside."[2] Jenny Holzer is one of these latter artists, whose work quotes historical texts and her own past work, as well as the contemporary language and ideas of others.

The term *ex-centric* plays with the meaning of its near homonym *eccentric*. Many of the artists whose work I discuss in this chapter, Carrie Mae Weems, James Acord, Guillermo Gómez-Peña, Coco Fusco, and MANUAL for example, are *ex-centric* in the sense that they do not occupy a place in the center of the art world and gallery and museum

**Figure 17.** Jenny Holzer, *Untitled with selections from Truisms*, 1987

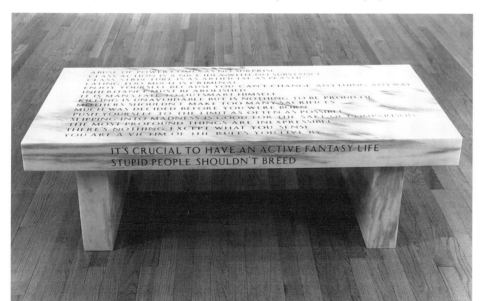

system, as well as being *ex-centric* in the sense that their art reflects meanings that are "out-of-self," not based on personal forms of expressionism that characterized much modernist art. Some of them are even eccentric in life style and/or style of art practice. Holzer, of course, is part of the now-developing canon of significant artists of the 1980s and 1990s and cannot be called either ex-centric or eccentric. She occupies a place at the center of at least one of the art worlds.

Holzer's process is that of a *bricoleur,* a "tinkerer" or "handyperson" who uses what has been created by others in new combinations.[3] When Claude Levi-Strauss used the term in structural anthropology, he was describing the way some cultures recycle and recombine both old and new elements for new uses. Artistic techniques developed in the twentieth century – such as collage, montage in all of its varieties, and assemblage – all can be described as forms of bricolage. In contrast to a modern western model of planned obsolescence with its "throw-it-away" mentality, the bricoleur continually reinvents with what is around. Perhaps this is not a fitting description of an artist whose media include the newest electronic technologies, but Jenny Holzer's *Truisms* series definitely reflects the practice of bricolage.

My intention in what follows is to offer a brief interpretation of the postmodern present and then to concentrate on discussing contemporary artists who fit within the broad category of postmodern parodic ex-centric bricoleur. I end the chapter by considering the impact of new media on the function of art in our culture.

## CHARACTERIZING THE PRESENT

How do we characterize the present moment? This question is significant because it bears on how we envision possibilities for the future, a major theme that informs this book. I ask it in full seriousness, simultaneously recognizing that it is extremely difficult to articulate the presuppositions that ground contemporary life, as both Hegel and R. G. Collingwood knew long ago.

As I have already asserted, the postmodern presumes concepts of the modern, modernity, modernization, aesthetic modernism, and the avant-garde. And like the modern, the postmodern is both a historical and a cultural category, full of contradictions and divergent interpretations. Although I will not rehearse these diverse interpretations here in detail, a few further comments are necessary to ground my discussion of postmodern roles of the artist.

One must be clear about whether one is using the term to refer to popular or academic culture, or in a broader cultural sense.[4] In the popular mind and popular culture, the postmodern is evidenced in the eclecticism of Michael Graves's architectural designs; the desequentializing music of Philip Glass, as well as rap and hip-hop; Alice Walker's denarrativizing literature; and Louise Lawler's and Carrie Mae Weems's defamiliarizing photography. Each of these forms of art incorporates aesthetic eclecticism, appropriating elements of past traditions for new purposes. To take the obvious narrative out of literature; to create music that repeats themes and minor variations, but does not develop these as composers did in the past; to use photography not to mirror reality, but to show us the underbelly of cultural institutions and beliefs: Such are the strategies of popular postmodern art. Lawler's decision to show the thimble collection of the Boston Museum of Fine Arts (1990–1) highlights issues around the politics of exhibitions themselves (Figure 7).

Weems's 1991 installation at the New Museum of Contemporary Art, New York, of *And 22 Million Very Tired and Very Angry People* examined the ongoing African American struggle for equality, raising questions about the interrelationship of race, gender, and class (Figure 18).[5] Linked to a 1941 photoessay by Richard Wright and Edwin Rosskam, *12 Million Black Voices: A Folk History of the Negro in the United States,* Weems's work carries this genre – of photographs combined with text – forward for the 1990s. The installation consisted of photographs on the walls of the gallery, each of which contained a label. A rolling pin was labeled "By Any Means Necessary"; a small Orishan votive figurine, "A Little Black Magic." Silk-screened banners, which were printed with the words of Fannie Lou Hamer, Franz Fanon, Luisah Teish, and Marx and Engels, among others, hung in the central gallery space. With this juxtaposition of diverse images and texts, Weems seemed to be saying, "We need all of these voices, today."

Postmodern academic culture turns on the ideas of (primarily) European and American male philosophers and theorists such as Jean-François Lyotard, Jean Baudrillard, Jürgen Habermas, Roland Barthes, Michel Foucault, Jacques Derrida, Ihab Hassan, Fredric Jameson, Jacques Lacan, and Edward Said. A few women, such as Julia Kristeva, Jane Flax, Rita Felski, and Linda Hutcheon, have also helped to shape academic discussions. The disproportionate number of male theorists is curious, given that feminists can claim some responsibility for initiating important postmodernist discussions about such issues as subjectivity and the politics of identity and difference. Nevertheless, much discus-

**Figure 18.** Carrie Mae Weems, *And 22 Million Very Tired and Very Angry People*, 1991

sion centers on topics like Lyotard's incredulity about master narratives, Baudrillard's procession of simulacra, or Barthes's-Foucault's-Derrida's decentered subject, all of which feed an ever-expanding academic appetite.

The actual determinants of postmodern culture lie elsewhere, however: in the impact of market forces on everyday life; in Europe's displacement by the United States as the major global influence (and possibly the present ongoing displacement of the United States by Asia); in the polarization of contemporary culture around issues of ethnicity, race, gender, and other differences; and in the general bureaucratization of society. The breakdown of categories of high and low art, the commodification of culture, and the commercialization of the arts are the results of these complex forces. There is an "interplay between profit-driven corporations and pleasure-hungry consumers in cultural affairs."[6]

Finally, an undeniable feature of postmodern culture is pervasive and increasing violence and fear. "America is in the midst of a mess of social breakdown . . . cultural decay is pervasive."[7] Cynicism and nihilism are also widespread. Cornel West refers to the "walking nihilism" he sees

in the black underclass: "It is the imposing of closure on the human organism, intentionally, by that organism itself. . . . We are talking about real obstacles to the sustaining of a people."[8] Or, as Lyotard put it: "The nineteenth and twentieth centuries have given us as much terror as we can take."[9] Such a statement might refer to international events of our century, or to daily life for citizens of Sarajevo and Jerusalem, New York and Los Angeles.

In this context, perhaps the most important question concerns the nature and quality of postmodernist praxis: Do we practice a postmodernism of reaction or resistance?[10] Do we react like Sandro Chia, getting down to the business of art in a reactionary business environment, or like Nauman's clown, screaming our "NO!" at the tops of our lungs?

Postmodernists of the 1960s (the neo-avant-garde described earlier) criticized modernist aesthetics and reclaimed both the heritage and the strategies of the European avant-garde. This early postmodernism attacked institutionalized "high" art, packaged and commodified in the culture industries, while it simultaneously validated popular culture and reflected technological optimism about postindustrial society. On the one hand, artists such as Andy Warhol, Roy Lichtenstein, and Richard Hamilton directly appropriated the images of mass culture. On the other, (male) artists such as Daniel Buren and Hans Haacke continued the critique of the institutions of high culture that had been initiated by the Dadaists and their successors.

Perhaps even more significant than the work of isolated individuals such as Buren and Haacke, however, was the initiation, around 1970, of a national Feminist Art movement. In several innovative ways, women contested the modernist canon and the formalist criticism that supported it. By introducing feminist content and new materials and techniques, and by creating a profound rupture in the traditional European-American "male litany of artistic criteria, aesthetic values, and art-historical practices,"[11] feminist artists radically altered the practice and history of art. By the late 1970s and 1980s a more affirmative eclecticism was widespread in the visual arts in mixed-media installation, performance, and various forms of multimedia exploration such as the (so-called) body art of Carolee Schneemann, Hannah Wilke, and Adrian Piper, as well as Nam June Paik's early robots.

Interpretations of these trends in postmodernist and neo-avant-garde art vary greatly, however. Peter Bürger articulated a bleak view of the potential of the neo-avant-garde, claiming that it has turned the avant-garde into another historical institution. I agree that this is certainly true of the way the art market and museum system have co-opted avant-

garde radicalism by making it into a highly saleable commodity. But, Bürger thinks that the avant-garde goals were never realized: "[A] developed aesthetic theory of engaged art does not exist."[12] Perhaps, if he had written his *Theory of the Avant-Garde* after 1984, in the wake of the political art of the late 1980s and early 1990s, and after having read the theory and criticism of scholars such as Lucy Lippard, Bürger might have come to other conclusions.

A much more grim assessment has been articulated by Donald Kuspit. I will here discuss his ideas in some detail, for I am convinced that the kind of pessimism reflected in Kuspit's writing is widespread among artists and critics. It is the result of examining only what I earlier called a postmodernism of reaction.

Building on Nietzsche's original articulation of the idea of ressentiment and its further elaboration by Max Scheler, Kuspit suggests that now artists commonly suffer from "a will full of ressentiment," a perversion or inversion of basic life values.[13] Scheler had identified ressentiment as a feeling of revenge, hatred, malice, or envy that results from feeling dominated by unreachable authorities. In this sense, it might be considered a basic condition of postmodern existence: a loss of the will to live, even on a global scale, interwoven with the idea that the world has become decadent, pathologically possessed by necrophilia. (If this is indeed a common condition, artists might well benefit by being excentric.) Because there seems to be no possibility of a future, neo-avant-garde artists are solely concerned with the past, preying on it like vultures, turning it into a "gruesome graveyard" of decay, making (in a slightly less morbid image) an "assemblage of history."[14] Decadence has become the norm, rather than creativity.

According to Kuspit, the goals of neo- or pseudo-avant-garde artists contrast with the loftier aspirations of the first avant-garde. Instead of artist as hero, we have artist as pretender; instead of presenting a direct translation of experience, the artist gives us the myth of art. I agree with Kuspit's thesis that our attitudes about the artist are undergoing a paradigm change, but where he sees the emergence of a new ambivalence, I see the potential for reaffirming the transformative power of art. Certainly, art can change society only in modest ways, first by changing the individual – an admittedly slow route to social transformation – but change is possible, as I insisted in Chapter 4.

Kuspit asserts, however, that artists no longer address personal and social ills in ways that would support cultural change. Art no longer engages the deepest needs of the public; if anything, artists often see the public only as a potential source of fame and fortune. (The examples

of art that I discuss later in this chapter substantiate the opposite claim, as we shall see.) The avant-garde artist expected fame for his or her art, if at all, through a process of negotiating the discrepancies between inner and outer worlds, thereby being of service to the world. But in a sad introversion of values, the neo-avant-garde artist expects personality rather than art to be the key to both fame and fortune, thereby doing [the world] a serious disservice by denying art "its sacred function as a temple in which humanity can find sanctuary"[15] Here we might usefully ask, can humanity find sanctuary any longer in art, in a culture where sanctuary is frequently defined by the passivity of the television screen?

This hyperfocus on personality is often coupled with and sustained by the idea that anyone can be an innovative artist through careful manipulation of publicity or extreme exhibitionism. In a process that becomes even more perverse, the art dealer can gain or assume the famous status formerly reserved for the avant-garde artist. This is "the final, subtlest, most utopian decadence: innovation that leads nowhere, develops nothing, produces nothing of social or individual consequence."[16] Perhaps this commodification of both artist and artwork is just the latest version of art-for-art's-sake aestheticism.

Under the sway of tradition and traditional values, especially in premodern cultures, the experience of decay and death led, however mysteriously, to the experience of resurrection (or, as in the case of the Tibetan Buddhist thangka discussed in Chapter 5, to liberation). This, of course, is the basis of the religious mythologies that fostered and continue to sustain artistic traditions. In modernity, rebirth was still a possibility but much more contingent and difficult to locate. Modernist avant-garde art such as that of Kandinsky, Rozanova, Malevich, Brancusi, and Mondrian was based on this possibility. But nihilist postmodernist world views (like the nihilism of some avant-garde strands) deny the possibility of regeneration and renewal, through art or otherwise, and remain caught in an endlessly depressive and narcissistic cycle of decadence. When ironic or parodic artistic strategies are based on an attitude of resignation, then nothing can ever be really changed.[17] Within the art world, it has become increasingly difficult to pose, or even imagine, questions that threaten the bourgeois status quo, as these can be too easily co-opted for market purposes.

Kuspit totally rejects appropriation art, seeing it as symbolic of the decline and impending death of art because it fully reveals the bankruptcy of creativity today. Contemporary appropriation art demonstrates that instead of their being able to move forward into a future, artists are capable only of looking backward and of moving back-

ward.[18] Against this view, however, as I suggested earlier, it may also be argued that appropriation art does bring new attention to history and tradition, which had been rejected by the modernist avant-garde.

Finally, for Kuspit the saddest legacy of contemporary art is the diminishment of the seriousness of art and culture more generally.[19] "Neo-avant-gardism signals the end of age-old notions of creative inspiration and critical self-consciousness"; this results in a situation in which art is no longer a calling, but an "honorable bourgeois career."[20] Perhaps this is the predictable result of a long trajectory of art and an art world built on patriarchal and necrophilic values.

What if gender, race, class, and other issues of cultural and political identity were brought to the fore? What if alienation in the arts were examined more carefully? How is it possible to reassert both the seriousness and gravity of our current global situation and the significance of the artist as a cultural worker in the midst of that situation? These are my questions, and I hope to provide a counter to Kuspit's pessimism. It is not enough for an artist simply to wish to be "good enough," as Kuspit has argued elsewhere.[21] Too much is at stake.

Pessimism about postmodernism and the neo-avant-garde is not the only possible vision. We need a nuanced sense of the pluralism of postmodernist expressions, as well as an interpretation of postmodernism as a world historical category. As suggested earlier, an alternative postmodernism arose in the 1970s and 1980s, which has been defined by its critique of and resistance to the status quo. Artists continue to draw on the resources of mass culture for energy, materials, and content.

The interpretation of the postmodern artist as a parodic ex-centric bricoleur is not, finally, adequate to describe the diversity of approaches to the arts in the 1990s and as we approach 2000. Nevertheless, I will consider in more detail examples of postmodernist art that expresses this vision of the artist's role.

## ARTIST AS BRICOLEUR

In *Bakhtin and the Visual Arts,* I noted three positive phenomena that must be taken into account in describing postmodern culture: the emergence of women as a creative presence, renewed energy to address pervasive ecological problems, and cultural pluralism.[22] In their work, using traditional artistic media as well as newer genres, artists such as Joan Snyder, Richard Long, James Acord, Miriam Schapiro, Guillermo Gómez-Peña, and Coco Fusco address these issues. These artists dem-

onstrate a commitment to the ongoing transformative power of art; they are only a few from a much longer list I could construct.

Women, once relegated to the domain of object in artistic representation, or often absent altogether from the creative domain, are now establishing themselves as subjects: theorists and practitioners in the cultural sphere. If women were largely excluded from being considered in the role of modern heroes, semidivine creators, and prophets, their work has been central to the sense that art has a larger transformative role in postmodern culture. Many women artists have been and remain ex-centric, marginal to the art world, while being thoroughly centered in their experiences as women.

In the mid-1960s Joan Snyder painted such subjects as altars and angels using collaged materials, and her turn to "stroke" paintings in the 1970s brought her early public recognition.[23] Since then her work has been exhibited widely. Many of Snyder's paintings have been about herself – personal events such as abortion, marriage, miscarriage, the birth of her daughter, and divorce. Drawing on diverse sources, such as the German Expressionists, primitive art, children's drawings, and personal symbols, and using a broad range of art and nonart materials, her paintings also deal with religious and political content. According to her self-description, Joan Snyder's art (especially from the 1970s and early 1980s) is marked by a "female sensibility." As part of the *Heresies* collective in the late 1970s, Snyder and others helped to define this "feminine aesthetic," which was linked to women's biology (sex) and later to personal and cultural factors (gender).

Snyder found the idea of female imagery and a distinctive female experience to be important to both the process and content of her painting. "For me the explanation is very simple. Women's lives and experiences are very different from men's, and therefore their art is going to be different."[24] Snyder echoes Lucy Lippard in trying to describe this female sensibility: "I know what it isn't. But I can't pinpoint what it is. . . . It has something to do with a kind of softness, layering, a certain color sensibility, a more expressive work than any man is going to do right now, and a repetitiousness – use of grids, obsessive in a way."[25] In discussing Snyder's 1977 painting *Resurrection* (Figure 19), however, I prefer to "unfix" the essentialist resonances in Snyder's definition of "female sensibility" in the direction of a more culturally based understanding of women's experience.

Snyder's work has also been characterized as a form of feminist expressionism, connected to both the Romantic and religious iconographic traditions.[26] In particular, *Resurrection* expresses a secular interpreta-

**Figure 19.** Joan Snyder, *Resurrection*, 1977

tion of religious and moral values. "Making art," Snyder wrote in the catalogue introduction to a 1987 Corcoran Gallery exhibition, "is . . . practicing a religion." "There is definitely something mystical about my work. It's my own religion, my own iconography."[27] In an art world, and the broader social and cultural world, where the notion of transcendence has lost its meaning, Snyder is working "to recover . . . and reinvent a sacred voice."[28]

Snyder painted *Resurrection* as a response to the epidemic of violence against women in our culture. One of the panels identifies the names of 102 actual women and girls between the ages of fifteen months and eighty-eight years who were beaten, stabbed, raped, strangled, burned, shot, blinded, dismembered, suffocated, and set afire. Specifically, however, *Resurrection* is about a woman Snyder imagined, who had been raped and murdered at Martin's Creek Farm, where Snyder was then living. "Someone needed to be buried. The painting became the story of one woman and many women's lives. It was about rape and murder and rage. It was also about the rich history of a woman aside from the fact that she was violated. Finally I had made a painting about someone else's experience."[29]

The painting is 26 feet by 6½ feet, and consists of seven painted and collaged panels, plus one narrow wood panel covered with paper. *Resurrection* combines text, newspaper collage, torn and glued fabric, and painted forms. Writing about Snyder's later work, the critic Roberta Smith said that the artist's use of collage "frequently turns her paintings into a combat zone of pictorial parts" that nonetheless conveys a stark sense of the global reality of political conflict.[30] Several panels of *Resurrection* do communicate this sense of visual and social conflict. Like much of Snyder's other work, some of the panels are abstract, others are figurative.

*Resurrection* communicates a strong moral message, ranging from images of the personal and specific (newspaper clippings documenting violence committed against individual women) to general and universal

themes (home, the sun, peace).[31] But does *Resurrection* also communicate an imperative to act against the values that sustain the high incidence of violence against women? This depends entirely on the viewer. In the wake of the violence that is described both visually and verbally, and the horror that is conveyed through this juxtaposition, the final panels seem too facile. Is transcendence, or resurrection, to use Snyder's title, really so easy for women, or for the families of women, who are the victims of such extreme violence as rape and murder? Is Snyder's message that resurrection is attained through death? If so, then the imperative to end violence against women is dampened. Perhaps there is another message here instead: a message of hope that, despite their enormous suffering, women can collectively overcome the various forms of personal and cultural oppression that affect us all.

\* \* \* \* \*

Many artists address the pervasive ecological problems and environmental catastrophes that we confront: Helen and Newton Harrison, Mel Chin, Betsy Damon, Dominique Mazeaud, Mierle Laderman Ukeles, Kim Abeles, and Alfredo Jaar, to name some of the best known. Their work continues to fuel critiques of modernity and modernization. Art that addresses these issues can take either subtle or overt forms; here I want to consider the examples of Richard Long and James Acord.

I have for many years been inspired by the transitory quality of Richard Long's work and by Long's commitment to working primarily with materials in nature (Figure 20).[32] Long works in two contexts: He takes walks in the world, documenting those walks and the resulting "artifacts" that he constructs (circles, lines, etc.) with a camera; and he creates installations in galleries and museums. Thus he has been able to establish a reputation in the art world. But the effemerality of the work does not mean that it belongs solely to a conceptual art tradition. "My work," as Long claims, "is real, not illusory or conceptual. It is about real stones, real time, real actions. I use the world as I find it."[33]

Long's art involves mapping: mapping literally where he has been, as in some of his early works, and metaphorical mapping that means his laying out and organizing stones, sticks, or other materials at a particular site. His images are paths or lines, crosses, circles, spirals, or meanders. His materials are water, stones, sticks, mud, and time. These are "universal," as Long asserts. "It is no coincidence that there are parallels between my work and work from certain people of other cultures and societies, as nature, which is the source of my

# TWO SAHARA STONES

## SITTING ON A MOUNTAINTOP
## IN THE HOGGAR
## CLAPPING TWO FLAT STONES TOGETHER
## A THOUSAND TIMES

### 1988

Figure 20. Richard Long, *Two Sahara Stones*, 1988

work, is universal. We all live in different cultures but we all share the same nature of the world. We all share the same air, the same water and everything."[34] Long eschews art historical analogs or precursors to his work (such as the English landscape tradition) but says, instead, "I suppose if you have to put some historical or political slant on my work, I hope it does tie up in some ways with the Green philosophy, 'small is beautiful', and of seeing the world as one place, and using its raw materials with respect. I like to see art as being a return to the senses."[35] He claims to be totally uninterested in theory. Long's work incorporates actual space, ordinary objects, unimportant materials, words, photographs, and maps, all of which are essential to his being able to present his walks to the art world. Yet, they do not seem to be solely instrumental, manipulated for the purpose of promoting his reputation.

The relationship of the human body to and in the landscape and nature is crucial to Long's work. These relationships are not abstract; instead, they are carried out in direct relation to the ground, to the earth. The role of touch is especially obvious in Long's hand and foot prints and in the realization that each stone has been moved by hand. Hence, Long's art is very different from that of other "earth" artists,

such as Michael Heizer, who use bulldozers. Although Long may allude to mountain climbing and competitive activity, "fame and fortune have not caused him to employ bulldozers after a lifetime of 'placing' sticks."[36] Perhaps as a result of this direct engagement, viewers find meditative and healing qualities in his art. In the context of our contemporary lives, these qualities are welcome and rare.

As Anne Seymour has noted, the idea of the journey and the path may be the central image of Long's work. "To walk a line is the easiest thing a human being can do to put his mark on a place. The idea of the path or way has meaning in all cultures from the most material to the most spiritual."[37] It is simultaneously visible and invisible: Long leaves visible marks, at least until they are erased through natural processes, but the experience itself remains invisible. In this sense, the work has both outer and inner dimensions. Long asserts that his work is "never a performance. It is usually a very private, quiet activity. I am happy to make it in solitude."[38]

Long's work can be criticized as self-indulgent, bourgeois (financial resources are clearly needed to make journeys to distant and isolated parts of the earth), elitist (especially because understanding it involves a sophisticated notion of what art is), and ultimately of little impact. Still, a viewer may be personally moved by the work – by its metaphoric power to evoke a different relationship with the earth and by its evocation of silence and solitude, all-too-infrequent aspects of postmodern life.

The work of James Acord would be impossible in solitude. Acord lives and works in Richland, Washington, near the Hanford nuclear site. Hanford is spread out over 560 square miles in southcentral Washington, and it has been recognized as a highly contaminated site. Many reactors have been shut down, some too contaminated to enter. Hanford still is an active dump site for spent radioactive material. Acord's community consists of the general public, the nuclear industry, and government officials.

In a 1991 exhibition titled "Transmutations: Art in a Nuclear Age,"[39] Acord showed two monumental sculptures, *Fiesta Studio Reactor* and *Monstrance for a Grey Horse*. Although it has humorous overtones, *Fiesta Studio Reactor* was designed to demonstrate the radioactive properties of Fiesta dinnerware, introduced in the 1930s with glazes containing radioactive materials such as uranium. *Monstrance for a Grey Horse* carries much deeper resonances. The artist wanted to build granite repositories for nuclear waste and spent nuclear fuel: *Monstrance* is an example of one such repository. As Acord said, "I keep thinking of the stupa. . . . Make it [any site of nuclear contamination] a sacred site,

**Figure 21.** James Acord, *Chalkboard*, 1991

encourage people to bury their dead there, do something so that it be-comes a sculpture park, a sacred space."[40] Stupas, the dome-shaped buildings used in Buddhist death rituals, later became shrines for pil-grimage and prayer. Acord's *Monstrance,* the name of which refers to the receptacle in which the host is carried in Roman Catholic rites, carries powerful religious connotations.

The majority of Acord's 1991 exhibition consisted of documentation of the artist's dialogue with the nuclear industry since 1987. It is worth describing here in further detail, as it shows some of the ethical ambi-guities of Acord's work. In that documentation, which includes chalk-boards covered with diagrams (Figure 21), sketches and photographs, and correspondence with nuclear industry officials, Acord recorded his painstaking and persistent attempts to gain permission to use the Fast Flux Test Facility at the Hanford nuclear site, to convince government and industry officials that he should be allowed to obtain nuclear ma-terial, and then to find sources for that material. Letters indicate that

Acord finally received permission to acquire Ruthenium, one of the elements he wanted, as well as a breeder blanket assembly containing 82 kilograms of depleted uranium.

Acord has said that "[A]rtistic use of America's most advanced reactor may accomplish things in addition to the purpose of creating sculpture: it brings art and science together in important societal decisions regarding technology, widens the possibilities of environmental restoration to include the arts and gives symbol and metaphor to the Nuclear Age in which we all live."[41] With such statements and in his successes, Acord has demonstrated admirable political savvy, but I think that his work lacks a clear political and moral consciousness. In an interview at the National Humanities Center, Acord noted that art and politics actually have little to do with each other. Given his obvious need to gain and maintain the support of conservative governmental and scientific groups, this statement makes some sense. But to fail to deal with questions about the political accountability of one's work denies the lessons of artists, writers, and other intellectuals, who have shown that every act, and every artistic work, is located in a particular nexus of power relations and has political and moral consequences.

Finally, Acord's work leaves the viewer with a series of questions related to, though different from, those suggested by Long's work. What does it mean to say, as Acord has, that art can "contribute toward civilization's understanding and mastery of the nuclear age in which we live"? Does his work give a sense of the profound, even sacred, responsibility that human beings bear for creating nuclear weapons of death and the resulting nuclear waste that will be toxic for generations to come? Or, does his work serve the nuclear industry, which craves public support for its mission? The answers to these questions remain ambiguous.

\*   \*   \*   \*   \*

As part of a new awareness of cultural pluralism, women artists and artists of color have offered significant critiques of high modernism.[42] Exploration of the gender, race, and class biases of modernist canons and traditions, of images of sexuality, of subjectivity, and of the politics of creation and representation have all become issues within the postmodern because of the work of women and minority critics, writers, and artists. Jenny Holzer, Joan Snyder, Martha Rosler, Carrie Mae Weems, Lorna Simpson, Fred Wilson, and Louise Lawler are only a few of the artists who are working in this vein. Here I will describe in more

**Figure 22.** Miriam Schapiro, *Mother Russia,* 1994

detail recent work by Miriam Schapiro and the team of Guillermo Gó-
mez-Peña and Coco Fusco.

Earlier I described parody as a form of critical awareness and love
of history, whereby old forms are given new meaning. As an example
of postmodernist parody, Schapiro's art continues to educate the artist
and her public. Her paintings recover women's art for others to see,
thus making it accessible in new ways. Arching across Schapiro's large
fan-shaped painting *Mother Russia,* are two words – *kooperatsiia,* lit-
erally, "cooperation," and *poezdka,* "journey" (Figure 22). Schapiro
calls her work from 1993 and 1994 "collaborations" – between the
artist and her Russian heritage, between the artist and Russian women
artists of the early twentieth century, and between the paintings and the
public. *Mother Russia* demonstrates these values. The painting refer-
ences Schapiro's own past work (fans, homage to earlier women artists),
as well as her Jewish and Russian heritages. This fan, however, also
carries historical narrative content and, unlike many earlier fans, images
of actual women.[43] Its ecstatic materiality is completely integrated with
content and form, as in many earlier works that used femmage and
pattern and decoration. Perhaps most significantly, it establishes a re-
lationship with eleven major women artists of the early-twentieth-
century Russian avant-garde.

The period from about 1890 until 1930 was a time of tremendous
upheaval and artistic creativity in Russia. Throughout the nineteenth
century women had been instrumental in radical political movements,
agitating for suffrage and for access to educational institutions. But their
contribution to culture was nowhere more prominent than in the visual

arts. Through her Neoprimitivist and Rayonist paintings Nataliia Goncharova helped to bring attention to indigenous Russian traditions, especially icons and *lubok* prints. Liubov Popova's Cubofuturist and Constructivist paintings led her finally to reject the fine art traditions as outmoded and useless. Olga Rozanova attempted a new synthesis of word and image with collages and illustrations for transrational poetry. Popova, Varvara Stepanova, and Alexandra Exter were among the first artists to work as designers in the Russian textile industry. Stepanova was committed to social and political issues, even working as a magazine designer in order to promote literacy. Exter threw herself into teaching after the revolution and participated in early forms of performance art. Many of these artists were active in the theater. Vera Mukhina was a gifted sculptor, whose heroic *Worker and Collective Farmworker* became the logo for the state film studio in Russia. Sonia Delaunay is well known; others, such as Antonina Sofranova, Nadezhda Udaltsova, Anna Golubkina, and Nina Simonovich-Efimova, are less so. Still others – Vera Ermolaeva, Maria Ender, Elena Guro, Nina Kogan, and Kseniya Boguslavskaya – are not part of Schapiro's work, but their presence is nevertheless invoked by Schapiro's act of cooperation and collaboration. In *Mother Russia* the faces and images of these women artists of the Russian avant-garde are brought to life.

*Mother Russia* also evokes the theme of *poezdka*, the journey. This painting continues Schapiro's feminist journey, which for many years has included retrieving the past and educating others about those women artists who have come before. Schapiro's collaborative journey expresses a keen sense of devotion to the women of the past and present who have made and continue to make her work possible.

But the encounter with cultures and cultural pluralism can take other forms. In their collaborative performance piece "The New World Border: Prophecies for the End of the Century," Guillermo Gómez-Peña and Coco Fusco offer a satiric and parodic, yet serious, examination of the politics of identity within culture generally and within the art world specifically. Gómez-Peña and Fusco are the stars; they act out ten "prophecies" about the future of "Art-maggeddon," which is "the end of the world, according to the art world, or the end of the art world itself."[44]

For instance, in Prophecy #II, "La Gringostoika," the two predict the fading of geopolitical borders and the impoverishment of "Gringolandia." They ask, "Are we closer to Art-maggeddon or are we merely experiencing the birth pains of the new [millennium]?"[45] Each "Prophecy" carries its own valence. Prophecy #IV defines new hybrid

identities for individuals, which can be best described not by using the old "melting pot" metaphor, but with "menudo chowder," where heterogenous ingredients float together but do not melt. Such an image is humorous. In contrast, Prophecy #V is frightening: It posits the development of "Robo-Raza," the new transcontinental youth, the "global culture cyborgs" with neither commitments nor convictions caught up in virtual reality games. In Prophecies #VI and #VII, an "official transculture" is developed, against which the "barrios of resistance" undertake clandestine activities; and in #VIII, "The New Paganism," the confused masses are worshipping new hybrid deities. "Culti-multural" art develops in which art about identity becomes popular, even a source of nostalgia. Finally, in Prophecy #X, various mafias emerge, with names like "Thin and Gorgeous Artists of Color" and "Straight White Guys Are Alright." These groups "cling to the past in order to experience an optical illusion of continuity and order."[46] Work by energetic, creative, critical, and funny artists such as Gómez-Peña and Fusco brings dramatic attention to issues of cultural identity and cultural survival.

Artists, writers, and cultural workers such as those I have just described, rather than tout arbitrarily assigned exceptional sensitivities and special insight, use their reasoning, critical faculties, and imagination to make sense of what is going on in the present and what might be in the future. Their attention to issues such as violence against women, our human relationship to the world in which we live, and the tensions in cultural pluralism are far from the nihilism implied by the name "parodic ex-centric bricoleur." We need to envision possible futures. To be able to do that, an artist must engage in the kind of discernment, the making of connections, the tracking of hypocrisy, and the articulation of hope that are vital components of a vocation embracing prophetic criticism and visionary imagination. Before discussing precisely what these value-laden terms might mean, however, it is important to consider the impact of new postmodern technologies and alternative forms of art on the role of the artist.

## ARTISTS AND THEIR MEDIA

Just as the technology of photography catalyzed modernist aesthetic ideals, electronic media (especially the copier, television and video, and the computer) have already hurtled us into the postmodern.[47] One unique aspect of this shift is that the later postmodern technologies do

not create consumable goods, but information and services.[48] The "de-materialization of the art object,"[49] begun in the evolution of conceptual, installation, and performance art as distinctive art practices, continues in a new guise. Although art in such forms as video, laser, CD-ROM, and computer disks does have a market, it is not yet of the same nature as the highly commodified world of painting and sculpture. We live in an "Image World," where the visual arts are increasingly integrated with the media and where the technical means of the media – television, film, photography, billboards, and so forth – intersect the world of art.[50]

Artists' responses to technology differ widely, ranging from embracing the latest technological advances, to refusing, in a variety of ways, to engage change.[51] The benefits of working with newer technologies include the possibility of inventing new art forms and exploring and clarifying cultural issues surrounding the complexities of the present. The risks or problems include lack of resources for expensive materials and lack of access to the technology, as well as the dominating character of the technologies themselves.

Among the artists who reject technology, some stalwartly believe in the primacy of handmade work and traditional practices. Others turn away from the outer world toward their own private inner worlds. Still others ground their refusal to engage high technology in a politics that recognizes the way power directs and controls technology for the benefit of some over others. This last possibility was well articulated by Walter Benjamin in his "The Author as Producer":

> They defend an apparatus over which they no longer have control which is no longer, as they still believe, a means for the producers but which has become a means to be used against the producers. This theater of complex machineries, gigantic armies of stage extras and extrarefined stage effects has become a means to be used against the producers (artists), not least by the fact that it is attempting to recruit them in the hopeless competitive struggle forced upon it by film and radio [and television].[52]

In both embracing and rejecting newer technologies, artists can deal with significant questions such as who owns and controls access to these technologies. That the technology itself is rooted in notions of social progress means that these questions must be examined as part of a complex pattern of social and economic development.[53]

For my purposes, the critical question concerns how the role of the

artist changes in this shift. If art is the arena for prophetic criticism and visionary imagination, and for reclamation of the future, then the use of various new or old media is not the most significant issue. What does change is the nature of the audience for the work; consequently, artists must begin to consider not only the range of possible audiences but also the kinds of interactions they wish to generate. With interactive media such as the World Wide Web, the work of art itself becomes less significant, or at least less subject to the artist's control, and the dialogues between artist and viewer and between the artwork and viewer are brought into new relief.

The tools artists use affect vision and thus the style, content, and philosophy of works of art.[54] Renaissance single-point perspective led to certain conventions in painting. The world artists represented tended to be based on a static single viewpoint. However, photography made possible the idea of multiple perspectives, as Eadweard Muybridge's many studies of people and animals in motion demonstrate. Cubists attempted to render this multiplicity in painting, but the development of film extended the sense that both time and space could be thoroughly explored and represented. All of these forms made certain assumptions about the viewer, as passive and located in a single space-time nexus. These assumptions have now been radically challenged by interactive electronic media. The manipulation of time, space and perspective, as well as shifting relations between the traditional artist, object, and viewer, will continue to evolve.

Among artists who have been pushing these boundaries are Suzanne Bloom and Ed Hill (MANUAL) and Bill Viola. In their collaborations, exhibited and circulated under the name MANUAL, Bloom and Hill combine Constructivist imagery, some of which they appropriated from Russian artists such as Malevich and El Lissitsky, with their own computer-generated and enhanced photographs (Figure 23).[55] Their goal in this unusual pairing of modes is to bring into focus some of the environmental paradoxes and dangers that face us. In their words:

> The sublimity of art consoles neither spotted owls nor men with chainsaws, both of whom are struggling to survive in a diminishing habitat. But here we mean to imply something more: not only does art not solve or salve the problems of the environment, it may be, in all its "innocence," part of the problem. In a subtle and insidious way art may serve to enable the ultimate destructive consumption of Nature, especially visual representations that celebrate our mastery over it.[56]

Figure 23. MANUAL (Ed Hill/Suzanne Bloom), *Picture This*, 1992

In particular, MANUAL is concerned with the ways in which the computer aids those who command it in shaping virtual worlds. If the oceans are polluted and old growth forests are cut down, what will stop those who live with(in) the screen from simply simulating what no longer exists in "real" space and time? "The danger is that while we sit mesmerized by the high-resolution wonders developing on our computer screen, thieves may be making off with all the goods."[57] Forests become forest "products"; the industrial world confronts the virtual world; and human beings, as well as other life forms, lose.

Television and video command complex emotional and intellectual responses from the viewer. The "TV ritual," to borrow the title of Gregor Goethals's book, provides us with tales of the good life, with images of our world, and with an often distorted view of other human beings. Television is developing its own myths, which are taken for reality. Yet myths, and rituals, have always provided models for human identity, self-knowledge, and action, helping us to structure our spirituality and religious experience. As the primary form of religious expression involving time, myths have helped human beings grapple with mortality and mystery. In appropriating the language of myth and the medium of video, Bill Viola gives the viewer an unusual opportunity to confront ultimate questions concerning birth, life, death, and the future.[58]

For instance, in Viola's 1992 installation *Heaven and Earth* (Figure 24), two black-and-white video monitors face each other in a tall columnar structure that connects the ceiling and floor. A voice permeates the gallery, whispering "Urge and urge and urge, always the procreant

**Figure 24.** Bill Viola, *Heaven and Earth*, 1992

urge of the world." On one screen, a child is born. The voice continues: "All goes onward and outward . . . and nothing collapses. And to die is different from what anyone supposed, and luckier. Has anyone supposed it lucky to be born? I hasten to inform him or her it is just as lucky to die, and I know it. I pass death with the dying, and birth with the new-washed babe." On the other screen, the face of an aged woman. She dies. In a powerful synthesis, only made possible because of the interaction of the two screens, the face of the one is reflected in the face of the other. Birth-death, death-birth. This is an *axis mundi*, a meeting point of heaven and earth, or (as in traditional mythological formulations) of the heavens, the earth, and the underworld. In-between, the Metaxy. Plato described the Metaxy as the space between human beings and the divine, concretized in history and time. Viola's work visualizes this space. His voice continues: "Do you see O my brothers and sisters? It is not chaos or death . . . it is form and union and plan." A vision of the integration of all things in time and space is given concrete form.

*Heaven and Earth* extends the visionary elements in Viola's earlier videos, *Anthem* (1983) and *Angel's Gate* (1989).

Regardless of the creative potential of newer technologies – and the work of artists such as MANUAL and Bill Viola clearly exhibit some of this potential – these technologies also present problems and conceptual fallacies to which artists and others may fall prey. Here I want to mention only four: the idea that somehow technology promises a total revolution; that there is a clearly knowable social continuity based on technological development; that technology offers a "fix" for various social problems and/or artistic dead ends; and that interactivity is a panacea for our consumer-oriented art world.

First, it is wrong to assume that new technologies totally revolutionize a particular field by replacing earlier forms. This is clear in the visual arts: Although some artists do explore the latest video and computer technology, others still grind their own rocks to make pigment. It is less likely that the use of new technologies will take over traditional forms of artistic practice and much more likely that they will enable, even force, us to reexamine what art is, because they offer new spaces for representation. In the process, changes in public awareness are also likely.[59] The emergence of electronic media in the postmodern era does not preclude the possibility that artists may use any or all of the older established practices and traditions. With the advent of new technologies, an artist can become not only the creator of works of art but also the publisher and distributor. Artists' books, mail and fax art, and copier art are but three of many new possibilities.

Second, it is wrong to assume that new technologies will have an impact only on that which is already known to us. New uses and new forms, and hence new questions, always evolve from the evolution of new technology. The developers of computers as "supercalculators" to solve scientific equations had no idea that computers would have applications in the visual arts or other areas of economic, political, and social life. We must be open to the creative potential of new technologies. Certainly there are many challenges for an artist, as well as for the critic or the historian, who contends with the unique powers, potentials, and problems of these technologies. Throughout the modern era, new forms of visual consumption continued to supplant one another; this process continues under postmodern, multinational capitalism, which is based on electronic and nuclear-powered technologies.

Third, it is wrong to assume that the latest technological breakthrough will be a panacea for all or even for some of the world's ills. Technology cannot fix what is already wrong, and it tends to create its

own problems. The most obvious and dangerous example is garbage, especially radioactive waste.[60] Artists such as James Acord have offered innovative responses to the complex question of what to do with the mountains of exceedingly toxic material we generate. MANUAL brings attention to the disparity between what we think we are doing in virtual reality and what we actually do in "real" space and time. There can be no technological fix.

Fourth, it is wrong to assume that interactivity is a panacea for passive consumption of either high art or mass culture. What is interactivity? Does it offer either the artist or the viewer/spectator true opportunities to participate in creative processes, or is it merely a new, highly touted, form of consumerism?[61] Television, though it is becoming mildly interactive, is also perhaps the most effective mode of managing viewers' attention that has yet been devised. The screen is in control less because of its visual content – although this is certainly significant – and more because of medium itself. If television has not yet become a mode of surveillance, it has already become a technique of subjectification and subjection for many viewers. Humans are separated from one another and from the world (from the "ancient" world of "real" trees, from actual phenomenological reality). We "interact" but do not actively engage. Sedentary antinomadic bodies are easier to control than peripatetic ones; as we sit in front of television and computer monitors, we risk losing our autonomy to corporate mandates and governmental dicta. Our ability to think, to make informed choices, and even to determine our actions depends upon more than limited "interactivity." In this sense, the artist as exile, as itinerant actor, is potentially less subject to control than the new docile body who lives his or her life in front of and through a screen.

Against contemporary iconoclasts who refuse to acknowledge the thoroughly visual nature of our environment, I hold that we must not only acknowledge the positive and negative effects of the ubiquitous screen (television, video, and computer) but also learn how to use the screen effectively. Of course, the incursion of the visual and visualizing technologies is not limited to the arts. In medicine especially, CT (x-ray imaging), PET (positive emission tomography), MRI scanners (magnetic resonance imaging), and ultrasound are literally reshaping the human body we thought we knew. Postmodernity is preeminently visual. We live within and through units of disembodied information: bits and bytes, codes of all kinds, pixels, and other snippets of visual and verbal messages. As Barbara Stafford noted, "Flesh and blood, or tactility, recede in the presence of [such] mediated encounters."[62]

There are many possible directions for exploring newer technologies. With computers, artists may continue to work with hybrid forms of montage – mixing sound, image, and text within interactive screen formats. Artists may also explore in a more speculative direction involving such processes as electronic sculpture and virtual technologies.[63] Or, we might, with Andrew Ross, identify some of these new directions not in terms of the technologies themselves, but in terms of what they portend for the role of the artist.

Ross names three possible responses to technology for artists and others: radical humanist, radical technologist, and radical ecologist.[64] The radical humanist, rooted in the human potential and New Age movements, employs, or at least advocates the employment of, evolving technologies to build a new species, and lobbies for biotechnology, bioengineering, and other advanced developments. The radical technologist uses technology "before it is used on you," as the cyberpunk dictum puts it. Essentially marked by its attitude of resistance, this response might combine acts of sabotage in the workplace with establishing alternative media institutions that promote democratic ideals. The radical ecologist is both utopian (like the radical humanist) and pragmatic (like the radical technologist). The greatest challenge for this response, as well as the greatest potential for change, lies in modifying consciousness through developing ecological awareness. Each of these responses carries its own potential and problems, but the radical ecological perspective presents those that are among the most interesting. Grounded in the Gaia Hypothesis, it allows one to contemplate the idea (and the reality) that species, including humans, are being and will be eliminated as climatic and other changes continue. The implications of this point of view are worthy of careful consideration, and this is one of the functions of the visionary imagination, as we shall see.

The idea of the end of art has been articulated since Hegel's 1827 essay. Whenever new conditions and new technologies challenge the old, some philosophers, theorists, and even artists have responded with predictions of the end of art. Actually, what is happening is that the ontological status of art is changing. What is art? What and who is an artist? What is the role of the artist in the new situation? The postmodern fusion of genres and the evolution of the artist as a parodic ex-centric bricoleur respond to a need for a new comprehensive vision or the renewal of an earlier one. Artists such as those I have described in Part II – Jenny Holzer, Bruce Nauman, Carrie Mae Weems, Joan Snyder, Richard Long, James Acord, Miriam Schapiro, Guillermo Gómez-

Peña, Coco Fusco, MANUAL, and Bill Viola – are engaged in this process of redefinition. These artists, and others I will discuss in Part III, offer new approaches for articulating both prophetic criticism and the visionary imagination.

# The Reclamation of the Future

# CHAPTER 9

# Prophetic Criticism

"Save Life on Earth" began as an effort of a small group of artists to organize an exhibition around the theme of "affirm[ing] life on a planet threatened by nuclear death."[1] Eventually 178 artists in twenty-two countries participated in an exhibition that opened in Budapest in June 1985, then toured cities in Europe, Asia, and North America. All of the drawings and paintings were produced on the same format – a white circle in a green field (Figure 25). The importance of this project lies not in the masterful execution of any one artist's contribution, but in its scope and inclusiveness. A book documenting the exhibition also contains essays by six writers from the United States, the former Soviet Union, China, the former East Germany, and Argentina, which are translated in the five languages of these nations. As Christa Wolf, a German feminist writes:

> Is it not comforting that an exhibition, that a book such as this should come to be, a mutual effort by so many artists from so many lands? Yes, it is. It is encouraging. It is a spark of joy. It strengthens. It can be a sign of hope to people on the brink of despair. Whether it can soften the rigid attitudes of others who cannot relinquish the notion of enemies, I do not know. I doubt it. Would they go to this exhibition? Would they pick up such a book as this?[2]

I doubt it, yet I maintain hope that such work can affect viewers. For here are artists from widely divergent backgrounds and contexts speaking with one another about possibly the greatest threat we face today. Many viewers have seen the exhibition and the book produced from "Save Life on Earth." Perhaps the prophetic and critical impulse expressed in it will continue to live, spawning new ventures.

\*    \*    \*    \*    \*

With Part III and with this chapter, I turn to the polemical core of *The Vocation of the Artist*. Implicit in the historical discussions of Part II is

the conviction that none of the roles previously attributed to the artist are appropriate in the historical situation we now confront. This is not meant, however, to imply that we should move on either to some more glorified vision of the artist's cultural function or to a cynical and nihilistic denial that the artist has any function in contemporary society at all. With the ideas of prophetic criticism and visionary imagination, I intend to reclaim older ideas that were prevalent in various strains of nineteenth-century Romanticism and the twentieth-century avant-garde, but to qualify the terms in specific ways. If prophecy is not simply a form of telling the future, then what is it? If imagination is not a lost art or a neglected human faculty, then what is it? These questions, and others, shape the chapters of this part of my book.

To approach the study of prophecy is daunting. The vast scholarly literature is filled with diverse perspectives: the history of single traditions, such as Judaism; cross-cultural perspectives on the phenomenon; and literary appropriations of prophetic thinking, to name three. Perhaps even more daunting is the enormous and always growing storehouse of popular prophetic literature. I agree with scholars who study prophecy that "there is no possibility of summarizing it adequately in the context of a study like this one."[3]

After offering preliminary definitions of prophecy and considering some of its historical manifestations, the rest of this chapter is structured around the process of prophetic criticism. As far back as the earliest biblical texts, prophecy has been linked to criticism. Prophecy is a social practice, that is, it is inextricably part of its social context. Four overlapping moments or aspects may be identified in the practice of prophecy.[4] First, a message is received or discerned by the prophet. Whereas reception implies an outer source for the prophetic insight, discernment emphasizes the role of the prophet's inner awareness, insight, and intuition. Second, the prophet then links this message to present concerns or core cultural values, thus making connections between what was, what is, and what might be. This is integrally related to the third moment, in which the prophet identifies and tracks hypocrisy in both the public and private spheres. Prophets seldom engage in neutral assessments about the past, present, and future; more often they criticize the disparities between word and deed in public and in private life. Fourth, a sense of hope that fuels engaged and committed action can grow out of presentation of the message. For prophecy to be effective, each aspect must be present. I end discussion of this process with consideration of the work of contemporary artists.

Before I elaborate on this process, however, I need to distinguish

**Figure 25.** Various artists, *Save Life on Earth*, 1985

between calling the artist a prophet and calling the artist a prophetic critic. The reasons for this distinction will become clear as I proceed, but I want to emphasize that I am not making a claim for the artist as prophet, especially in the sense that this title was used among avant-garde artists and modernist art historians. To call the artist a prophetic critic is both more modest and more specific. One of my goals here is to show how the artist, working as a prophetic critic, might also understand his or her process using this fourfold model.

## DEFINING PROPHECY

Prophecy, while often associated with the Hebrew Bible and the later Christian tradition, is actually an ancient practice with diverse roots and forms: *baru* (diviner) guilds of Babylonian priests; Cassandra and the Sibyls in ancient Greece, as well as the prophetic aspects of the mystery religions; *kahins* (seers) and dervishes in the Arab world; ecstatics and shamans in traditional Native American or Siberian cultures;

and religious leaders such as Muḥammad or Zarathustra (Zoroaster). But what, exactly, is prophecy, and who qualifies as a prophet?

The word "prophecy" comes from the Greek *prophētēs,* and in the classical period it referred to a person who usually worked as a cultic functionary by relaying messages from the god or gods. It means literally "one who speaks forth," "one who speaks before," "one who proclaims," or "one who speaks of the future." The word came into English and other European languages through the Latin *propheta.* Hellenistic Jews and writers of the Septuagint (the Greek version of the Bible, begun in Alexandria during the third century B.C.E.) rendered the Greek *prophētēs* with the Hebrew *nābhî or navi'.* In Hebrew the word means a call "to act like one beside himself," not necessarily predicting the future, or "one who is in the state of announcing a message that has been given to him [or her]." The Akkadian verb *nabû,* which means "to call," "to announce," or "to name," and the Arabic verb *nabba'a,* "to inform," both may be linked to the noun *navi',* "the prophet." Although this much can be said, ambiguity remains about the deeper etymological roots and the usages of both *prophētēs* and *navi'.*[5] The prophet as *navi'* is most familiar in the arts as a late-nineteenth-century appellation for a group of French painters, the Nabis, which included Paul Gauguin, Pierre Bonnard, and Maurice Denis, among others.

In various societies, the prophet has also been associated with the priest, the shaman, the healer, the diviner or foreteller, the possessor of psychic or magical powers, and the mystic. Each of these figures had slightly different, though often overlapping, cultural functions. Another way of identifying these distinct roles would be to separate prophets into categories depending upon their cultural function. Thus, we might speak of divinatory prophets, who purport to foretell the future; cult- or priest-prophets, who serve particular small groups; institutional prophets, who work within larger social or political institutions; missionary prophets, who help to found new traditions; and restorative/purificatory versus reformative/revolutionary prophets, who alternatively help either to stabilize or to transform cultural traditions and institutions. From the third century of the common era, and reflecting the growing insecurity of the times, private mediums, "prophets without a temple," were increasingly used by those in power.[6]

In general, access to the gods came from these persons. Diviners often used both observational and manipulative means to interpret symbols and signs in the natural world as a way of predicting the future. Observational means included interpreting bird and animal movement and

cataloging both auspicious and inauspicious events. Manipulative means included casting lots, interpreting dreams, and examining the entrails of animals. Oracles and oral prophecies were often given during ecstatic states involving music, dancing, drums, other body movement, and self-laceration.[7] People not associated with established religious sites or sanctuaries used the latter, ecstatic oracular behavior, whereas cultic officials were more common within established hierarchies and employed less threatening forms of prophetic behavior.

This dichotomy is visible among the prophets in Israel, as we shall see. There were prophetic figures, like priests, who operated within and helped to maintain tradition, alongside those who were more innovative and tried to promote reform. Following Robert R. Wilson's categories developed for understanding prophets in ancient Israel, we could say that there are central and peripheral (or marginal) prophets.

Some prophets helped to establish traditions, such as the Hebrew prophets, Zarathustra, Jesus, Mani, and Muḥammad, whereas others had little or no influence on the founding of later religious traditions. For example, Zarathustra (Zoroaster) founded Zoroastrianism during the seventh–sixth century B.C.E. He may have been a mythical figure or an ecstatic priest-singer who used techniques such as mantras and intoxication to put himself into trances. Although little can be said about the historical Zarathustra, the evidence of numerous sources, including poetry, folktales, and Zoroastrian texts such as the *Fravasi Yast* and the *Denkart* would support an interpretation of his life as a prophet.[8] Zoroastrian ideas contributed greatly to Greek philosophy, Judaism, and Christianity. In relation to prophecy, it may have been responsible for the ideas in early Christianity of the advent of a savior born of a virgin and of predictions of supernatural signs of his coming, which were derived from the Zoroastrian doctrine of *Saoshyant,* the Savior of the Future.

Although it is difficult to see what such founders of religious traditions had in common, at least five features are discernible in these cases.[9] First, all understood their prophetic activity as the result of a divine call. This sense of a call or vocation served as the main legitimation of a prophet's claim to be able to speak for or with God. God, however God was understood, literally called to these prophets through dreams, visions or auditory phenomena, or through the mediation of another prophet. Second, traditions arose around so-called founding prophets, as communities accepted the unique qualities of their revelations. In fact, many prophets participated in guilds. Third, they and

their communities regarded their messages as universal truth. Fourth, they functioned as social critics. Fifth, they worked simultaneously to maintain and to reform their religious traditions.

Given this diversity of interpretation about who or what a prophet is, it is not surprising that there are many approaches to the study of prophecy. One might study prophecy as an exclusivist confessional practice within a particular tradition or as a process whereby prophets support the power structure within a particular group or social order. Prophecy can also be studied as an expression of the needs, perceptions, and experiences of the disenfranchised within a given tradition. Or, linked to this and within a larger framework of social evolution, prophecy can be studied as it helps to mark periods of transition. My approach here focuses primarily on these last two approaches. I am less interested in how prophecy serves the exclusive aims of a particular group or the structures of power within that group and more concerned with the ways it can aid in cultural transformation. As a practice related to transformation, prophecy has often been linked to the apocalyptic. Before turning to the practice of prophecy, it is therefore useful to differentiate between these two forms.

Considerable effort has been expended by scholars of late antiquity (approximately 250 B.C.E. to 250 C.E.) to evaluate and define the category "apocalypse" or "apocalyptic," especially to distinguish it from prophecy.[10] "Apocalypse" is a transliteration of the Greek *apokalypsis*, "to uncover or disclose"; it is simply the Greek word for "revelation." But apocalypse has been used loosely and vaguely in literature (apocalypse as a literary genre), in sociology (apocalypse as a sociological ideology), and in theology and comparative religion (apocalyptic eschatology as a particular religious perspective). Although a few Jewish, Christian, and Gnostic manuscripts were titled *Apokalypsis*, many of these do not relate to modern usages of the term. For instance, the "Apocalypse of Moses" deals with the lives of Adam and Eve.

Prophecy is often interpreted as the way humans give voice to the apocalyptic. But some scholars see these two forms as distinct from each other. Prophecy calls on us to repent, to change our way of life in order to change the present and future. Apocalypse points to a future that is already determined; hope for change in this life, therefore, must be deferred.[11]

From his study of numerous texts of late antiquity that had been written in the area of the eastern Mediterranean, John Collins developed a comprehensive definition of "apocalypse" meant to clarify the vagueness of various usages of the term.[12] The important elements of Collins's

definition are its narrative framework, otherworldly mediator, human recipient, and future salvation in a personal afterlife. The latter is the element most consistently found in apocalypses of this period. In fact, a primary distinguishing characteristic of Jewish apocalyptic eschatology is the idea of the transcendence of death. This idea is not unlike the traditional Greek doctrine of the immortality of the soul, and it shows the Hellenistic influence on Jewish thought.[13] In Judaism, prophecy and apocalyptic thought can be separated, although they are closely related.

Beyond these elements in the concept of apocalypse, the phrase, "the apocalyptic" actually contains a threefold distinction.[14] Apocalyptic is a literary and artistic genre; apocalyptic eschatology is a religious perspective; and apocalypticism can also be a social and religious movement. *As a genre,* apocalyptic was a new phenomenon of the third–second centuries B.C.E., although its origins can be located both in archaic roots and in the prophetic traditions of the sixth and fifth centuries B.C.E. The eighth–sixth century B.C.E. Hebrew prophets (such as Amos, Joel, Isaiah, Jeremiah, and Ezekiel) dealt with their present, criticizing and urging people to repent. They saw the struggle of good and evil in individual terms. Strictly apocalyptic writers interpreted events in cosmic terms, seeing history as revealing God's divine plan through symbol and allegory. *As a historical religious perspective,* apocalyptic eschatology consisted in abandoning the prophetic task of translating the vision of God's acts into human and historical terms. This new perspective emerged in the context of an intracommunity struggle in the period of the Second Temple (between 520 and 420) between the disenfranchised and alienated, on the one hand, and those in power, on the other.[15] Finally, *as a social and religious movement,* apocalypticism has its roots in, but is not synonymous with, apocalyptic eschatology. Apocalyptic writings always evolved in particular cultural contexts, as people struggled to come to terms with social customs, political movements, and economic structures.[16] Although this is no longer a novel insight (scholars in nearly all disciplines in the late twentieth century are attuned to the need for such grounding), I mention it here to stress that such ahistorical appropriation or manipulation of apocalyptic ideas is not my intention.

Three main biblical sources are usually identified as apocalyptic: the Books of Ezekiel and Daniel and the Revelation of John. Jewish apocalypses, such as those described in Ezekiel and Daniel, were usually pseudepigraphic, written by or attributed to a sage or mythic figure of the past: figures such as Ezra, Enoch, Baruch, Abraham, or Daniel. (This

was also true of early Christian sources.) Their social context was usually a time of crisis. Ezekiel was written about 586 B.C.E.; chapters 37–39 contain the apocalyptic material. Daniel, written about 167–164 B.C.E., describes the Maccabean rebellion against Seleucid/Syrian control and is celebrated in Hanukkah. Both of these biblical books date from periods when Jews faced national extinction.[17]

The Book of Revelation, the third major biblical apocalyptic text, was written when its author, John, was a prisoner on Patmos. The text dates from around 81–96 C.E., when Christians in Asia Minor faced persecution by Romans if they failed to participate in the cult of emperor worship. Contemporary biblical historians tend to interpret the Book of Revelation as a response to the eschatological expectations of the embattled early church, but some scholars assert that all cultures of the ancient Mediterranean world had analogous myths of war on a cosmic scale. Therefore, the visions of Revelation should be read more generally as poetic expressions of human experience and human longing.[18] The text, also known as "The Apocalypse," is graphically visualized in Benjamin West's 1796 and 1817 paintings titled *Death on the Pale Horse*.[19] Although the two paintings differ in detail, the image of Death riding a pale horse figures prominently in each.

In the century following the Enlightenment, philosophers and theologians scorned apocalypticism. But in the aftermath of the two world wars, more and more people have found confirmation for and solace in apocalyptic ideas. "There is in the *Zeitgeist* today a widespread 'sense of an ending'. . . . an apocalyptic literature, though to modern taste mythical and crude, portrays the conflict between life and death forces which once again seems to give accurate portrayal of life as it really is."[20]

Apocalypticism takes at least three different forms in contemporary American thought: religious apocalypticism, linked to popular prophetic movements; scientific apocalypticism, linked to scenarios of global ecological destruction and the end of life as we know it (as in Jonathan Schell's *Fate of the Earth* or Freeman Dyson's *Freedom and Hope*); and postmodernist aesthetics, which combines fascination with the sublime or unrepresentable and prophecies about the grim fate of the west.[21] The reading and writing of apocalyptic pronouncements have gone in and out of fashion for centuries, even millennia.

In fact, the apocalyptic has been a common and almost predictable genre in human thought and culture, recurring at the ends of recent centuries.[22] Understood as a mode of thought that allows its audience to live in times of disorientation and disorder by revealing to them a fundamental cosmic plan, apocalyptic seems as "natural" as any form

of discourse. Apocalyptic often plays on the perception of the audience or reader that they have no control over a world "turned strange."[23] This is an effective strategy because apocalyptic also reassures its audience that there is indeed an order and a design in history. This is precisely why theologians and philosophers such as Martin Buber argued that apocalyptic writing appears in times of decadence.

The most fundamental question raised by apocalyptic writing concerns the relationship of the prophet to history. A prophet speaks in the present, in an "actually happening history," because choices matter, and decisions must be made in that context.[24] Prophecy assumes the human being as agent. Although the time may be one of struggle, time itself has duration and continuity. For an apocalyptic thinker, the direction of historical destiny has already been determined; and therefore, human action can have no further decisive effect. Apocalyptic therefore assumes the human being as spectator. Time is coming to an end; signs and mysterious allegories must be interpreted in this decadent historical situation.

Although I admitted in the Preface that a certain apocalypticism informs my thinking, I wish to be clear at this point that prophecy and prophetic criticism are distinct from the apocalyptic. Prophecy is a critical practice designed to bring attention to the nature of the present and to show the consequences of present actions as they extend into the future. The prophetic critic speaks as an agent who believes in the ongoing possibilities of change. In contrast to the "givenness" of apocalyptic pronouncements, prophecy may be described as a form of *forthtelling*, rather than *foretelling*, the future. ("Forthtellers" are those who speak critically of the present, whereas "foretellers" are those who purport to know the future and to speak of what will be.) Such a claim may seem controversial; the best way to establish its veracity is to examine further the process of prophecy in specific historical contexts.

## PROPHECY IN HISTORICAL PERSPECTIVE

Knowledge about prophecy and prophets in antiquity is scanty, because of the oral traditions of cultures in areas such as pre-Muslim Arabia and presettlement Israel.[25] In general, scholars assume that in these cultures prophets functioned to petition the gods or to interpret various signs for the group. This was the case in ancient Egypt, from which we have mantic or divinatory texts such as the *Potter's Oracle* that include prophetic sayings. The *Potter's Oracle* dates from the period of King

Amenhotep, during the second millennium B.C.E. It was probably composed in Greek, the language in which it has been preserved. Containing a prophecy of Greek domination, a tale of cosmic and social chaos, and an account of a war with a Syrian king, the *Potter's Oracle* describes how Alexandria will be destroyed. Finally, however, a king sent by the goddess Isis will arrive from the sun, to restore Egypt to its former glory.

Later, in cultures of Mesopotamia and areas of the Mediterranean where there were written records, similar mantic and divinatory functions were important, but we have more information about them. For instance, there are texts from Mari in northern Mesopotamia that show similarities to Hebrew prophecy but that date back to the eighteenth century B.C.E. The *baru* (diviner) guilds in Babylonia, founded by Enmeduranki, interpreted dreams and other mysterious signs and symbols. The Akkadians also practiced a kind of predictive prophecy. Akkadian prophecy often consisted of prose composition, which contained post-facto "predictions" of past events. It might then conclude with either a "prediction" concerning phenomena in the writer's own time or with a genuine effort to forecast the future.

In the Greek and Roman worlds there were prophets who foretold the future and interpreted divine messages, as well as mantics, visionary seers, and astrologers. The cultures of Babylonia influenced the development of these roles. The oracle at Delphi is certainly the best known of Greek oracular sites. As messages from a god that were usually interpreted by a human recipient in response to a petitioner's question, oracles such as the one at Delphi were widely consulted. But whereas the Hebrew biblical prophets spoke out during periods of crisis and upheaval, the consultation of oracles was, in the Greco-Roman world, a "regular means for reducing the risks inherent in various forms of human enterprise."[26]

Prophecy may have also played a role in ancient Greek mystery cults. Mystery religions in Greece tended to focus on the worship of female divinities; they incorporated rites that could be undergone only by those initiated. Many involved vows of secrecy, confession, baptism, sacrifice, ascetic preparation, pilgrimage, self-mortification, cleansing, reception of a new name, reading of scriptures or texts, mastery of foreign expressions or secret formula, dancing, silence, veiling, donning new garments, offering of incense, masks, and fermented alcoholic drinks. These rituals took place in various sanctuaries, no two of which were alike. Less well-known than the Dionsysian cult at Eleusis was the mystery religion at Samothrace in the northern Aegean. According to Arrian, a second-century writer, while in an ecstatic state the Korybantes, who

were male attendants of the major goddess of the sanctuary, would prophesy future events.[27] Although the role of prophecy in the Samothracian mystery cult remains unclear, the evolution of the cult's moral framework and concern with death and dying may have been a direct result of prophetic practices.[28]

Prophecy, however, was not associated only with oracular sites or mystery cults. Individual prophetic figures, both legendary and historical, are frequently mentioned in Greek literature.[29] The Sibyl was a wandering female prophetess who offered spontaneous prophecies and oracles. She was first mentioned by the sixth-century B.C.E. philosopher Heraclitus as the woman who utters "words mirthless" with "frenzied lips."[30] The Sibyl's messages were thought to be divinely inspired, spontaneous, and grave, because they were often prophecies of doom. But their fulfillment was not necessarily placed in the near future. Later a Sibilline tradition developed. As they became popular, her oracles were associated with Delphi, and the term "Sibyl" was given to diviners who gathered and interpreted the oracles.

Among the individual Greek prophets, Cassandra presents an interesting case. Apollo had granted her mantic gifts. When she refused to have sexual intercourse with him, he asked her if he could have a kiss; during their kiss he spat in her mouth, which meant that her prophecies would not be believed. Like those of a number of other female prophets, including the Cumaean Sibyl of Virgil's *Aeneid* and Pasiphae (mother of the Minotaur in the Cretan myth), Cassandra's story might be read as one of sexual victimization.[31] In other texts where she plays a part, as well as knowing the past Cassandra sees what will happen in the future.

In pre-Muslim Arabia there were several types of prophetic figures. Among these, the *'arraf* and *kahin,* or seer, were very important. The *kahin* was able to perform miracles when possessed by a *jinni,* or spirit. Often a *kahin* was a sheikh or leader, and sometimes the position was inherited. During his early life, Muḥammad was considered a *kahin.* Through contemplation and prayer, Muḥammad received auditory visions, given by the angel Gabriel, which were recorded by his wife Khadijah and have been preserved as the Qur'ān.

In Islam proper, there are generally thought to be two kinds of prophets: the *nabi,* who hears or sees a vision of God, and the *rasūl,* the special messenger who, like Moses, Jesus, or Muḥammad, founds a tradition. Muḥammad thought of himself as a *rasūl,* the final prophet in a long tradition that included Adam, Noah, Abraham, Isaac, Jacob, Moses, David, and Jesus. For Muslims, because Muḥammad brought

"true" monotheism to the world, there was no further need of other prophets. Especially in Islam, the book became even more important than the living prophet or priest as the transmitter of tradition, and therefore exegesis or interpretation of the texts became a more important activity than prophetic utterances. These savants or religious leaders kept alive the *Sunnah,* or the life of the prophet, and the *Ḥadīth,* or the traditions about Muhammad's speech and actions.[32]

An interesting twist on fundamental Islamic values was given by Avicenna (Ibn Sina), who during his life at the end of the tenth and beginning of the eleventh centuries C.E. considered prophecy as still important to Islam. Instead of being possessed by and expressing God's spirit, the prophet, for Avicenna, was gifted with an intelligence, insight, and prophetic ability that helped make of such a person a leader in society. As we shall see later, Avicenna's vision of the angel Gabriel was also notable.

This is not the place for a full description of the role of prophecy in all of the world's traditions, as I have already said, but some further elaboration is necessary. One needs to distinguish between traditions such as Judaism, Christianity, and Islam, where the founding prophets saw themselves as called or elected by God to lead their communities, and others such as Buddhism, Jainism, Confucianism, and Taoism, where leaders and teachers evolved through a process of practical discipline and perfection.[33] Confucianism in particular emphasized the importance of rationality over inspiration and divination. In Hinduism, passages in texts such as the Puranas are prophetic, but these were often written after the events had occurred. Buddhist texts such as the Kausambi prophecy detail the death of the Dharma, the end of Buddhism on earth. This prophetic text, which appears in many versions in Asia, shares more with Hebrew prophetic literature than with apocalyptic writing in Judaism, Christianity, or Zoroastrianism, primarily because its focus is self-criticism of Buddhist communities and exhortation to act in certain ways.[34]

If in many traditions prophecy had an ambivalent or minor history, in the religion of ancient Israel it flowered.[35] Historians and theologians such as Abraham Heschel have asserted that the Hebrew prophets were unique; and Heschel cautions against identifying these figures with any of the other types of prophets in traditions such as those I have just described. He provides an extended rebuttal of the tendency to link different historical groups and ritual practices to the specificity of the Hebrew prophets.

> Prophecy in Israel was not an episode in the life of an individual, but an illumination in the history of a people. . . . Prophetic incidents, revelatory moments, are believed to have happened to many people in many lands. But a line of prophets, stretching over many centuries, from Abraham to Moses, from Samuel to Nathan, from Elijah to Amos, from Hosea to Isaiah, from Jeremiah to Malachi, is a phenomenon for which there is no analogy.[36]

Heschel insists that these figures are not to be understood on models such as ecstatic possession, poetic inspiration, or psychosis. Prophetic revelation and inspiration did not arise from the prophets' own imaginations or unconscious, or from the zeitgeist. Nor can their prophetic utterances be interpreted solely as a technique of persuasion or as a literary device. Prophets were not professional agitators or patriots; rather, they were called by God in an experience that can only be called an event.[37] Although I understand the ideological basis for Heschel's insistence on the special character of Hebrew prophecy, I am also explicitly interested in the broader relevance of prophets' roles as social critics outside the unique chronotope of ancient Israel.

Although prophecy also existed in Israel before the monarchical period – that is, before 1020 – in figures such as Miriam, Deborah, Abraham, and Moses, most of the country's prophets were active following the establishment of monarchy in Israel, between about 1020 and 587–586 B.C.E. At this time the neo-Assyrian empire ruled the region. In the northern kingdom of Israel, Amos and Hosea appeared, while Micah and Isaiah were active in the Judean south. During the second half of the seventh century, as neo-Assyrian rule gave way to the Babylonian empire, Nahum, Habakkah, and Zephaniah were active. Slightly later, Jeremiah worked until the collapse of Jerusalem in 587–586. Obadiah appeared shortly after this in Jerusalem. Ezekiel was active around this same time with Jews during the Babylonian exile. Deutero-Isaiah appeared in the mid-sixth century. Zechariah and Haggai prophesied at the time of the escape from exile and the reconstruction of the Temple in Jerusalem. Malachi documented the postexilic crises in the fifth-century period when the region came under Persian rule.[38]

By about the eighth century B.C.E., prophets began to write down their oracles, though scholars are not sure why this took place. But this move, from oral to written traditions, constitutes a major change in the history of religions. The transmitters of prophecy also shifted from ecstatics and visionaries to the priests and scribes who passed along tradition to succeeding generations. The last of the Hebrew biblical

prophetic books that are considered canonical was written down by about 350 B.C.E. Possibly the end of the religious and political institutions that supported the prophets, following the destruction of the Temple in 587–586, was critical in this changed role of prophecy.

Among Hebrew prophets the word *prophētēs* was not the only word for describing their activity. As already mentioned, another title was *nābhî* or *navi'*, from an Akkadian verb "nabû" (to call, announce, or name). The *navi'* preserved traditions, especially in the north of Israel; and this was probably the most common prophetic title there. Elsewhere, prophets were known as *ḥozeh,* or "visionaries," individuals who received revelatory visions. Less widely used prophetic titles were *ro'eh,* or the "one who sees" through visions, dreams, and divinations; *ish ha-Elohim,* the "man of God" who could control divine power and perform miracles; and *benei ha-nevi'im,* or the "sons of the prophets," members of the prophetic guilds whose hierarchical structure centered around a male figure.

Scholars have developed various schema for interpreting the nature and function of prophecy in ancient Israel, identifying at least six kinds of prophets: cultic officials, shrewd political advisors, isolated mystics or seers, ecstatics, guardians of Israel's religious traditions, and the creators of ethical monotheism.[39] Regardless of the type of prophet, legitimacy was conferred through a group's acceptance of that person's messages. In contrast to Heschel, Johannes Lindblom and Robert Wilson suggest that the early Hebrew prophets were not unique in their activity. From as early as the eighteenth century B.C.E., there is evidence (for instance, from the Mesopotamian city of Mari on the Euphrates) that oracular practices were part of the culture. It is especially important to understand prophetic activity within a social context, for prophets were integral members of the societies in which they lived; and they had to conform to standards of behavior that their society already recognized as prophetic. They needed to fit within a recognized theological tradition and to remain rooted in it. For one to be fully accredited as a prophet, one's words also needed to come true.

Prophetic behavior centered around certain patterns of action and speech. Ecstatic behavior included hallucinations and visions, reduced sensitivity to outside stimuli, skewed perception of the surroundings, and loss of control of speech and other actions. More rarely, prophets worked miracles. They may have worn distinctive clothing or had a special mark of their guild. Prophetic speech sometimes followed a pattern that began with the call to or commissioning of the prophet, followed by an accusation and announcement of judgment.[40] This

language was drawn from various aspects of life, such as the courts and temple. In general, prophetic conflicts were a common element of social life, and accusations of false prophecy were used for social control.

The question of true versus false prophecy is difficult to resolve. In the simplest terms, a "true" prophet is one whose prophecies come to pass; analogously, a false prophet is one whose prophecies do not happen. But the evaluation of truth or falsity also may have rested with the authorities that held power or with those who supported a particular prophet or prophetic school.

Martin Buber has offered another criterion for distinguishing false prophecy that is pertinent here.[41] False prophets worship success: They want it for themselves, and by promising success to the people (and, in some cases, genuinely wanting success for the people), they are able to achieve it. The false prophet thus is nurtured by dreams and acts as if those dreams constituted reality. The true prophet, who speaks from sources other than the desire for worldly success, cannot make glib promises about what will happen. In this sense, true prophets are "politicians of reality," for they articulate their viewpoint with a self-conscious understanding of historical realities. By contrast, false prophets are akin to politicians who foster illusions; they "use the power of their wishful thinking to tear a scrap out of historical reality and sew it into their quilt of motley illusions."[42]

As noted earlier, all prophets both delivered messages from God and communicated petitions and messages back to God. But beyond this basic similarity, there were significant differences between the so-called central prophets, who worked at the court or in the central religious sanctuary, and the more marginal or peripheral prophets, who worked outside of or at the fringes of the centers of power. Whereas central prophets were primarily concerned with helping to maintain the existing social order, marginal prophets usually advocated reform and were, therefore, agents of rapid social change.[43] Later rabbinical Judaism (influenced by rabbis and other scholars and commentators on the Bible), understood prophecy mainly as a phenomenon of the past.

Philo of Alexandria, a Hellenistic Jew who lived at about the same time as Jesus (as well as the medieval Jewish philosopher Moses Maimonides), understood prophecy not as something that could be acquired, but as an emanation of God toward the human intellect. Philo linked the biblical prophets with the Greek mystery religions. By identifying prophecy and ecstasy, Philo developed a comprehensive approach to prophecy that has influenced writers ever since.[44]

Christians have regarded prophecy in the New Testament largely as

a fulfillment and termination of Hebrew biblical texts, but Christian prophecy took over elements of both the Hebrew and Hellenistic revelatory traditions. Early Christians thus added little to the fundamental understanding of prophecy.[45] As Christianity became institutionalizied and prominent in the structures of authority in the ancient world, prophecy was practiced only within heretical Christian groups. The earlier prophetic function of articulating basic norms and values was assumed by teachers, ministers, theologians, and other church leaders.

Mystical experience in Judaism, Christianity, and Islam can be understood as analogous with the nature of prophecy in earlier traditions, insofar as both mystics and prophets claimed immediate and nonmediated experience of the divine. But their cultural roles were very different and changed over time. For instance, the revelations of Christian mystics and of Sufi mystics within Islam were accepted only so long as they conformed to the authority of the church and texts such as the Bible and the Qur'ān. Later Jewish mystics, such as Abraham Abulafia, relied upon the Torah and Talmud as well as tradition.[46]

In the modern European west, prophecy has remained an important form for articulating religious longings. Between 1490 and 1530, for instance, prophecy in verse was one of the most popular literary genres. More than fifty works, printed quickly on poor quality paper, still exist from that time; they were anonymous and bore no publisher's imprint; and they were intended for readers from modest social and cultural levels.[47] This plethora of texts may be linked to upheavals during those years – in 1494 Charles VIII of France swept into Italy; in 1527–30 Rome was sacked and Florence fell. But further changes in the political and ecclesiastical situation led to the demise of prophecy after about 1530. A subterranean vein of prophecy continued among the popular and artisan classes in Venice into the 1570s, but changing laws during the Catholic counterreformation and persecution ended prophetic charisma, especially as it was expressed by women in the female hagiographic tradition.

During the eighteenth century, Enlightenment values helped to destroy confidence in the idea of divine revelation, replacing it with observation and critical reasoning. Nevertheless, in succeeding years artists and philosophers such as William Blake and Friedrich Nietzsche did consider themselves to be prophets, although they redefined concepts such as inspiration, revelation, and truth according to more contemporary standards. Probably of more importance in the ongoing reassessment of notions of prophecy, however, was the diminishing authority of the church in Europe after the reformations. As I tried to

show earlier, the secularization of European culture was the result of complex ideological processes that also involved increasing urbanization, industrialization, and technological development. Among the values this secularization called into question was the notion that prophecy was important, possible, or useful.

Even so, belief in prophecy has had an enduring appeal that is nowhere more apparent than in modern American culture, as Paul Boyer has documented.[48] Belief in prophecy is one way of ordering one's life and experience; it not only gives an overarching shape to history, but it also provides meaning for individual life. It is more widespread in America than most people think; and individuals believing in dispensational premillenialism have already played a significant role in shaping political decisions and public attitudes. Dispensational premillenialism is a cornerstone of fundamentalist Christian theology: It is dispensational because God is revealed in history in stages, in dispensations, each of which ends with a violent disruption – the expulsion from Eden, the flood, and so forth. It is premillenial because Jesus is to return before the millennium or thousand-year reign, and the faithful will be carried away, saved from the violence of the end.[49]

Throughout seventeen hundred years of western Christian history, prophecy belief has endured with remarkable adaptability. It has served radical ends (in challenging the established order) and has become politicized, thereby acting as a force in public secular life. Many modern prophecy scenarios are actually updated versions of ancient prophecies, which articulate the grievances of the dispossessed or advance the goals of the powerful. In either case, prophecy gives a means and a language for expressing deep longings.[50]

Belief in prophecy has been tenacious in American history because of several characteristics of prophetic teachings.[51] First, believers claim that their faith can be scientifically and empirically validated. Second, prophecy tends to offer a middle way between age-old dilemmas such as the relationship of free will and determinism and the relationship of the present to the future. Third, prophecy presents a theology of and for the people that is skeptical toward authority (except God!). Fourth, prophecy offers an interpretation of meaning in history, especially that history is predetermined, unified, and moving toward a majestic end. Here prophecy belief joins forces with apocalyptic thinking; the full impact of such thinking has yet to be felt in the political arena of contemporary American culture.

The United States has also been the site of (at least) two other forms of prophecy, although they are not directly related to the prophecy be-

lief that Boyer studied. Both may be linked to early American coloni-
alism and imperialism. One evolved in the tradition of African
American spirituality, the other in Native American traditions. Al-
though these two traditions have many significant differences, they both
arose because of oppressive and repressive practices of European-
Americans, especially in the attempt to control indigenous peoples and
to impose a particular way of life on Africans brought here against their
will.

In Native American traditions, for instance, modern prophets
emerged among many groups as a result of complex factors, including
decimation of population due to military defeat, massacres, and disease;
forced relocation on reservations; and Christian missionary activity. By
all accounts the nineteenth century was an apocalyptic time for native
peoples. "Broken treaties, land encroachment, depletion of game, and
assimilationist programs of the Bureau of Indian Affairs had demoral-
ized the tribes to such an extent that they awaited deliverance from
their depression and sorrow."[52] Native American prophets shared sev-
eral characteristics, though not universally.[53] The individual may have
been a dissolute figure, an alcoholic, and/or a shaman (they are not
mutually exclusive) before hearing the prophetic call, which usually oc-
curred during an experience of death. The message may have been na-
tivistic, based on a return of the dead; sometimes, as in the prophet
Wovoka's case, the call had military consequences.

Wovoka, also known as Jack Wilson, was perhaps the most famous
of the prophets who emerged within the Native American context.
Originally a prophet of weather and a healer, Wovoka founded the
Ghost Dance among the Paiute of Nevada. His prophetic message,
which spoke of cataclysmic events and a great revitalization of the In-
dian tribes, spread rapidly among western tribes. By the 1890s it had
reached the Dakotas, where it was implicated in the massacre at
Wounded Knee. But he was not the only active prophetic figure. John
Slocum founded the Indian Shaker church among the Squaxin tribe in
the Pacific Northwest. Handsome Lake belonged to a Seneca tribe in
the Iroquois nation. Tecumseh and his brother Tenskwatawa worked
among the Shawnee to resist further encroachment by the United States
onto tribal lands.[54]

What, finally, do these historical examples demonstrate? That the
impulse to prophesy takes diverse forms across time and cultures, but
that the human propensity to speak of the present in relation to the
past and the possible future is universal.

## THE PROCESS OF PROPHETIC CRITICISM

A major undercurrent of this chapter, although not explicitly articulated, is the link between prophetic traditions and cultural criticism. Against ideas about prophecy as a form of foretelling the future, I have tried to show that prophetic criticism is a form of critical reflection about the past and the present, and about what the present portends for the future. Now I carry this idea a step further, by considering the ways in which prophetic criticism is another form of cultural criticism and by looking at examples of contemporary art that function in this way. Such art does not fit within narrow definitions of the "political," but has broader aims. First, however, what do the terms "culture" and "criticism" really mean?[55]

"Culture" is one of the most complex words in the English language. Rather than reduce the complexity of actual usage or select the "correct" definition, I prefer to identify culture as the name for the matrix of relations among human beings, a particular way of life, and the practices of the many verbal and visual arts. *Culture* is distinct from both *society,* understood as the body of institutions and relationships within which a given group of people live, and *the state,* understood as an organization that draws on social and cultural networks, but for the purpose of wielding power. Generally, society and the state are organized in terms of causal and functional relations: who can do what for whom in order to accomplish an end. Culture is organized in terms of the production of meaning – the signifying and symbolic systems that are used to present and maintain a way of life. Both art and religion are, in this sense, cultural systems.

My intention here, however, is not to evoke a neutral definition of culture. The word "critical," and its noun form "critic," have their forerunners in the Latin *criticus* and the Greek *kritikos*. These share the Greek root *krités,* meaning "a judge." The predominant idea that these words conveyed up until the early modern era was that of judging and faultfinding. During the Enlightenment this sense of evaluative judgment developed into the idea of authoritative, objective, and disinterested judgment found in Kant's philosophical writing, which has influenced our understanding of cultural criticism up to the present. From this period, instead of engaging in analysis of how and why artistic practices develop within certain contexts, cultural criticism became increasingly formalistic.[56] Concerned with maintaining the autonomy of art, critics focused on such issues as the pleasure that is derived from particular

formal qualities in a work of art or, in our century, on the formal qualities themselves.

Still, criticism is ideological. Far from being objective, disinterested, or autonomous within culture, criticism is a practice rooted in active and complicated relationships within specific networks of power. Opposition and resistance, rather than detachment, give criticism its shape and potential influence, even though detachment and disinterest are often still touted as desirable. Criticism, in my view, functions best between the extremes of philosophical detachment and "treasonous engagement."[57]

In that interstice, cultural criticism is a particular form of discourse, directed to members of a specific social group. It describes the fundamental or epistemic principles that govern the group's thinking, which include ideals of what constitutes the good life. Beyond this, cultural criticism also demonstrates the gaps that exist between those principles and other beliefs and practices. As such, it is part of larger processes of cultural elaboration and affirmation by which the longings and hopes of that group and its individual members are made manifest.[58]

In particular, the integration of themes from differing critical perspectives should be central in art that deals with living in a nuclear and environmentally threatened world. In a prescient statement published in 1985, Lucy Lippard wrote:

> It has been suggested that survival is the only modern topic, and artists seeking immortality in the nuclear age must confront the notion that there may be no posterity. In this context, art can be seen either as an escape or as a strike for peace. It is the artist's job to conceive the inconceivable, and to move us – to move us closer to realization, to empower us to imagine, even to imagine the most dreadful things. But artists are as scared as everybody else to get too close to the fires of extinction. Contemporary art is a clear reflection of how the American people fail to cope with reality.[59]

Survival is the only modern topic. There may be no posterity, no future. In this context, art can be an escape or it can empower us to imagine. Everyone is scared. Not just contemporary art but much of contemporary culture reflects a deep failure to examine and criticize the realities in which we find ourselves. These are sobering reflections that underline the importance of prophetic criticism.

Art that takes its mission of prophetic criticism seriously not only needs to empower us to image the dreadful in terms of nuclear extinction but also should address issues such as racism, invasions of the

underdeveloped world, multinational complicity in governmental cor-
ruption, the feminization of poverty, the impact of technology on our
lives, and the larger fate of the earth. We bear religious and moral
responsibility for others and for the world. The results of abdicating
that responsibility are apparent in the world at large by even the most
cursory glance at ecological devastation in Alaska, in the republics sur-
rounding the sarcophagus of Chernobyl, and in the Amazon rain forest.
The results of abdicating responsibility for other persons are apparent
in the inner cities, where poverty, homelessness, inadequate health care,
and increasingly violent crime are rife.

The artist as a prophetic critic deals with such themes. But as Lippard
has also acknowledged, a contradiction is implicit in the creation of a
profound art about suffering, destruction, and death. "Art is a creative
act; it's supposed to be committed to life. There are times when refusal
to depict the wholesale death that may be awaiting us is a cowardly
act; there are times when it is an act of courage."[60] How do we know
which is which? Although no absolute answers to this question are pos-
sible, willingness to engage in reflection about the timing and appro-
priateness of varying responses is part of the artist's task.

Let us return now to the four moments or aspects of prophecy iden-
tified at the outset of this chapter. First, prophecy implies that a message
is received, then shaped and responded to, by the prophet. Prophetic
language was commonly linked to other kinds of discourse: ritual rep-
etition of texts, prayers, storytelling, and doctrinal debate. It invoked
tradition and moral laws known by the audience; yet these traditions
and moral laws also underwent revision. In other words, the prophetic
message depends upon previous messages; prophets are generally not
concerned with originality. Discernment means the ability to analyze
critically the present in relation to the past. For this, one needs a nu-
anced sense of history, as well as a strong clear vision of contemporary
society. We do have resources for regeneration; discernment is but the
first component in the prophetic process.

The second aspect of prophecy is connection: a moral consciousness
that evolves out of empathy and the ability to feel connected with the
plight of others. A prophet makes connections between what was, what
is, and what might be. Traditionally, the individual based the claim to
be a prophet both on this personal revelation and on charisma, or what
Max Weber called "charismatic authorization" – the possession of mag-
ical and ecstatic abilities such as divination.[61] A prophet could be "eth-
ical," in the sense that she or he is seen as an instrument for the
expression of divine will. In preaching and public presentation such an

ethical prophet demands obedience to this will. But a prophet could also be "exemplary," insofar as she or he demonstrates a way to salvation or renewal through a life lived in accordance with core cultural values. As a source of moral authority, the exemplary prophet is most suitable to the present. Mary Daly has argued vividly that the ethical prophet is too phallic and hierarchical, whereas the exemplary prophet participates in an immanent, pantheistic divinity and invites others to do the same.[62]

The third aspect is tracking hypocrisy, or self-critically examining the gap between one's principles and the way in which one puts them into practice. If the prophet is not self-critical and humble, then she or he becomes self-righteous. This aspect of the prophetic process is both self-reflexive (the prophet examines her or his own tendencies toward hypocrisy) and critical within the public sphere.

Beyond the personal dimension, prophetic messages often identify the hypocrisy of public pronouncements and public opinion. The prophet cuts through the levels of deception surrounding us, offering symbols that are adequate to describe the horrors we face. This person not only uses metaphor to give public expression to the fears and hopes embedded in the present, but she or he also speaks concretely about the "deathliness that hovers over us and gnaws within us."[63] In the process of offering symbols for interpreting the present, the prophet educates us regarding dominant reality, helping us to recognize how language shapes our consciousness and defines that reality.

Such prophecy is grounded neither in utopian idealism nor in a nihilistic rejection of the world. The prophet may attack behavior and institutions based on deception and hypocrisy; this concern for social reform in the present links the prophet to the teacher of social ethics. She or he may also search for ways of articulating core values and demand that everyday life accord with these values.

The fourth component of prophetic thought is hope that leads to action. Because I will have more to say about hope later, suffice it to say here that even in the face of the devastating events in our century, we must nurture hope for the future. To give up hope means the end of human possibility. Because history is incomplete, the world unfinished, and the future open-ended, hope can be invigorating; it can help energize people for action in the world. Hope exists in a dialectical relationship with resistance. Prophetic criticism depends upon the ability to resist what is and to nurture other visions of what could be. As noted earlier, this is one of the distinguishing characteristics of the prophetic over the apocalyptic, which tends to encourage passivity. Indeed,

we could say that the future depends upon our capacity to nurture traditions of criticism and resistance; and that capacity is itself based in hope.

Prophets are persons who actively seize their power and engage in action. For instance, women, who have long been denied full subjectivity and the authority that accompanies recognition of selfhood, now must awaken communally to exercise that authority and power. A sense of personal calling is therefore important in defining who receives a prophetic message and who attempts to articulate a consciously integrated and meaningful worldview. As I implied earlier, however, the sense of calling is not dependent upon, and cannot be validated by, external authority. While a community, however that is defined, may be essential to one's identity in some ways, the calling to articulate perceptions and to act as a prophetic critic must be grounded in a person's inner conviction.

Perhaps the most perplexing question that arises from considering prophecy concerns the source or standard that directs or guides prophetic criticism. For the Hebrew prophets, God was the Supreme Subject; for the Greeks at Delphi, Apollo himself spoke through the Pythia, the woman who sat within the temple. Each group that sanctioned the practices of prophecy, understood here in the broadest sense, measured it against a commonly accepted standard: God or one of the gods. But what standard guides prophetic criticism today when it is not linked to a particular religious tradition? By what standard might an artist claim to speak in the public sphere as a prophetic critic?

For fundamentalist Christians, an inerrant God and God's inerrant Word, the Bible, stand supreme. But most of us cannot claim such certainty. Others might find that standard against which to measure the veracity of prophecy in an idealized Nature.[64] Unfortunately, "Nature," like "God," is not really accessible to us in a straightforward manner. We cannot do without nature or the natural world, as it provides most of the resources that make human life possible. We buy and sell real estate, ocean shores, and mountains; nations even define boundaries on the high seas. But there is sense in which we cannot ever own or control nature and natural processes, as earthquakes, droughts, hurricanes, and tornadoes constantly remind us. Simultaneously, we construct ideas about nature that reflect historically and ideologically determined values. In this sense, nature is inseparable from culture.

Prophetic criticism must be grounded in more modest human and humane values than "God" or "Nature." Might we say that prophecy and prophetic voice evolve from a nuanced sense of intuitive truth? In

our time, many senses have been depleted; these include not only the five physical senses, but a sense of what it means to be an embodied person; a sense of beauty, qualified and refined by a sense of the ugly; a sense of justice; a sense of the morally good; and, especially, a sense of truth.

What is truth from a postmodernist perspective? Certainly it is not the capital "T" Truth of the Greek philosophers or the Enlightenment philosophes. That Truth, as postmodernists insist, has died. But if "Truth" has died, the many truths have not. Postmodernist theorists are fond of demarcating our time by talking about the end of meta-narratives or modernist totalistic ideologies such as Truth, Reason, Progress, and Freedom. But this does not mean that human beings have ceased to believe in truths worth living and dying for. An abstract ahistorical notion of Truth must be replaced by a pragmatic and fully contextualized conception of truths in life and experience. Here I agree with American pragmatists, such as William James, Josiah Royce, and more recently Cornel West, that how we live and act is more significant than abstract philosophical values. A sense of truth demands stubbornness of ego and the determination to persevere. Perhaps it is, finally, not definable.

The search for objective criteria against which to judge prophecy is essentially a philosophical gesture, and prophecy differs from philosophy in that it does not rely on such objective or absolute criteria. "The prophetic word is its own criterion and refuses to submit to an external tribunal which would judge or evaluate it in an objective or neutral fashion. The prophetic word reveals its own eschatology and finds its index of truthfulness in its own inspiration and not in some transcendental or philosophical criteriology."[65] In other words, prophetic criticism cannot be evaluated objectively, against an externally agreed upon standard, because its truth lies in the vision that inspires it and in the community that receives it.

How, finally, can the practice of prophecy be understood by contemporary artists? Prophetic criticism assumes both a history and a future, thus passage and continuity through time. We typically think of visual art as standing still in time and space, inviting the viewer to fill in and to fill out what is not present in the image. But in fact, this entire process is one of extended answerability, a process that also has duration. The artist is called to present a response to and in the world. This "call" in turn calls to the viewer to become animated, to respond in the world. The 178 artists, whose images were represented in "Save Life on Earth," were all participating in this answerable process.

The metaphors of "spinning," and "sparking" are useful for interpreting activist art that expresses religious and moral values with a critical and prophetic impulse. According to Mary Daly's *Webster's First New Intergalactic Wickedary of the English Language,* spinning is "Dis-covering the lost thread of connectedness within the cosmos and repairing this thread in the process . . . whirling away in all directions from the death march of patriarchy." Sparking means "speaking with tongues of Fire; igniting the divine Spark in women . . . building the Fire that is fueled by Fury – the Fire that warms and lights the place where we can Spin and Weave tapestries of Crone-centered creation."[66] Both spinning and sparking necessitate acknowledgment of deep personal and cultural differences.

The metaphors of spinning and sparking describe the kind of prophetic criticism linked to action, which is embodied in projects such as "Save Life on Earth," *The Peace Ribbon,* the outdoor murals organized by Judy Baca with community groups in Los Angeles, Kim Abeles's smog collectors, the installations and paintings of Nancy Spero and Leon Golub, and Mary Beth Edelson's gallery installations.[67] Each of these projects involves an assessment of the present as a time of danger, a creative procedure that directly opposes the traditional gallery and museum system, and the production of a final work of art that envisions the future in innovative ways. The artists who participate in these projects are actively fulfilling the vocation of the artist as prophetic critic, though they do not necessarily identify themselves as cultural critics or prophets. These works "spin": They seek to discover and express the connections between us and to show the fatal consequences of patriarchal consciousness. They "spark": They express and evoke anger, even rage; they also endeavor to provoke renewed hope and commitment.

These projects also cross the line from being simply socially and politically concerned to being socially and politically involved.[68] Although they may be readily identified as political art, they are not usually defined as explicitly religious or theological. However, from the outset I have defined "religious" as that which is concerned with such issues as the meaning of birth, death, love, injustice, and suffering and with ultimate values and loyalties. Projects such as "Save Life on Earth," along with *The Peace Ribbon* and Baca's multicultural murals, Edelson's wall paintings, Abeles's smog catchers, and the installations and paintings of Spero and Golub are moral and religious precisely because they urge us to confront questions regarding our relative political loyalties and our ultimate concerns. Such strategies and practices of resistance may

quickly disappear from public awareness, but the memory of their importance as exemplary creative projects must not be allowed to die.

*The Peace Ribbon* was a collaborative and collective project. It was initiated by Justine Merritt, who decided that she wanted to commemorate the fortieth anniversary of the bombing of Hiroshima by putting a ribbon around the Pentagon. In 1982 Merritt stirred interest in the idea through letters to friends, churches, and other groups. She then helped to form a fourteen-member board that was responsible for organizing and executing the project. Eventually, participation spread throughout the United States. Each panel was eighteen inches high and thirty-six inches long; by the time it was completed, the ribbon of twenty-five thousand panels stretched for over fifteen miles. On August 4, 1985, the ribbon was looped around the Pentagon, the Lincoln Memorial, and much of the Mall and Capitol in Washington, D.C.[69]

Judy Baca is a Chicana artist who works with various groups to design and paint murals that represent the interests and diversity of cultural communities in Los Angeles. Through the Social and Public Art Resource Center (S.P.A.R.C.)[70] – an organization she helped to found in the late 1970s – Baca worked on *The Great Wall of Los Angeles*. Between 1976 and 1983, four hundred and fifty young participants, representing many of the city's cultural communities and supported by local businesses, community organizations, forty scholars, and over one hundred support staff, painted a massive mural that depicts California's multicultural history from prehistoric times to the present. *The Great Wall of Los Angeles* is painted on flood-control channels in Studio City in the San Fernando Valley, and it is the longest mural in the world. Baca has also undertaken another large-scale project, a *World Wall*, which consists of eight fifty-foot murals with images depicting a future world without war.

My emphasis here on collective projects does not negate the possibility that individuals may create critical and prophetic works of art. Kim Abeles made her first images using smog and particulate matter in 1987, but she did not develop a series of *Smog Collectors* until 1990 (Figure 26). A *Smog Collector* is made by cutting a stencil – Abeles has used images of body organs, industrial sites, and presidential portraits – and exposing it for up to sixty days to particulate matter in the polluted Los Angeles environment. Typically, the artist places the stencils on the roof of her studio, but they have also been placed in other sites as well. For instance, a sculpture series of smog collectors was commissioned by the California Bureau of Automotive Repair in 1991–2; these were set up throughout Los Angeles. When the stencils were re-

**Figure 26.** Kim Abeles, *Smog Collector*, 1991–2

moved, the images created by the smog were then exposed. Of course, much more is also exposed with such works. As Abeles eloquently put it, "The *Smog Collectors* materialize the reality of the air we breathe. . . . Since the worst in our air can't be seen, *Smog Collectors* are both literal and metaphoric depictions of the current conditions of our life source. They are reminders of our industrial decisions: the road we took that seemed so modern."[71]

The prints and paintings of Nancy Spero and Leon Golub are more well-known than Abeles's work. They, too, examine the values that have guided the contemporary world, but they focus on violence against, and the celebration of, women—in Spero's prints, wall paintings, and installations – and on the horrors of war and human rights violations – in Golub's over-life-size canvases.

Mary Beth Edelson's installations in galleries from 1985 to the present depict many different themes: from an encounter with the subcon-

**Figure 27.** Mary Beth Edelson, *Combat Zone*, 1994

scious and her reappropriation of Greek mythology, to a more theoretical exploration of "a critical bifurcation point" in contemporary culture, to a multimedia interactive installation and program such as her 1994 *Combat Zone* (Figure 27), which deals with domestic violence and abuse.[72] As part of her installations and earlier public rituals, Edelson had developed "story-boxes" to gather the responses of other artists, writers, and viewers to new paradigm thinking, ecofeminism, ecology, and the role of spirituality, among other themes. In her storyboxes Edelson posed the following questions: "How does spirituality affect your political involvements? Do you feel it galvanizes you toward social action?" Among the respondents, Susan Griffin replied:

Lately there is a great deal of confusion about this. A sort of equation of "spirituality" and social apathy, or worse "forbearance." Truth telling and the refusal to collaborate with wrong-doing are essential spiritual acts. In order to engage in these one must be able to tell right from wrong, to *judge*. To be silent in the name of "spirituality" can aid and abet terrible and cruel acts. . . . Real spirituality galvanizes

toward political action, and also sustains through difficult times, not as a balance, but as a path, a way of living.[73]

Here Griffin has articulated just that link between the broadly religious, moral, and political that characterizes all of the projects I have described.

Edelson's recent *Combat Zone* gives these moral and political issues even more direct form. Alongside the multimedia installation (originally open to the public between October and December 1994), were a variety of other formats to communicate Edelson's primary objectives. Lectures, workshops, self-defense classes, a poster and photo project, and programming for battered women and children living in shelters were among the activities designed not only to educate the public about domestic violence but also to provide a model for taking responsibility for stopping abuse against women and children. Linked to other efficacious feminist art projects, such as Suzanne Lacy and Leslie Labowitz's *In Mourning and In Rage,* Edelson's work is a fine example of the way an artist engages in prophetic criticism.

Prophetic criticism is engaged rather than neutral. It aims to arouse memory of the past, recognition of and indignation about what is happening in the present, and repentance that will lead to a different future. As sources of moral authority, prophetic critics are thus persons who commit themselves to action, to creating a breakthrough into another cultural order, and this break is seen as morally legitimate. For feminists, this breakthrough will help to disrupt oppressive patriarchal structures; it demands reimagining and renaming the world in which we live. Prophecy must also be energizing if it is to be effective.

Prophetic criticism might therefore be considered as a special form of answerability. The critic answers to the tradition and to a perceived need in the present with the goal of promoting an active, committed, and responsible answer from the audience. This sense of connection, and a commitment to sustained critical (and self-critical) reflection, gives prophetic criticism its power. The critic then speaks with a specific message to a particular group in a given situation. Indeed, prophetic criticism is most powerful not because of its universalistic message, but precisely because of its particularism.

The vocation of the artist can be prophetic when it is structured around these moments and is based on a conviction that the artist has a personal calling to relay an interpretation of the dilemmas we face, thereby giving voice to personal and collective hopes, fears, and experiences. In some cases, the artist may simply be naming the "demons"

around us. When an artist works in this way, her or his vocation is also oriented to this world, to the present as it moves inexorably toward the future. It is concerned with core values such as love and justice. But these are not simply abstract ideals. The artist is also active, urging engagement and commitment in the world to bring about the political, social, and cultural transformation necessary for the full expression and embodiment of love and justice. Responsibility and obligation are both personal and communal.

If artistic creativity – both the process and the produced work – is defined by broadly religious and moral concerns, as I have sought to demonstrate, then it is appropriate to describe the artist's vocation in terms of prophetic criticism. Is there a common thread that weaves through the various names we might give to the artist: prophet, cultural critic, prophetic critic? I think that there is. Like Mary Daly's "lost thread of connectedness" that we seek to find and repair, the metaphor of a common thread provides a clue.

The artist is connected to others and to the earth in relationships of profound risk and answerability. Relationships are contingent and relative; they are fragile, and they always involve risk. The quality of life, even the continuing possibility of life, is uncertain. As a response to this situation, Sharon Welch eloquently describes an "ethic of risk": "an ethic that begins with the recognition that we cannot guarantee decisive changes in the near future or even in our lifetime. The ethic of risk is propelled by the equally vital recognition that to stop resisting, even when success is unimaginable, is to die."[74] A mature ethic of risk involves not only recognition that evil exists and is entrenched in society and culture but also acceptance that an adequate response to evil will require the work of generations. Such work is essential in affirming the delight and wonder of life itself.[75]

Further, recognition of and commitment to answerability does not promise safety and comfort to an artist or to any individual who takes seriously what this means. Making art that is prophetic and critical, that strives to create social change, is an act of faith. It cannot be done as a formal artistic exercise, for ego gratification, or to gain exposure and fame in the art world.[76] The creative process itself expresses connectedness; works of art live because they give shape to the consciousness of the self in relation to an animate or inanimate Other. Through our creativity, we humans are inextricably bound to one another and to our environment. Our inner and outer boundaries shift and change: We harden in separate spheres, we attempt to merge, we recognize our unavoidable outsideness from one another. But just as no

one ever fully escapes from the condition of contingency and risk, so the artist cannot avoid responsibility for her or his actions. Art answers to life and life answers in art, as Bakhtin wrote in 1919: "Art and life are not one, but they must become united in me – in the unity of my answerability."[77]

# Visionary Imagination

A calm sea, a somber and gray sky, the indication of stars: These form the background of *On the Horizon, the Angel of Assurance and in the Somber Sky a Questioning Look* (Figure 28). Occupying the center of the space, a singular eye – static, unblinking, coolly objectifying. Not just questioning, *interrogating*. Hovering above the globe of the eye, an inchoate form seems almost to coalesce into a figure or a face. Is it the viewer's imagination? Then, a rent in the fabric of the sky, behind which hovers the angel of the title. Who is this angel, and what is its role? A hand, tentatively held at shoulder level; a small wing, hardly functional for an imagined angel's duties; a soft face and gentle regard. This "angel of assurance" questions with its lifted hand and tentative look.

It is significant that I begin this chapter with a Symbolist image, a lithograph by Odilon Redon from the series *To Edgar Poe* (1882). As the name for a loose grouping of artists and writers, Symbolism designates an interest in what Dmitri Merezhkovsky called "mystical contents, symbols, and a broadening of artistic sensibility."[1] Beside their interest in reconnecting form and content, Symbolist artists saw art as a form of higher knowledge, as a way of exploring and revealing hidden truths. Redon himself was especially interested in the workings of the imagination and the unconscious.

Here we see that Redon's imaginative meandering has produced an image simultaneously oppressive and hopeful, embodying many of the paradoxes and problems associated with vision and imagination. Vision may be an existential gift, but it can also be disconnected from the other senses and from incarnate experience. The globular eye reminds us of vision's panoptic power to survey and the imagination's synoptic ability to comprehend. The angel reminds us that these are indeed potentially dangerous human faculties. Simultaneously, however, as in some of Redon's other prints, perhaps the eye is meant to be an object of veneration, "the luminous inner vision that nurtures thought," a reference to the artist whose subjective vision creates the art of the future.[2]

A l'horizon , l'Ange des CERTITUDES , et dans le ciel sombre un regard interrogateur.

**Figure 28.** Odilon Redon, *On the Horizon, the Angel of Assurance and in the Somber Sky a Questioning Look*, 1880

\* \* \* \* \*

"Imagination," like "prophecy," is a word with a long and vivid history. Derived from the Greek and Latin words *phantasia, eikasia,* and *imaginatio* – "fantasy," "illusion," and "imagination," respectively – it refers to the image-making capacity in human beings. It can be as varied as dreams, fantasies, illusions during daily life, artistic creativity, mystical visions, or the ability to envision other people's lives or a better world.[3] Its vocabulary is slippery, and therefore imagination might be considered more a myth than a concept. Like a myth, it has a complex history full of diverse interpretations.

Imaginative activity must be placed in relation to and gauged by experience in the world. Analogously, the truths of the world, shaped by individual lives and places, must be proven in imagination.[4] Imagination has a role in individual lives, as daydreams, fantasies, and reveries, but the greater work of imagination proceeds in relation to experience in the world. And, as I have said, it is my experience in the world that prompts me to call for renewed attention to visionary imagination. Imagination is not the special domain of the artist, but a capacity shared by all human beings. An artist is, however, under a strong injunction to develop and use her or his imaginative capability to its fullest creative potential, toward its *visionary* potential.

In seeking to justify this claim, I organized this chapter around three major questions. First, what is imagination? As in my discussion of other concepts, such as vocation or prophecy, I do not wish to assert a transhistorical idea of imagination that applies to all times, cultures, and people. In fact, this chapter is not an attempt to define imagination in a traditional sense, a task that has occupied philosophers since the pre-Socratics. Rather than ask for a definition as clarification and delimitation, I think we ought to ask how the word has been and is used.[5] We need to have before us a sense of some of the dominant views of imagination that have shaped contemporary culture; part of this chapter thus is organized around the three paradigms that I used earlier for discussing roles of the artist: the mimetic, productive, and parodic imagination.

There is a certain slippage between my attention to imagination, on the one hand, and to vision and the visionary, on the other. Ideas about imagination usually presuppose the primacy of vision over the other senses; the visionary would be impossible without both vision and imagination. We also need to differentiate between vision as a perceptual process with the two eyes and vision as an inner process that depends

upon outer sight, but is amplified by imagination. The eyes are receptive organs, but they can also be aggressive, as recent art historical writing about the power of the gaze has shown. Vision and imagination are both individual and social; they are interlocking and interdependent. This means that any attempt to encourage personal vision must simultaneously examine how collective visions are constructed and sustained. Consequently, my discussion moves back and forth between these concepts. In promoting the idea of the visionary imagination, a primary goal is to reconceptualize this in more fully embodied terms.

Second, why should visionary imagination be recuperated and even valorized in the postmodern present? The history of western thought has been profoundly ocularcentric, or vision centered. We esteem vision as the most powerful and synoptic of all the senses. Our language is thoroughly dependent upon visual metaphors; my writing here provides the most immediate example of this. Imagination is usually "seen" as grounded in basic assumptions around vision as well. But from John Berger's germinal work on ways of seeing (how men look and women are to be looked at), to Norman Bryson's distinction between the gaze and the glance, and to Linda Nochlin's and Griselda Pollock's examination of the politics of vision in nineteenth- and twentieth-century art, contemporary art historians and cultural theorists have begun to reexamine the determinative character of vision and visual perception in human experience and, especially, to articulate a sophisticated understanding of the gendered nature of vision.

As a consequence of these and other interrogations of this "noblest of the senses," the privileging of vision has met with increasing skepticism. In fact, modernity can be interpreted as a period of increasing skepticism about and criticism of scopic regimes, a process that continues unabated among many postmodernists. This antiocularcentric discourse is especially prevalent in French postmodernist thought, as Martin Jay has shown, but can be found elsewhere as well.

I am particularly concerned with how the postmodern parodic imagination might be radically reconceived not, as some theorists would suggest, by denying the power of visionary imagination, but by reinterpreting it in terms of self–other relationships.[6] Postmodern deconstructive criticism of imagination shows us the limitations of grounding imagination in the cult of the self but does not yet indicate a way forward. We cannot, in my view, simply deny the subject or the person a role in fashioning and refashioning history, thereby submitting to nihilistic and pessimistic versions of the present as it hurtles toward the future. A parodic imagination, drawing from the historical traditions

that it loves and newly appropriates, can show that way forward. It will be a moral imagination, positing new relationships for self and other.

Our era may actually be another iconoclastic period, different from but related to earlier iconoclasms of the eighth and sixteenth centuries. There have always been defenders of vision and the image, even during the most virulent iconoclastic periods. For example, John of Damascus's treatise *On the Divine Images,* which I described in some detail in Chapter 4, provided a new foundation for understanding the power and necessity of images during the iconoclastic controversies of the eighth century. Analogously, even Martin Luther, who led many Protestant reform activities, understood and supported a modest use of images in the newly reformed churches of sixteenth-century Germany. If traces – indeed, broad currents – of antiocularcentrism and iconoclasm can be found in contemporary culture, then I intend to provide an alternative point of view, a defense of vision, visual images, and the visionary imagination.

In particular, the distinction between outward sight and inner vision brings attention to the profound differences between imagination that plays a game with perception, memory, and fantasy, and visualization that is accomplished through disciplined self-awareness.[7] Where can we gain insight into the transformative power of imagination? Where do we look for help in reinterpreting, even reinventing, the visionary imagination? The yogic traditions are based on profound respect for and cultivation of the power of visualization. Having argued that it is essential to reclaim the visionary imagination, my reflections about visualization are intended to indicate one way in which that reclamation might be initiated.

The third question that shapes this chapter concerns the nature of postmodern vision and imagination. How might a contemporary artist use the unique powers of the visionary imagination? I will examine the work of three artists – Porfirio DiDonna, Laurie Anderson, and Lynn Randolph – who have, in diverse ways, wrestled with their visions.

## MODELS OF THE IMAGINATION

When I was four years old I had imaginary friends. They accompanied me to the corner when I was punished; they answered my communicative needs when there were too many other siblings in the household. My earliest dream, with the image of a jar of spilled pickles on the

floor, confirmed that the universe was greater than the world of immediate sensory experience. Later in my youth, I was captivated by watching clouds, because in their ephemeral shifting I could see faces, figures, animals, *things*. I wrote my first essay on clouds at age eight. These are but three moments in my early formative relationship to imagination, but what is imagination really?

The concept of imagination is critical, yet so ubiquitous that it seems almost empty.[8] The human mind naturally and freely fantasizes; in the sense that an artist attentively awaits the activity of imagination, it is like prayer. As I suggested earlier, there is a dialectical, even dialogical, relationship between imagination and experience in the world. Imagination is a moral discipline requiring courage, for the activity of the imagination prepares us for action. Imagination thus is essential for the processes of being in the world.

As an initial way of imagining and imaging imagination, we might consider it as a continuum.[9] At one end is our unconscious activity as we experience the world; at the other is the inventive power of the person whose primary work involves the discipline of imagination. Uncontrolled fantasy is countered by the imagination of the artist, poet, philosopher, or scientist.

The idea of creative imagination as the inspiration for artists, poets, and others evolved through and after the Enlightenment, but the view of imagination that most European-based westerners rely on today is grounded in the traditions of the Greek, Hebrew, and Christian cultures of antiquity. All ideas about imagination presuppose a conception of consciousness and of the structure of the mind. Over time, the dominant metaphors that have been used to describe the mind have changed. Greek philosophers such as Plato and Aristotle assumed the metaphor of the mimetic mirror. Modern philosophers such as Kant and Coleridge worked with the conception of the mind as a productive lamp. Postmodernists are developing new metaphors for consciousness and the mind as a parodic labyrinth of mirrors or as the multiplication of a thousand eyes. Each of these metaphors carries its own values; this section of the chapter is organized around them.[10]

The *mimetic paradigm* of the premodern, biblical-classical-medieval imagination privileged the metaphor of the mirror. This paradigm is mimetic because philosophers believed the mind to be a mirror that reflects or imitates reality and the external world. Although this interpretation is now largely discarded, we can learn from it that imagination always responds to the demands both of the world and of other persons existing outside the self. The Platonic and Aristotelian views of imagi-

nation were typical of this perspective. It must also be acknowledged, however, that the authority and problems of sight and imagination were recognized long before Plato, in the writings of Heraclitus and Parmenides (475 B.C.E.). For these philosophers, everyday perception was full of dangerous deceptions; but imagination, vision, and visionary experiences were also esteemed and found expression in early mythological and religious rites, such as those at Eleusis and Samothrace.

Plato's ideas about imagination can be seen as a reaction against mythological narratives, where life was conceived as a series of relationships and struggles between various deities and human beings. Plato attempted to articulate another basis for understanding human existence, including the mind and imagination. For him, imagination is a "presentation or appearance; some kind of picture in the mind. Our conscious picture of what we look at in the world is a *phantasia*."[11]

In texts such as the *Republic* (Books VI, VII, and X), Plato articulated a view of imagination as an inferior capacity of the mind, a product of the lowest level of consciousness.[12] If reason, *nous,* allows us to contemplate truth, then imagination, *eikasia* or *phantasia* (illusion or fantasy), can only present false imitations that appeal to the lower, less rational aspect of our nature. Reason is separated from imagination by the "Divided Line" (*Republic* VI, 510). For Plato, the visions of poets and diviners, as well as the artistic imagination more generally, were part of the mantic or irrational world of belief and illusion; as such they were inferior to philosophy and mathematics, which were higher forms of knowledge. Using the idea of the bed or couch (*Republic* X, 597), Plato claimed that there are three sorts of beds: the one essential "Form of Bed" created by God; the real bed made by a carpenter who is trying to make ultimate reality unique; and the artist's representation of a bed, which stands at a third remove from reality. With this example and his extended criticism of poets such as Homer, Plato made plain his opposition to imagination, claiming that it suffers from a series of interrelated "crimes":[13] its own ignorance; its pretension to know more than it does; its inability really to teach us about reality; its irrationality; its power to corrupt the viewer through false imitations; and its tendency to worship the products of its own activity, a particular form of idolatry.

Plato, like Kant after him, saw a second level of imagination as a "creative stirring spirit, attempting to express and embody what is perfectly good, but extremely remote."[14] Only if imagination and the images produced by it fulfilled three main conditions could it be deemed legitimate. Imagination must acknowledge, first, that it is always an

imitation, never original; second, that it remains subordinate to reason; and third, that it serves the Good and True. For Plato, the human imagination was mimetic and derivative, never able to claim access to divine truth.[15]

If Plato was mainly concerned to protect the polis from the problems of idolatry, Aristotle's contribution to developing ideas about imagination must be seen on a more psychological level. In texts such as *On the Soul* and *On Memory and Recollection*, Aristotle shifted attention to the psychological workings of imagination, interpreting it primarily as the capacity to translate sense perception into concepts and rational experience. According to his view, the mind is structured with reason and conceptual thought as the most highly esteemed capacities; sense perception and imagination are lower on the scale. But imagination has an essential function, as a kind of bridge between the outer and inner worlds. Imagination for Aristotle, as for Plato, functions as a picturing activity of the mind, but the two philosophers differed in their assessments of this process. Aristotle brought attention to the internal process that characterizes imagination rather than its external effects; he saw it as a precondition of reason, rather than being extraneous to *nous;* and he described it as mediating sensory experience, rather than leading only toward dangerous illusions.[16]

In Aristotle, *phantasia*, or imagination, is linked to, though different from, dreams. In imagination we may conjure terrifying images but are able to remain detached from them in ways that are impossible with dreams and nightmares. Imagination can be summoned; dreams are not subject to control. But the process of imagination is also similar to dreams for Aristotle: Something looks like something else because of a faint resemblance, and this causes a form of seeing that sometimes gives rise to veridical dreams. Further, imagination "hovers" (if one may use a spatial metaphor here) between perception and thinking, because it is impossible to think without imagining. For instance, an artist who thinks of the idea "triangle" usually imagines a specific triangle, even though this image may be meant as a representation of all triangles. Thinking about such abstract ideas cannot proceed without the aid of imagination.[17]

For Aristotle imagination is not solely the mediator between sensation and reason. Imagination has a second function as well: to rearrange the bits of sense perception to form new ideas – the centaur and the unicorn are two often-quoted examples of what Aristotle had in mind. Further, because it is an integral part of the finite human experience of such abstractions as desire and time, imagination is essential in the

moral orientation of behavior and in allowing us to anticipate the future. Because of our imaginative images and thoughts, we are able to calculate and to deliberate about the relationship of things future to things present.[18]

Neoplatonists such as Plotinus understood imagination in yet another way. Contact with the *nous* or *logos,* the transcendental intellectual principle, is through knowledge, which is achieved through either Plato's dialectic or Aristotle's logic. However, this need not be a conscious process; imagination can also be a mirror of the mind. It is therefore the source of both literary inspiration and creative problem solving, as when we sleep and awaken to find major insights about problems we are working on.

Among medieval thinkers, Moses Maimonides (1135–1204) provides a useful point of reference in the present context, for he explicitly linked imagination to prophecy.[19] In *Guide to the Perplexed,* Maimonides described prophecy as a natural phenomenon in human beings who are of morally acceptable behavior and of intellectual ability and whose rational and imaginative abilities are affected by grace from God. Therefore, such people can communicate truths to the religious community.[20] A prophet is one who combines these attributes with a strong imagination.

Imagination is important in Maimonides' description of prophecy because it combines sense perception and action. In medieval philosophy, imagination was not as closely tied to rationality and abstract thinking as it would be during and after the Enlightenment. As implied in Aristotle, imagination was also closely tied to what will happen in the future and to how the person will experience and react to those events.

More specifically, in the *Guide,* Maimonides gave several differing interpretations of imagination but developed an especially positive view of prophecy imagination. For the person with a prophetic imagination, the senses are fairly dormant, and "it is then that a certain overflow overflows to this faculty according to its disposition, and it is the cause of veridical dreams. This same overflow is the cause of the prophecy."[21] When the senses are dormant, the "overflow" of mental activity reaches both the imagination and the rational faculty. Alone, the latter leads to speculation. But when imagination and abstract thinking function together, they are able to prophesy. The rational faculty works out what will happen, and the imagination puts this information into the form of sensory data. Reason develops arguments, but imagination presents these arguments in figurative form. Maimonides borrowed, from Aris-

totle and from the Islamic philosopher Avicenna, the idea that the things of the world can be known through syllogistic reasoning that mirrors the world's basic structure. Syllogistic reasoning is based on the logical premises that if $A = B$ and $B = C$, then $A = C$. The physical and social worlds themselves, according to Maimonides, can be best understood deductively, because "all things bear witness to one another and indicate one another."[22] The prophet thus is able to connect the present to the future through imagination and thought.

In this process, the soul – common sense – receives impressions from the five senses and passes them to the imagination, imaged as an angel. The imagination converts these representations into symbols and ideas that are then relied upon as messages directing some kind of action. "They then grasp the future course of events, perhaps in the form of a dream which takes place when they are not concerned with more pressing matters."[23] For Maimonides, this process is similar to what happens in prophecy.

Thus, the premodern perspective depended upon the metaphor of the mind as a mirror of the world, with imagination the faculty that enables one to hold up the mirror, to present the world to the beholder. Early western philosophical systems also conceptualized thought itself, and imagination as a thought process, in terms of vision. Vision gives us nobility; our eyes are organs of pride that give us the ability to survey, to comprehend, to fix and stabilize what we see and to gather everything in the visual field into a (more or less) coherent whole. Vision thus became the paradigm for knowledge.[24]

In the arts and in culture more generally, the discovery of perspective and the rationalization of sight in the Italian Renaissance by Filippo Brunelleschi and Leonbattista Alberti gave a distinctly modern interpretation to older ideas about vision and imagination. Alberti thought representation a physical act of embracing the three-dimensional world, but the act, of course, created an illusion. Through perspective, line, contour, and color, the momentary nature of experience and vision could be stabilized. The transitory thus could be made more real in art than it could ever be in life.[25] From the time of Alberti, this stability was also established through the relationship of creator and viewer: The viewer was expected to take up the position of the painter of a scene. Both would then look through the same viewfinder, to see a spatially unified world organized along strict geometric axes and to see an informationally unified world organized around a core narrative structure.[26]

This "Cartesian perspectivalism" combined Renaissance notions of

perspective, developed in the visual arts, with Cartesian ideas of subjectivity and rationality, developed in philosophy. Several characteristics of Cartesian perspectivalism can be identified.[27]

A preference for conceived light as divine *lumen* rather than perceived *lux* expressed the sense that God's will and being were intricately connected with the mathematical regularity of optical phenomena. Space was regarded as uniform, identical in all directions, and rectilinear. It could be best rendered on a two-dimensional surface by using geometric forms such as cones and pyramids. The canvas was both a flat mirror (Alberti's metaphor) and a transparent window, which reflected this geometrically defined ospace. The eye, as in Redon's lithograph, was singular: static and unblinking, rather than dynamic and constantly moving.[28] The coldness and so-called objectivity of the perspectival gaze, well illustrated in Dürer's famous prints depicting how to draw using a grid, encouraged the withdrawal of emotional involvement in the image. The gendered nature of this gaze is vividly expressed in one of Dürer's prints where the object of the male artist's gaze is a reclining female, whose pose brings to mind the tradition of the odalisque.

Cartesian perspectivalism gained its power from the idea that images would encourage participation in their emotional, spiritual, or intellectual content. But as this latter sense decreased in influence, so did the belief in the efficacy of the Cartesian worldview. The fear aroused by what Augustine had called "ocular [or visual] desire"[29] led, with a few notable exceptions, to further objectification of the image. This became especially apparent in the objectification of women, which has been studied and criticized in the last few decades by feminist art historians. This separation of desire from the image also meant that, particularly in the modern era, artistic form became increasingly abstracted from meaningful content. Following the ideology of art-for-art's-sake, artistic images ceased to be related to any external purpose and thus shared in the scientific rationalization of the world, whereby all the spheres of culture and life – science, morality, and art – were separated from one another. Cartesian perspectivalism also encouraged the commodification of art, insofar as what was depicted, for instance, in a painting, could become yet another portable commodity circulating in a capitalist economy.[30] Bourgeois economic and social values were thus upheld and strengthened.

Cartesian perspectivalism has been criticized from many philosophical, historical, and art historical points of view. For instance, criticism of such ideas as that the world is a mirror of the mind; that an ahis-

torical, disinterested, disembodied subject exists outside of this world; that the multiplicity of the world can be adequately represented by the rules of perspective; or that monocular vision with an implied spatially and temporally static viewer provides adequate information, has been vociferous. And critics have thoroughly explored the gender, race, and class biases of this perspective as well. Finally, Cartesian perspectivalism has been shown to be actually less monolithic than previously supposed, and there have been numerous attempts, subtle and overt, to subvert its hegemony.[31]

In the Enlightenment, the mimetic metaphor of the mind as a mirror was replaced by the idea that the mind is a lamp illuminating what it perceives with its own inner light. The *productive paradigm* of the modern, Enlightenment-based imagination thus privileged the metaphor of the lamp. This paradigm is productive, or we might say *constructive*, because it recognizes how human perception and thought actually create visions of and possibilities for the world. From this metaphor we learn that we are always answerable: Although we may try, we can never really abdicate personal responsibility for inventing, making decisions about, and acting in the world. Kant's and Coleridge's interpretations of imagination exemplified this view.

Like Plato and Aristotle, Kant saw imagination as the mediator between sense perception and concepts, but he also insisted that it is one of the fundamental faculties of the human soul. "Sensibility," he wrote, "gives us forms (of intuition), but understanding [the power of thought, the faculty of concepts and judgment] gives us rules."[32] Without the syntheses of imagination, we would be unable to create a bridge between these other mental faculties. "Imagination is a spontaneous intuitive capacity to put together what is presented to us so as to form a coherent spatio-temporal experience which is intellectually ordered and sensuously based."[33] In other words, imagination fuses sense perception and thinking. But there was an essential difference between the earlier premodern conceptions of the Greek philosophers and Kant's distinctly modern view. Whereas the premodern philosophers saw imagination as dependent upon preexisting faculties of sense perception and reason, modern philosophers such as Kant posited the imagination as an autonomous faculty, both prior to and independent of sensation and reason.[34]

In both his *Critique of Pure Reason* and *Critique of Judgment,* Kant separated aesthetic imagination from ethics and morality, as well as from cognition (and an empirical imagination that is not independently creative). He saw the imagination as a free, playful, speculative faculty

of the mind, "purposiveness without a purpose." Against this view, I would assert that imagination can never be morally neutral. Even when we perceive, we are evaluating; the nature of our judgments changes both perception and action.

Samuel Taylor Coleridge knew this and differentiated primary from secondary imagination. Primary imagination is the power and agent of perception. As the act of perceiving, it selects and unifies what is sensed or seen. It is *educare:* "a leading of the mind into the world."[35] As Coleridge himself put it, "The primary imagination I hold to be the living power and prime Agent of all human Perception, and as a repetition in the finite mind of the eternal act of creation in the infinite I AM."[36] Secondary imagination is an echo of this primary process. Co-existing with and informed by the conscious will, secondary imagination dissolves and diffuses perception to create new unities. This action also modifies primary perception and imagination by providing symbols for the primary imaginative process. Whereas primary imagination involves involuntary or automatic perception, secondary imagination is self-conscious and controlled by the will. Both are integral to poetic and artistic creativity; for Coleridge, imaginative art mediates between nature and human beings.[37]

Imagination also helps to awaken and form the moral sensibility. In particular, secondary imagination, because of the way it exercises choice and judgment, cannot avoid genuine moral choices. Coleridge recognized that one could simply deny that humans have any moral aspect – nihilistic postmodernists would certainly make this move – but he countered that our moral values are based, ultimately, on conscience, faith, will, and belief. Although it cannot dictate or even establish the moral life, art can give it form.[38]

Coleridge's notion of creative imagination was not original; he knew German and British philosophy thoroughly, and he was conversant with eighteenth-century interpretations of imagination. He derived many ideas from his predecessors and was in dialogue with his contemporaries. But his brilliance, if it can be called that, was in his being able to link differing interpretations in his own creative synthesis, a synthesis that does not constitute a system, but provides fruitful images for contemplation and understanding. Analogously, my goal in this chapter is not to create a systematic reinterpretation of the concept of imagination, but to suggest some possibilities for reaccenting the visionary imagination.

Building on Coleridge's distinctions, we might thus posit two active faculties, one more mechanical, the other creative. But we must be care-

ful not to simplify the distinction and apply value judgments of good and bad to forms of imagination. Whatever the categories given, in the western traditions that evolved out of Greek and Hebraic thought, imagination has been understood in two main ways: as a representational faculty that presents images of reality and as a creative faculty that invents original images.[39]

By the mid-nineteenth century, such ideas about imagination and vision were under increasing philosophical attack.[40] Nietzsche, for instance, formulated an extremely influential critique of the privileging of vision in the nineteenth century. In place of the "herd mentality" and readiness "to shut our eyes to the truth," Nietzsche promoted a multiplicity of perspectives that subverted the authority of one vision, one Truth, and one God. Building on Nietzsche's ideas later, Heidegger identified the "malice of rage" and nihilism of modernity with its ocularcentrism, its *das Gestell,* its enframing in representations. That he never actively fought against this, especially in its Nazi forms in Germany, has caused many contemporary philosophers to question the perspicacity of his philosophy. More recently, Michel Foucault carried both of these critiques still further, by emphasizing how the power to see and to make visible is integral to the power to control. In the institutions on the "carceral continuum" (families, medical clinics, asylums, schools, and prisons), bodies are disciplined through the technologies of vision to become passive and docile. At least from the eighteenth-century Enlightenment, the hegemony of vision made possible "a reflective, critical rationality and the visions of a utopian imagination."[41] But in our own time, we see the underbelly of this great beast: the phallocentric, logocentric, violent, and increasingly nihilistic consequences of esteeming certain kinds of vision and imagination.

If, earlier, we lived in the imaginary worlds of the mirror and the lamp, which carried their own models of a divided and alienated self, we now increasingly live in the world of the screen, of networks of interactivity, of interactions that never demand "real" engagement. The emergence of this new paradigm in the mid-twentieth century marks a radical departure from modern and modernist trajectories of thought. The *parodic paradigm* of the post-1950s postmodern imagination privileges the metaphor of a labyrinth of mirrors or looking glasses, or the multiplication of a thousand eyes. I prefer the metaphor of the multiplication of eyes to the labyrinth of mirrors, for such a labyrinth affords visions only of itself, whereas the multiplication of eyes implies a plurality of possible visions.

The postmodern paradigm is parodic because many (though not all)

of its strategies of representation are based on parody and pastiche, as I discussed earlier. Parody is not just the repetition or ridicule of images and ideas from the past. At its most productive, parody can mean a critical awareness and love of history, where new meaning is given to old forms. This parodic imagination teaches that we are living in a global network of images that simultaneously brings us into contact with others and threatens "to obliterate the very 'realities' its images ostensibly 'depict.' "[42] Pushed to its limits, parody becomes pastiche, the random cannibalization of styles of the past. Although not "bad" in itself, pastiche often (as in the art of Jeff Koons and the like) merges with the worst elements of the capitalist consumerist ethos.

We need to acknowledge "the plurality of scopic regimes now available to us," as Martin Jay has written, rather than erect another hierarchy that esteems only one kind of visual paradigm.[43] The same may be said about imagination. To paraphrase Jay, we must acknowledge the plurality of models of the imagination now available to us. We need to wean ourselves of the fictions surrounding earlier models of imagination as the product of exemplary genius or as a free, playful, speculative faculty of the mind, "purposiveness without a purpose" as Kant described it, and revel instead in the many possibilities opened up by the concepts already invented, as well as those that are yet to come.

One such carefully worked out articulation of the role of imagination in helping to shape our most fundamental picture of the cosmos and of our place in it can be found in Gordon Kaufman's constructive theology.[44] Here we find a distinctly postmodern interpretation of the imagination and its powers, developed out of Christian and Neo-Kantian roots, which attempts to take into account the radically new epistemological and ecological situations we now confront. In this sense, Kaufman's work exemplifies a postmodern parodic imagination. Kaufman's central premise is that we must recognize how all philosophical systems, including theologies and aesthetic systems, are *imaginatively constructed.*

For Kaufman, *imagination* serves two very specific functions. First, it is the only human faculty capable of creating and of holding in consciousness notions of ultimacy, of God, and even of ultimate ending. God is conceived in his work as the ultimate point of reference by and through which everything is understood. As a kind of limit concept, God is "that than which nothing greater can be conceived," as Anselm asserted. Many traditional characterizations – Creator of all things, Lord of history and nature, Alpha and Omega, Schleiermacher's "whence" of our sense of absolute dependence, Hegel's Absolute Spirit,

and Tillich's Ground of Being – point to the fact that it is impossible to conceptualize anything more significant and more ultimate than God. Through neither feeling alone nor thought alone can one elaborate an adequate conception of God. Imagination is necessary. The "God" Kaufman espouses is not personal, but is expressed through the serendipitous, open-ended processes of creativity, through love, through human and humane values, and ultimately, in mystery. The second function of imagination is to provide pictures of the world and of human life using significant cultural symbols (for instance, God, Allah, Brahman, or emptiness) within a particular historical stream. The "Jewish," "Christian," "Muslim," "Hindu," and "Buddhist" are among the many frameworks created by human imagination for the orientation of life.

So far I have emphasized the nature and function of imagination in Kaufman's thought. But Kaufman also focuses on the *constructed* nature of our most closely held beliefs and values. Concepts of the divine in all religious traditions have been built from images drawn from ordinary experience and history. For instance, historically, Christian images and beliefs evolved from their origins in the theistic perspective of the Hebrews and in Greek myths and culture. But Kaufman asserts that the integral place of constructive elements in theology has not been fully understood before.

Many Christian theologies are based on untenable presuppositions, such as: (*a*) the idea that we know definitively who or what God is; (*b*) the idea that God is self-revealing and trustworthy; (*c*) the idea that God revealed Godself decisively in the Bible and in Jesus Christ; and (*d*) the idea that a proper method of interpreting God's revelation is available to us. All of these assumptions must now be framed as questions. Who or what is God? How do we know God? What was revealed in the life and death of Jesus? What method will enable us to interpret scripture and tradition adequately?[45] Given that we can no longer accept the ultimate authority and truth of tradition – a given that is the result of developments in the scientific worldview, complex processes of secularization, and critiques put forth by philosophers such as Ludwig Feuerbach, Karl Marx, Friedrich Nietzsche, and Sigmund Freud in the nineteenth century and carried forward by feminists and liberation theologians, among others, in the twentieth – Kaufman suggests that we recognize the extent to which theology is human work, *constructed* to meet human needs in particular cultural situations. Understood in this way, theology is an open and evolving discourse rather than a set of revealed and tradition-bound doctrines. Imaginative construction is

a form of authorship, to use Bakhtin's language, that helps us to articulate our place within the cosmos.

From this excursus, one major idea has emerged. Our ideas about ourselves as human beings, about our context (the cosmos, universe, or world), and even about the divine are shaped through processes of imaginative construction. Imagination helps us to construct the concepts and pictures of the world, human life, and the sacred, and thus it helps to orient and guide our lives. Without imagination, we would simply inherit the past uncritically. Whereas earlier premodern and modern philosophers from Aristotle to Kant understood the significant role of imagination in human experience, only within a postmodern context have we been able to understand exactly how determinative and essential imagination is.

Historically, a mimetic model of imagination as a mirror of the world was displaced, first, by the modern model of the mind as a lamp that illumines the world, and second, by the model of the mind as a multiplication of a thousand eyes, a model that allows for a new range of subjectivities, new truths, and new visions that incorporate what has come before. I have described, albeit briefly, how imagination has been understood within these mimetic, productive, and parodic paradigms. Much more could certainly be said about the basic intellectual tendencies that have shaped notions about imagination and vision.[46] Like vision, imagination has frequently been ocularcentric – centered on the eyes to the exclusion of the other senses. I therefore turn now to a discussion of the problems of ocularcentrism and a vision-centered imagination.

## OCULARCENTRISM

Many interrelated complaints about the ocularcentrism of modern western philosophy and culture have been articulated; here I will summarize only some of the major points.[47] Vision and visual images objectify experience. Very often, images produce an object outside of the self for manipulation, rather than for an authentic relationship. The ideological nature (for example, the gender, race, and class biases) of vision means not only that this process is never neutral but that relationships of domination and subordination are both implied in and acted out through images. Vision is also too disconnected from other forms of experience and cognition, including the activity of the senses and body more generally. Visual images, because they depict reality simultaneously, cannot

show the temporality of experience. (This was central to Henri Bergson's criticism of vision and visual images.)

Visual images show fragments of reality without temporal continuity: In this sense, they are pointillist. It is extremely difficult to depict past-present-future relationships, except with newer media such as film and video. The fact that images are able to represent simultaneous or instantaneous reality means that they foreclose the possibility of a search for truth(s) that is open-ended, temporally based, and linguistic. Against the Bergsonian assertion that vision lacks temporality and duration, however, Norman Bryson has suggested that the structure of a painting unfolds in a process that is analogous to language. First, it unfolds in the artist's act of painting, and again, in the viewer's looking. And like language, painting possesses an iconographic repertoire that the viewer must know if the image is to be decodified.[48]

I find these objections to vision and visual images worthy of serious consideration, but others seem more spurious. For instance, it has been argued that because images show external appearance and behavior, they often cannot depict deeper levels of meaning. Related to this, images do not and cannot represent the truth; they actually deceive us by showing only artifice. Finally, images cannot produce genuine mystery, but only a sense of dis-ease. Yet all of these ideas are contradicted by even a cursory examination of the reception of abstract art in the twentieth century, which has been valued precisely for its ability to depict truths about human existence and to evoke a sense of mystery as the ultimate context and meaning of life.[49]

Vasily Kandinsky's *Compositions* series from the 1910s, for instance, has been studied precisely for the ways in which the works depict hidden content.[50] But this is not true only of early-twentieth-century abstraction, or even of midcentury Abstract Expressionism. As we shall see, Porfirio DiDonna's paintings of the mid-1980s demonstrate that abstraction functions at times better than figurative representation for expressing deeper levels of meaning, truth(s), and even mystery. That his paintings were based on and evolved out of imaginative vision rather than from seeing the physical world underscores the larger themes of this and the next chapter. DiDonna's earliest paintings dealt with traditional Christian themes, such as the stations of the cross and crucifixion. In the 1970s his work took on a minimalist vocabulary, using "dot-and-dash" forms, but in the 1980s he returned to the hazy ground between abstraction and figuration.[51] That we can identify many artists such as Kandinsky and DiDonna, whose work effectively meets some of the objections to vision and visual images, suggests that vision and

imagination are far from being eclipsed, even if antiocularcentric discourse prevails in philosophical circles.

In the narrative of increasing resistance to the ocularcentrism of western philosophy, Mikhail Bakhtin (1895–1975) and Maurice Merleau-Ponty (1908–61) occupy intermediate positions. Neither philosopher completely rejected vision, but both chose to emphasize other aspects of experience. Before his emphasis on the word and dialogic imagination, which characterized his writing between 1929 and the early 1970s, Bakhtin articulated the basis for a moral philosophy grounded in embodied existence. His view of subjectivity and self–other relations depended less on vision or language alone than on the uniqueness of a human being, embodied in a particular time-space or chronotope. For Bakhtin, such radical singularity results in powerful imperatives to act in morally answerable ways.[52]

Writing somewhat later in our century, Merleau-Ponty was more attuned to problems of the philosophical tradition that related specifically to vision. He therefore tried to articulate and "defend an alternative philosophy of the visual," insisting on the ambiguities of perception.[53] He wrote a notable essay on Cezanne's doubts about vision and about the act of painting itself. In it he claimed that Cezanne's work renews perception, "returning us to that primordial experience before the split between imagination and sensation, expression and imitation."[54] By adding earth tones, black, and white to the Impressionists' limited palette and by giving objects more density, Cezanne rejected the myth of distance between object and viewer, showing the immediacy and newness of objects in space. The painter demonstrated the multiplicity of perspectives, asserting through his art that perspective is neither geometric nor photographic, but depends upon lived experience. As Merleau-Ponty put it, Cezanne wanted to "make *visible* how the world *touches* us,"[55] to integrate sight with all of the other senses so that we can better "make sense" of the world. I agree that touch especially needs to be emphasized, because through the popularization of microscopy, the increasing use of technologies such as the magnifying lens, and the ubiquitous television and computer screen, touch has largely "dropped out" of our experience of the world.[56]

Bakhtin evidently did not have the acute visual sensibility of Merleau-Ponty. For instance, even though he was in Vitebsk when Kasimir Malevich's students were plastering the city with colorful abstract banners and murals, Bakhtin did not remark on their presence. But, like Merleau-Ponty, he did posit a crucial role for touch in moral and aesthetic

development. As the most formative influence in an individual's personal evolution, the (m)other, especially her touch, is crucial.

There are several "residues" of the visionary tradition in both Merleau-Ponty and Bakhtin.[57] First, Merleau-Ponty insisted that perception, although it may be intensely active, also invites even the strong ego to surrender, to let things be as they are. As in mystical illumination, viewer and viewed intermingle in a way that rejects traditional distinctions between subject and object. Bakhtin's concept of answerability and his insistence that a second consciousness is necessary for an aesthetic event to occur are related to this refusal of traditional distinctions. Second, the richness of visible creation and incarnation produced in both men a sense of wonder. In Bakhtin this took the form of a benign view of the universe, all the more notable because he lived through years of personal privation and the assassination of close friends. Although Bakhtin's roots were in Russian Orthodoxy and Merleau-Ponty's in Catholicism, they never went as far as earlier thinkers in the visionary tradition such as Meister Eckhart, who saw redemption and reconciliation in the ideas of surrender to and wonder about the natural and human worlds.

Later in his life, Merleau-Ponty delved into the mysteries surrounding the visible and invisible, what can and cannot be known. He was especially interested in the role of painting in this process, writing not only about Cezanne but also about Henri Matisse, Paul Klee, and Dutch art. Merleau-Ponty recognized that even though painters might be able to evoke primary perceptual knowledge, language was still necessary to make those meanings clear.

At least since Henri Bergson's influential writing, the use of sight metaphors in philosophy has been dwindling. Contemplation, *nous,* has been increasingly replaced by speech, *logos,*[58] a trend that is evident in Bakhtin's work, as already mentioned. Modern philosophers from Heidegger to Horkheimer have bemoaned the decline in the capacity for seeing that occurred with the advent of new technologies such as the telescope, microscope, x-ray, radio, and film. Arguably, in hysterically overstimulated media environment, with television, video, MTV, computers, and digital imaging vying for our attention, we could posit that people (at least some parts of the population) are developing a different relationship to sight, hearing, and touch.

On the one hand, the oversaturation of our visual and aural environments may mean that people no longer see or listen very well. Silence, the absence of visual and aural stimuli, is rare, and it especially

needs to be cultivated in the artist's studio. (This, of course, may be very difficult for artists who prefer to work with music or who live in urban environments where noise is a constant.) On the other hand, perhaps we are developing new capacities that have yet to manifest themselves fully. I do not hold a benign view of technology and its effects on human beings and on culture more generally, but I wish to remain open to the unknown possibilities for its evolution in the future.

This weakening of people's faith in vision has been extended to the project of enlightenment (rationality, progress, and so on) that is the hallmark of modernity. Cartesian perspectivalism has been shown to be inadequate for conceptualizing the complex multiplicities that characterize life in our time. Many difficult questions have been raised about the role of the visual and about imagination by this intense questioning of the dominant paradigms that have shaped contemporary culture.

Such questioning has not been unequivocal or univocal, for many of the theorists who have most criticized the role of sight and vision – Andre Breton, Merleau-Ponty, and Michel Foucault, to name but three – have also shown a "keen personal appreciation of the lust of the eyes."[59] The fact that many of these theorists are male gives this conclusion a problematic character. In feminist and queer theory, in cultural and film studies, and in postcolonial studies, women and men are articulating new models of visuality, new subjectivities and new objects of desire, and are redefining the nature of visual (and other) pleasures. Clearly, the "proliferation of models of visuality" encouraged by ocularcentric discourse also has a hopeful side. "Ocular-*ec*centricity rather than blindness . . . is the antidote to privileging any one visual order or scopic regime." This "multiplication of a thousand eyes" suggests possibilities for reinterpreting vision in all its complexity.[60]

Over seventy percent of the sense receptors in the body are located in the eyes. Through seeing, we appraise and understand the world in which we live. But sight is not the sole source of understanding, and are there really only five senses? What is the role of proprioception; that is, how do we know, at any given moment, the position of the body? How do spatial and muscular perception operate? Dowsers, like butterflies and whales, may have an elaborately developed electromagnetic sense. Humans, like plants, are also phototropic. Other animals use ultrasonics, infrared, vibration, and heat-sensing ways of perceiving.[61] Hindu and Buddhist rishis and yogis have known for millennia that physical perception is only a small part of our ability to process experience. Other powers of perception, such as intuition and clairvoyance, are more difficult to describe, but they are no less real. "Seeing" involves

not only the physical eyes and the mind's imaginative eye but also other more subtle organs of perception.

Many of our linguistic metaphors are drawn from bodily and erotic life, as Giambattista Vico already observed in the seventeenth century.[62] The head is the top or beginning. We speak of the shoulders of a hill, the eye of a needle, the lips of a cup, the teeth of a rake, the tongue of a shoe, the bowels of the earth, and so forth. Fields are thirsty, willows weep: Numerous other examples could be given. Vico's fully embodied "seeing" involves ears that hear the call of wild things – tree frogs, crickets, red-winged blackbirds – as well as the moaning of the earth. Such "vision" involves hands that are not afraid to touch the earth and yet remain capable of reaching out to embrace other persons.

We have barely begun to understand the unique visionary powers of hearing and touch. Hearing is perhaps the most abstract of the senses; we cannot touch it or see it. Through touch, however, our fundamental relationships to and in the world are formed. From Feuerbach to Buber, Bakhtin, Merleau-Ponty, and, more recently, in feminist philosophy and theology, many writers have understood the formative role of touch in forging ethical relationships through I-Thou encounters. But vision is also related to touch. As Merleau-Ponty put it, "every vision takes place somewhere in the tactile space."[63] This makes common sense. Artists, for instance, learn contour drawing by developing their sense of the connection between eye and hand and the surface of the object or person being drawn.

In what ways should we nurture the receptive qualities of vision, hearing, and touch to stimulate the visionary imagination? Practices, such as meditation, that train the capacity for concentration, focus, and paying attention will help.[64] Vision, as the entire tradition of western European art demonstrates, not only objectifies, but it grasps and seeks to master what it sees. A meditative practice of vision will help to train the gaze not to grasp and seek to dominate what comes into its purview; and it will help to awaken the other physical and subtle organs of perception.

Earlier I examined some of the definitions and attitudes toward imagination that shaped modern artistic traditions and are continuing to shape postmodernity. With these comments in mind, I want to consider now the yogic distinction between outer sight and inner vision, which will further specify possibilities for recuperating the visionary imagination. From Hindu and Buddhist forms of yoga we learn that the difference between outward sight and inward vision depends upon sustained development of the powers of imagination and visualization.

Although this move might be interpreted as reverting to and cele-
brating premodern ideologies and values, I see it as a distinctly post-
modern gesture. Clearly, western traditions are not the sole sources of
insight about the role and function of imagination. This move is post-
modern because it assumes the pluralism of our present cultural context.
Never before in history could an individual of one culture – Euro-
American and secular in my case – have had such rich opportunities to
study the doctrines and practices of so many other cultures. Part of what
postmodernity means is the relative accessibility of these other traditions
for those interested and committed enough to explore them. Moreover,
this move is more than a mere gesture, for my worldview and ethos
have been shaped by my personal encounter with the traditions and
religious practices of Asia.

The word "yoga," from the Sanskrit *yug,* means "union." "Yoga"
thus is related to *religio,* which means "to attach or link again" or "to
knot, join, or fasten together." *Ligo* and *jugo* come from *yeug-yug,* "to
harness or join." Both words suggest the original meaning of knots as
a method of communication between humans and the sacred.

Yoga doctrine – articulated in Patanjali's *Yoga Sutras* and the
*Samkhya-Karika,* and more properly called *Samkhya-Yoga* – sees the
human condition as full of suffering because humans constantly identify
the self with a particular body, ego, and mind. Like all forms of Indian
philosophy and mysticism, yoga aims to emancipate the person from
suffering. By the first century of the common era, there were at least
four major types of yoga. Though not mutually exclusive, they are com-
monly called *jnana yoga,* the quest for knowledge; *bhakti yoga,* the
yoga of love and devotion; *karma yoga,* the yoga of work and selfless
action; and *hatha yoga,* the physical and mental disciplines that are
detailed in what follows.[65]

Through a series of eight steps (although the image of a step conveys
too small an increment), one proceeds to eradicate this mistaken suf-
fering and to develop perfect awareness. The exoteric or outer practice
consists of the first five stages: following moral rules (*yama*) such as
nonviolence and not stealing; following bodily and psychic disciplines
(*niyama*) such as cleanliness and asceticism; physical postures (*asana*);
specific techniques to discipline breathing (*pranayama*); and separating
consciousness from external objects to cultivate inner silence (*pratya-
hara*). The three stages of the esoteric inner practice consist of concen-
tration (*dharana*), yogic meditation (*dhyana*), and finally *samadhi,*
difficult to translate, but meaning union, totality, absorption and com-
plete concentration of mind.

Within the Hindu yogic tradition, as well as in Buddhist tantric yoga, out of which thangka painting developed, imagination (*kalpana*) is generally one of the perceptual and mental processes that must be overcome in traversing these stages of practice. Like sense perception and memory, the unsought spontaneous drifting of imagination, whether representational or creative, must be stilled before the other techniques for the autonomy of the self can be learned.[66] In short, imagination, as it is understood within the general western European context, is a deterrent to deeper awareness.

Perhaps the easiest way to understand the idea of outward sight is with the metaphor of a camera with a large lens but very small focal point. Through this lens we observe the multiplicity of phenomena in the world, but we are unable to see it all simultaneously. Instead, we must constantly allow the eye to roam, fixating on different elements in the field of vision in a serial fashion. This ability to focus attention is the great strength of outward sight. If there is anything the eye (or the imagination) does not want to see, it merely turns away. Analogously, if there is anything the eye wants, it takes. The eye wields power: "Our eye exults in its power to take control at will of whatever object it chooses from those spread before it; it senses its sovereignty in the giving or denying of attention."[67]

This ability to exert power is problematic, as we have "seen"; it is part of the problem of the profound, and gendered, ocularcentrism that dominates European-based cultures. Nevertheless, most traditional western artistic traditions are based on holding outward vision in high esteem, bringing attention to the problems and celebrating the perfections of embodied life.

In the philosophical and artistic systems of India, however, at least before they were heavily influenced by European norms, and particularly in the artistic images related to yoga, outer sight is not esteemed in this way. Instead, inner vision is cultivated. In the western vernacular, inner vision might have many meanings: referring to the dream world and the notion of active imagination as developed by Jungian and archetypal psychologists; to paranormal powers, such as clairvoyance and extrasensory perception; to intuition and the New Age attitude of "going with the flow"; or to Surrealist paintings by Remedios Varo and Symbolist prints of Odilon Redon.

Yogic inner vision is none of these: It is a highly developed ability to call forth visual images in the imagination. Yogis and other adepts practice this particular form of visualization in meditation. If the image of a camera lens with a small focal point can characterize outward sight,

then inner vision might be compared to a large opaque screen on which at first one sees only dim shadows and blurred outlines, but later one learns to visualize clearly outlined, sharply focused images.[68] This ability is learned through lengthy training and extensive practice in prescribed meditative rituals. Its goals are not those related to outward sight, but rather they are related to the rigors of spiritual discipline: They point beyond the material world to the essence of existence. In words from the *Taittiriya Upanishad,* inner vision reveals an essence "before which, words and even thought itself must retreat without ever having reached it."[69]

The tensions between outward sight and inner vision that I have been describing can be seen in both yogic yantras and Buddhist thangkas. Neither of these forms of "art" attempts to represent external reality for its own sake. Outward sight may influence representation of human figures in space, as in the *Wheel of Existence* thangka discussed at the outset of Chapter 5, but the ultimate conception and execution is a result of the interaction of tradition and inner vision.

Ocularcentrism, vision-centeredness, has been a dominant trope in western philosophical and aesthetic systems. I have tried to problema-tize this, first, by showing some of the conflicting values that have co-existed with ocularcentric discourse, and second, by presenting an alternative way of conceptualizing vision. What, we can finally ask, might postmodern vision and imagination look like?[70]

## RECUPERATION OF THE VISIONARY IMAGINATION

It should be clear by now that, against all forms of modern and post-modern philosophy that denigrate vision and the imagination, my agenda is to recuperate the visionary imagination. What does this really mean? How does one recuperate the visionary, or the imagination? Re-cuperation implies healing and renewal, the possibility of bringing back what has been lost. But recuperation from an illness – and the loss of visionary imagination is a kind of cultural disease – is seldom a straight-forward process. It proceeds by fits and starts, with setbacks. Various forms of mediation, medication, and meditation may be useful in the healing.

The inner vision–outer sight distinction that I developed in the last section is not only useful for interpreting works that come from an Asian context; it can also be used to understand contemporary art by

**Figure 29.** Porfirio DiDonna, *Untitled (PDN 4)*, 1985

artists such as Porfirio DiDonna and Laurie Anderson. Most commentators on DiDonna's paintings have been reluctant to name the religious, and visionary, dimension of his work, except in the most general terms. In the years prior to his death, very little was said except by reviewers such as John Baker who knew the work intimately. Since DiDonna's death, others have at least acknowledged this aspect of his work.[71] His paintings may be viewed as one artist's attempt to reinterpret religious mystery and presence – inner vision – in ways appropriate to postmodern sensibilities.

What is the main shape that graces DiDonna's paintings of the mid-1980s, as in *Untitled (PDN 4)* (Figure 29)? The paintings of this period may be interpreted along a continuum, which ranges from a secular reading of the imagery to a more strict Christian theological interpretation. At one extreme, this shape has been interpreted as a nuclear power plant or an hourglass, suggesting a state of perennial flux. Some

commentators have called it simply a vessel; others have dubbed it the Holy Grail.[72] One male reviewer wrote that it represents "sacramental mystery . . . identified with the female body."[73] Although this seems to me the writer's projection of a cultural stereotype – the female body is curvaceous, therefore a curvaceous form equals the female body – nevertheless, the form might be read as referring to the human body. These secular interpretations certainly offer insight into the painting, yet a theological interpretation is also possible.

At the other extreme, we may read the painting in terms of sacraments such as the Eucharist, and the crucifixion and resurrection of Christ. In the traditional Eucharist, the body and blood of Christ are evoked in an attitude of thanksgiving, commemoration, and recognition of the mysteries surrounding incarnation and redemption. Such a Christian interpretation is warranted especially by examination of the development of DiDonna's images and symbols from his notebooks of the early 1960s. Unlike many painters of his generation, DiDonna did not reject his Roman Catholic roots and faith.

However, a more compelling interpretation of the late paintings, which would mediate between these other two approaches, focuses on the paintings' general religious or spiritual significance. Here the emphasis is explicitly on mystery: the mysterious presence of spirit within life, the infusion of the divine into matter. I submit that DiDonna's late paintings are not directly about worship of a Christian God and faith in Christ. Rather, they are informed by an inner vision that cannot be encapsulated by presenting images gleaned from outer sight. Ultimately their meaning remains open: They are polyphonic, open to multiple interpretations and multiple revelations. In face of the mystery that surrounds us, a visionary imagination such as DiDonna's offers powerful evocation of the ineffable. Imagination based on outer sight must be distinguished from imagination based on inner vision, which means developing the ability to visualize and to use those visualizations in sustained ways.

I am not suggesting that DiDonna practiced the techniques of visualization that were traditionally taught to thangka painters, but that he followed an intuitive inner process. He frequently was not able to articulate verbally either the specific meaning or the more general content of his paintings. Instead, he worked with and through the creative process, responding to what appeared through that process. This is not surprising, given that DiDonna was trained as a musician. He had a classical education on the piano, he played the organ, and he also studied jazz improvisation. In his earliest notebook he had written rules for

himself, emphasizing the disciplined and controlled use of color and shape so that he would not become confused about the relationship of musical notes, chords, and keys to color and shape.[74] Consequently, DiDonna chose a restrained vocabulary, consisting of a few shapes (the cross, the pedestal, a vessel that alludes to the human body, a cocoon, or a sarcophagus-like form and a limited coloristic palette.

It is significant that music provided DiDonna with the main metaphors for his creative work. Music is arguably the most abstract of all the arts. Stressing its separation and abstraction from the material, aestheticians and philosophers such as Hegel have thus identified music as the highest of the arts. Auditory metaphors emerge as more appropriate than visual metaphors for interpreting DiDonna's work. According to his own account, DiDonna waited to hear and to see what would be revealed through the creative process. Perhaps his paintings are less visionary than they are revelatory.[75] DiDonna worked organically using a visual vocabulary that evolved through many years. Unlike many other postmodernist painters, DiDonna did not appropriate images or forms from other artists. He saw painting as an everyday activity that evolved with its own jazzlike rhythm.

Such themes can be seen in several of the last paintings DiDonna executed before his death, including *Untitled (PDN 4)*.[76] Like Leon Golub's paintings of mercenaries, torture, and violence, these untitled paintings are larger than life size. But in contrast to Golub's images, which distance or even terrify the viewer, DiDonna's paintings embrace the viewer. This is a strange way to describe their power, but here I speak from repeated and extended viewing of his work.

*PDN 4* consists of fixed linear forms. The boundaries between the shapes in the painting are set; clear lines demarcate shapes and colors. Like the mythical *axis mundi,* the cosmic pillar that connects the earth both to the heavens and to the underworld (and which I earlier related to Bill Viola's *Heaven and Earth*), the central figure in DiDonna's painting simultaneously ascends and descends, is open at the top and at the bottom.

At first glance this painting seems symmetrical, even static. Yet on closer inspection we see that the shapes are actually asymmetrical. The corners are uneven, and the yellow and brown shapes bounding the two sides differ from each other, lending a dynamism to the painting. DiDonna's choice of colors is also dynamic and suggestive. Using a traditional Christian interpretive schema, red suggests blood, life: the blood of Christ. Blue reminds of the mantle of Mary in early Christian iconography. Yellow may represent gold as light, energy, and the divine

spirit. In this painting the three primary colors remain discrete and separate from one another. The suggestion of the human body and human experience makes this painting profoundly humanizing; that is, we are urged to reflect upon our condition as limited, finite, yet connected living beings.

Boundaries are thus important internally in *PDN 4*. Outer boundaries dissolve. The painting arbitrarily ends where the canvas ends, but the viewer has the feeling that the image continues beyond its borders into another, unseen dimension. We might say, in fact, that the image moves into a fourth dimension, an ineffable space and time beyond human perception. Theorists of the earlier twentieth century such as Claude Bragdon, Charles Hinton, and Petr Ouspensky linked this idea to the spiritual realm.[77] Many of DiDonna's late paintings seem to exist in a timeless space and spaceless time, surrounded by and shrouded in mystery.

The idea that the divine can never be fixed in any one particular form is especially clear in sketches that were hanging in DiDonna's studio at the time of his death (Figure 30). Prominent in these images is a sarcophagus form that is intimated at the edges of *PDN 4*.[78] The shape suggests both the beginning and the end of life, the womb and the grave.

Laurie Anderson's 1995 performance piece, *Stories from the Nerve Bible,* also alludes to the tensions between life and death. In fact, Anderson is apocalyptic. At one point in *Nerve Bible,* she sits down to tell the audience, in everyday conversational speech, the story of her near-death experience in the Himalayas. The reason for the narrative, she says, is simple: The audience may be wondering why she has already told so many other stories and presented so many images about death. Although most of Anderson's work is not personal and intimate, it deals with what theologians call "issues of ultimate concern." One of the most compelling of such sections of Anderson's long performance is taken almost verbatim from Walter Benjamin.

In writing about the rise of fascism in 1940, Walter Benjamin had described his picture of the "angel of history":

> His face is turned toward the past. Where we perceive a chain of events, he sees one single catastrophe which keeps piling wreckage upon wreckage and hurls it in front of his feet. The angel would like to stay, awaken the dead, and make whole what has been smashed. But a storm is blowing from Paradise; it has got caught in his wings with such violence that the angel can no longer close them. The storm irresistibly propels him into the future to which his back is turned,

**Figure 30.** Porfirio DiDonna, Studio photograph, 1986

while the pile of debris before him grows skyward. This storm is what we call progress.[79]

Anderson simplifies Benjamin's description:

She said: What is history?
And he said: History is an angel
Being blown backwards into the future
He said: History is a pile of debris,
And the angel wants to go back and fix things,
To repair the things that have been broken.
But there is a storm blowing from paradise
And the storm keeps blowing the angel
Backwards into the future.
And this storm, this storm

Is called
Progress.[80]

Benjamin's, and Anderson's, angel looks toward the past as he is propelled into a future scene of great cosmic violence and upheaval. Why doesn't this angel turn around? Angels are divine beings; what might the angel see if it faced directly into the future? That the future is *not* progress? Might it see that the end of progress is further destruction? "Is this good? Or is it bad?," Anderson intones several times in *Nerve Bible.* She does not answer.

The capacity for visionary imagination has to do with our self-development as human beings and with the social, political, economic, and cultural conditions within which we live. The personal pain and suffering that vision – seeing what is – brings not only can help us to identify the social conditions we need to change but also can show us how to proceed in that process. It is perhaps not unrelated that Di-Donna, while working on the painting I have discussed, was dying of a brain tumor. And, facing destruction, Anderson cannot answer her own questions. For an individual to engage constructively with society, the sense of pain, whether from a personal or a social source, must be acute enough to stimulate a desire for change.

Committing ourselves to self-transformative work is also a social practice, which means that we may encounter limits on what is possible within a particular institution or social-political nexus. Because the self is not separate from society, to engage in trying to change the self inevitably leads, even in modest ways, to the need to transform society. And that, as I have already said, is a complex task, which is connected to how one thinks about time.

To develop an awareness of past-present-future, of the meaning of human existence in time and history, is crucial: To know about the past, to let it *be* past, to be capable of re-collecting and re-claiming the past. To live in the present, to let it *be* present, to see its relationship to the past. And to anticipate the future, to envision possible futures – not thereby spoiling enjoyment of the present or hoping always for something better, but living *as if* there will be a future. The visionary does not seek to master or grasp the meaning of history in its entirety – that would be pure hubris, beyond an individual human intellect.[81]

Another way of understanding this radical capacity for visionary imagination would be to say that the visionary is not locked into the roles, practices, and social stereotypes of ego-identity with its dichotomous subject-object thinking. Instead, the visionary has a wider sense

of self as fluid and open to change, capable of various styles, types, and dimensions of experience. Using the visionary imagination, one embraces past-present-future. One embraces all-that-is, and one is thus open to suffering and joy, to fear and to hope.[82]

Vision has two aspects, at least in English and French. One is vigilant, masterful, "spiritual," vision disembodied, decarnalized – the gaze. The other is subversive, random, and disorderly – the glance. With both the gaze and the glance we *consider* what is before us. The word "consideration" refers to the transcendent aspect of vision. The stars, *sidera,* are seen together, but every constellation of stars always exceeds the boundaries of the empirical glance.[83] Vision can never take in the constellation, let alone the night sky, all at once.

What is the role of the night, of darkness, and of the stars in stimulating vision and provoking the visionary imagination? Our vision is increasingly separated from the experiences of the sun-daylight-brightness and the moon–starry night–darkness that were fundamental to human beings prior to the technological inventions that have changed our environment, our perception, and our capacities for vision. What does it mean, for instance, that in many places it is not possible to see the stars?[84] Or that the "stars" we regularly do see may be on computer screen savers?

Mystics such as St. John of the Cross have spoken of the "dark night of the soul" as essential to authentic vision. Western metaphysics and philosophy have assumed the primacy of light as the source of vision but in so doing have neglected the potential insight of other kinds of "seeing." Indeed, the experience of the night disturbs our sense of reality and helps to penetrate culturally defined "ego-logical" defenses that we have developed.[85] Absence, indistinctness, ambiguity, transitoriness: All point to the sense of mystery that cannot be fully comprehended in the light.

Perhaps we need to reconnect vision based on light, rational cognitive processes, and daytime consciousness, with the visionary imagination, which is not afraid of the unknown. Healing, which is one of the goals of visionary imagination, means establishing a more balanced relationship between what is visible and what remains (and must remain) invisible.

Whether to call the artist a prophetic critic or a visionary is not, finally, the main point. Each of these ways of specifying the vocation of the artist emphasizes different aspects of the artist's cultural function. The artist as prophetic critic attends to what is wrong in the present situation, relating the present to the past and future. The artist as vi-

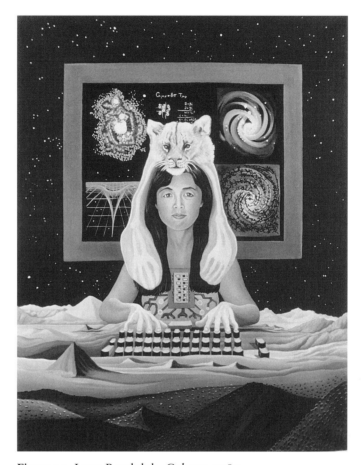

**Figure 31.** Lynn Randolph, *Cyborg*, 1989

sionary attempts to envision possible futures. This is what it means to say that the vocation of the artist is the reclamation of the future.

What future would the visionary imagination reclaim, and what would that future look like? Neither the paintings of Porfirio DiDonna nor the performances of Laurie Anderson enable the viewer to answer such questions. In fact, I hesitate to posit any answers at all, for it is the task of the artist who takes such ideas seriously to work out those answers for herself or himself. This conviction notwithstanding, I end this chapter with two paintings by Lynn Randolph that present images of moving into the future: *Cyborg* (Figure 31) and *Skywalker Biding Through* (Figure 32).

In Lynn Randolph's 1989 *Cyborg,* a Chinese woman not only sits at, but her hands are connected to, a computer keyboard. She links the various domains – animal, vegetable, mineral – but is herself not of

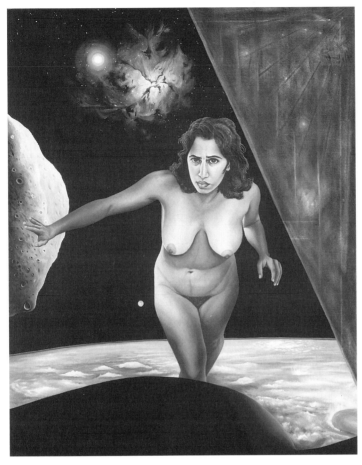

**Figure 32.** Lynn Randolph, *Skywalker Biding Through*, 1994

them. For the figure is a cyborg, a mixture of human and machine, an expression of the latest technological possibility. Randolph's *Cyborg* directly engages Donna Haraway's concept.[86] The cyborg is both myth and tool, a frozen moment in time and an imaginative reality. The integrated circuit board on its chest represents the possibility of connecting with other galaxies in the vast universe.[87] The cyborg exists at the boundary of the animal and human realms and at the boundary of the machine and the human. It has no unitary identity. Born where automation meets autonomy, the cyborg expresses an important element of transgression. Haraway means for this border crossing to be a progressive alternative to patriarchal fantasies of the domination of nature, of woman, and of the machine. But is Randolph's cyborg really free?

The landscape she inhabits is desolate, nowhere we know. The desolation of the land suggests a moonscape. The background is a starry

night but not the familiar night sky; it is the cosmos. Directly behind the central figure is a screen, on which appear four computerized images alongside three handwritten ciphers, including Einstein's relativity formula and a chaos theory equation. The entire image is totemic: keyboard, the torso of a cyborg, a human face, the animal head (is it skinned or still alive?), and handwritten ciphers. Northwest Coast tribes such as the Kwakiutl, Tlinglit, and Haida typically carved totem poles to invoke the presence of their deities, but what is invoked here? In the background, a tic-tac-toe diagram is filled, not with Xs and Os, but with symbols for male and female. If we are creators of our own salvation, then what is suggested by this mutant creature, a creature whose actuality becomes more and more real every day?

Randolph's *Skywalker* suggests another set of values about the future than *Cyborg*. Randolph had stopped painting nudes for a period of years, not wanting to participate in the objectification, exploitation, and commodification of women's bodies. Simultaneously, however, she did not and does not want to pretend that women's bodies do not exist, thereby underlining women's invisibility. Wrestling with the problems surrounding gender and representation, Randolph seeks to incorporate self-love in nonpatriarchal visions. As the artist puts it: "By refusing to participate in oppositions like theory versus fiction and truth versus art, which are hierarchical, a space opens up that transforms the logic of power into new methods that interrupt, intervene, short circuit, disperse and diffract endlessly, making energy explode into a new poetics of the body which will shelter many interpretations."[88]

In *Skywalker Biding Through,* a nude woman strides confidently toward the viewer, pushing aside planets or asteroids, perhaps pushing aside the veil that separates the past and present from the future. Like the *Cyborg,* she inhabits cosmic space, but here the woman is center stage, the sole agent in this starry night. Not afraid of the dark, *Skywalker*'s gaze, like Olympia's, locks with ours, but she is no passive spectacle awaiting the consummation of a business proposition. She commands her space and her right to stride into the darkness and into the unknown.

Perhaps, in the end, the visionary imagination must remain open to what artists and others will make of it. Even when all master narratives have been debunked, or at least seriously thrown into question, we still need to recognize the importance of stories. Narratives form the past, present, and future archive of human experience; and "narrative identity is a *task* of imagination."[89] *The Vocation of the Artist* should be read as a narrative containing possibilities for consideration.

Imagination is an active psychological and cognitive process. Part of the problem with imagination is that it has been routinized, bureaucratized, and colonized, subjected to analogous processes that have made vision and the visionary so problematic. This subjection (and abjection) of imagination means that we are seldom able to step out of our habitual patterns. Even given the problems with language that privileges vision, the activity of envisioning our collective present and possibilities for the future is essential for survival. Artists can fulfill an important cultural role in this process.

What, then, is the role of imagination in postmodernity, when many other modernist myths have been discredited? Some will argue that as a modernist and Romantic ideal, visionary imagination has been thankfully debunked, along with other modernist myths such as faith in science, progress, and reason that I discussed earlier. Against this view, I believe that imagination is essential to our *be*-ing in the postmodern world, especially now, in a time that seems devoid of emancipatory projects and when many of us have lost the ability to imagine alternatives, either by remembering the past or by anticipating the future.[90] Like other contemporary theorists, I find the term "visionary" problematic, even as I persevere in using it.

As Karl Marx long ago pointed out, "the forming of the five senses is a labor of the entire history of the world down to the present," and it continues to change.[91] In fact, our will to create change is crucial. If vision and imagination no longer show a clear path toward knowledge and freedom, wisdom and redemption, does that mean that they are at fault? Or, is the problem the narrow frame of vision and the narrow interpretation of imagination that have been extolled in the European-American west?

We must reinterpret the postmodern imagination in terms of self–other relations, relationships between the self – a newly de- and reconstructed self that cannot be centered on itself – and the other. The face of the other is not an anonymous mask; it is the face of a suffering or joyous or loving human being that calls us into answerable relationship. Vision is an existential capacity, a gift we can cultivate, abuse, or deny.[92] As such it offers the opportunity for psychological individuation and for moral responsibility within the larger social order. The question what is the vision of my life and my possibilities? can be expanded to ask, what is the future vision of my community and the world? As William James put it, "Where there is no vision, the people perish."[93]

James's comment also offers a key to the inner meaning of Redon's *Angel of Assurance.* In his lecture on Gustav Theodor Fechner, James

exalted Fechner's imaginative vision of the liveliness and concreteness of all things, especially the earth itself. The landscape is a face, and human eyes are like diamonds among dewdrops. But human beings also create imaginative visions of angelic beings, who need neither food nor drink, but are messengers between ourselves and the divine. "So," James hypothesized, "if the heavens really are the home of angels, the heavenly bodies must be those very angels. . . . Yes! the earth is our great common guardian angel, who watches over all our interests combined."[94] The globular eye in Redon's print may be the earth; the interrogating gaze, the angel's. Lest we miss this upon first glance, Redon presents another visage of the angel, less the all-seeing, all-knowing one, and more like ourselves. The angel of certitude is not certain, but inquires of us: What is our vision?

When people do not have a vision, they will die. Vision, in this sense, is dependent upon imagination. In the new ethical aesthetics, we must now *reimagine* the possibilities for prophetic criticism and visionary imagination. Let Walter Benjamin's and Laurie Anderson's angel of history turn from the wreckage of the past and present, leaving behind the storm we call progress. Let us make whole what has been smashed, or at the least, begin the process of reclamation.

# Creativity,
# Utopia, and Hope

James Turrell's *Roden Crater Project* (Figure 33) is not only about vision and perception, but it also incorporates a profoundly visionary intention. The Roden Crater is a 500,000-year-old extinct volcanic crater, located about fifty miles northeast of Flagstaff, Arizona, in an area known as the Painted Desert. With a base two-and-one-half-miles wide and an interior bowl more than twelve hundred feet in diameter, the crater is the site of a project that Turrell initiated in 1972. He chose the site in 1974; several foundations helped him to buy the crater in 1977; and since then Turrell and many others have been working to create numerous spaces within and around the crater, each of which will disclose unique aspects of light and space. Four cardinal spaces and seven other major spaces will be accessible by numerous paths traversing the site. At the very center of the crater's bowl, which has been reshaped with a bulldozer, one can lie on a small narrow ledge to observe the way the entire sky seems to form a huge dome, a celestial vault, emanating from the crater's edges.

Turrell is not interested in earthworks as such, where the mark of the artist upon nature usually dominates; instead, he wants to create a setting in which the observer can truly experience changes in the seasons and daily changes in the perception of the sun, moon, stars, and landscape. While acknowledging that human beings inevitably change their physical environment, the *Roden Crater Project* seeks to establish a new relationship between human beings and nature. In Turrell's words, "I'm also interested in the reflexive act of coming to see your own perceiving. My work is more about your seeing than it is about my seeing. . . . I'm also interested in the sense of presence of space; that is, spaces where you feel a presence, almost an entity – that physical feeling and power that space can give."[1]

Indeed, it is the sense of awe, of "connecting with something that's beyond our secular life,"[2] as Turrell has said, that gives the project its peculiar visionary power. When an artist undertakes a work of this scale and duration, a deep commitment to the future is given concrete form.

This artist's creative activity allows *us* to look at and to see the world in which we live. The power and range of human perception is the true content of James Turrell's *Roden Crater Project.*

\*   \*   \*   \*   \*

At the end of this book on the prophetic and visionary vocation of the artist, I offer a series of four *medi(t)ations,* which seek to weave the many themes of *The Vocation of the Artist* together, to read the parts of the book in relation to the whole. Once everything is said – about the significance of vocation, about the historical roles of artists and the education of artists today, about the prophetic traditions and historical interpretations of the imagination – where do we stand? More importantly, how do we act? For, the possibility of action in the world, indeed the necessity for action in the world, is one of the central beliefs that has motivated this book. Some would say that belief is a dangerously ephemeral foundation on which to construct anything, let alone a persuasive polemic regarding the contemporary role and function of the artist. Belief, however, is also a mighty force, as religions have always known. What if we set aside skepticism concerning the possibility of postmodern creativity, our visions of a techno-necrophilic dystopia, and our nihilism and apathy concerning the fate of our (and other) species and the earth itself? What if we think about the future *as if* there could, would, *will be* a future? What if we reclaim the future?

## CREATIVITY

In the era of appropriation art and of irony, parody, and pastiche, to contemplate the nature of creativity is to tread a narrow path bordered by a steep precipice. One needs, perhaps, to hug the ground in traversing such a potentially treacherous path, staying closely attuned to the placement of one's hands and feet, to balance. In other words, one must attend to one's philosophical and theoretical presuppositions.

Philosophically, I understand that as long as life persists, creativity will endure. Creativity is intrinsic to the flow of the seasons, to the energy stored in seeds and buds. I have written much of this book in front of a large window overlooking a park. The many trees have been bare for months, but now the view is changing predictably, inexorably. Soon, the forest of trees will be obscured by the leaves of those individual trees closest to my window. In the cyclical processes of nature and against the destructiveness of so much human activity, creativity insists itself again, and again.

**Figure 33.** James Turrell, *Roden Crater*, 1972–present

Human creativity, artistic creativity, is like this. In individuals, it can be blocked; indeed, even whole communities may be incapable of generating creative responses to a particular present. This was the point of my reference, early in the book, to our inability to imagine possible futures other than total devastation. Winter is not only a season but an apt metaphor for part of the creative process. Creativity is dependent upon imagination, which also has its seasons. In ancient Greek philosophy, Plato's suspicion of the imagination was countered by Aristotle's conviction that the imagination was essential to the moral orientation of behavior and to the possibility of deliberating about the relationship of past and present to the future. This tension is still apparent today in the rejection and deconstruction of creative imagination by postmodern artists and philosophers from Jeff Koons to Jacques Derrida.

Just as definitions of the postmodern vary depending upon whether one examines popular culture, academic debates, or our broader historical and cultural context, so the possibilities for postmodern imagination and creativity are subject to differing interpretations. Although the paradigms for it change, the imagination's persistence as a creative human faculty does not. Postmodern imagination may not be construc-

tive or inventive in the same way that modern Kantians thought it to be, but the idea of a labyrinth of mirrors, which sees only itself, multiplied infinitely, also does not describe the potentially transformative character of contemporary art and postmodern creativity. Transformation always implies, and demands, work.

Earlier I discussed the evolution of ideas about vocation: conceptualizing work from divine calling to secularized job, carried out, as Studs Terkel so dispassionately reported, with profound discontent, monotony, and only occasional delight. To understand vocation as a form of creative action as I suggested, rather than as labor or work, has several significant consequences.

We labor in repetitive cycles, producing materials that we consume every day. We eat and we clean. We take care of children and of those who are dying. We are *animal laborans*. With our labor, we support life itself. For most of us, this role is a given, a part of life that cannot be avoided.

In this laboring society, we also work, producing the world of things that we live with and use. Using tools, we literally build the world through work. Many works of art are part of this process of production and consumption. Creativity expressed in work is directly related to consumer values. As consumers, we are always urged to have the latest model of a product. Planned obsolescence makes older models outdated long before they are truly used up. The bureaucracies that establish this marketplace of ever-new models maintain their ascendancy over individuals by sustaining a destabilizing rate of change. Thus, during the nineteenth and twentieth centuries the very notion of selfhood has been linked to this relentless pressure "to catch up."[3] In the studio, artists and writers have a unique opportunity to stop this cycle of production and consumption; they can stop hurrying to catch up. To be silent, to listen to themselves and others, to hear, to wonder what is going on, to consider their work as action: All of these are aspects of the artist's vocation.

Action, in contrast to both labor and work, does not necessarily use or create artifacts. Action is process; it consists in transactions. It is the interstice between persons or between a person and the world of nature or a constructed world. Action is unpredictable, irreversible, often anonymous, and completely dependent upon the conviction that creativity is ongoing and ubiquitous.

What is the result of the creative act understood as action? I have not attempted to define it here, because "it" cannot be defined. Perhaps products are produced, perhaps not. The evolution of new artistic gen-

res since the 1950s – installation, performance, video, and electronic and digital imaging, among others – has introduced new sets of issues surrounding the traditional triad of creator, object, and viewer. At the least, the artist engaging in the creative process understood as action would be less concerned about the production and marketing of objects and about becoming an art superstar, which imply certain relationships between the object and its creator. Artists might instead be more concerned with issues such as collective memory and time (the relationship of past and present to the yet-to-be future) and with the relationship of human life to an ever-changing planetary environment that becomes less hospitable to many life forms with each passing year. The *Roden Crater Project* is a stunning example of such *action*.

In the face of the potentially depressing, even devastating, situation that artists face in the contemporary art world and art market, artists need to cultivate specific attitudes and virtues, although not necessarily in the following order.[4] They need "developmental realism": a recognition of their present status in relation to their past experience and future aspirations. Artists need to develop conviction, humility, and resolve; to keep vigilant over true desire (in contrast to the false desire to "be an artist" that develops as they try to succeed in the art world); they need to become conscious of how the mystique of art and being an artist, rather than more intrinsic desires, shapes one's work; they need to care for, relate to, and be affiliated with others; and they need to work from both a self-defined motivation and a larger self-transcendent motivation, which was originally and again might be provided by ideas about the sacred. In my view, artists should be self-determining but not overly individualistic, guided by moral purpose and a sense of living tradition, and they should believe in and act on the communicative power of art. The education of artists should foster these values.

Can we say anything further about the outcome of understanding creativity and the artistic vocation as action? In *Coming to Writing*, Hélène Cixous describes the results of the creative act using language that is full of vivid images related to the many intertwining strands of this book.

> When I have finished writing . . . all I will have done will have been to attempt a portrait of God. Of the God. Of what escapes us and makes us wonder. Of what we do not know but feel. Of what makes us live. I mean our own divinity, awkward, twisted, throbbing, our own mystery – we who are lords of this earth and do not know it,

we who are touches of vermilion and yellow cadmium in the haystack [Kandinsky's words on seeing Monet] and do not see it, we who are the eyes of this world and so often do not even look at it, we who could be the painters, the poets, the artists of life if only we wanted to; we who could be the lovers of the universe, if we really wanted to use our hands with mansuetude, who so often use our booted feet to trample the world's belly.[5]

To speak of a portrait of God is the purest contradiction, because God is that mystery, that twisting and throbbing creativity, ever present, but never easily available or at hand. I have hesitated to evoke the concept or image of God in these pages, for the complex question of who or what God is does not lend itself to facile explanation. Instead, I have repeatedly emphasized the importance of mystery as the shifting ground against which the artist works and plays. To attempt to say more than this would be to reduce complicated, even ineffable, concepts to simple speech.

Yes, we are the eyes of the world (a function we may share with other higher mammals), but as far as we know, we are the only creatures who also alter our environment. We are even in the process of altering ourselves through our work. We could be lovers of the universe, and our own lovers, expressing that love through art, with mansuetude. The term "mansuetude" is derived from the Latin *mansuescere*, "to tame" – from *manus*, "a hand," plus *suescere*, "to accustom." Thus the word implies gentleness and taming. To be the hands and the eyes of the world, to create a portrait of our own and life's mysteries, of the future and its multifarious possibilities: Creativity expressed in these ways is prophetic and visionary. It is also utopian, but what does that mean?

## UTOPIA

To invoke utopia at this point may seem gratuitous. My intention, however, is far from this. This meditation on utopia provides a necessary link between creativity and hope and between imagination and actual work in the world. The verb "invoke" has the same root as "vocation": Both are derived from the Latin *vocare*, "to call or summon." To invoke utopia is therefore to summon the reader yet again to the vocation of prophetic criticism and visionary imagination. I agree with Oscar Wilde that "a map of the world that does not include Utopia is not even worth glancing at."[6]

U-topia is, literally, no place: no place we know or have ever seen. It also makes us think of *this* chrono-tope, this particular time-space in which we live, work, and create. Through art and literature we human beings shape ourselves, formulate questions about ourselves, and show how our objectives can be attained. In this sense, all art and literature that have something to say about human existence and human aspirations are utopian. Yet there is no single utopian content, as this changes with the social and cultural context.[7] For instance, there are social utopias that express the longing for a better life, or technological utopias, or medical utopias focused on the elimination of pain and death. There is also a generalized utopian sensibility that longs for happiness, fulfillment, freedom, or other particular values.

Another way to describe this diversity of utopian forms and content, the plurality or multiplicity of postmodern views of utopia, is with the term *heterotopia*. Coined by Gianni Vattimo to name the changing relationship between art and everyday life since the 1960s, the term seems to me an especially fitting way to bring attention to the fact that the singularity, uniformity, and order of classical and modern utopian thinking is inadequate.[8] To appreciate multiplicity, difference, and other ordering systems such as chaos and synchronicity is one of the goals of the kind of utopian/heterotopian aspirations that have guided my writing here.

I have repeatedly noted that we live in a time of crisis, a crisis that is nowhere more keenly felt than in the perception of time. What is the future of a culture so badly in debt that it cannot imagine living on its (our) present resources? What is the future of a culture that places the very air it breathes in hock? Unfortunately, once the rain forests and other old-growth forests around the world are cut down, the pawnbroker will close the door of the shop. Once all the potable water is contaminated, once the aquifers are drained, human life will be truly dystopic. The ability and the willingness to extend one's thinking forward in time, to try to imagine alternatives, to undertake projects that are themselves commitments to the future: This is what I want to encourage with the language of utopia and heterotopia.

According to Ernst Bloch, the utopian quality of a work of art is determined by its sense of anticipatory illumination, its *Vor-Shein*, meaning a way of being that awakens utopian consciousness and indicates a path toward that which has "not-yet-become."[9] Utopia expresses the longing for the true home we have yet to experience. But there is an additional element in the German *Vor-Shein*. The word combines a sense of anticipation with the idea of shining, enlightening, or

showing the way. The artist sheds light on the goals of humankind. To be capable of this, the artist must, however, also try to go beyond the personal self and the projection of personal wishes and desires to make artifacts or actions that contain something more than what she or he intended. Is this not grandiose? To speak of the "goals of humankind" as if we could know or generalize disparate goals of widely divergent communities presumes too much. Modifying Bloch's formulation, we might say that the artist critically reflects upon the gap between human aspirations and human deeds, in her own life, his own community, in the greater world. Such acts, intellectual and artistic, are prophetic insofar as they demonstrate the connections between the past and present, and the future.

Still, not all art is utopian. To think about utopia is to invoke its opposite, dystopia. A dys-topia is a "bad" place, an imaginary place or state in which the conditions of life are bad. George Orwell's *1984* and Aldous Huxley's *Brave New World* are dystopias; they are joined by many contemporary films and television programs. As a culture we are profoundly dystopic; even the many new possibilities of interacting in cyberspace and virtual reality are based, covertly if not tacitly, on an assessment of the "real" world as dangerous. HIV and AIDS, random street violence, terrorist bombings: These and other characteristics of contemporary life make life on line increasingly preferable to life in the streets.

Earlier, in writing about imagination, I discussed Plato and Kant within the space of a few pages. Kant agreed with Plato that imagination mediates between sense perception and thinking, but whereas the Greek philosopher saw imagination as both dependent upon and inferior to sensation and reason, Kant granted imagination autonomous, a priori status. Imagination thus becomes, as in the example of Gordon Kaufman's theology, the most significant faculty that allows us to construct images and concepts of the divine and to understand our place in the world.

Another potent link between Plato and Kant concerns their views of the relationship of the philosopher to those who govern.[10] Plato believed that in a utopian state either the philosopher should rule or that philosophers should educate those who exercise civil power. Kant, living as he did in the modern world, understood that power corrupts those who wield it; therefore, he insisted that neither should philosophers be kings nor rulers philosophize. Rather, rulers should allow philosophers to express their ideas in public.

In more contemporary parlance, we could say that intellectuals and

artists should exercise their analytical and critical powers in the public domain. The prophetic and visionary spirit of the public intellectual and artist must not be silenced or constrained by those who wield political power. (This may itself be a utopian dream!) The artist does not believe that she or he possesses a timeless sense of truth, but instead connects her or his message to the present situation. The artist does not confront the public with some pantopia or even utopia, but she or he is bound to, inextricably a part of, the particular *topos*, place and community, in which it is necessary to speak. Acting thus, the artist shares more with the Hebrew biblical prophets than with either Plato (who finally was silent and withdrew from public life) or Kant (who glorified aesthetic disinterest and detachment).[11] The lesson of prophets such as Isaiah and Jeremiah is that, although their utterances were often misunderstood, misinterpreted, or misused, still, they spoke.

Like the biblical prophets, we need to recollect the past and to criticize the present in order to be prepared to think ourselves into a future. As Herbert Marcuse put it, "[T]he authentic utopia is grounded in recollection."[12] Obviously, the idea of an "authentic utopia" must remain an abstraction, for who can really judge what that might be? Linking utopia, which means *something* about the future, to recollection, which means a complex relationship to the past, raises a crucial question. What constitutes that link between the past and the future?

Although no single quality enables us to imagine what might be in the face of what has been and what is, hope and desire are essential. In fact, the link between hope and desire is dialectical.[13] Heterotopian visions not only express what is most desired, but they also carry the hope that those desires may actually be met. Utopia arises from desire, but its realization depends upon hope, which is itself grounded not in wishful thinking but in willed action.

## HOPE

Hope cannot exist alone. It thrives in a context. In our time, uncertainty has become a major characteristic of life, thus making it more and more difficult to conjure hope. Many artists respond to this uncertainty with cynicism or nihilism; they may suffer from the "will full of ressentiment" that Donald Kuspit described. But I hope, if my descriptions and examples have shown anything, that there is more to say than this.

We can never foretell the outcome of an action with certainty because action has no end. In the face of this characteristic of action, how is

one to live in the world, and to act? Forgiveness and the ability to make and keep promises are two essential qualities that make hope and action possible as we face the contingency and fragility of the future.[14]

Forgiveness helps to redeem the irreversibility of actions, whereas the ability to make and keep promises helps to remedy the unpredictability and uncertainty of the future. Both of these capacities depend upon community, plurality, and the presence and the actions of others. We need the Other in order to forgive; and we need the Other in order to feel bound by our promises. Enacted in solitude or in isolation from others, forgiveness and promises are only roles played on a narcissistic stage. Forgiveness is the only "re-action" that can produce the unexpected. Because it is not conditioned, like revenge is, by the act that provoked it, forgiveness frees both the one who forgives and the one who is forgiven from further consequences. Although love is the primary basis of forgiveness in intimate relationships, respect is also essential. The loss of respect in our world is part of the increasing and dangerous depersonalization of both personal and public life.

The unpredictability of action is also dispelled by the ability to make promises, for a promise, however contingent, does provide a degree of security in the face of the unknown. Promises, however, are always mediated by the fact that human beings can never guarantee today what they will be, or will be able to do, tomorrow. We can neither promise categorically, nor can we control what we produce. Knowing how to do something does not mean that we know what we are doing or what our action means.[15] One of the prices of freedom is that we cannot unconditionally promise something for tomorrow. Nevertheless, we articulate our intention – a promise of sorts – all the while knowing the limitations and fallibility of the human heart.

Ultimately, faith and hope come from "natality," from the fact that new persons and new beginnings are forever being born as others die.[16] Hope is related to a perspective that apprehends the ongoing creativity of life in the universe. But it is not confidence. Hope is surrounded by dangers; it may well be the consciousness of danger, as well as of fragility and contingency.[17]

I have returned several times in the course of writing this book to the theme of memory and time. We normally think of memory as retrospective, but in the visual arts at least, memory also has a prospective character: "[I]ts object was not only what happened but what was promised."[18] This was especially true of religious imagery and cult relics. Because of the increasing secularization of European and American culture, this power of images has become somewhat remote. Icons of

the Virgin and Child, or of Divine Wisdom–Sophia, or of Gabriel, for example, conveyed to the viewer-worshipper a sense of the divine in both the already-completed past and the promised yet-to-be future. Even the Tibetan *Wheel of Existence* thangka, traditionally set in the vestibule of temples or carried as a teaching thangka, evokes these retrospective and prospective aspects of memory. And I submit that even contemporary art may carry this double function, if and when the artist decides to consider the interrelationship of memory, time, and hope in the creative process.

Hope, however, is profoundly different from optimism. Optimism is based on the conviction that everything will turn out well in the end, that all adversities will be overcome in a final harmony. Optimism, like pessimism, is oratorical. The optimist and pessimist are "makers of speeches," who think that the "I-myself" is the source of faith.[19]

By contrast, hope is difficult to describe, more mysterious; and it is inextricably linked to despair. Despair is an attitude of capitulation and acceptance, whereas hope implies a relaxed kind of nonacceptance. Hope never fully accepts what is as the finalized end, yet it expresses this nonacceptance in an attitude of relaxation and patience. "In hoping, I do not create in the strict sense of the word, but I appeal to the existence of a certain creative power in the world."[20] Thus, hope implies the sense of the ongoing creativity of life that I have emphasized.

Even more significant, however, is the notion that hope implies a special relationship to and consciousness of time. Despair sees time as a prison, closed and finalized. Hope is visionary, not in the sense that it sees what will be, but in that it affirms the future *as if* it sees what will be. Hope thus pierces the veil of time. Hope "aims at reunion, at recollection, at reconciliation: in that way and in that way alone, it might be called a memory of the future."[21]

*Hope is a memory of the future.* What a strange and counterintuitive statement. Yet it contains the same invitation to metanoia that is part of my claim that the vocation of the artist is the reclamation of the future. Hope implies, as Gabriel Marcel insisted, a "superlogical connection between a return *(nostos)* and something completely new *(Kaïnon ti)*."[22] Hope refuses to see time as closed and understands that time is a spiraling continuity. Hope does not claim anything, or insist upon its rights to anything in particular, but it waits. How do we make sense of its central paradox? Hope, like reclamation, implies a powerful role for memory. For it is only with a powerful memory of what *was* that we might be compelled to imagine a different future than the one we seem to be living ourselves into.

Integral to the process of waiting and imagining is the willingness to take risks. To hope means not to be caught in the "shackles of ownership," not to be "entangled in the inextricable meshes of Having."[23] In fact, our desires to have and to possess – objects, experiences, particular attainments – even perhaps our desire to create certain kinds of art and artifacts and to present them in the world, stand in the way of hope. Hope, like love, is a gift; it cannot be bought.

Where does hope come from, and why do we hope? These are clearly difficult questions to answer. Hope is like other virtues: love, charity, goodness, patience. Like them, hope can be refused, or it can be cultivated. Perhaps we hope because we are thinking and feeling beings – in a word, human.

Hope is a form of imaginative remembering that brings past and future into one phrase. "Its value is as a tool that can regenerate the lost, hidden, creative, spiritual, and intuitive aspects of human life which capitalism has denigrated."[24] Art based in hope expresses the unspeakable, the ineffable – our deepest desires and dreams that cannot be expressed in any other way. This idea is itself utopian because it holds out the hope that art has enough power to annihilate the realities of materialism, consumerism, and the general commodification of culture.[25] In this process, the aesthetic dimension of life is particularly significant, for it is through carefully articulated form that ideas, and especially the idea of hope, are best expressed. There are two main conditions for the most effective utopian or heterotopian art: The artist must deal with society's hidden conflicts and contradictions, and the work itself must embody hope.[26] Hope is possible because of the unique human capacity for imagination.

How does one cultivate creativity that is grounded in hope? What is the role of hope, or what Charles Jencks has called "tragic optimism," in the artist's practice? My role here is not, finally, to prescribe how these values translate into an artist's practice. But I can reiterate some of the ideas outlined earlier concerning the education of artists.

In addition to the imperative for rigorous technical background, practicing and aspiring artists need to develop a relationship to tradition. The nature of what constitutes tradition has changed rapidly in the postmodern world, as the history of world cultures and of their diverse artistic traditions has become available to us. Related to this, artists need to become cognizant of, and enter into dialogue with, contemporary cultural theory. In my view this is a question not of faddish sycophantism or tactical self-aggrandizement, but of understanding significant issues such as pluralism, ecological and environmental concerns,

and the role of Others, especially women, in the cultural sphere. The complex image-world in which we live requires informed and trained artists who can bring unique perspectives to the task of reinterpreting and reshaping the world.

As well as being strongly grounded in historical and theoretical discourse and developing the values described earlier, artists also need to be taught about, or at least encouraged to reflect on, the nature of the audience they wish to reach and the most effective strategy for reaching that audience. The twentieth century has been marked by at least two major periods (the early avant-garde years and the present) when the gap between artists and their public has been very wide. If that gap, and the hostility that many members of society feel toward art, is ever to be bridged in even a modest way, then artists must think about who their *ideal* viewer would be and who their *actual* viewers are likely to be. How much do aspiring artists know about their prospective audiences? Have they been encouraged to think how best to reach those audiences? Only after attempting to answer these questions will aspiring artists have the possibility of breaking free of "the confines of the art world's terminally hip subculture."²⁷ In addition, many people, including artists, express deeply felt cynicism and nihilism about the world in which we live, which can be challenged by developing a more comprehensive and critical perspective on the present. Most significantly, this also helps to create a sense of possibility about and hope for the future. Indeed, developing new, and alternative, visions of the future may be one of the most pressing needs of our time.

Erik Bulatov's ambiguous 1975 painting *Idu (I Am Going)* (Figure 34), although it does not visualize any particular future, does express this sense of unfinalizable possibility. In Russian, *idu* is the first-person form of the indeterminate verb of motion, *idti*, "to go." It means "I am going," or "I am coming." Visually, the word written on the clouds seems simultaneously to approach and to retreat from the viewer. Clouds – those ephemeral shifting shapes in the sky that invite contemplation and projection – provide the background for our motion in time. We *are* going, but toward what?

## ARTIST AS PUBLIC INTELLECTUAL

At the outset of the book, I suggested that our situatedness in a largely pluralistic, postmodern, and nuclear era calls for a radical revision of possibilities for the future, indeed, for *reclamation* of the future. But

**Figure 34.** Erik Bulatov, *Idu (I Am Going)*, 1975

here, at the end, I must also acknowledge that the view of the present on which this book is based is certainly not the only possible interpretation of our cultural condition today. One might instead emphasize the more positive possibilities of choice and broad tolerance that are opened up when people are thrown back onto themselves.

Any analysis that brings attention to a positive dimension of the present, however, or that attempts to accept the present as it is, must also take account of the many forms of cultural backlash of the 1990s. For example, the Roe v. Wade Supreme Court decision of 1973, which treated abortion as a personal decision and fundamental constitutional right, has been effectively whittled down through hard-fought cases that culminated in a series of more recent decisions (Bellotti v. Baird, 1979; Harris v. McRae, 1980; City of Akron v. Akron Center for Reproductive Health, 1983; Webster v. Reproductive Health Services, 1989; and Planned Parenthood v. Casey, 1992). The hypocrisy of antiabortion ac-

tivists who want to decrease governmental interference in private life, while simultaneously legislating some of our most personal decisions regarding reproduction is further evidenced in the violence and murder practiced by some of these supposedly "pro-life" activists. In many nations of the world, intolerance leads to "ethnic cleansing," practices of genocide that are certainly older than the present, but which have taken particularly vicious forms in recent years.

Or, one might simply adopt a more accepting and philosophical attitude concerning the many problems that face us. This attitude is not the same as nihilism or apathy. Thus one acts locally, as the saying goes, and thinks globally, but does not despair at the potentially radical transformations – climatic change, species extinction, and so forth – that will continue at an accelerating pace. Evolution is an inextinguishable process, and human beings are not the sine qua non of life forms. Contemplating the end of life as we know it is not the end of life as such.

There may never have been a significant place for artists or for intellectuals in American culture, and there is also presently no clear place in the fundamentally antiintellectual and visually illiterate climate of the United States today.[28] Artists might experience this as an onerous burden, but they also might see it instead as a challenge to be met self-consciously if they want to have an impact on a public audience. Self-aggrandizement and ego promotion are part of the "terminally hip art subculture" in major cities in this country. Artists seriously considering how best to reach their intended viewers might therefore consider some of the values I have described here.

We live in a culture of increasing right-wing conservativism. Various forms of backlash – neofascism, anti-Semitism, and fierce racism, along with antifeminism and misogyny – are on the rise. All of these are rooted in a profound anti-intellectualism, a point of view that rejects self-reflection and critical analysis. By contrast, artists who are seeking to exercise their prophetic and visionary roles must engage in sustained self-reflection and critical analysis of culture. They will in their work link the ethical and aesthetic dimensions of experience. In this sense, then, it is worthwhile to consider some of the links between prophetic and visionary activity and the role of intellectuals.

Prophetic criticism and the visionary imagination are grounded in developing self-reflective and critical powers not unlike those of intellectuals. I suspect, however, that few postmodern artists would feel comfortable labeling themselves as intellectuals. The word suggests a highly educated elite, learned in knowledge acquired from books and

possibly separated from the work with content, form, and materials that are the tools of visual artists.

So far, I have emphasized prophetic criticism and visionary imagination as faculties that may be usefully developed by practicing artists. But this point of view on the vocation of the artist as prophetic critic and visionary has much in common with notions about the organic, or the specific, or the dissident intellectual – the public intellectual.[29] What might it mean to identify the artist as an intellectual? What is at stake in the claim that an artist is an intellectual, and what might artists gain by considering their activity as aligned with that of other specific, dissident, or public intellectuals?

The sense of intellectuals as a distinct and self-conscious group had its origins in the mid-nineteenth century term "intelligentsia," which was borrowed from Russian.[30] The idea was first formally articulated in the writings of Alexander Herzen as an intellectual order that arose from the lower ranks of society: "[T]hose who labor with the intellect . . . may become ideologically and politically bound to the mass of workers and peasants, but they are not, at bottom, an order economically bound to the interests of the masses."[31] However, the origins of the intelligentsia as a social group may be traced to much earlier associations in medieval and early modern Europe: masonic fraternities, guild organizations, troubadours, clergy, humanists who either had patrons or were employed in the universities, salons, coffeehouses, and political clubs.[32] Although none of these groups in itself constituted the intelligentsia in the modern sense, all were part of the historical background for affiliations of intellectuals, artists, and artisans. As is still true today, these early intellectuals could be attached to institutions or to a local community, or they could be detached free agents.

More recently, in the writings of Antonio Gramsci, Michel Foucault, and Julia Kristeva, these general ideas about the intellectual have been given new levels of definition. In his prison notebooks from 1926–37, Gramsci discussed how each social class develops its own organic intellectuals, the group that makes conscious and thus helps to legitimize the particular social, political, and economic claims of that class. For example, "ecclesiastics," the monopolizers of religious ideology, philosophy, science, education, morality, and justice, were organically tied to the landed aristocracy.

Gramsci took an even more radical step, however, in stating that "there is no human activity from which all intellectual intervention can be excluded – *homo faber* cannot be separated from *homo sapiens*."[33] All human beings develop some intellectual activity. A person may be

a worker, a philosopher, an artist, a person of taste; by contributing to the maintenance or transformation of conceptions of the world, each person thus may encourage new forms of thought. Most significantly, Gramsci asserted that the new organic intellectual must not only arouse passions through eloquent writing or speech, but this person must also be actively involved in practical life, persuading people to work for change, organizing that activity, and thus helping to build the future.

Michel Foucault built on Gramsci's formulations in describing the activity of the specific intellectual.[34] The organic, left, bourgeois, or universal intellectual, as Gramsci had described this person, acted as a spokesperson for local and global organizations. This person was a "bringer of truth." Purporting to speak of universal truths, such an intellectual claimed to be the consciousness and conscience for all in the larger society. The writer was the intellectual par excellence, who, in contrast to technicians, magistrates, or teachers, claimed to be a free subject, a universal consciousness. But the powers associated with writing, the author, and the universal intellectual began to change around World War II, with the emergence of the specific intellectual. This new intellectual is political in the sense that she or he uses knowledge in political struggles. The role of this intellectual is no longer to separate from the collective, but to struggle *with* others against those forms of power that transform persons into objects and instruments in particular spheres of knowledge, discourse, and activity.

In contrast to the older universal intellectual, whose model was the "man" fighting for universal justice, the notion of the specific intellectual derives from the savant or expert. This person "has at his disposal, whether in the service of the State or against it, powers which can either benefit or irrevocably destroy life."[35] Because of the potentially powerful implications of this position, the specific intellectual must be self-conscious in several ways: of class position, of the conditions of life and work (for instance, in the university, factory, or business), and of the specific politics of truth in a given society. The phrase "politics of truth" means that what counts as truth has an economic and political role in society. The particular social location of the intellectual allows that person access to and perception of a specific way in which truth functions. The intellectual's role, then, is to engage in analysis and action – theory *and* practice – at just this juncture. The organic or universal intellectual is replaced by the specific intellectual who struggles in a specific setting, within a specific community, for specific goals.

Julia Kristeva has taken both a broader and a narrower view of the intellectual, describing four types of dissident intellectuals in contem-

porary culture.³⁶ First is the rebel, who attacks political power, thereby remaining within the given master-slave couple. Second is the psychoanalyst, who resists systems such as religion and is able to challenge the all-embracing rationality that accompanies such totalizing systems. As an early student of the writings of Bakhtin and his circle, Kristeva's point here is similar to Bakhtin's critique of theoretism and all forms of monologism.³⁷ Third is the writer, who tries to produce texts outside the law (understood psychoanalytically in Kristeva's writing) and outside of patriarchy. Kristeva's fourth category is women, for whom sexual difference itself constitutes a form of dissidence.³⁸

In her discussion of what makes dissident writing possible, Kristeva suggests that exile is necessary. For Kristeva, ours is the age of exile. Exile is an existential state and exiles are persons living in that condition, where ties to country, family, or native language have been cut. Exiles are intellectuals who attack the premises of rationality, including the notion of a complete historical cycle, as it is expressed in language, institutions, and culture. The dissident intellectual ruthlessly and irreverently dismantles the processes by which thought is translated into ideological discourse, which then is itself translated into actual existence. This activity, while analytical, is also a particular form of action.

What is gained by calling the artist an intellectual? I concur with Gramsci that all persons, and hence all artists, are to some extent intellectuals (if they will only realize it) and that intellectual activity must be grounded in practice. However, I would modify Gramsci's understanding of the universal or organic intellectual who speaks with authority for and to the collective. Here I agree with Foucault. Many writers have extolled the virtues of the artist as universal prophet, the bringer of truth. Such a glorified understanding of the cultural role of the artist is appealing, especially because of the chronic global crises that threaten the continuance of life.

The claims to truth of the artist as a specific intellectual are much less grand, and a certain relativism must be understood as intrinsic to those claims. The issue of how to act, how to take a stand, in the midst of relative values is not easy to resolve. The emphasis should be on evaluating the relative worth of differing points of view with full consciousness of both the conflicts of interest that will arise and the disparity of resources among individuals and communities. Self-conscious and self-critical evaluation is absolutely essential.³⁹

The artist's particularity, defined in terms of gender, age, race, ethnicity, class, sexual preference, and other markers of difference, gives access to a more limited but also a potentially more transformative

sphere of imagination, vision, and action. Both Foucault and Kristeva point to the need for ideological analysis, although they use slightly different language. How is what counts as "truth" in a given sphere and a given time related to political or economic exigencies? How does a dominant ideology – for instance, that accumulating more money is better than voluntary poverty – influence the interaction of artists, dealers, and prospective investors?

Kristeva's concept of exile adds still another dimension to this understanding of the intellectual. If an artist takes seriously the values expressed here, and acts responsibly based on such values, this may involve the artist's cutting of previous ties and repudiation of financial success and of certain kinds of power. Living and work may become more of a risk.

Many commentators, cultural critics, and artists such as Joseph Beuys have noted that our society has completely integrated aesthetic production into commodity reproduction, with the serious consequence that most opposition or resistance can easily be co-opted or neutralized. But does this situation justify a retreat? Should artists decide to forgo risk taking? No. In the endless spiral of conflicting, contingent, and relative choices, we are still obligated to make ethical decisions. We must be willing to say, "here I stand," or collectively, "here we stand."[40] I see this willingness to risk taking a stand in the public sphere, even amid choices, the consequences of which we cannot know, as perhaps the most significant aspect of the artist's role as a public intellectual. Among the artists whose work I have discussed in these pages, Carrie Mae Weems stands out as one whose work asserts that not only can everyone be an artist (as Beuys insisted), but that everyone can be an intellectual insofar as they think and act on ideas.[41]

There are, of course, problems with the concept of the intellectual and with the way the intellectual life is actually lived.[42] Intellectuals may have a tendency toward introversion, retreat, and isolation from life. Their engagement with ideas, or with books and art or with electronic media, may give them a false sense of identification with change, especially if ideas are not actualized within a specific context. Further, their ability to communicate ideas with some fluency may give them an illusion of mastery, even when the ideas exist only in abstraction from life. Finally, to be an intellectual may be its own form of self-glorification, wherein the grandiosity of one's ideas is satisfactory for its own sake.

In general, for the artist to be a public intellectual in our culture, she or he must cultivate a number of psychological characteristics besides

those already mentioned: a willingness to engage in self-scrutiny and self-revision; adaptability; the capacity for empathy and compassion; the urge to explore the unfamiliar; and the ability to be comfortable with uncertainty, which means to have an open horizon and an openness to alternative possibilities of reflection and action. To engage life as a public intellectual means to be involved in continual processes of evaluating and diagnosing the present, seeking and evaluating choices, and locating and understanding differing points of view.[43] For an artist to engage life as a public intellectual means practicing ethical aesthetics, reconnecting the ethical and aesthetic dimensions of the world in her or his own work.

While working on this book, I was reminded of James Baldwin's essays, collected in *Nobody Knows My Name*. Indeed, Baldwin may have been the first prophetic writer I encountered as an adolescent. In "Notes for a Hypothetical Novel,"[44] Baldwin articulated ideas about the function of the writer in the United States that are directly relevant to what I have described about the prophetic and visionary vocation of the artist. To paraphrase him: The function of the artist is to describe things that other people are too busy to describe, to help transform this country. We – artists – have helped to create the country we are living in. Now *we must make it over*. For Baldwin, the central question in that essay concerned the fictions and illusions Americans have about freedom. Although many of those same fictions and illusions, *and* lack of freedom, racism, and oppression, persist today (in times of backlash like the present, they not only continue, but they even increase), still, the more pressing issue concerns the future. To work for pragmatic change, to end social injustice and economic inequity, is part of the struggle. There may not be much of a world at all unless we engage in the act of reenvisioning the future.

In such a context, the prophetic and critical voice and vision of the artist can provide alternatives. Describing the role of the Hebrew prophets, Abraham Heschel wrote vividly: "A people may be dying without being aware of it; a people may be able to survive, yet refuse to make use of their ability. . . . It is not a world devoid of meaning that evokes the prophet's consternation, but a world deaf to meaning."[45] Our contemporary context may well be a world in which people are dying, yet refuse to use their knowledge to survive, a world that can neither see nor hear what the prophetic, critical, and visionary artist has to say.

Reclamation is a powerful act, (re)constructive and imaginative. If many of us engage in such acts, from radically diverse perspectives, the future may indeed be different from what it would be without that

engagement. Still, none of what I have written is meant to imply that the artist is the "savior" of the world. Reclamation is not redemption. Admittedly, a messianic impulse informs my thinking: a passion that says, let us try to make the future different from the past and present. Let us try to create new human and humane possibilities; let trees live, let other life forms coexist beside us. The statement that artists cannot save the world, and no one else can – alone – bears repeating. We need communities of committed cultural workers, artists and others, whose attitudes of hope combine with creative passion to produce multifarious and heterotopian visions for the future.

Is the future at risk? I believe that it is, and I have tried to show how and why I hold this belief. Can it be reclaimed? We must live, and work, in the proverbial cloud of unknowing.

# A Final Image

I began this book with the image of Durga, the mighty Hindu goddess who conquered the demon that threatened the world, thus saving it from total annihilation, and with a personal narrative about the genesis of my thinking. I end it with a few further personal remarks and with the image of the Jewish-Christian-Muslim angel Gabriel.

A prophetic and visionary intention clearly informs *The Vocation of the Artist*. Prophetic and visionary utterances have often been demarcated by special framing devices, formulas that establish the significance and veracity of the speaker's voice and vision. In the Greco-Roman, Hebrew, and early Christian prophetic traditions, these include variations on six basic formulas.[1] The messenger formula – "Thus says Zeus" or "Thus says the Holy Spirit" – identifies the bearer of the prophecy. The commission formula – "Go and say to X, thus says Y" – commands the hearer to speak. The proclamation formula – "Let those with ears hear what the Spirit says" – gives directions about the address. The legitimation formula – "This is the Spirit of the Lord, which is not false" – often comes at the end of a prophecy and identifies the divine speaker. The oath formula – "I swear that what I say is true" – insures the veracity of the speaker and the speaker's statement. Finally, the mystery formula – "I tell you a mystery" or "I know a mystery" – is often used in describing the unfolding of future events.

This book makes use of various framing devices, especially the *epi-eikons* at the outset of each chapter, as well as the Preface and this final short chapter. If my use of these framing devices has any connection to the aforementioned formulas, it is to the last, the mystery formula. I clearly do not purport to have particular insight into the unfolding of events in the future, but my emphasis has been on attending to the past and present as they extend into the yet-to-be future.

"I tell you a mystery." Mystery is the ground of our existence. We do not know from whence we come in any ultimate sense, nor do we know where we are destined to go. There are both personal existential

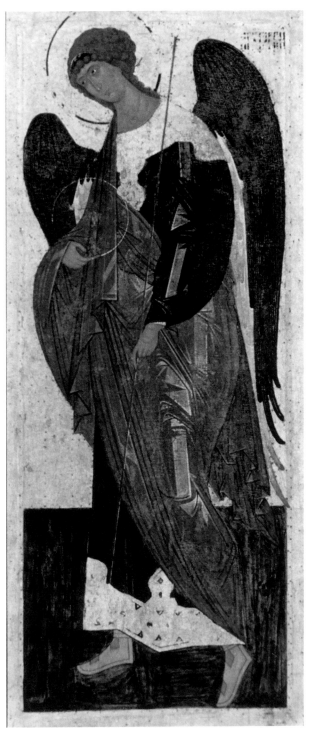

**Figure 35.** Dionysius and Workshop, *Archangel Gabriel*, 1502–3

and planetary dimensions to this. Death, to me, is the greatest of all mysteries, even more mysterious than birth. Even though we cannot know our personal futures, we speculate and plan. We know we will finally die, but most of us live life as if there will be a future. However, such awareness of personal mortality is not the only aspect of this great mystery.

One of my own larger goals is to understand, or at least to reflect about, the links between personal death and the social and planetary disintegration we are presently experiencing. By one model of encountering death, people go through stages of denial, anger, and then acceptance. We are clearly in a stage of planetary denial (at least most of us are). If we are dying as a species, then is the most appropriate response to inculcate acceptance? Or does one deal with the issue of denial first, with a campaign of confrontation? When dominant cultural practices are necrophilic, another response is to fling this necrophilia back at society in anger. An artist might present and re-present inner-city violence and environmental devastation, to name but two aspects of this death-loving and death-seeking compulsion. An alternative approach would be to promote biophilia, love of life in all of its multiplicity.

Our planet is dying: I know this is a controversial claim. But look at the trees; look at the contamination of the earth, the air, the water; look at the growing disparities between rich and poor in every nation. Pay attention to the ever-growing violence of everyday life. Electronic technologies, especially computers and television, promise a safe insulated life for many, especially in the United States. Still, some of us will ask, is a life lived through the screen really life at all?

Let me turn now to a final image, to an image of the angel Gabriel. If Durga saves the world from destruction, then Gabriel announces the possibility of the future. Obviously, there can be no casual or etiological relationship between these two, who occupy places in the mythologies of completely different cultures. Here they serve metaphoric purposes only, helping us literally to picture what this book is about.

Gabriel is a complex character who figures in Jewish, Christian, and Muslim texts. The name is related to a Sumerian root *GBR*, which means "gubernator" or "governor," and to *Gibor,* "power" or "hero." Unlike most other angels, Gabriel, it may be argued, is female: S/he sits on the left side of God, is the ruler of the first heaven, and hence is the closest to human beings. Popular lore also suggests that Gabriel instructs the soul to be born while it is in the womb.[2]

Gabriel is one of the four archangels and, with Michael, the highest ranking. These two are the only angels who appear by name in the

Hebrew Bible. Gabriel's most vivid appearance is when he helps Daniel to interpret an apocalyptic vision of the "time of the end" (Daniel 8: 17). Daniel's vision of the ram and the he-goat is interpreted as an oracle about the Greek overthrow of the Persians in power. But this grim function, of interpreting the end time, gradually shifts in later Christian and Muslim contexts.

In the New Testament gospels, Gabriel appears in Luke 1:11–20 and 1:26–38. First, he announces the miraculous birth of John the Baptist to Zechariah, whose aged wife Elizabeth is beyond childbearing years. He then tells a reluctant Mary of Jesus' impending birth. An unnamed angel, often interpreted as Gabriel, also appears to Joseph in Matthew 1:20–21 to announce that Mary's pregnancy before marriage had a divine origin and momentous consequences. From Giotto and Fra Angelico to Dante Gabriel Rosetti, European Christian painters have represented these events. Dionysius's famous icon of Gabriel (Figure 35), however, shows none of these events. Although intended as part of a deesis, Gabriel is alone.

But in the Islamic context Gabriel really comes into his own, playing a major role in the foundation of the tradition. He is well-known as the angel who brings revelation, the Qur'ān, to Muḥammad. In medieval Islamic philosophy and mysticism, writers such as Avicenna identified Gabriel with the Universal or Active Intellect, with which the human intellect aspires to be united. If Avicenna's ontology and metaphysics help to demonstrate the contingency of the Universe on God, the One, then his cosmology can be understood as outlining the continuities between God and all worldly manifestations.[3] Angels are crucial in his cosmological order, for they are the vehicles of creation. His angelic hierarchy depends upon the schema originally articulated by Plotinus, with ten orders of reality on a ladderlike hierarchy, from the One Necessary Being down to the First through Tenth Intellects. But Avicenna interpreted this schema differently than did Plotinus, extending it to include the emanation of the letters of the Arabic alphabet and the language of revelation in the Qur'ān.

Avicenna's psychology resembled Aristotle's, which is not surprising given that medieval Muslim philosophers were responsible for resuscitating interest in early Greek philosophy. The mineral, plant, and animal kingdoms also exist in a hierarchical relationship to one another: minerals lower than plants; plants and animals respectively incorporating all of the virtues of the lower kingdoms. Animals have the faculties of motion and desire, as well as the five external senses and five other internal senses ("the *sensus communis,* the power of retaining forms or

representation, sensitive imagination, estimation and retention, and recollection").[4] Human beings have all of the virtues of the mineral, plant, and animal kingdoms, but with humans a new faculty arises: the rational or human soul. The soul consists of four levels to which humans can aspire: *intellectus materialis,* which allows one to acquire knowledge; *intellectus in habitu,* which helps one develop correct thinking; *intellectus in actu,* which allows one to generate one's own thought; and *intellectus adeptus,* which is a special state open only to those who have perfected their nature. Above these lies the Universal or Active Intellect, identified with and visualized by Gabriel, the tenth angel, the Active Intellect, "the angel of revelation and Spirit of Holiness in the Qur'ān."[5] Angels were essential to Avicenna's world view, for they help to direct the universe and provide guidance for humans.

In the later Muslim sage Suhrawardi (1153–91), Gabriel is also identified as the supreme revealer of all knowledge. Suhrawardi's *Chant of the Wing of Gabriel* narrates how the human being is "a word of God and a chant of the wing of Gabriel."[6] Gabriel's wings extend over all of the heavens and earth, both the "Occident," the world of shadows shown as the shadow of the left wing, and the "Orient," the world of angelic lights reflected in the right wing. The chant itself is the sound of the wing. Thus, not only is Gabriel the source of the primary revelation of the tradition, the Qur'ān, but the sound of Gabriel's wing also brings forth human life.

I began *The Vocation of the Artist* with a meditation on a warrior goddess; I end it with an angel, whose wing can sing. We are the sound of this angel's wing, its chant. What, indeed *whether,* we will be in the future depends, however, not upon angels but upon us.

# Notes

**PREFACE**

1. Liz Stanley, *The Auto/Biographical I: The Theory and Practice of Feminist Auto/Biography* (Manchester: Manchester University Press, 1992); Bella Brodski and Celeste Schenck, eds., *Life/Lines: Theorizing Women's Autobiography* (Ithaca, NY: Cornell University Press, 1988); and Domna Stanton, ed., *The Female Autograph: Theory and Practice of Autobiography from the Tenth to the Twentieth Century* (Chicago: University of Chicago Press, 1984). Stanley's book contains an extensive bibliography.
2. Stanley, *Auto/Biographical I*, pp. 131–2. Stanley is paraphrasing Roland Barthes.
3. Stanley, *Auto/Biographical I*, p. 255.
4. Mary Caroline Richards, *Centering in Pottery, Poetry, and the Person* (Middleton, CT: Wesleyan University Press, 1964), pp. 5–6.
5. There are by now many books and articles on the Gaia Hypothesis, but an excellent beginning point, with articles by James Lovelock and Lynn Margulis, among others, is *Gaia: A Way of Knowing, Political Implications of the New Biology,* ed. William Irwin Thompson (Great Barrington, MA: Lindisfarne Press, 1987).
6. In Carol Becker, ed., *The Subversive Imagination: Artists, Society, and Social Responsibility* (New York: Routledge, 1994), p. 56.

**CHAPTER 1. INTRODUCTION**

1. Quoted in Manly P. Hall, *An Encyclopedic Outline of Masonic, Hermetic, Qabbalistic and Rosicrucian Symbolic Philosophy* (Los Angeles: Philosophical Research Society, 1977), p. lxxxiii.
2. Private conversation, March 26, 1995.
3. Ludwig Wittgenstein, *Culture and Value,* ed. G. H. von Wright, trans. Peter Winch (Chicago: University of Chicago Press, 1980), p. 3e.
4. Linda Nochlin, *The Politics of Vision: Essays on Nineteenth-Century Art and Society* (New York: Harper and Row, 1989), pp. xiv–xv.
5. The phrase "ethical aesthetics" was suggested to me by Barbara Stafford's use of "aesthetical ethics" in her *Body Criticism: Imaging the Unseen in Enlightenment Art and Medicine* (Cambridge, MA: MIT Press, 1991), pp. 470–1. The point with both terms is that the Enlightenment separation of ethics and aesthetics must be overcome.
6. Ellen Dissanayake, *Homo Aestheticus: Where Art Comes From and Why* (New York: Free Press, 1992), p. 223.
7. For discussion of some of the conflicts in this relationship, see Samuel Laeuchli, *Religion and Art in Conflict: Introduction to a Cross-Disciplinary Task* (Philadelphia: Fortress Press, 1980). A more affirmative attempt to reconnect reli-

gion to aesthetics is Frank Burch Brown's *Religious Aesthetics: A Theological Study of Making and Meaning* (Princeton, NJ: Princeton University Press, 1989). Here he explores the aesthetic dimension of religious experience and expression.

8. See Wilson Yates, *The Arts in Theological Education: New Possibilities for Integration* (Atlanta: Scholars Press, 1987), pp. 23–41. On the various kinds of theological interpretation in relation to the arts, see pp. 131–45. Although one must be careful in using the word "theology," which evolved in Jewish and Christian contexts, to discuss other world religions such as Buddhism or Hinduism where it is problematic to speak of a theology, I maintain that this term has heuristic value.

9. On the breadth-depth metaphor, see Stafford, *Body Criticism,* p. 39. On dealing with complex material complexly, p. 470.

10. See his essay, "On Thinking for Oneself," in *Complete Essays of Schopenhauer,* trans. T. Bailey Saunders (New York: Willey Book Company, 1942), pp. 42–55.

11. This idea about the value of postmodernist perspectives, especially for feminism, is given by Linda Nicholson, "Feminism and the Politics of Postmodernism," *boundary* 2 19 (Summer 1992): 68. The entire issue of the journal deals with feminism and postmodernism.

12. See Brown, *Religious Aesthetics.*

13. See, for instance, Hillel Schwartz, *Century's End: A Cultural History of the Fin de Siècle from the 990s to the 1990s* (New York: Doubleday, 1990); Saul Friedländer et al., *Visions of the Apocalypse: End or Rebirth?* (New York: Holmes and Meier, 1985); and Barry Brummet, *Contemporary Apocalyptic Rhetoric* (New York: Praeger, 1991).

14. Mikhail Bakhtin, "Author and Hero," in *Art and Answerability: Early Philosophical Essays by M. M. Bakhtin,* trans. Vadim Liapunov and Kenneth Brostrom, ed. Michael Holquist (Austin: University of Texas Press, 1990), p. 51.

15. Michael S. Roth, "We Are What We Remember (and Forget)," *Tikkun* 9 (November–December 1994): 41–2+.

16. William Olander, "Fragments," *The Art of Memory, The Loss of History* (New York: New Museum of Contemporary Art, 1985), p. 7.

17. Mark Freeman has defined a few of these myths in his study of artists and artistic creativity, *Finding the Muse: A Sociopsychological Inquiry into the Conditions of Artistic Creativity* (New York: Cambridge University Press, 1994).

18. See Rosemary Crumlin, ed., *Aboriginal Art and Spirituality* (North Blackburn, Victoria: Collins Dove, 1991); Terence Barrow, *Maori Art of New Zealand* (Paris: Unesco Press, 1978), esp. chapter two; and Jehanne Teilhet, "The Role of Women Artists in Polynesia and Melanesia," in *Art and Artists of Oceania,* eds. Sidney Mead and Bernie Kernet (Mill Valley, CA: Ethnographic Arts Publications, 1983).

19. This idea is developed in Margaret Ferguson and Jennifer Wicke, "Introduction," *boundary* 2 19 (Summer 1992): 7.

20. Richard Rorty, "The historiography of philosophy: four genres," in *Philosophy in History: Essays on the Historiography of Philosophy,* eds. Richard Rorty, J. B. Schneewind, and Quentin Skinner (Cambridge: Cambridge University Press, 1984), pp. 49–75, esp. 65–7.

21. Deborah Haynes, *Bakhtin and the Visual Arts* (New York: Cambridge University Press, 1995), esp. chapter seven.

22. This issue has been widely discussed. See, for instance, Nancy K. Miller, ed., *The Poetics of Gender* (New York: Columbia University Press, 1986); and Bar-

bara Christian, "The Race for Theory," *Feminist Studies* 14 (Spring 1988): 67–80.

23. Griselda Pollock, *Vision and Difference: Femininity, Feminism, and Histories of Art* (London: Routledge, 1988), p. 4. She is quoting Raymond Williams, *Problems in Materialism and Culture* (London: Verso, 1980), p. 46.

## CHAPTER 2. A PROPOSITION

1. For more on the concept of the chronotope, see Mikhail Bakhtin, *The Dialogic Imagination: Four Essays by M. M. Bakhtin*, ed. Michael Holquist, trans. Caryl Emerson and Michael Holquist (Austin: University of Texas Press, 1981).

2. Cornel West, *Prophetic Reflections: Notes on Race and Power in America* (Monroe, ME: Common Courage Press, 1993), p. 150. The foregoing assessment is set forth on pp. 148–9.

3. My thinking about this is indebted to Oleg Grabar.

4. Sharon Welch, *Communities of Resistance and Solidarity: A Feminist Theology of Liberation* (Maryknoll, NY: Orbis Press, 1985), p. 81.

5. Mary Daly, *Beyond God the Father: Toward a Philosophy of Women's Liberation* (Boston: Beacon Press, 1973). This idea is the foundation of her chapter, "After the Death of God the Father."

6. See Martin E. Marty and R. Scott Appleby, *Accounting for Fundamentalisms: The Dynamic Character of Movements* (Chicago: University of Chicago Press, 1994).

7. This theme, so central to the theological perspective of Gordon D. Kaufman, is further developed in Part III.

8. Hélène Cixous, *Coming to Writing and Other Essays*, ed. Deborah Jenson, trans. Sarah Cornell et al. (Cambridge, MA: Harvard University Press, 1991), p. 24.

## CHAPTER 3. VOCATION

1. Matthew Fox, *The Reinvention of Work: A New Vision of Livelihood for Our Time* (San Francisco: HarperSan Francisco, 1994), p. 105.

2. Miroslav Volf, in *Work in the Spirit: Toward a Theology of Work* (New York and Oxford: Oxford University Press, 1991), makes similar points, pp. 7–8. An excellent recent attempt to describe similarities and differences among attitudes and practices around work is *Comparative Work Ethics: Judeo-Christian, Islamic, and Eastern*, with essays by Jaroslav Pelikan, Joseph Kitagawa, and Seyyed Hossein Nasr (Washington, DC: Library of Congress, 1985). For the most comprehensive bibliography on comparative work ethics, see *A Bibliographic Guide to the Comparative Study of Ethics*, eds. John Carman and Mark Juergensmeyer (Cambridge, England: Cambridge University Press, 1991), esp. pp. 803–7.

3. Karl Holl, "Die Geschichte des Worts Beruf," *Gesammelte Aufsatze zur Kirchengeschichte*, Vol. 3 (Tübingen: Verlag von J. C. B. Mohr (Paul Siebeck), 1928), pp. 189–219. Translation available as a typed transcript at Andover-Harvard Library Archives: "The History of the Word Vocation (*Beruf*)," trans. Heber F. Peacock." For further reflections about the linguistic development of the word and related terms, see Max Weber, *The Protestant Ethic and the Spirit of Capitalism*, trans. Talcott Parsons (New York: Charles Scribner's Sons, 1958), notes to chapter 3, pp. 204–17. My account is based largely on these two sources.

4. Holl, "History of the Word Vocation," p. 14, and Weber, *Protestant Ethic.* Weber sees a larger role for monasticism than does Holl. Holl also mentions the importance of Berthold of Regensburg, Thomas Aquinas, and Tauler in developing the idea of vocation.

5. Holl, "History of the Word Vocation," pp. 19, 22.

6. Holl, "History of the Word Vocation," p. 20.

7. Weber, *Protestant Ethic*, pp. 80–1. See Martin Luther, *Luther's Works*, 55 vols., Jaroslav Pelikan and Helmut T. Lehmann, gen. eds. (Philadelphia: Fortress Press, 1958–86), especially Vol. 41, 177; Vol. 46, 252; Vol. 27, 56ff; Vol. 5, 311. Luther first used *Beruf,* "calling," in 1522 in a sermon of the *Kirchenpostille,* to mean both a sacred calling and an occupation. See Holl, "History of the Word Vocation," p. 34. Weber also takes up "Luther's Conception of the Calling" in *Protestant Ethic,* especially chapter 3. Weber claims that the use of *Beruf* had antecedents in sixteenth-century secular literature, as well as in biblical translations after the fifteenth century.

8. This is Volf's approach in *Work in the Spirit,* pp. 107–9. Volf wants to establish his own perspective based on *charisms,* or the multiple callings to work both in and out of the church that are reflected in the special gifts we all have. My agenda is different from Volf's in that I want to look behind Luther, to reclaim earlier senses of vocation, before it was secularized.

9. Volf, *Work in the Spirit,* p. 129.

10. Paul Althaus, *The Ethics of Martin Luther,* trans. Robert C. Schultz (Philadelphia: Fortress Press, 1972), p. 39.

11. Adam Smith, *An Inquiry into the Nature and Causes of the Wealth of Nations,* ed. Edwin Cannan (Chicago: University of Chicago Press, 1976); Karl Marx, *Karl Marx: A Reader,* ed. Jon Elster (Cambridge, England: Cambridge University Press, 1986); Sigmund Freud, *Civilization and Its Discontents,* trans. James Strachey (New York and London: W.W. Norton and Co., 1961); Hannah Arendt, *The Human Condition* (Chicago: University of Chicago Press, 1958); and Dorothee Soelle, *To Work and To Love: A Theology of Creation* (Philadelphia: Fortress Press, 1984).

12. Volf, *Work in the Spirit,* pp. 26–7. Volf's book is an excellent starting point for comparing Smith's and Marx's ideas about work.

13. Volf, *Work in the Spirit,* pp. 49–50.

14. George Stigler, "Preface," Smith, *Wealth of Nations,* p. xii.

15. Volf, *Work in the Spirit,* p. 57.

16. Bakhtin, "Problems of Content, Form, and Material in Verbal Art," in *Art and Answerability,* p. 279.

17. In Elster, *Karl Marx: A Reader,* p. 41.

18. In *Capital I,* excerpted in Elster, *Karl Marx: A Reader,* p. 76.

19. Erich Fromm, *Marx's Concept of Man* (New York: Frederick Ungar Publishing Co., 1961), pp. 41–2. Fromm's book also includes the first English translation of Marx's *Economic and Philosophical Manuscripts,* by T. B. Bottomore.

20. Volf, *Work in the Spirit,* p. 54.

21. Volf, *Work in the Spirit,* p. 58.

22. For an excellent survey of Marxist and earlier concepts of alienation back to the Hebrew Bible, see *A Dictionary of Marxist Thought,* ed. Tom Bottomore (Cambridge, MA: Harvard University Press, 1983), pp. 9–15. Erich Fromm also describes his interpretation of this development in *Marx's Concept of Man,* pp. 44–6.

23. Soelle, *To Work,* pp. 55–7.

24. Volf, *Work in the Spirit,* p. 60.

25. Marx, *Economic and Political Manuscripts of 1844*, in Fromm, *Marx's Concept*, p. 151.
26. Freeman, *Finding the Muse*, pp. 272, 280.
27. Freud, *Civilization and Its Discontents*, p. 36.
28. Freud, *Civilization and Its Discontents*, p. 29.
29. This is Richard D. Altick's formulation of the time in the "Introduction" to Carlyle's *Past and Present* (New York: New York University Press, 1965), pp. x, xi.
30. Carlyle, *Past and Present*, p. 201.
31. Carlyle, *Past and Present*, p. 196, 197. Whether and in what ways Carlyle saw his statement as applicable to both men and women is hard to assess here. But in another book, *On Heroes and Hero Worship* (1840), he clearly saw sincerity, originality, and inspiration as qualities of the male artistic genius. See Christine Battersby's discussion of Carlyle's ideas in *Gender and Genius: Towards a Feminist Aesthetics* (Bloomington: Indiana University Press, 1989), pp. 13–14.
32. The painting is in Manchester, England, and measures 54" × 77.75".
33. Eric Gill, *A Holy Tradition of Working: Passages from the Writings of Eric Gill* (Ipswich: Golgonooza Press, 1983).
34. Gill, *Holy Tradition*, pp. 44, 103.
35. Gill, *Holy Tradition*, p. 120.
36. Gill, *Holy Tradition*, p. 131.
37. Studs Terkel, *Working: People Talk About What They Do All Day and How They Feel About What They Do* (New York: Pantheon Books, 1972).
38. Arendt, *Human Condition*, p. 19.
39. See Arendt's chapter on "Labor," *Human Condition*, pp. 79–135.
40. Arendt, *Human Condition*, p. 133. See her chapter "Work," pp. 136–74.
41. Arendt, *Human Condition*, p. 151.
42. Arendt, *Human Condition*, p. 184.
43. These three ideas are developed by Soelle, *To Work*, pp. 83–113.
44. Donald Hall, *Life Work* (Boston: Beacon Press, 1993), p. 68.
45. Arendt, *Human Condition*, p. 5.

## CHAPTER 4. THE EFFICACY OF ART

1. Quoted in Norma Broude and Mary D. Garrard, eds., *The Power of Feminist Art: The American Movement of the 1970s, History and Impact* (New York: Harry N. Abrams, 1994), p. 149.
2. Ibid., p. 299. See also Suzanne Lacy, "In Mourning and In Rage (with Analysis Aforethought)," in *Femicide: The Politics of Woman Killing*, ed. Jill Radford and H. Diane Russell (New York: Twayne/Maxwell Macmillan International, 1992).
3. Hans Belting, *Likeness and Presence: A History of the Image before the Era of Art*, trans. Edmund Jephcott (Chicago: University of Chicago Press, 1994).
4. See, in addition to Belting, *Likeness and Presence*, David Freedberg, *The Power of Images: Studies in the History and Theory of Response* (Chicago: University of Chicago Press, 1989); Susanne Kappeler, *The Pornography of Representation* (Minneapolis: University of Minnesota Press, 1986); Annette Kuhn, *The Power of the Image: Essays on Representation and Sexuality* (London: Routledge and Kegan Paul, 1985); Margaret R. Miles, *Carnal Knowing: Female Nakedness and Religious Meaning in the Christian West* (Boston: Beacon Press, 1989), and *Image as Insight: Visual Understanding in Western Christianity and Secular Culture* (Boston: Beacon Press, 1985); Craig Owens, "Representation,

Appropriation and Power," *Art in America* 70 (May 1982): 9–21, as well as his essays, collected in *Beyond Recognition: Representation, Power, and Culture* (Berkeley: University of California Press, 1992); and W. J. T. Mitchell, *Iconology: Image, Text, Ideology* (Chicago: University of Chicago Press, 1986).

5. Freedberg, *Power of Images*, 26, xxii.

6. For more on the iconoclastic controversies, see: L. W. Barnard, *The Graeco-Roman and Oriental Background of the Iconoclastic Controversy* (Leiden: Brill, 1974); Edwyn Bevan, *Holy Images: An Inquiry into Idolatry and Image-Worship in Ancient Paganism and in Christianity* (London: George Allen and Unwin, 1940); Anthony Bryer and Judith Herrin, eds., *Iconoclasm: Papers Given at the Ninth Spring Symposium of Byzantine Studies* (Birmingham: Centre for Byzantine Studies, 1977); Carl C. Christensen, *Art and the Reformation in Germany* (Athens: Ohio University Press, 1979); Joseph Gutmann, ed., *The Image and the Word: Confrontations in Judaism, Christianity and Islam* (Missoula, MT: Scholar's Press, 1977); Ernst Kitzinger, *The Cult of Images in the Age Before Iconoclasm* (Cambridge, MA: Harvard University Press, 1954); E. J. Martin, *A History of the Iconoclastic Controversy* (London, 1930; reprint, New York: Macmillan, 1978).

7. See *Saint Bonaventura: The Soul's Journey to God*, trans. Ewert Cousins (New York: Paulist Press, 1978); and Thomas Aquinas, *Commentarium super libros sententiarum: Commentum in librum III*, dist. 9, art. 2, qu. 2, discussed in Freedberg, *Power of Images*, p. 162.

8. Mitchell, *Iconology*, p. 113.

9. In John Calvin, *Institutes of the Christian Religion*, in two volumes, Library of Christian Classics, Vol. 20, ed. John T. McNeill, trans., Ford Lewis Battles (Philadelphia: Westminster Press, 1960), 1.11.12.

10. Freedberg, *Power of Images*, p. 316. Freedberg, of course, is not the first to speak of the body in art historical discourse. Feminist art historians and film critics such as Lisa Tickner and Laura Mulvey, and interdisciplinary scholars such as Margaret Miles, preceded Freedberg in their insistence on the important role of the body.

11. Ibid., p. 191.

12. Ibid., p. 430.

13. See Miles, *Carnal Knowing*, esp. her appendix titled "The Power of Representation – Productive or Repressive?," pp. 187–90.

14. Miles, *Carnal Knowing*, p. 187–8. Miles is quoting Frigga Haug, *Female Sexualization* (London: Verso, 1987), p. 204.

15. Miles, *Carnal Knowing*, p. 188.

16. Foucault's vivid and unsettling description of this process is the subject of *Discipline and Punish: The Birth of the Prison*, trans. Alan Sheridan (New York: Vintage Press, 1979), especially the last chapter, "The Carceral."

17. Miles, *Image as Insight*, p. 36.

18. In Susanne Langer, *Philosophical Sketches* (New York: Mentor Books, 1962), p. 90.

19. Langer, *Philosophical Sketches*, p. 93.

20. See Haynes, *Bakhtin and the Visual Arts*, esp. Chapter Four for more on these issues. Just how images are productive needs to be studied in greater depth.

21. Griselda Pollock, *Vision and Difference: Femininity, Feminism and the Histories of Art* (London: Routledge, 1988), p. 6.

22. Pollock, *Vision and Difference*, p. 20.

23. This is a major theme in Barbara Stafford's *Body Criticism: Imaging the Unseen in Enlightenment Art and Medicine* (Cambridge, MA: MIT Press, 1991).

24. In *Power of Images,* p. 61. Freedberg mentions the work of Xenophanes, Heraclitus, Antisthenes the Cynic, and Zeno the Stoic as exemplifying this view. See Moshe Barasch, *Theories of Art from Plato to Winckelmann* (New York and London: New York University Press, 1985) for further discussion of Greek iconoclasm.

25. See his *Orthodox Faith,* in *Saint John of Damascus, Writings,* trans. Frederic H. Chase, Jr. (New York: Fathers of the Church, 1958), esp. IV.16, pp. 370–3; and Saint John of Damascus, *On the Divine Images,* trans. David Anderson (Crestwood, NY: Saint Vladimir's Seminary Press, 1980).

26. Henry Maguire, *Art and Eloquence in Byzantium* (Princeton, NJ: Princeton University Press, 1981), p. 10.

27. Quoted in Bryer and Herrin, *Iconoclasm,* p. 181.

28. John of Damascus, *On Divine Images,* pp. 18, 20.

29. See Martin, *A History of the Iconoclastic Controversy,* p. 136; and George Galavaris, *The Icon in the Life of the Church* (Leiden: Brill, 1981), p. 3.

30. Freedberg, *Power of Images,* p. 166. A nascent theory of signs is articulated in Augustine's *Confessions* X.6. See *Saint Augustine Confessions,* trans. R. S. Pine-Coffin (New York: Penguin Books, 1961), pp. 211–13.

31. These are listed in Chapter 1.6 of *The Soul's Journey.* As translator Ewert Cousins notes, for Bonaventure conscience is "the natural tendency of the soul toward goodness," p. 62.

32. Ibid., p. 75–6, Chapter 2.11.

33. Ibid., p. 77, Chapter 2.13.

34. Freedberg, *Power of Images,* p. 166.

35. For a description of how Lessing defined this, see his 1766 *Laocoön: An Essay upon the Limits of Poetry and Painting,* trans. Ellen Frothingham (New York: Noonday Press, 1957), p. 63.

36. Though marginally Marxist, Greenberg argued (persuasively to many) that focusing on the formal aspects of an art work, such as the flatness of painting after the Cubists, was more important than dealing with its subject matter or context. Greenberg wrote many essays touching on this topic, but see especially, "The Crisis of the Easel Picture," *Partisan Review* 4 (1940): 154–7; "After Abstract Expressionism," *Art International* 6 (October 1962): 24–32; and "Modernist Painting" in *The New Art: A Critical Anthology,* ed. Gregory Battcock (New York: Dutton, 1966), pp. 100–10. All of Greenberg's essays have now been collected in *Clement Greenberg: The Collected Essays and Criticism,* ed. John O'Brian, 4 vols. (Chicago: University of Chicago Press, 1986–93).

37. Freedberg, *Power of Images,* p. 374.

38. Herbert Marcuse, *The Aesthetic Dimension: Toward a Critique of Marxist Aesthetics* (Boston: Beacon Press, 1978). I am grateful to Carol Becker's essay, "Herbert Marcuse and the Subversive Potential of Art," for bringing my attention back to Marcuse, whose work I originally encountered many years ago. Her essay appears in *The Subversive Imagination: Artists, Society, and Social Responsibility,* ed. Carol Becker (New York: Routledge, 1994), pp. 113–29. Becker's questions are related to my own: Where do artists fit within the dynamics of a democratic society? What is the responsibility of the artist to society, and of society to the artist? When and where have artists really had an impact? Can artists interested in producing nonobject objects succeed in refusing the dynamics of bourgeois society and capitalism? An insightful interview with Marcuse appears in Richard Kearney, *Dialogues with Contemporary Continental Thinkers: The Phenomenological Heritage* (Manchester: Manchester University Press, 1984).

39. See Chapter Four of my *Bakhtin and the Visual Arts* for a discussion of outsideness.

40. Marcuse, *Aesthetic Dimension,* p. 9.

41. Kearney, *Dialogues,* p. 74.

42. Ibid., p. 86.

43. Marcuse, *Aesthetic Dimension,* pp. 32–3.

44. Ibid., p. xiii.

45. Ibid., p. 40.

46. Ibid., pp. 13, 29, 45.

47. Kearney, *Dialogues,* pp. 76–7. These seem to me a variation on the two primary functions of art discussed earlier.

48. A recent interview with both artists speaks to these issues: Martha Burkirk, "Interviews with Sherrie Levine, Louise Lawler, and Fred Wilson," *October* 70 (Fall 1994): 99–112.

49. See Patterson Sims, *The Museum: Mixed Metaphors* (Seattle: Seattle Art Museum, 1993), p. 29.

50. Ibid., p. 3.

51. Becker names these briefly in *Subversive Imagination.*

52. Kearney, *Dialogues,* p. 83.

53. Ibid., pp. 64–5.

54. Becker, *Subversive Imagination,* p. 127.

55. This has been well understood by contemporary critics such as Dave Hickey, whose *Invisible Dragon: Four Essays on Beauty* (Los Angeles: Art Issues, 1994) addresses beauty in relation to ugliness. Nineteenth-century interest in "the ugly" as an aesthetic category had its origins with Victor Hugo's 1827 play *Cromwell.* Hugo insisted that to have a full cognition and rendering of nature, the ugly must be depicted, along with the beautiful. It exists, therefore it must be shown. Karl Rosenkranz, in his *Aesthetik des Hässlichen,* similarly asserted that the ugly should be considered because it is necessary in order to understand beauty. See Barasch, *Modern Theories,* pp. 378–9.

56. I thank Adrianne Aron for presenting her translation of this play in Cambridge, Massachusetts, in June 1994.

57. Kearney, *Dialogues,* p. 77.

58. Quoted in Suzi Gablik, *The Reenchantment of Art* (New York: Thames and Hudson, 1991), p. 14.

59. Gablik, *Reenchantment of Art,* p. 25.

60. Marcuse, *Aesthetic Dimension,* p. 69.

61. Becker, *Subversive Imagination,* pp. 117, 115.

62. Kearney, *Dialogues,* p. 84. See Martin Heidegger, *What Is Called Thinking?,* trans. Fred D. Wieck and J. Glenn Gray (New York: Harper and Row, 1968). Just mentioning Heidegger here invokes the question of how one uses the authoritative voices of others, as well as the larger question of the relationship between a philosopher's ideas and life practice. See Richard Wolin, ed., *The Heidegger Controversy* (Cambridge, MA: MIT Press, 1993) for a sampling of the debates about Heidegger's Nazism, the usefulness of his work, and an excellent bibliography. An exchange of letters between Marcuse and Heidegger is also included, pp. 152–64.

63. Anaïs Nin, *The Diary of Anaïs Nin, 1939–44,* ed. Gunther Stuhlmann (New York: Harcourt, Brace and World, 1969), p. 299.

64. Lucy Lippard, "First Strike for Peace," *Heresies* 20 (1988): 15.

65. Martin Walsor, quoting Brecht in "A Beautiful Life: A Sermon on the Occasion

of the 25th Anniversary of the Death of Bertolt Brecht," trans. Gitta Honegger, *Performing Arts Journal* 17 (1982): 42.

## CHAPTER 5. PREMODERN THEOCENTRIC MIMETIC CRAFTSPERSON

1. For more on this type of thangka, see E. Olson, "The Wheel of Existence," *Oriental Art* 9 (1963): 2–7; Lama Anagarika Govinda, *Foundations of Tibetan Mysticism* (York Beach, ME: Samuel Weiser, 1969), pp. 234–57; Blanche Christine Olschak with Geshé Thupten Wangyal, *Mystic Art of Tibet* (Boston: Shambhala, 1987), pp. 106–7; and *Catalog of the Tibetan Collection and Other Lamaist Material in the Newark Museum*, Vol. 3 (Newark, NJ: Newark Museum, 1971), plate 24 and description.

2. Three of these categories come from Richard Kearney, *Wake of Imagination*, pp. 12–13. I have added avant-garde artist as prophet, which specifies the modern in particular ways.

3. Barnett Newman, "The Sublime Is Now," in Herschel B. Chipp, *Theories of Modern Art: A Source Book by Artists and Critics* (Berkeley: University of California Press, 1968), p. 553.

4. For careful treatment of naive art, see Oto Bihalji-Merin, *Masters of Naive Art: A History and Worldwide Survey*, trans. Russell M. Stockman (New York: McGraw Hill, 1971); and Jane Kallin, *The Folk Art Tradition: Naive Painting in Europe and the United States* (New York: Viking Press, 1982). On Harriet Powers's biblical quilts, see Marie Jeanne Adams, "The Harriet Powers Pictorial Quilts," *Black Art* 3 (1979): 12–28.

5. Adams, "Harriet Powers," p. 16. See also pp. 24–5 on possible African influence.

6. Merry E. Wiesner-Hanks, "Artisans," in *Encyclopedia of Social History*, ed. Peter N. Stearns (New York and London: Garland Publishing, 1994), pp. 55–6. Besides this excellent article, my summary here is based on several sources: the *Encyclopedia of Social History* article titled "Guilds"; the *Encyclopedia Britannica* entry "Work"; two volumes of *The Cambridge Economic History of Europe*, Vol. 3, *Economic Organization and Policies in the Middle Ages*, ed. M. M. Postan, E. E. Rich, and Edward Miller (Cambridge: Cambridge University Press, 1963), esp. Chapter V, "The Gilds," and Vol. 5, *The Economic Organization of Early Modern Europe*, ed. E. E. Rich and C. H. Wilson (Cambridge: Cambridge University Press, 1977), esp. Chapter VII, "The Organization of Industrial Production"; and Andrew Martindale, *The Rise of the Artist in the Middle Ages and Early Renaissance* (New York: McGraw Hill, 1972), esp. Chapter One.

7. These are some of the areas of discussion in Arnold Hauser's self-consciously conjectural account of the changing role of the artist in prehistory and recorded history, in *The Sociology of Art*, trans. Kenneth J. Northcott (Chicago: University of Chicago Press, 1982), esp. pp. 243–66.

8. George Galavaris, *The Icon in the Life of the Church: Doctrine, Liturgy, Devotion* (Leiden: E. J. Brill, 1981), pp. 1–2. General information about the early history of icons can be gleaned from many sources: Boris Uspensky, *Semiotics of the Russian Icon*, ed. Stephen Rudy (Lisse: Peter de Ridder Press, 1976); M. Alpatov, *Color in Early Russian Icon Painting* (Moscow: Isobrazitelnoye Iskusstvo, 1974); Nikolai A. Vorobyev, *History and Art of the Russian Icon, from the Tenth to the Twentieth Centuries*, trans. Boris M. Meerovich, ed. Lucy Maxym (Manhasset, NY: Siamese Imports, 1986); Cyril G. E. Bunt, *Russian*

*Art, from Scyths to Soviets* (London: Studio, 1946); H. P. Gerhard, *The World of Icons* (New York: Harper and Row, 1957); Kurt Onasch, *Icons* (New York: A. S. Barnes, 1963); and John Stuart, *Ikons* (London: Faber and Faber, 1975). On the history of Orthodoxy in Russia, see Timothy Ware, *The Orthodox Church*, reprint ed. (New York: Penguin, 1993), and David MacKenzie and Michael W. Curran, *A History of Russia, the Soviet Union, and Beyond* (Belmont, CA: Wadsworth Publishing, 1993).

9. I first heard the phrase "saccharine style" in a conversation with the art historian A. Dean McKenzie in 1987, though it also appears in various texts.

10. Ware, *Orthodox Church*, pp. 231–8. See also Constantine Cavarnos, *Orthodox Iconography* (Belmont, MA: Institute for Byzantine and Modern Greek Studies, 1977), especially Chapter 3, "The Functions of Icons"; and Belting, *Likeness and Presence*, pp. 203–4, 314–23.

11. Quoted in Tamara Talbot Rice, *Russian Icons* (London: Spring Books, 1963).

12. Uspensky, *Semiotics*, p. 10. He is quoting from the preface to a manuscript *podlinnik*, a practical manual on icon-painting used in Russia.

13. Uspensky, *Semiotics*, p. 10.

14. For a detailed description of how this process evolved, see Robert L. Nichols, "The Icon in Russia's Religious Renaissance," in William Brumfield and Milos M. Velimirovic, eds., *Christianity and the Arts* (New York: Cambridge University Press, 1991), pp. 131–44. Cf. George Galavaris, *Icons from the Elvehjem Art Center* (Madison: University of Wisconsin Press, 1973), p. 29.

15. John Baggley, *Doors of Perception: Icons and Their Spiritual Significance* (Crestwood, NY: St. Vladimir's Seminary Press, 1988), pp. 56–7. For direct experience of many of the ideas discussed here, I thank iconographer Tom Howard, whose icon workshop I attended during the summer 1994 at the Grünewald Guild near Leavenworth, Washington.

16. See Maxim Gorky, "In the World," in *Autobiography of Maxim Gorky*, trans. Isidor Schneider (London: Elek Books, 1953), especially chapters 12–14 about his experience working in an icon-painting shop. Gorky presents a grim picture of the boredom and discontent among apprentices and workers in the late nineteenth century. A more positive image is given by Nichols in "The Icon in Russia's Religious Renaissance," pp. 140–1.

17. This understanding of the role of the painter is articulated in Galavaris, *Icons from the Elvehjem*, p. 29.

18. Pavel Florenskii, "On the Icon," in *Eastern Churches Review* 8/1 (1976): 18. The full text of Florenskii's "Stat'i po iskusstvu" [Articles on Art] was published in *Sobranie Sochinenii I* (Paris: YMCA Press, 1985), pp. 33–352.

19. Baggley, *Doors*, pp. 62–74.

20. *The Philokalia: The Complete Text*, comp. St. Nikodimos of the Holy Mountain and St. Makarios of Corinth, trans. G. E. H. Palmer, Philip Sherrard, and Kallistos Ware (London: Faber and Faber, 1979), Vol. 1, p. 163.

21. Florenskii, "On the Icon," p. 30.

22. See Helmut Hoffman, "Early and Medieval Tibet," in *The Cambridge History of Early Inner Asia*, ed. Denis Sinor (Cambridge: Cambridge University Press, 1990), pp. 371–99; and Marylin M. Rhie and Robert A. F. Thurman, *Wisdom and Compassion: The Sacred Art of Tibet* (New York: Harry N. Abrams, 1991), esp. pp. 20–38 on the general history of Tibet, of Buddhism, and of the artistic traditions in Tibet. Other interpretations of this history, from which some of the details of my account are drawn, come from George Roerich, *Tibetan Paintings* (Paris: Librairie Orientaliste, 1925); David Snellgrove and

Hugh Richardson, *A Cultural History of Tibet* (New York: Frederick A. Praeger, 1968); Pratapaditya Pal and Hsien-ch'i Tseng, *Lamaist Art: The Aesthetics of Harmony* (Boston: Museum of Fine Arts, 1969); and *Catalog, Newark Museum*, Vol. 3.

23. S. K. Pathak, *The Album of the Tibetan Art Collections* (Patna: Kashi Prasad Jayaswal Research Institute, 1986), p. 18.

24. For the modern Chinese perspective on these developments, see Ngapo Ngawang Jigmei et al., *Tibet* (New York: McGraw-Hill, 1981), and Liu Lizhong, *Buddhist Art of the Tibetan Plateau*, ed. and trans. Ralph Kiggell (San Francisco: China Books and Periodicals, 1988). A fascinating and detailed account of the evolution of the Tibetan mandala from Chinese bronze mirrors is given in Schuyler Cammann, "Suggested Origin of the Tibetan Mandala Paintings," *The Art Quarterly* (Spring 1950): 107–19. This article highlights the ongoing debate about the nature and extent of Indian and Chinese influences on Tibetan Buddhist art.

25. Thurman, "Tibet, Its Buddhism," in *Wisdom*, p. 31.

26. A date of 1479, given in *Catalog, Newark Museum*, p. 43, has since been extended back in time. Other details about the purposes of thangkas and their iconography can be found in P. H. Pott, *Introduction to the Tibetan Collection of the National Museum of Ethnology, Leiden* (Leiden: E. J. Brill, 1951), p. 58; Pal and Tseng, *Lamaist Art*, pp. 24–5; and Lokesh Chandra, *Buddhist Iconography of Tibet*, 2 vols. (Kyoto: Rinsen Book Co., 1986). The latter is one of the most complete sources of drawings for thangkas and other paintings. Descriptions of the actual processes of painting and consecrating a thangka are elaborated in Roerich, *Tibetan Paintings*, pp. 16–21; Pott, *Introduction*, pp. 49–51; and Marco Pallis, *Peaks and Lamas* (London: Cassell, 1939), pp. 336–8.

27. Materials about the training of thangka painters are few. The information here is gleaned from the following sources: David P. Jackson and Janice A. Jackson, *Tibetan Thangka Painting: Methods and Materials* (London: Serindia Publications, 1984); Gega Lama, *Principles of Tibetan Art: Illustrations and Explanations of Buddhist Iconography and Iconometry According to the Karma Gardri School*, 2 vols. (Darjeeling: Jamyang Singe, 1983); and Pratapaditya Pal, *Art of Tibet: A Catalogue of the Los Angeles County Museum of Art Collection* (Berkeley: University of California Press, 1983). See also A. Macdonald and A. V. Stahl, *Newar Art: Nepalese Art during the Malla Period* (Warminster, England: Aris and Phillips, 1979); G. Tucci, *Tibetan Painted Scrolls*, 3 vols. (Rome: La Libreria Dello Strato, 1949), pp. 271ff.; Loden Sherap Dagyab, *Tibetan Religious Art* (Wiesbaden: Otto Harrassowitz, 1977); and Olschak, *Mystic Art of Tibet*.

28. Pal and Tseng, *Lamaist Art*, p. 23.

29. Dagyab, *Tibetan Religious Art*, p. 37.

30. See P. N. Goswamy and A. L. Dahmen-Dallapiccola, *An Early Document of Indian Art* (New Delhi: Manohar Book Service, 1976), p. 24, n. 36. Also Mathew Kapsner, "Thanka Painting," *Chö Yang: The Voice of Tibetan Religion and Culture* 3, ed. Pedron Yeshi (no date): 17–24, esp. p. 20.

31. Pal, *Art of Tibet*, pp. 51–3. Loden Dagyab also names famous artists, their schools and influences in *Tibetan Religious Art*, pp. 36–8.

32. This value is particularly linked to Vajrayana Buddhism, the "third vehicle." The first, Monastic or Individual, corresponds to but is not the same as today's Theravada Buddhism. The second, Universal Vehicle, is Mahayana. The third,

Vajrayana, the Apocalyptic or Tantric Vehicle, is seen as the esoteric aspect of the second. For a brief and clear discussion of these distinctions, see Rhie and Thurman, *Wisdom and Compassion*, p. 24.

33. Mikhail Bakhtin, "Discourse in the Novel," in *The Dialogic Imagination: Four Essays by M. M. Bakhtin,* ed. Michael Holquist, trans. Caryl Emerson and Michael Holquist (Austin: University of Texas Press, 1981), p. 421.

34. Mikhail Bakhtin, *Speech Genres and Other Late Essays,* trans. Vern W. McGee, eds. Caryl Emerson and Michael Holquist (Austin: University of Texas Press, 1986), p. 170.

35. One of the few articles on the effects of cultural dislocation on Tibetan art, which examines positive as well as negative consequences, is Clare Harris, "Desperately Seeking the Dalai Lama," in *Disrupted Borders: An Intervention in Definitions of Boundaries,* ed. Sunil Gupta (London: Rivers Oram Press, 1993), pp. 104–14.

36. Lewis Hyde, *The Gift: Imagination and the Erotic Life of Property* (New York: Random House, 1983), p. 274.

37. I developed this idea further in *Bakhtin and the Visual Arts* (New York: Cambridge University Press, 1995), esp. Chapter 3.

38. Hyde, *The Gift,* p. 148.

39. I must credit this particular way of describing silence in the studio to Carol Becker, from a conversation at the School of the Art Institute of Chicago, November 1994.

40. Donald Hall develops these ideas concerning contentment in *Life Work* (Boston: Beacon Press, 1993), pp. 23–6.

41. Stafford, *Body Criticism,* p. 471.

## CHAPTER 6. MODERN ANTHROPOCENTRIC ORIGINAL INVENTOR

1. Joseph Leo Koerner, *The Moment of Self-Portraiture in German Renaissance Art* (Chicago: University of Chicago Press, 1993), p. xviii.

2. Ibid., p. 21.

3. Ibid., p. 35.

4. This is the approach Cornel West has taken in *Prophetic Thought in Postmodern Times* (Monroe, ME: Common Courage Press, 1993), pp. 7–10. In fact, I have found West's historical interpretations insightful in general and draw on those insights throughout my narrative. In *Prophesy Deliverance* (Philadelphia: Westminster Press, 1982), West developed another persuasive account of the development of the modern period, relying on the work of Ernst Cassirer, Peter Gay, Ernst Troeltsch, Theodor Adorno, and Max Horkheimer.

5. The following is a more detailed description of ideas that appear in my *Bakhtin and the Visual Arts* (New York: Cambridge University Press, 1995), Chapter Seven.

6. Nicholas V. Riasanovsky, in *The Emergence of Romanticism* (New York: Oxford University Press, 1992), has noted that "romanticism was produced only by Western Christian civilization.... In my view, it would be likely to emerge independently only if another civilization had a concept of God and of man's relation to God at least very similar to the Christian," p. 83. In short, the development of Romanticism is intimately linked to Christian beliefs and Christian culture.

7. These categories come from Peter Gay's *The Enlightenment: An Interpretation,* 2 vols. (New York: Alfred A. Knopf, 1966).

8. See Raymond Williams, *The Country and the City* (New York: Oxford University Press, 1973).

9. This is part of Ernest Mandel's thesis that the three fundamental stages in the evolution of capitalism can be linked to types of technology and artistic developments. See his *Late Capitalism,* trans. Joris De Bres (London: NLB, 1975). Mandel's ideas have been expounded by Fredric Jameson in the title essay in *Postmodernism, or, the Cultural Logic of Late Capitalism* (Durham, NC: Duke University Press, 1991).

10. This is precisely the theme taken up by Ann Bermingham, *Landscape and Ideology: The English Rustic Tradition, 1740–1860* (Berkeley: University of California Press, 1986).

11. David MacKenzie and Michael W. Curran, *A History of Russia, the Soviet Union, and Beyond* (Belmont, CA: Wadsworth Publishing Company, 1993), p. 423.

12. A. A. Fyodorov-Davydov, *Isaac Ilyich Levitan: His Life and His Work, 1860–1900* (Moscow: Iskusstvo, 1976), pp. 13, 9. So far there has been no thorough study of Levitan's life and work, although Fyodorov-Davydov has published this book and articles on the artist. His essay in *Levitan* (Leningrad: Aurora Art Publishers, 1988) summarizes the same information but fails to take account of the general apocalyptic climate of the last years of the nineteenth century. Levitan's letters and other documents have been published as *Levitan: Pis'ma, dokumenti, vospominaniia* (Moscow: Iskusstvo, 1956).

13. Levitan, *Pis'ma,* p. 30. He wrote the letter in 1887.

14. Sarah Pratt, *Russian Metaphysical Romanticism: The Poetry of Tiutchev and Boratynskii* (Stanford, CA: Stanford University Press, 1984), pp. 42–3. Pratt develops these concepts in relation to literature, but I think they are equally applicable to painting.

15. Christine Battersby, *Gender and Genius: Towards a Feminist Aesthetics* (Bloomington: Indiana University Press, 1989), p. 26.

16. For a good summary of these distinct ideas about alienation, see Raymond Williams, *Keywords: A Vocabulary of Culture and Society,* 2nd ed. (New York: Oxford University Press, 1983), pp. 33–6.

17. Especially see Vol. 1, *The Rise of Modern Paganism,* of Gay's two-volume *The Enlightenment.*

18. Bernard Smith, *The Death of Artist as Hero: Essays in History and Culture* (Melbourne: Oxford University Press, 1988), pp. 8–9. I have found Smith's interpretation of the artist as hero quite persuasive and I build on it in what follows. But one of the important elisions in Smith's account of the mythologies surrounding the artist concerns unacknowledged assumptions around gender. The failure to consider the extent to which common models of the artist as hero, mystic visionary, or prophet are founded upon an assumption that only men could be artists is a glaring oversight in Smith and most other sources.

19. This is essentially the point of view developed by Ernest Mandel, in *Late Capitalism,* in his explication of differing technologies that fueled early, modern, and late capitalism.

20. Smith, *Death of the Artist as Hero,* pp. 8–29. For summaries of the myths, see the entries in Pierre Grimal, *The Dictionary of Classical Mythology,* trans. A. R. Maxwell-Hyslop (Oxford: Basil Blackwell, 1985).

21. Martindale, *Rise of the Artist,* p. 98.

22. Ibid., pp. 117–19. Spread of bubonic plague made for especially difficult living conditions during the 1300s and 1400s. Artists such as Masaccio (in 1428) and Giorgionne (in 1510) died from the plague.

23. For another explication of *artiste*, from craftsperson or artisan to Romantic "man" of imagination, see Maurice Z. Shroder, *Icarus: The Image of the Artist in French Romanticism* (Cambridge, MA: Harvard University Press, 1961), pp. 2–11.

24. Martindale, *Rise of the Artist*, pp. 40, 100. For an interpretation of Giotto's work, see Michael Baxandall, *Giotto and the Orators* (Oxford: Clarendon Press, 1971).

25. Bram Kempers, *Painting, Power and Patronage: The Rise of the Professional Artist in the Italian Renaissance*, trans. Beverley Jackson (London: Penguin, 1993).

26. Jean Gimpel, *Against Art and Artists* (Edinburgh: Polygon, 1991), p. 29.

27. Smith, *Death of the Artist as Hero*, pp. 13–15, 18.

28. Hans Belting, *The End of the History of Art?*, trans. Christopher S. Wood (Chicago: University of Chicago Press, 1987), p. 77. Belting's reassessment of Vasari's legacy includes considerable commentary on the changing role of artists during the Renaissance. Also see Bernard Smith on the way Renaissance humanists articulated their understanding of the Fine Arts as part of Liberal Arts, in *Death of the Artist as Hero*, pp. 14–16.

29. Martindale, *Rise of the Artist*, pp. 101–2.

30. Belting, *End of the History*, p. 79. See also Rudolf Wittkower and Margot Wittkower, *Born under Saturn: The Character and Conduct of Artists* (London: Weidenfeld and Nicolson, 1963; reprint ed., New York: Norton, 1969) for further description of the changing artists' roles in the transition from the medieval to modern world. Perhaps the most detailed account of the rise of the artist in the princely courts is Martin Warnke's *The Court Artist: On the Ancestry of the Modern Artist*, trans. David McLintock (Cambridge, England: Cambridge University Press, 1993).

31. These are described in Warnke, *Court Artist*, pp. xiv–xv.

32. Ibid., p. 252. Warnke discusses examples such as van Eyck, Mantegna, and Cellini.

33. Belting, *End of the History*, p. 83.

34. Warnke, *Court Artist*, p. 254.

35. A detailed description of this process is given in Kempers, *Painting, Power and Patronage*, Parts II, III, and IV.

36. Gimpel, *Against Art*, see p. 5. "Artist: The one who works in an art, or the genius [or spirit] and hand [of the one who] should unite [them]. A painter and an architect are artists." For Gimpel, the evolution of the art world provides key evidence of the decline of European civilization and, as the title of his latest book suggests, "the end of the future."

37. Smith, *Death of the Artist*, p. 19.

38. Barasch, *Modern Theories*, p. 347. Barasch is discussing Fromentin's views on the artist, but they also apply to Proudhon.

39. Hauser, *Sociology*, p. 288.

40. Ibid., p. 292.

41. Gimpel, *Against Art*, p. 79. See Denis Diderot, *Essais sur la peinture, Salons de 1759, 1761, 1763* (Paris: Hermann, 1984), pp. 101, 156–7, 164–5, 233–4. Also see Jean Seznec and Jean Adhémar, eds., *Salons*, 3 vols. (Oxford: Clarendon Press, 1957–63). Diderot began supervising translations for *L'Encyclopédie* in 1746; the final volumes appeared in 1765.

42. Smith, *Death of the Artist*, pp. 17–18.

43. For nineteenth-century artists, these themes are thoroughly explored in Marilyn R. Brown, *Gypsies and Other Bohemians: The Myth of the Artist in Nine-*

*teenth-Century France* (Ann Arbor, MI: UMI Press, 1985). Also see Wittkower, *Born under Saturn,* Chapters Four through Seven.

44. Quoted in Gimpel, *Against Art,* p. 37. See Paul Oskar Kristeller, *The Philosophy of Marsilio Ficino,* trans. Virginia Conant (Gloucester, MA: Peter Smith, 1943), p. 119, for a slightly different translation.

45. See my *Bakhtin and the Visual Arts* for more on these themes. Guyau's ideas about "art-for-life's-sake" are developed in *The Problems of Contemporary Aesthetics, Book I,* trans. by Helen L. Mathews (Los Angeles: De Vorss and Co., 1947).

46. Moshe Barasch, *Modern Theories of Art from Winckelmann to Baudelaire* (New York: New York University Press, 1990), especially his chapter "The Artist," pp. 284–390. Barasch has ably traced in some detail developments about the artist from William Duff to Charles Baudelaire, but he has been less concerned with the role of the artist than with the way the artist as person and creative personality was viewed.

47. Hauser, *Sociology,* p. 297.

48. Riasanovsky, *Emergence,* p. 89.

49. Published as a translation of *La Gaya Scienza,* Friedrich Nietzsche, *The Joyful Wisdom: The Complete Works of Friedrich Nietzsche,* ed. Oscar Levy, trans. Thomas Common (New York: Russell and Russell, 1964), Volume 10, Book 3, 125, pp. 167–8.

50. Stafford, *Body Criticism,* p. 15. See Antoine Schnapper, ed., *Jacques-Louis David, 1748–1825,* exh. cat. (Paris: Editions de la Réunion des Musées Nationaux, 1989), p. 209.

51. Battersby, *Gender,* p. 91. For her description of five strands in the modern usage of the term "genius," only one of which can be recuperated, see pp. 156–7.

52. Ibid., p. 159.

53. Barasch, *Modern Theories,* pp. 296–300.

54. Ibid., p. 306.

55. These are described in considerable detail in Rudolf M. Bisanz, *German Romanticism and Philipp Otto Runge: A Study in Nineteenth-Century Art Theory and Iconography* (DeKalb: Northern Illinois University Press, 1970), pp. 49–55.

56. Barasch, *Modern Theories,* p. 369.

57. Quoted in ibid., p. 351.

58. Shroder, *Icarus,* p. 40.

59. Ibid., p. 47.

60. T. J. Clark has pointed out, "something happened in the history of art around Manet which set painting and the other arts upon a new course"; or, as he suggests in more recent work, with the unveiling in 1793 of Jacques Louis David's *Death of Marat.* See T. J. Clark, *The Painting of Modern Life: Paris in the Art of Manet and His Followers* (Princeton, NJ: Princeton University Press, 1984), p. 10, and "Painting in the Year Two," *Representations* 47 (Summer 1994): 13–63.

61. Walter Benjamin, "Theses on the Philosophy of History," *Illuminations,* ed. Hannah Arendt, trans. Harry Zohn (New York: Schocken Books, 1969), p. 256.

62. This is the hypothesis of Fredric Jameson, in applying Ernest Mandel's three stages of capitalism (in *Late Capitalism*) to the development of realism, modernism, and postmodernism. See Jameson's title essay in *Postmodernism.*

63. An intriguing exhibition catalogue that documents and discusses Indian paint-

ing during the period of British colonial rule is Stuart Cary Welch, *Room for Wonder* (New York: American Federation of Arts, 1978).

## CHAPTER 7. AVANT-GARDE PROPHET

1. The poem is available in many translations. The original Russian is in Aleksandr Sergeevich Pushkin, *Stikhotvoreniia, 1820–1826*, Vol. 2 (Moscow: Izdatel'stvo, 1949), pp. 341–2. Sidney Monas suggests that the poem was a result of Pushkin's reading of the Qur'an in "Modern Russian Poetry and the Prophetic Tradition," *World Literature Today* 59 (Winter 1985): 190–3. Monas's translation is given here. Pushkin composed his famous novel *Eugene Onegin* between 1823 and 1831. The novel has been called "an encyclopedia of Russian life," which illustrates a range of definitions of the writer's role, genres, and distinct styles. Early in this period he composed "The Prophet," at the time he had been recalled from exile by the tsar. See William Mills Todd III, *Fiction and Society in the Age of Pushkin: Ideology, Institutions, and Narrative* (Cambridge, MA: Harvard University Press, 1986), pp. 106–7. There are numerous sources on Vrubel in Russian and English. The most thorough in any language remains Aline Isdebsky-Pritchard's *The Art of Mikhail Vrubel (1856–1910)* (Ann Arbor, MI: UMI Research Press, 1982). Her analyses of "The Prophet" and "Six-winged Seraph" are excellent. The most significant primary source on Vrubel is *Vrubel, Perepiska – Vospominaniia o Khudozhnike* (Moscow: Iskusstvo, 1963), 2nd ed. with additional materials, 1976.
2. See *Vrubel, Perepiska*, pp. 165, 198, 227. Cf. Mikhail Guerman, *Mikhail Vrubel*, trans. John Greenfield and Valery Kereviaghin (Leningrad: Aurora Art Publishers, 1985), p. 38.
3. An excellent source on Symbolism is Henri Dorra, ed., *Symbolist Art Theories: A Critical Anthology* (Berkeley: University of California Press, 1994). For additional materials on Russian Symbolism, see Ronald E. Peterson, ed., *The Russian Symbolists: An Anthology of Critical and Theoretical Writings* (Ann Arbor, MI: Ardis, 1986).
4. Isdebsky-Pritchard, *Art of Mikhail Vrubel*, p. 127.
5. Even my admittedly brief survey of materials addressing the concept of the avant-garde turned up over 575 books and, between 1987 and 1995, 102 articles on the topic. I have referred to both older well-known and newer sources on the avant-garde, including the following: Peter Bürger, *Theory of the Avant-Garde*, trans. Michael Shaw (Minneapolis: University of Minnesota Press, 1984); Matei Calinescu, *Five Faces of Modernity: Modernism, Avant-Garde, Decadence, Kitsch, Postmodernism* (Durham, NC: Duke University Press, 1987); Antoine Campagnon, *The Five Paradoxes of Modernity*, trans. Franklin Philip (New York: Columbia University Press, 1994); Donald Drew Egbert, "The Idea of the 'Avant-Garde' in Art and Politics," *American Historical Review* 73 (1967): 339–66; Hal Foster, "What's Neo about the Neo-Avant-Garde?" *October* 70 (Fall 1994): 5–32; Richard Gilman, "The Idea of the Avant-Garde," *Partisan Review* 39 (1972): 382–96; Clement Greenberg, "Avant-Garde and Kitsch" and "Towards a Newer Laocoon," in *Collected Essays;* Richard Kostelanetz et al., *Dictionary of the Avant-Gardes* (Chicago: A Cappella Books, 1993); Rosalind E. Krauss, *The Originality of the Avant-Garde and Other Modernist Myths* (Cambridge, MA: MIT Press, 1985); Renato Poggioli, *The Theory of the Avant-Garde*, trans. Gerald Fitzgerald (Cambridge, MA: Harvard University Press, 1968); and Donald Kuspit, *The*

*Cult of the Avant-Garde Artist* (Cambridge, England: Cambridge University Press, 1993).

6. Foster, "Neo-Avant-Garde," p. 10. One engaging attempt to link the first avant-garde to later work of the Situationists of the 1950s and 1960s and punk music of the 1970s is Greil Marcus, *Lipstick Traces: A Secret History of the Twentieth Century* (Cambridge, MA: Harvard University Press, 1989).

7. This particular list is given in Foster, "Neo-Avant-Garde," p. 10.

8. Calinescu, *Five Faces*, p. 102. Saint-Simon's writing can be found in *Oeuvres de Saint-Simon et d'Enfantin* (Paris: E. Dentu, 1865). For the important dialogue about the role of the artist in relation to the industrialist and the scientist, see "L'Artiste, le savant et l'industriel: dialogue," in *Opinions littéraires, philosophiques et industrielles* (Paris: Galerie de Bossange pére, 1825). Extracts of these and other works are published in English in Keith Taylor, trans. and ed., *Henri Saint-Simon (1760–1825): Selected Writings on Science, Industry and Social Organisation* (London: Croom Helm, 1975).

9. "The Artist, the Scientist, and the Industrial: Dialogue," in *Henri Saint-Simon*, p. 281. Taylor takes the position that this text was the product of Saint-Simon, not Rodrigues.

10. Calinescu, *Five Faces*, p. 103.

11. Poggioli, *Theory of Avant-Garde*, p. 9.

12. This is the approach taken by Egbert, "Idea." Also see Linda Nochlin's "The Invention of the Avant Garde: France 1830–1880," in Nochlin, *The Politics of Vision: Essays on Nineteenth-Century Art and Society* (New York: Harper and Row, 1989).

13. See *The Collected Works of William Morris* (London: Routledge and Thoemmes Press, 1992), reprints of 1910–15 edition, esp. Vol. 22, *Hopes and Fears for Art and Lectures on Art and Industry,* and Vol. 23, *Signs of Change and Lectures on Socialism.*

14. Klaus-Jürgen Sembach, *Henry Van de Velde* (New York: Rizzoli, 1989), p. 9.

15. Ibid, p. 52.

16. Egbert, "Idea," pp. 355–8.

17. According to Renato Poggioli, precursors of the avant-garde can be found in Romanticism, in the Romantic cult of novelty, and in the love of the strange. See Poggioli, *Theory of Avant-Garde*, p. 50.

18. Calinescu, *Five Faces*, p. 111.

19. Campagnon, *Five Paradoxes*, p. 33.

20. Arthur Rimbaud, *Complete Works*, trans. Paul Schmidt (New York: Harper and Row, 1976), p. 102. The so-called *Lettres du voyant* are two letters that Rimbaud wrote to Georges Izambard and Paul Démeny in May 1871. They appear in *Complete Works*, pp. 100–5.

21. Ibid., p. 104.

22. Greenberg, "Avant-Garde and Kitsch." See also "Towards a Newer Laocoon," for further explication of these ideas.

23. This theme is developed very persuasively by Rosalind Krauss in *Originality of the Avant-Garde.*

24. Krauss, *Originality of the Avant-Garde*, p. 158.

25. See Antoine Campagnon's recent *Five Paradoxes* as an example of serious consideration of Poggioli's ideas. For an excellent critical look at Poggioli and at Peter Bürger's *Theory of the Avant-Garde*, see Benjamin Buchloh, "Theorizing the Avant-Garde," *Art in America* 72 (November 1984): 19–21.

26. Poggioli, *Theory of Avant-Garde*, pp. 97, 127.

27. Bürger, *Theory of the Avant-Garde.*
28. Bürger does not discuss the characteristics of the avant-garde developed by Poggioli, but he thinks it a mistake to give too broad a definition to the avant-garde. A contrasting definition of the avant-garde was developed by Richard Schechner in the 1970s and 1980s. In several articles published in *Performing Arts Journal,* and later collected in *The End of Humanism* (New York: Performing Arts Journal, 1982), Schechner discusses the decline of avant-garde theater, interpreting its decline in terms of five problems: the end of activism more generally in society; a shrinking economy and few actual resources; stupid journalism; the dissolution of various performance groups, including The Performance Group with which Schechner himself worked; and failure to pass on what had been learned to a new generation of artists. Further, the emphasis on the individual performer over the writer or director had weakened the communities that supported the avant-garde; consequently, there was no sense of collective action. He uses the term avant-garde to mean diverse forms of experimental theater. See "The Decline and Fall of the (American) Avant-Garde, Part I," *Performing Arts Journal* 14 (1981): 48–63; "The Decline and Fall of the (American) Avant-Garde, Part II," *Performing Arts Journal* 15 (1981): 9–19. Largely critical responses to Schechner's two-part essay were given in another article, "The Decline and Fall of the (American) Avant-Garde, Part III," *Performing Arts Journal* 16 (1981): 38–67, by Spaulding Gray, Elizabeth LeCompte, and Bonnie Marranca, among others.
29. This is one of Buchloh's main criticism's of Bürger in "Theorizing the Avant-Garde," p. 19.
30. This is the approach taken by Richard Kostelanetz in compiling the *Dictionary of the Avant-Gardes.*
31. Buchloh, "Theorizing the Avant-Garde," p. 19.
32. Richard Cork, *A Bitter Truth: Avant-Garde Art and the Great War* (New Haven: Yale University Press, 1994), p. 8. Nash's full statement appears in his *Outline: An Autobiography and Other Writings* (London: Faber and Faber, 1949), p. 211.
33. Poggioli, *Theory of Avant-Garde,* pp. 61, 68.
34. Ibid., p. 69.
35. Bürger, *Theory of the Avant-Garde,* pp. 12–13, 49, 50.
36. Kuspit, *Cult,* pp. 9, 8.
37. Bürger, *Theory of the Avant-Garde,* p. 36. Bürger identifies the aesthetics of Kant and Schiller, though different from each other, as crucial to providing formal justification for this autonomy, but the process has been both ideological and historical.
38. Bürger, *Theory of the Avant-Garde,* p. 70. Bürger builds his idea partly on Walter Benjamin's ideas in several influential essays of the 1930s and 1940s.
39. See my "Gender Ambiguity and Religious Meaning in the Art of Remedios Varo," *Woman's Art Journal* 16 (Spring–Summer 1995): 26–32.
40. Hope will be further discussed in the final chapter; the phrase "tragic optimism" comes from Charles Jencks, "The Post-Modern Agenda," in *The Post-Modern Reader,* ed. Charles Jencks (New York: St. Martin's Press, 1992), pp. 10–39, esp. 31–7.
41. Bürger, *Theory of the Avant-Garde,* p. 77. In "Theorizing the Avant-Garde," Benjamin Buchloh has argued that Bürger oversimplified Benjamin's theory of allegory and montage; especially, there were radical changes in montage aesthetics between 1915 and 1925. Bürger also failed to acknowledge that Benjamin developed an entirely different theory of the nonorganic work of art in

his 1934 "The Author as Producer" essay. For more on the very interesting history of montage, see Matthew Teitelbaum, ed., *Montage and Modern Life, 1919–1942* (Cambridge, MA: MIT Press, 1992).

42. The most common understanding of the relationship of the artist and prophecy is exemplified in Francis Haskell, *History and Its Images: Art and the Interpretation of the Past* (New Haven, CT: Yale University Press, 1993). Haskell offers a genealogy of this point of view, beginning with detailed descriptions of Van Dyck's 1635 three-angle portrait of Charles I and David's *Oath of the Horatii*. Both paintings were interpreted later as having foretold the future: in Van Dyck's case, that Charles's court was doomed; in David's, that his evocation of Roman struggles and allegiances presaged the French Revolution.

43. Haskell, *History and Its Images*, p. 400.

44. Ibid., p. 394.

45. Ibid., p. 402.

46. Ibid., p. 408.

47. Ibid., p. 415.

48. See Germain Bazin, *Le Crépuscule des images* (Paris: Gallimard, 1946), and Michael Sadler, *Modern Art and Revolution* (London: L. and Virginia Woolf at the Hogarth Press, 1932).

49. Quoted in Haskell, *History and Its Images*, p. 429. Bazin's example is Tintoretto.

50. Bakhtin, "Author and Hero," in *Art and Answerability*, p. 191.

51. Much has been written on this theme. See, for example, Monas, "Modern Russian Poetry," pp. 190–3.

52. For a detailed examination of this painting in relation to others in the series, see Magdalena Dabrowski, *Kandinsky Compositions* (New York: Museum of Modern Art, 1995).

53. From "Of the Book by Gleizes and Metzinger Du Cubisme," translated by Henderson, in *The Fourth Dimension*, p. 368. Matiushin was quoting P. D. Ouspensky, who had written in *Tertium Organum: A Key to the Enigmas of the World*, trans. Nicholas Bessaraboff and Claude Bragdon, 2nd ed. (New York: Alfred A. Knopf, 1922), p. 162, that the artist was a clairvoyant and magician, possessing the power to see what others cannot and able to make others see what "he" does. An excellent article on Matiushin and Malevich is Charlotte Douglas's, "Beyond Reason: Malevich, Matiushin, and Their Circles," in *The Spiritual in Art: Abstract Painting, 1890–1985* (New York: Abbeville Press, 1986), pp. 185–99.

54. In Kasimir Malevich, *The Artist, Infinity, Suprematism: Unpublished Writings, 1913–1933*, Vol. 4 of *Essays on Art*, trans. Xenia Hoffman, ed. Troels Andersen (Copenhangen: Borgens Forlag, 1978), p. 9.

55. Kasimir Malevich, "The Question of Imitative Art," *Essays on Art*, Vol. 1, trans. Xenia Glowacki-Prus and Arnold McMillin, ed. Troels Anderson (Copenhagen: Borgen, 1968), p. 171.

56. My *Bakhtin and the Visual Arts* examines Malevich's *Black Square* in relation to the icon of the *Spas nerukotvornyi* [Savior not made by human hands]. For more on the *Sportsmen*, see Charlotte Douglas, *Malevich* (New York: Harry N. Abrams, 1994), and Karen E. Todd, "The Hollow Icon: Malevich's 'Sportsmen' and the Tradition of Icon Painting in the Context of a Revolutionary Society" (bachelor's thesis, Harvard University 1995).

57. Brancusi's work has received extensive treatment in two recent books: Anna C. Chave, *Constantin Brancusi* (New Haven, CT: Yale University Press, 1994); and Cork, *Bitter Truth*, esp. pp. 310–14.

58. Chave, *Constantin Brancusi*, p. 163.
59. Quoted in Chave, *Constantin Brancusi*, p. 162. See Chapter 4 for a full elaboration of these themes.
60. Kuspit, *Cult*, p. 7.
61. Ibid., pp. 11, 101.
62. Calinescu, *Five Faces*, p. 121.
63. A very interesting case is developed by Foster, "Neo-Avant-Garde," where he builds especially on the ideas of Benjamin Buchloh.
64. For a counterreading of Haacke's work, see Paul Mann, *The Theory-Death of the Avant-Garde* (Bloomington: Indiana University Press, 1991), esp. pp. 126–30.
65. Foster, "Neo-Avant-Garde," pp. 16, 23.
66. Mann, *Theory-Death*, p. 143.
67. Quoted in Suzi Gablik, *The Reenchantment of Art* (New York: Thames and Hudson, 1991), pp. 178–9. For the full text of Chia's and twelve other artists' comments on art and money, see Lilly Wei, "Making Art, Making Money," *Art in America* 78 (July 1990): 133–41+.
68. Paraphrase of a statement by the artist at a panel, College Art Association meeting, February 1992.
69. This judgment includes my appropriation of Benjamin Buchloh's definition in "Theorizing the Avant-Garde," p. 21.
70. Robert Storr, "Beyond Words," *Bruce Nauman*, exh. cat., gen. ed. Joan Simon with Janet Jenkins and Toby Kamps (Minneapolis: Walker Art Center, 1994), p. 62.
71. Ibid.
72. Linda Hutcheon develops a nuanced view of parody in "Theorizing the Postmodern: Towards a Poetics," in Charles Jencks, ed., *The Post-Modern Reader* (New York: St. Martin's Press, 1992), pp. 83–91. Fredric Jameson has written about pastiche and parody in "Postmodernism, or the Cultural Logic of Late Capitalism," *New Left Review* 146 (July–August 1984), pp. 64–5.

## CHAPTER 8. POSTMODERN PARODIC EX-CENTRIC BRICOLEUR

1. Michael Auping, *Jenny Holzer* (New York: Universe, 1992), p. 90.
2. Linda Hutcheon, "Theorizing the Postmodern," in *The Post-Modern Reader*, ed. Charles Jencks (New York: St. Martin's Press, 1992), p. 87.
3. For one artist's self-conscious interpretation of his work as a bricoleur, see Ross Coates, "Interview with the Bricoleur," *Universe* 8 (Spring 1995): 2–5.
4. Cornel West, *Prophetic Reflections: Notes on Race and Power in America* (Monroe, ME: Common Courage Press, 1993), especially see the chapter "Postmodern Culture," pp. 37–43, where West develops some of the following ideas.
5. For more on this exhibition, see Andrea Kirsh and Susan Fisher Sterling, *Carrie Mae Weems* (Washington, DC: National Museum of Women in the Arts, 1993), pp. 29–32.
6. West, *Prophetic Reflections*, p. 41.
7. Ibid., p. 51.
8. Ibid., p. 102.
9. *The Postmodern Condition: A Report on Knowledge*, trans. Geoff Bennington and Brian Massumi (Minneapolis: University of Minnesota Press, 1984), p. 81.
10. See my *Bakhtin and the Visual Arts*, pp. 157–72, for further discussion of this issue, the terms for which come from Hal Foster, "Postmodernism, A Preface," *The Anti-Aesthetic: Essays on Postmodern Culture* (Port Townsend, WA: Bay

Press, 1983), and Suzi Gablik, *The Reenchantment of Art* (New York: Thames and Hudson, 1991). Another influential discussion was set forth by Andreas Huyssen in *After the Great Divide: Modernism, Mass Culture, Postmodernism* (Bloomington: Indiana University Press, 1986).

11. Faith Wilding, "The Feminist Art Programs at Fresno and CalArts, 1970–75," in *The Power of Feminist Art: The American Movement of the 1970s, History and Impact,* eds. Norma Broude and Mary D. Garrard (New York: Harry N. Abrams, 1994), p. 32.

12. Bürger, *Theory of the Avant-Garde*, p. 98.

13. Donald Kuspit, *Cult*, p. 14. He builds on ideas of Max Scheler, *Ressentiment* (New York: Free Press, 1961); see Kuspit's discussion on pp. 120–1.

14. Kuspit, *Cult*, p. 17.

15. Ibid., pp. 25, 26.

16. Ibid., p. 19.

17. Ibid., p. 102.

18. Ibid., p. 106–7.

19. Ibid., p. 112.

20. Ibid., p. 133.

21. Donald Kuspit, "The Good Enough Artist: Beyond the Mainstream Avant-Garde Artist," in *Signs of Psyche in Modern and Postmodern Art* (New York: Cambridge University Press, 1993), pp. 292–9.

22. These ideas originated with Andreas Huyssen. In *The Reenchantment of Art*, Suzi Gablik offers many descriptions of artists' work that fits within these parameters. The value of her book is that, although it lacks adequate analysis, it presents hopeful evidence of artists' commitments to cultural transformation.

23. Joan Snyder was born in 1940 and was educated at Douglas College and Rutgers University in New Jersey. She did not decide to study art or paint until her last year in college. For more biographical information, see Susan Gill, "Painting from the Heart," *Art News* 86 (April 1987): 128–35.

24. In an interview with Ruth Iskin, "Toward a Feminist Imperative: The Art of Joan Snyder," *Chrysalis* 1 (1977): 111.

25. In Lucy Lippard, *From the Center: Feminist Essays on Women's Art* (New York: Dutton, 1976), p. 86.

26. See, for example, Jed Perl, "Mixed Media," *The New Criterion* 8 (April 1990): 49–55. It is not surprising that, in a conservative journal, a critic would discuss the more traditional characterizations of Snyder's work, rather than linking it to feminism or cultural change.

27. In "Joan Snyder," *Art in America* 70 (December 1982): 63.

28. Bill Jones, "Joan Snyder," *Arts Magazine* 64 (Summer 1990): 76.

29. Joan Snyder, in *Joan Snyder, Seven Years of Her Work,* essay by Hayden Herrera (Purchase, NY: Neuberger Museum, 1978), p. 34. Snyder discusses the preparatory work for this painting in her interview with Ruth Iskin, "Joan Snyder," *Chrysalis,* p. 109.

30. Roberta Smith, "Images of Women, Dignified or Not, but Always Nude," *New York Times,* 23 February 1990, sec. C.

31. For Snyder's comments on her use of symbols such as the house and heart and her methods of working such as cutting and tearing the canvas, see Iskin, "Joan Snyder," *Chrysalis,* p. 108.

32. The best survey of Long's work is Richard Long and Herman Lelie, *Richard Long: Walking in Circles* (London: South Bank Center, 1991). Anne Seymour's essay, "Walking in Circles," provides an excellent assessment of his work. As she suggests, we know Long's presence by his absence.

33. Long and Lelie, *Walking*, p. 8.
34. Ibid., p. 251.
35. Ibid., p. 252. These comments are from an interview with Richard Cork in October 1988.
36. Hamish Fulton, in Long and Lelie, *Walking*, p. 245.
37. Ibid., p. 27.
38. Ibid., p. 248. Long writes "about" his work, if lists of what he has seen can be described in this way. An example comes from his 1989 "Early Morning Senses Tropical Island Walk" on Frigate Island in the Indian Ocean: "sun cumulus bougainvillea dove white birds coco de mer lizard centipede blue flowers" and so forth. The list numbers 84.
39. October–November 1991, at the Spokane, Washington, Spokane Art School. See my review of that exhibition, "Nuclear Bower," *Artweek* (November 14, 1991): 14.
40. Quoted in Philip Schuyler, "Profiles (James L. Acord, Jr. – Part II)," *The New Yorker* (October 21, 1991): 101–2. Schuyler's extraordinary article on Acord, the first part of which appeared in the October 14, 1991 issue, details Acord's life and ongoing work.
41. In Stephen Wicks, *Forest of Visions* (Knoxville, TN: Knoxville Museum of Art, 1993), p. 14.
42. This argument was first developed persuasively in a 1982 article by Craig Owens, "The Discourse of Others: Feminists and Postmodernism," in Foster, *Anti-Aesthetic*, pp. 57–82.
43. Thalia Gouma-Peterson, " 'Collaboration' and Personal Identity in Miriam Schapiro's Art," *Miriam Schapiro* (New York: Steinbaum Krauss Gallery, 1994), p. 7. Also see Deborah J. Haynes, "Miriam Schapiro at Steinbaum Krauss Gallery," *Woman's Art Journal* (Spring/Summer 1996).
44. Guillermo Gómez-Peña, " "The New World Border: Prophecies for the End of the Century," *The Drama Review* 38 (Spring 1994): 120. In a related article, "The Other Side of Intercultural Performance," Coco Fusco documents another performance piece "The Couple in the Cage: A Guatinaui Odyssey," *The Drama Review* 38 (Spring 1994): 143–67.
45. Gómez-Peña, "World Border," p. 129.
46. Ibid., p. 140.
47. This is Margot Lovejoy's main thesis in *Postmodern Currents: Art and Artists in the Age of Electronic Media* (Englewood Cliffs, NJ: Prentice Hall, 1992). (A thoroughly revised second edition of the book was published by Prentice-Hall in 1996.) Lovejoy is especially concerned with the impact of the internet and interactive media in general on the role of the artist. The following discussion draws on her book and a number of other sources, including Timothy Druckrey, ed., *Iterations: The New Image*, exh. cat. (Cambridge, MA: MIT Press, 1993), especially his article "Revisioning Technology," pp. 17–39; Gretchen Bender and Timothy Druckrey, eds., *Culture on the Brink: Ideologies of Technology* (Seattle: Bay Press, 1994); Bob Cotton and Richard Oliver, eds., *The Cyberspace Lexicon: An Illustrated Dictionary of Terms from Multimedia to Virtual Reality* (London: Phaidon, 1994); and Frank Popper, *Art of the Electronic Age* (New York: Harry N. Abrams, 1993). The range of materials on electronic media, digital imagery, lasers and holography, virtual reality, interactive media, hypertext, and other such processes is staggering. For a fascinating study that deals primarily with literary examples, see Scott Bukatman, *Terminal Identity: The Virtual Subject in Postmodern Science Fiction* (Durham, NC: Duke University Press, 1993). Bukatman's term, *terminal identity*, is meant

to name both the "end of the subject" (as some postmodernists and poststruc-turalists describe it) and the way subjectivity itself is being refigured and re-presented in cyberspace. Cyberspace itself can be defined as "the virtual space of computer memory and networks, telecommunications and digital media," in Cotton and Oliver, *Cyberspace Lexicon*, p. 54.

48. Lovejoy, *Postmodern Currents*, p. 3

49. The phrase comes from the title of Lucy Lippard, ed., *Six Years: The Dema-terialization of the Art Object from 1966–1972* (New York: Praeger, 1973).

50. For more on this, see Marvin Heiferman and Lisa Phillips, *Image World: Art and Media Culture* (New York: Whitney Museum of Art, 1989).

51. Lovejoy, *Postmodern Currents*, pp. 7–11.

52. Quoted by Lovejoy, *Postmodern Currents*, p. 263.

53. Druckrey, *Iterations*, p. 21.

54. Lovejoy, *Postmodern Currents*, p. 21.

55. On these artists' work, see articles in Druckrey, *Iterations*, pp. 114–9; Stephen Hobson, "Manual: Et in Arcadia Ego," *Perspektief Magazine* 47/48 (June 1994): 72–82; and Wicks, *Forest of Visions*, pp. 36–9.

56. MANUAL, in *Forest of Visions*, p. 38.

57. Ibid.

58. Bill Viola's work has been the subject of numerous articles and a major ret-rospective at the Museum of Modern Art in 1987–8. A fine catalogue, *Bill Viola: Survey of a Decade* (Houston: Contemporary Arts Museum, 1988), describes his work up until 1988. His *Reasons for Knocking at an Empty House: Writings, 1973–94* (Cambridge, MA: MIT Press, 1995) brings Viola's own published essays nearly up to date. About a 1992 exhibition at the Donald Young Gallery in Seattle, see my "Ultimate Questions: Bill Viola at the Donald Young Gallery," *Artweek*, May 21, 1992, p. 5. Other exhibitions of the early 1990s were reviewed in major art magazines, for instance, Donald Kuspit, "Bill Viola, The Passing," *Artforum* 32 (September 1993): 144–5+, and Peter von Ziegesar, "Bill Viola at the Parrish Art Museum," *Art in America* 82 (Novem-ber 1994): 135.

59. Lovejoy, *Postmodern Currents*, p. 262.

60. This is the point of departure for Paul Virilio's "Sanitary Ideology," in *Crash: Nostalgia for the Absence of Cyberspace*, eds. Robert Reynolds and Thomas Zummer (New York: Thread Waxing Space, 1994), pp. 98–101. *Crash* itself is a "catalogue" of sorts that poses, and answers, questions such as "What is an artist in the late twentieth century?" with pages by visual and performing artists.

61. This is a paraphrase of a comment by Jonathan Crary, at a Harvard University symposium, April 8, 1995. "Interactivity," he said, "is a new form of shop-ping."

62. Stafford, *Body Criticism*, p. 26.

63. Druckrey, *Iterations*, p. 30.

64. Andrew Ross, "The New Smartness," in Bender and Druckrey, *Brink*, pp. 329–41.

## CHAPTER 9. PROPHETIC CRITICISM

1. Nyna Brael Polumbaum, ed., *Save Life on Earth* (Berlin: Elefanten Press, 1986), p. 2. The exhibition and book were sponsored by International Physicians for the Prevention of Nuclear War.

2. Ibid., p. 102.

3. Thomas Overholt, *Channels of Prophecy; The Social Dynamics of Prophetic Activity* (Minneapolis: Fortress Press, 1989), p. 5. See also David Peterson, "Introduction: Ways of Thinking about Israel's Prophets," in *Prophecy in Israel*, ed. D. L. Peterson (Philadelphia: Fortress Press, 1987), p. 2.

4. My understanding of the process of prophecy has been largely shaped by Walter Brueggemann, *The Prophetic Imagination* (Philadelphia: Fortress Press, 1978); Cornel West, *Prophetic Thought in Postmodern Times* (Monroe, ME: Common Courage Press, 1993); Mary Daly, *Beyond God the Father* (Boston: Beacon Press, 1973); and Michael Walzer, *Interpretation and Social Criticism* (Cambridge, MA: Harvard University Press, 1987).

5. For details of the etymology of *prophētēs* and *navi'*, see Abraham Heschel, *The Prophets* (New York: Harper and Row, 1962), pp. 405–7; H. H. Rowley, *Prophecy and Religion in Ancient China and Israel* (New York: Harper and Brothers, 1956), esp. p. 4; J. Reiling, *Hermas and Christian Prophecy: A Study of the Eleventh Mandate* (Leiden: E. J. Brill, 1973), p. 12; Alfred Guillaume, *Prophecy and Divination Among the Hebrews and Other Semites* (London: Hodder and Stoughton, 1938), pp. 112–13. On the biblical tradition, see Johannes Lindblom, *Prophecy in Ancient Israel* (Oxford: Basil Blackwell, 1962); Joseph Blenkensopp, *A History of Prophecy in Israel* (London: SPCK, 1984); and R. Coggins, A. Phillips, and M. Knibb, eds., *Israel's Prophetic Traditions* (Cambridge: Cambridge University Press, 1982). Two excellent overview articles by Gerald T. Sheppard and William E. Herbrechtsmeier, and Robert Wilson, are listed under "Prophecy," in Mircea Eliade, general ed., *Encyclopedia of Religion*, Vol. 12 (New York: Macmillan, 1987), pp. 8–23. On the hermetic traditions, see the essays and bibliography in *The Spiritual in Art: Abstract Painting, 1890–1985* (New York: Abbeville Press, 1986).

6. Prophets have also often served as mediums for a variety of other daemonic or supernatural personalities: spirit mediums; god-boxes (in Polynesia); *prophetai*, spokespersons for the supernatural; *entheoi*, those filled with god; demon-ridden, *daimonontes;* a person temporarily or permanently disturbed, *ekstatikoi;* belly talkers or *engastrimuthoi; pneumatikoi*, a person filled with spirit. In all of these cases, the person could experience two main types of "dissociation": The subject's normal consciousness might exist alongside an intrusive personality, or a deeper trance is experienced so that the subject no longer remembers what was said or done. See E. R. Dodds, *Pagan and Christian in an Age of Anxiety: Some Aspects of Religious Experience from Marcus Aurelius to Constantine* (New York: Cambridge University Press, 1965), pp. 53–7. Dodds covers the era from about 121 until 330 C.E.

7. On oracles, see Aune, *Prophecy*, pp. 23–4. The idea of the "mantic" offers another way of conceptualizing the prophetic. First, whereas the prophetic may be associated with declarations related to the future, the mantic may deal with the past, present, or future. Second, whereas prophecy usually refers to "declarations of knowledge obtained by revelation or from some inner light," mantic refers to the possession, cultivation, and declaration of knowledge in general. The *mantis* in Homer's *Odyssey*, for example, is the "worker for the public weal," a person who might also be seen as the direct descendant of the shaman or medicine man. The Greek *mantis*, translated by a variety of words – "diviner," "soothsayer," "seer," or "prophet" – was relied upon for the interpretation of divine messages. For more on these themes, see N. Kershaw Chadwick, *Poetry and Prophecy* (Cambridge: Cambridge University Press, 1942), pp. xiii–xiv; W. R. Halliday, *Greek Divination: A Study of Its Methods and Principles* (London: Macmillan and Co., 1913), pp. 57, 58; and Aune, *Prophecy*, p. 23.

8. For an article that grapples with the applicability of the title "prophet," see William R. Darrow, "Zoroaster Amalgamated: Notes on Iranian Prophetology," *History of Religions* 27 (November 1987): 109–32. For more on these ideas, see Mary Boyce, *Textual Sources for the Study of Zoroastrianism* (Totowa, NJ: Barnes and Noble, 1984); and Mary Boyce, *A History of Zoroastrianism,* 2 vols. (Leiden: E. J. Brill, 1975 and 1982).

9. Sheppard and Herbrechtsmeier, "Prophecy," pp. 9–10.

10. John J. Collins, "Introduction: Morphology of a Genre," *Semeia* 14 (1979): 1–20.

11. Charles B. Strozier, *Apocalypse: On the Psychology of Fundamentalism in America* (Boston: Beacon Press, 1994), p. 2. For an articulation of this view, see Martin Buber's article, "Prophecy, Apocalyptic, and the Historical Hour," in *Pointing the Way: Collected Essays,* trans. and ed. Maurice Friedman (London: Routledge and Kegan Paul, 1957).

12. Collins, "Introduction," p. 9. His definition reads: " 'Apocalypse' is a genre of revelatory literature with a narrative framework, in which a revelation is mediated by an otherworldly being to a human recipient, disclosing a transcendent reality that is both temporal insofar as it envisages eschatological salvation and spatial insofar as it involves another, supernatural world." For further development of these ideas see Collins's *The Apocalyptic Imagination: An Introduction to the Jewish Matrix of Christianity* (New York: Crossroad, 1984), pp. 4, 6, 30.

13. This is the central thesis of John J. Collins's article, "Apocalyptic Eschatology as the Transcendence of Death," in *Visionaries and Their Apocalypses,* ed. Paul D. Hanson (Philadelphia: Fortress Press, 1983), pp. 61–84, esp. p. 75. Hanson's excellent introduction, pp. 1–15, gives a brief overview of various interpretations of apocalyptic.

14. Paul D. Hanson, *The Dawn of Apocalyptic* (Philadelphia: Fortress Press, 1975), p. 29. The following discussion also draws on Paul Boyer, *When Time Shall Be No More: Prophecy Belief in Modern American Culture* (Cambridge, MA: Harvard University Press, 1992).

15. This theme is powerfully elaborated by Elisabeth Schussler-Fiorenza in her series of essays collected in *The Book of Revelation: Justice and Judgment* (Philadelphia: Fortress Press, 1985).

16. Hanson, "Introduction," *Visionaries,* p. 13.

17. Other Jewish sources include II Enoch, IV Ezra, II and III Baruch, and parts of the Dead Sea (Qumran) scrolls. The Essenes, writers of the scrolls, were among the last Jewish apocalypticists. Boyer, *When Time,* pp. 24–33.

18. This is Adela Yarbro Collins's perspective in *Combat Myths in the Book of Revelation* (Missoula, MT: Scholar's Press, 1976), pp. 2, 3. Quoted in Boyer, *When Time,* p. 44.

19. See Helmut von Erffa and Allen Staley, *The Paintings of Benjamin West* (New Haven, CT: Yale University Press, 1986), esp. pp. 388–92, for more on his paintings and drawings on this theme, which occupied him from 1783.

20. Hanson, "Introduction," *Visionaries,* p. 3.

21. Martin Jay, "The Apocalyptic Imagination and the Inability to Mourn," *Force Fields: Between Intellectual History and Cultural Critique* (New York: Routledge, 1993), pp. 84–98, esp. pp. 85–7.

22. Barry Brummett, *Contemporary Apocalyptic Rhetoric* (New York: Praeger, 1991), p. 172.

23. Brummett, *Contemporary,* pp. 9, 173.

24. Buber, "Prophecy, Apocalyptic, and the Historical Hour," p. 201.

25. The following information about the ancient world is adapted from John J. Collins, *The Apocalyptic Imagination*, pp. 21–2, 27–8. Collins draws his account in part from A. K. Grayson, *Babylonian Historical-Literary Texts* (Toronto: University of Toronto Press, 1975).

26. Aune, *Prophecy*, pp. 23, 50. Aune offers an excellent short survey of Greco-Roman prophecy, pp. 23–79. See also H. W. Parke and D. E. W. Wormell, *The Delphic Oracle* (Oxford: Blackwell, 1956).

27. Aune, *Prophecy*, p. 42. Cf. his detailed note on p. 360. In *The Greeks and the Irrational* (Berkeley: University of California Press, 1956), pp. 7–75, 86, E. R. Dodds argues that prophetic ecstasy or madness is at least as old as the religion of Apollo, and it may well have been a central part of Dionsyiac rites.

28. Since I visited the site in 1985, the Samothracian cult has been of great personal interest to me. During the seventh and sixth centuries B.C.E., rituals flourished at many sites, including Samothrace, although there is no archaeological evidence prior to the second half of the fifth century B.C.E., the date of the earliest ceramic inscriptions. Following this period, during the classical and Hellenistic eras, the Samothracian sanctuary and its mysteries attracted many visitors. In 84 B.C.E. it was looted by pirates, and a major catastrophe, probably an earthquake, caused extensive damage. Some of the buildings were remodeled, and the site continued to flouish until the late fourth century C.E., when the cult was forced out of existence. The archaeological work that was begun in the nineteenth century and in 1863 yielded the Nike, the Winged Victory that is now in the Louvre, continues to the present. But further destruction of the site was carried out by Bulgarian soldiers during World War II, and even today, the island is used as a target for Greek war games.

   For information on the mystery cults in general, see Jane Ellen Harrison, *Prolegomena to the Study of Greek Religion* (New York: Arno Press, 1975; reprint ed., Cambridge University Press, 1903), pp. 150–1; S. Angus, *The Mystery Religions: A Study in the Religious Background of Early Christianity* (New York: Dover, 1975; reprint of *The Mystery Religions and Christianity*, London: John Murray, 1925); Walter Burkert, *Greek Religion*, trans. John Raffan (Cambridge, MA: Harvard University Press, 1985); and Ugo Bianchi, *The Greek Mysteries* (Leiden: Brill, 1976). On Samothrace in particular, see Karl Lehmann, *Samothrace: A Guide to the Excavations and the Museum*, 5th ed. (New York: Institute of Fine Arts, 1983); and Susan Guettel Cole, *Theoi Megaloi: The Cult of the Great Gods at Samothrace* (Leiden: E. J. Brill, 1984).

29. Aune, *Prophecy*, pp. 36–8, 70–2.

30. Aune, *Prophecy*, p. 37. Aune notes that this attribution to Heraclitus is disputed.

31. Susan Skulsky, "The Sibyl's Rage and the Marpessan Rock," *American Journal of Philology* 108 (Spring 1987): 56–80. Versions of the legend are given in Servius, in the *Aeneid* 2.247, and in Aeschylus's, *Agamemnon* 1202–12. Cassandra is also the subject of a fascinating contemporary novel by Christa Wolf, *Cassandra: A Novel and Four Essays*, trans. Jan van Heurck (New York: Farrar, Straus, Giroux, 1984).

32. In "The Signs of Prophecy: The Emergence and Early Development of a Theme in Arabic Theological Literature," *Harvard Theological Review* 78 (1–2, 1985): 101–14, Sarah Stroumsa develops the idea that finding signs of true or false prophecy came about as a Christian and Jewish response to Muslim claims about the prophetic grounding of Islam; that is, Muḥammad claimed to be a prophet and the Qur'ān a miraculous divine revelation. Prior to such claims,

earlier Jewish and Christian writers and leaders were not so concerned about the truth or falsity of prophecy.

33. A good short overview of the world's traditions is given in *The New Encyclopaedia Brittanica, Macropaedia,* Vol. 15 (Chicago: William Benton, 1977), pp. 62–8.

34. A careful examination of over twelve versions of this prophecy in various languages and Buddhist traditions is the subject of Jan Nattier's *Once Upon a Future Time: Studies in a Buddhist Prophecy of Decline* (Berkeley, CA: Asian Humanities Press, 1991). See p. 284 where she compares various prophetic traditions.

35. There are two sources for understanding Hebrew prophecy: the fifteen prophetic books in the Bible (Isaiah, Jeremiah, Ezekiel, Hosea, Joel, Amos, Obadiah, Jonah, Micah, Nahum, Habakkuk, Zephaniah, Haggai, Zechariah, and Malachi) and the six books (Joshua, Judges, Samuel 1 and 2, and Kings 1 and 2) that describe prophetic activity.

36. Heschel, *Prophets,* p. 472.

37. Ibid., pp. 426–46. Heschel's interpretation of the event shares much with other philosophers out of the German philosophical tradition, such as Wilhelm Windelband and Mikhail Bakhtin. For my interpretation of this concept in these latter two philosophers, see *Bakhtin and the Visual Arts,* esp. Chapter 3. The "God" referred to here – father, lord, ruler, judge – is precisely the one called into question by Jewish and Christian feminist and constructive theology during the past few decades. See Mary Daly's books, especially *Beyond God the Father;* Susannah Heschel, ed., *On Being a Jewish Feminist: A Reader* (New York: Schocken Books, 1995); Gordon Kaufman, *In Face of Mystery: A Constructive Theology* (Cambridge, MA: Harvard University Press, 1993); Sallie McFague, *Models of God: Theology for an Ecological, Nuclear Age* (Philadelphia: Fortress, Press, 1987); Judith Plaskow, *Standing Again at Sinai: Rethinking Judaism from a Feminist Perspective* (San Francisco: Harper and Row, 1990); and Rosemary Radford Reuther, *Gaia and God: An Ecofeminist Theology of Earth Healing* (San Francisco: HarperSan Francisco, 1992).

38. For a fuller account of the prophets' activities, see Hans Walter Wolff, "Prophecy from the Eighth through the Fifth Centuries," *Interpretation* 32 (1978): 17–30, esp. p. 18.

39. This particular list comes from Sheppard and Herbrechtsmeier, "Prophecy," but similar lists are given in other sources as well. See, for instance, Aune, *Prophecy,* pp. 81–101; Lindblom, *Prophecy;* and Robert R. Wilson, *Prophecy and Society in Ancient Israel* (Philadelphia: Fortress Press, 1980).

40. See Wolff, "Prophecy," pp. 20–25.

41. Martin Buber, "False Prophets," in *Israel and the World: Essays in a Time of Crisis* (New York: Schocken Books, 1948), pp. 117–18.

42. Ibid., pp. 116–17.

43. Wilson, *Prophecy,* pp. 87–8.

44. Heschel, *Prophets,* pp. 335–6. Heschel, of course, disagreed with Philo's proposition, but saw its historical importance. Philo's writing about prophecy can be found in *Philo of Alexandria: The Contemplative Life, The Giants, and Selections,* trans. David Winston (New York: Paulist Press, 1981), pp. 143–57.

45. Aune, *Prophecy,* p. 338. Cf. David Hill, *New Testament Prophecy* (London: Marshall, Morgan and Scott, 1979).

46. Colette Sirat, *A History of Jewish Philosophy in the Middle Ages* (Cambridge: Cambridge University Press, 1985), pp. 262–6.

47. Ottavia Niccoli, "The End of Prophecy," *Journal of Modern History* 61 (December 1989): 668.
48. Boyer, *When Time*. My account relies on Boyer's book.
49. For an excellent description of this belief, see Strozier, *Apocalypse,* pp. 9–11, 183–4.
50. Boyer, *When Time,* p. 55. Although it is difficult to chart a clear evolution of prophetic beliefs in American history, there is a remarkable continuity of themes, including speculation about America's destiny, the prophetic role of the Jews, the identity of the Antichrist, the sequence of end-time events, and visions of a different world. See Boyer's discussion, pp. 68–78.
51. These are discussed in depth in Boyer, *When Time,* pp. 293–324.
52. L. G. Moses, " 'The Father Tell Me So!' Wovoka: The Ghost Dance Prophet," *American Indian Quarterly* 9 (Summer 1985): 335.
53. James R. Lewis, "Shamans and Prophets: Continuities and Discontinuities in Native American New Religions," *American Indian Quarterly* 12 (Summer 1988): 221–8.
54. See Overholt, *Channels of Prophecy,* on Wovoka and Handsome Lake in particular. Overholt interprets their work as similar to the Hebrew prophet Jeremiah.
55. The following discussion builds on numerous sources, including: Raymond Williams, *Keywords: A Vocabulary of Culture and Society* (New York: Oxford University Press, 1983); Giles Gunn, *The Culture of Criticism and the Criticism of Culture* (New York: Oxford University Press, 1987); Terry Eagleton, *The Function of Criticism: From the Spectator to Post-Structuralism* (London: Verso, 1984); Michael Walzer, *Interpretation and Social Criticism* (Cambridge, MA: Harvard University Press, 1987); Walter Brueggemann, *The Prophetic Imagination* (Philadelphia: Fortress Press, 1978); Max Weber, *The Sociology of Religion,* trans. Ephraim Fischoff (Boston: Beacon Press, 1964); and Daly, *Beyond God the Father.*
56. Gunn, *Culture of Criticism,* p. 17.
57. Walzer, *Interpretation,* p. 59–60.
58. Raymond Geuss, *The Idea of a Critical Theory: Habermas and the Frankfurt School* (Cambridge: Cambridge University Press, 1981), p. 63. The heart of criticism for the Frankfurt School is critique of ideology. Chapters One through Four of Geuss's book offer a detailed discussion of the descriptive, pejorative, and positive uses of the concept of ideology.
59. Lucy Lippard, "First Strike for Peace," *Heresies* 20 (1985): 12.
60. Ibid., p. 14.
61. Weber, *Sociology of Religion,* p. 47.
62. Daly, *Beyond God the Father,* p. 165.
63. Brueggemann, *Prophetic Imagination,* p. 50.
64. David Ehrenfeld has argued that Nature functioned this way in George Orwell's writing. See his "The Roots of Prophecy: Orwell and Nature," *Hudson Review* 38 (Summer 1985): 193–213.
65. Jacques Derrida, in Richard Kearney, *Dialogues with Contemporary Thinkers,* p. 119.
66. Mary Daly, *Webster's First New Intergalactic Wickedary of the English Language* (Boston: Beacon Press, 1986), pp. 96, 165. I thank Sharon Welch for the suggestion that Daly's metaphors might be an appropriate way of reconceiving artistic work. For a critique of the implicit racism in some of Daly's writing, see Audre Lorde, "An Open Letter to Mary Daly," in *Sister Outsider,* pp. 66–71.
67. See Polumbaum, *Save Life;* Marianne Philbin, ed., *Ribbon: A Celebration of*

*Life* (Asheville, NC: Lark Books, 1985); Judith Francisca Baca, "Our People Are the Internal Exiles," and Nancy Angelo, "A Brief History of S.P.A.R.C.," in *Cultures in Contention,* eds. Douglas Kahn and Diane Neumaier (Seattle: Real Comet Press, 1985), pp. 62–75; Mary Beth Edelson, catalogue, *Seven Sites: Painting on the Wall,* 1988; and Edelson, *Seven Cycles: Public Rituals* (New York: A.I.R. Gallery, 1980); Kim Abeles, *Encyclopedia Persona A–Z* (Los Angeles: Fellows of Contemporary Art, 1993); and *Leon Golub and Nancy Spero: War and Memory* (Cambridge, MA: MIT List Visual Arts Center, 1994). For a short description of other types of activist projects see Lucy R. Lippard, "Trojan Horses: Activist Art and Power," in *Art After Modernism: Rethinking Representation,* ed. Brian Wallis (New York: New Museum of Contemporary Art, 1984), pp. 341–58.

68. Lucy Lippard develops the distinction between socially concerned and socially involved art in "Trojan Horses," p. 348–51.

69. See Marcia Lee Brown, "Facing the Fire: Images of Hope from Ages of Anxiety" (honors thesis, Radcliffe College, September 1986), for analysis of the specific symbols used in the Peace Ribbon.

70. Besides mural painting, S.P.A.R.C.'s other activities include organization of local exhibitions, training in mural painting and its traditions, and literacy projects. See Baca, "Our People Are the Internal Exiles," and Angelo, "A Brief History of S.P.A.R.C.," in *Cultures in Contention,* pp. 62–75.

71. Abeles, *Encyclopedia,* p. 86.

72. See Edelson, *Seven Sites,* for text and photographs that describe some of these paintings and ideas. Her *Firsthand: Photographs by Mary Beth Edelson, 1973–1993,* and *Shooter Series* (New York, 1993) provides a retrospective of Edelson's work in photography, with an analytical essay by Jan Avgikos.

73. Quoted in Mary Beth Edelson, "Story-Box: The Spirituality Question," *Heresies* 24 (1989): 58.

74. Sharon Welch, *A Feminist Ethic of Risk* (Minneapolis, MN: Fortress Press, 1990), p. 20.

75. Ibid., p. 70.

76. Lucy Lippard, "Hanging Onto Baby, Heating Up the Bathwater," in *Reimaging America: The Arts of Social Change,* eds. Mark O'Brien and Craig Little (Philadelphia: New Society Publishers, 1990), p. 234.

77. Bakhtin, "Art and Answerability," in *Art and Answerability,* p. 2.

## CHAPTER 10. VISIONARY IMAGINATION

1. Dmitri Merezhkovsky, "On the Reasons for the Decline, and the New Currents, in Contemporary Russian Literature," in *The Russian Symbolists: An Anthology of Critical and Theoretical Writings,* ed. and trans. Ronald E. Peterson (Ann Arbor, MI: Ardis, 1986), p. 18. Perhaps the finest book on Redon to date is *Odilon Redon, Prince of Dreams, 1840–1916,* eds. Douglas W. Druick et al. (Chicago: Art Institute of Chicago, 1994), with numerous essays that reassess the artist's relationship with Symbolism and the other currents of his time, as well as essays on other topics such as the way Redon constructed his own artistic image. Although this lithograph, along with the five others that form the series, is ostensibly linked to Edgar Allan Poe's writing (as the series title suggests), Redon's use of Poe's name may have been a strategic move designed to attach his own value as an artist to the writer's current reputation. See especially, Chapter Three, "In the Public Eye, 1879–1889," of *Prince of Dreams.*

2. Douglas Druick and Peter Kort Zegers, "In the Public Eye," in *Prince of Dreams*, p. 127.

3. J. M. Cocking, *Imagination: A Study in the History of Ideas* (New York and London: Routledge, 1991), p. xiii. I have consulted a wide variety of materials about imagination, ocularcentrism, and visionary traditions. The following have especially helped to shape this chapter: Diane Ackerman, *A Natural History of the Senses* (New York: Random House, 1990); Norman Bryson, *Vision and Painting: The Logic of the Gaze* (New Haven, CT: Yale University Press, 1983); Martin Jay, *Downcast Eyes: The Denigration of Vision in Twentieth-Century French Thought* (Berkeley: University of California Press, 1993); Martin Jay, *Force Fields: Between Intellectual History and Cultural Critique* (New York: Routledge, 1993); Richard Kearney, *The Wake of Imagination: Toward a Postmodern Culture* (Minneapolis: University of Minnesota Press, 1988); David Michael Levin, *The Opening of Vision: Nihilism and the Postmodern Situation* (New York: Routledge, 1988); David Michael Levin, ed., *Modernity and the Hegemony of Vision* (Berkeley: University of California Press, 1993), especially Levin's "Introduction," and Andrea Nye, "Assisting at the Birth and Death of Philosophical Vision"; Iris Murdoch, *Metaphysics as a Guide to Morals* (London: Penguin, 1992); Linda Nochlin, *The Politics of Vision: Essays on Nineteenth-Century Art and Society* (New York: Harper and Row, 1989); Griselda Pollock, *Vision and Difference: Femininity, Feminism, and the Histories of Art* (New York: Routledge, 1988); and Alan White, *The Language of Imagination* (Oxford: Basil Blackwell, 1990).

4. Wendell Berry, *Home Economics* (San Francisco: North Point Press, 1987), p. 96.

5. Or, in the words of Ludwig Wittgenstein: "One ought to ask, not what images are or what happens when one imagines anything, but how the word 'imagination' is used," *Philosophical Investigations: The English Text of the Third Edition,* trans. G. E. M. Anscombe (New York: Macmillan, 1968), p. 116e.

6. This is also the approach of Richard Kearney, in *Wake of Imagination*, p. 363.

7. Heinrich Zimmer, *Artistic Form and Yoga in the Sacred Images of India,* trans. Gerald Chapple and James B. Lawson (Princeton, NJ: Princeton University Press, 1984), esp. pp. 52–81 for his discussion of this distinction.

8. Murdoch, *Metaphysics*, p. 322.

9. This image of the continuum comes from Murdoch, *Metaphysics*, p. 309. I do not, however, follow her in positing the exemplary genius as the pole opposite of unconscious activity. For Murdoch, the exemplary genius uses imagination in ways completely different from the mediocrity of imitation.

10. M. H. Abrams was the first to propose the mirror and lamp metaphors, suggesting that in the eighteenth-century Enlightenment the central metaphor of the mirror, which had shaped the understanding of the mind in the European west, began to change to that of the lamp. See *The Mirror and the Lamp: Romantic Theory and Critical Tradition* (New York: Oxford, 1953).

11. Cocking, *Imagination*, p. 269.

12. Plato, *The Republic*, 2 vols. (Cambridge, MA: Harvard University Press, 1930).

13. For a clear exposition of these, see Kearney, *Wake of Imagination*, pp. 91–9.

14. Murdoch, *Metaphysics*, p. 320.

15. Kearney, *Wake of Imagination*, p. 105.

16. Ibid., pp. 108–9. A detailed discussion of Aristotle's views can be found in M. Schofield, "Aristotle on the Imagination," in *Aristotle on Mind and the Senses,* eds. G. E. R. Lloyd and G. E. L. Owen (Cambridge: Cambridge University Press, 1978), pp. 99–140.

17. Aristotle's own words are a bit more circuitous: "It is impossible even to think without a mental picture. The same process occurs in thinking as in drawing a diagram; for in this case, although we make no use of the fact that the magnitude of the triangle is a finite quantity, yet we draw it as having a finite magnitude. In the same way the man who is thinking, though he may not be thinking of a finite magnitude, still puts a finite magnitude before his eyes, though he does not think of it as such." In "On Memory and Recollection" (449b31–450a5), *On the Soul, Parva Naturalia, On Breath* (Cambridge, MA: Harvard University Press, 1935), p. 285.

18. See Aristotle, *On the Soul* 3, 7, 431b3–431b9, p. 179: "The thinking faculty thinks of its forms in mental pictures and just as what is pursued and avoided is defined in them, so also it is outside perception. . . . But at other times one calculates by images or thoughts residing in the soul as if one saw them, and plans for the future in view of the present."

19. Oliver Leaman, "Maimonides: Imagination and the Objectivity of Prophecy," *Religion* 18 (1988): 69–80.

20. Ibid., p. 70.

21. Moses Maimonides, *The Guide to the Perplexed,* trans. Shlomo Pines (Chicago: University of Chicago Press, 1963), 2, 36: 370.

22. Maimonides, *Guide,* 2, 38: 377. Quoted in Leaman, "Maimonides," p. 73.

23. Leaman, "Maimonides," p. 77.

24. Levin, *Opening of Vision,* p. 97. The idea of the nobility of vision was developed by Hans Jonas, "The Nobility of Sight: A Study in the Phenomenology of the Senses," in *Philosophy of the Body,* ed. S. Spicker (Chicago: Quadrangle, 1970).

25. Stafford, *Body Criticism,* p. 36.

26. Bryson, *Vision and Painting,* p. 104.

27. Martin Jay has used this phrase in many of his essays and books. My summary here is based on his essay, "Scopic Regimes of Modernity," in *Force Fields,* p. 115–24.

28. Jay, "Scopic Regimes of Modernity," p. 116.

29. For a careful reading of Augustine on desire, see Margaret R. Miles, *Desire and Delight: A New Reading of Augustine's Confessions* (New York: Crossroad, 1992).

30. Jay, "Scopic Regimes of Modernity," p. 118.

31. For example, Svetlana Alpers, in *The Art of Describing: Dutch Art in the Seventeenth Century* (Chicago: University of Chicago Press, 1983), has emphasized the ways in which Dutch seventeenth-century painting esteemed visual surface, description, fragmentariness, arbitrary frames, and immediacy of vision over storytelling, all of which were central to Italian Renaissance models. Christine Buci-Glucksmann, in *La raison baroque: de Baudelaire à Benjamin* (Paris: Galilee, 1984), translated by Patrick Camiller as *Baroque Reason: The Aesthetics of Modernity* (London: Sage Publications, 1994), and in *La folie du voir* (Paris: Galilee, 1986), has written about the ways in which baroque vision provided a more tactile quality, as well as a stronger sense of the unrepresentable, than strict Cartesian perspectivalism would permit. These are described in Jay, "Scopic Regimes of Modernity," pp. 120–4.

32. Immanuel Kant, in *The Critique of Pure Reason,* trans. Norman Kemp Smith (London: Macmillan, 1958), p. 146. Kant wrote about imagination in both *The Critique of Pure Reason,* pp. 112, 142ff., plus numerous other references; and in *Critique of Judgment,* trans. J. C. Meredith (Oxford: Clarendon Press, 1952), pp. 30–2, 86, 89, 115, 210, 212, 236. He initially worked out his ideas

in relation to the categories of space and time. Later, he distinguished between the productive and reproductive imagination, the later being of less importance to his formulation of the a priori nature of knowledge. See *Critique of Pure Reason*, p. 165.

33. Murdoch, *Metaphysics*, p. 308. See her chapter on imagination, pp. 308–48. Just how this process happens has been much disputed and is really not my concern here. See the brief description in Kearney, *Wake of Imagination*, pp. 169–71.

34. Kearney, *Wake of Imagination*, pp. 111–12.

35. Engell, *Creative Imagination*, p. 343.

36. Samuel Taylor Coleridge, *Biographia Literaria*, 2 vols., ed. J. Shawcross (1817; reprint, London: Oxford University Press, 1965), 1: 202.

37. Coleridge, *Biographia*, 1: 167. Coleridge's image of the imagination is evocative: "They and they only can acquire the philosophic imagination, the sacred power of self-intuition, who within themselves can interpret and understand the symbol, that the wings of the air-sylph are forming within the skin of the caterpillar; those only, who feel in their own spirits the same instinct, which impels the chrysalis of the horned fly to leave room in its involucrum for antennae yet to come. The know and feel, that the *potential* works *in* them, even as the *actual* works on them!"

38. Engell, *Creative Imagination*, pp. 359–60.

39. This summary is from Kearney, *Wake of Imagination*, p. 15.

40. An excellent summary of these developments is given in Levin, "Introduction," *Modernity*.

41. Levin, "Introduction," *Modernity*, p. 7.

42. Kearney, *Wake of Imagination*, p. 390.

43. Jay, "Scopic Regimes of Modernity, p. 125. As he continues, "We may learn to wean ourselves from the fiction of a 'true' vision and revel instead in the possibilities opened up by the scopic regimes we have already invented and the ones, now so hard to envision, that are doubtless to come."

44. Kaufman has written extensively about his theological framework. A fine short introduction is Gordon Kaufman, *Theology in a Nuclear Age* (Philadelphia: Westminster, 1985), and a fuller discussion can be found in his *In Face of Mystery: A Constructive Theology* (Cambridge, MA: Harvard University Press, 1993).

45. Kaufman, *Theology for a Nuclear Age*, p. 18.

46. For recent surveys of these developments, see J. M. Cocking, *Imagination*; Kearney, *The Wake of Imagination*; and White, *The Language of Imagination*.

47. These are detailed in Jay, "The Rise of Hermeneutics and the Crisis of Ocularcentrism," in *Force Fields*, pp. 99–113. Many of the same arguments are developed in more detail in *Downcast Eyes*. An important reference for anti-ocularcentrist and contemporary iconoclastic discussions is Jacques Ellul, *The Humiliation of the Word*, trans. Joyce Main Hanks (Grand Rapids, MI: Eerdman's, 1985).

48. Bryson, *Vision and Painting*, p. 120.

49. A sustained attempt to show this is Roger Lipsey's *An Art of Our Own: The Spiritual in Twentieth-Century Art* (Boston: Shambhala, 1989).

50. This has been well-documented in Magdalena Dabrowski, *Kandinsky Compositions* (New York: Museum of Modern Art, 1995).

51. DiDonna (1942–86) was educated at Pratt Institute in Brooklyn and Columbia University. For biography and background on his life, see Addison Parks, "Into the Garden: The Paintings of Porfirio DiDonna," *Arts Magazine* 63 (January

1989): 28–31; and John Yau, ed., "A Tribute to Porfirio DiDonna (1942–1986): Testimonials by Friends and Reproductions of DiDonna's Work," *Sulfur* 19 (Spring 1987): 50–63; and a forthcoming book by John Baker. Several details of DiDonna's biography are pertinent to the following interpretation of his painting. He was a devout Catholic and served as an altar boy at The Church of the Visitation of the Blessed Virgin Mary in Brooklyn. He attended church regularly with his family, and he played the organ during services. According to his mother, DiDonna had said while he was an art student at Pratt that he wanted to be a religious painter. See Anton van Dalen, "Notes of a Telephone Conversation with Porfirio's Mother, Saturday, 24 January 87," in *Sulfur* 19, p. 52. Perhaps because his teachers disapproved of such an aspiration, perhaps because the prevailing aesthetic did not encourage it, he abandoned traditional religious imagery in favor of a minimalist vocabulary of dots and dashes. Most critics have written of these paintings in terms of this minimalist vocabulary. Nina Nielsen and John Baker contend that even the drawings and paintings of this so-called dot-and-dash period contain veiled religious symbolism and referents. (Private conversation, June 20, 1990.) Eventually DiDonna returned to figuration in his late paintings. The religious impulse remained in his work, but it was expressed through more abstract shapes and symbols.
52. See Mikhail Bakhtin's four early essays especially for his moral philosophy and embodied aesthetics, published in *Art and Answerability: Early Philosophical Essays by M. M. Bakhtin*, trans. Vadim Liapunov and Kenneth Brostrom, ed. Michael Holquist (Austin: University of Texas Press, 1990), and *Toward a Philosophy of the Act*, trans. Vadim Liapunov, eds. Vadim Liapunov and Michael Holquist (Austin: University of Texas Press, 1993). As noted elsewhere, my *Bakhtin and the Visual Arts* offers an extensive description and interpretation of these essays.
53. Jay, *Downcast Eyes*, pp. 299, 307.
54. Ibid., p. 306.
55. Maurice Merleau-Ponty, "Cezanne's Doubt" in *Sense and Non-Sense*, trans. and ed. Hubert L. Dreyfus and Patricia A. Dreyfus (Evanston, IL: Northwestern University Press, 1964), p. 19; also see Judith Wechsler, *The Interpretation of Cezanne* (Ann Arbor, MI, 1981).
56. Stafford, *Body Criticism*, p. 36.
57. The idea of residues is taken from Jay's account of Merleau-Ponty, in *Downcast Eyes*, p. 309. Certainly, Merleau-Ponty's gendered account of vision must be criticized, along with his presumption of male sexuality and subjectivity. See Judith Butler, "Sexual Ideology and Phenomenological Description: A Feminist Critique of Merleau-Ponty's *Phenomenology of Perception*," in *The Thinking Muse: Feminism in Modern French Philosophy*, ed. Jeffner Allen and Iris Marion Young (Bloomington: Indiana University Press, 1989). Butler suggests that in his later essays, collected posthumously in *The Visible and the Invisible*, Merleau-Ponty gave a more nuanced account of sexuality that granted tactile experience a larger role.
58. Levin, *Modernity*, p. 2.
59. Jay, *Downcast Eyes*, p. 590.
60. Ibid., p. 591.
61. Ackerman, *Natural History*, pp. 230, 302–4.
62. Giambattista Vico, in *The New Science* (Ithaca, NY: Cornell University Press, 1970), p. 88; discussed in Levin, *Opening of Vision*, p. 226.
63. Merleau-Ponty, "The Intertwining – The Chiasm," *The Visible and the Invis-

*ible,* ed. Claude Lefort, trans. Alphonso Lingis (Evanston, IL: Northwestern University Press, 1968), p. 134. Quoted in Levin, *Opening of Vision,* p. 254. See Levin's reflections about the tactile nature of vision on pp. 253–6.

64. Levin, *Opening of Vision,* p. 234. I am indebted to Levin's writing in what follows. His writing has provoked me to ask new questions and think new thoughts; for that I am most grateful.

65. Mircea Eliade, *Yoga, Immortality and Freedom,* trans. Willard R. Trask (Princeton, NJ: Princeton University Press, 1958), p. 129.

66. Eliade, *Yoga,* p. 69ff.

67. Zimmer, *Artistic Form,* p. 55.

68. Zimmer introduces these metaphors in *Artistic Form,* pp. 55, 58.

69. Quoted by Zimmer, *Artistic Form,* p. 232.

70. This is a paraphrase of a question posed by Levin, *Modernity,* p. 3.

71. Before DiDonna died, John Baker had written, "And it was, perhaps, the problem of how to make a personal mark in this spiritual realm that kept him repeating these drawings. . . . Marks function as a locus by which we see timeless space." In "Porfirio DiDonna," *Arts Magazine* 58 (December 1983): 15. Addison Parks, "Into the Garden," p. 29, wrote "Now, the religious aspect of this work is too difficult to comment on, but it can't be overlooked. He believed it. It supported him as he supported it. Like so much about his painting, it is a personal thing." Lenore Malen, "Porfirio DiDonna," *Art News* 87 (February 1988): 147–8, wrote "DiDonna was trying to achieve an expression of pure feeling or spirit unencumbered by form, as if following the Symbolist dictum to paint not the thing but the effect it produces." Barry Schwabsky, "Porfirio DiDonna," *Flash Art* 139 (March–April 1988): 114, wrote, "[H]aving renounced any absolute separation between figure and ground, he turned the figure into a vessel . . . capable of enclosing the ground within a vibratory stillness in which the evacuation of the mystery beyond things gave way to the Wittgensteinian mystery *that things are,* the mystery 'whereof one can not speak.' "

72. Such typical interpretations can be read in Christine Temin's many reviews from 1982 to 1988 in the *Boston Globe* and Michael Brenson's reviews for *The New York Times,* 1983–4.

73. Michael Brenson, review, *The New York Times,* Friday, November 20, 1987.

74. I thank John Baker for showing me these notebooks.

75. John Baker, private conversation, June 20, 1990.

76. A note on DiDonna's practice around giving titles to his paintings: DiDonna habitually titled paintings only after they had been chosen for a particular exhibition. The paintings discussed here were painted after DiDonna's last show in Boston in 1985 and before his surgery for a brain tumor later that year. In a sense, this practice of titling the paintings may have veiled their religious or visionary meanings. In traditional words: Only those who have eyes to see, will see, and only those with ears to hear, will hear.

77. Linda Dalrymple Henderson's *The Fourth Dimension and Non-Euclidean Geometry in Modern Art* (Princeton, NJ: Princeton University Press, 1983) explores how these ideas were developed by artists of the Russian avant-garde, including Malevich.

78. Nina Nielsen used this image in a private conversation, June 20, 1990.

79. Walter Benjamin, *Illuminations,* ed. Hannah Arendt, trans. Harry Zohn (New York: Schocken Books, 1969), pp. 257–8.

80. This is the final text in Laurie Anderson, *Stories from the Nerve Bible: A Ret-*

*rospective, 1972–1992* (New York: HarperPerennial, 1994), p. 282. In the performance itself (Boston, March 31, 1995), this text occurs near the beginning.

81. Levin, *Opening of Vision*, pp. 459, 457.
82. Levin, *Opening of Vision*, p. 462.
83. Bryson, *Vision and Painting*, p. 95.
84. Levin, *Opening of Vision*, p. 87.
85. Ibid., p. 352.
86. Donna Haraway, *Primate Visions: Gender, Race, and Nature in the World of Modern Science* (New York: Routledge, 1989), p. 139. Also see her earlier "A Cyborg Manifesto: Science, Technology and Socialist-Feminism in the 1980s," in *Simians, Cyborgs, and Women* (New York: Routledge, 1989). A fascinating perspective on the cyborg, which discusses Haraway's formulation, is offered in Bukatman, *Terminal Identity*, pp. 321–5.
87. This is Randolph's own characterization of the painting, in "Shape Shifting: Toward Multifaceted Re-Presentations of Women's Bodies," unpublished paper, presented at College Art Association, February 1992.
88. Lynn Randolph, "*The Illusas* (deluded women): Representations of women who are out of bounds," slide presentation, The Mary Ingraham Bunting Institute of Radcliffe College, November 30, 1994.
89. Kearney, *Wake of Imagination*, p. 396.
90. This phrase is Kearney's, in *Wake of Imagination*, p. 30.
91. Quoted in Levin, "Introduction," *Modernity*, p. 7. From Marx, *Economic and Philosophical Manuscripts of 1844*, 1964, p. 141.
92. Levin, *Opening of Vision*, pp. 56–7.
93. William James, *A Pluralistic Universe* (Cambridge, MA: Harvard University Press, 1977), p. 77.
94. Ibid., p. 76.

### CHAPTER 11. CREATIVITY, UTOPIA, AND HOPE

1. Turrell is quoted in Craig Adcock's essay, "Light, Space, Time: The Visual Parameters of Roden Crater," in Julia Brown, ed., *Occluded Front: James Turrell* (Los Angeles: Lapis Press, 1985), p. 102.
2. James Turrell, "Open Space for Perception," *Flash Art* 24 (January–February 1991): 112.
3. Carter Ratcliff, in the foreword to Margot Lovejoy, *Postmodern Currents: Art and Artists in the Age of Electronic Media* (Englewood Cliffs, NJ: Prentice Hall, 1992), p. xx.
4. Freeman, *Finding the Muse*, p. 256. This list is my summary of his conditions of creativity in Chapter Six, pp. 251–307. His work demonstrates overlapping areas of concern with my own, even though his evolved through differing methods of study and assessment.
5. From Hélène Cixous, "The Last Painting or the Portrait of God," *Coming to Writing and Other Essays*, ed. Deborah Jenson, trans. Sarah Cornell et al. (Cambridge, MA, and London, England: Harvard University Press, 1991), pp. 129–30.
6. Quoted in Ernst Bloch, *The Utopian Function of Art and Literature: Selected Essays*, trans. Jack Zipes and Frank Mecklenburg (Cambridge, MA: MIT Press, 1988), p. 17. See Oscar Wilde, "The Soul of Man under Socialism," *Selected Essays and Poems* (London: Penguin, 1954), p. 34.
7. Bloch, *Utopian Function*, pp. 4–5.

8. On heterotopia, see Gianni Vattimo, "From Utopia to Heterotopia," in *The Transparent Society,* trans. David Webb (Cambridge, England: Polity Press, 1992), pp. 62–75. For a fascinating set of essays on the varieties of heterotopias in postmodernity, see Tobin Siebers, ed., *Heterotopia: Postmodern Utopia and the Body Politic* (Ann Arbor: University of Michigan Press, 1994).

9. Bloch, *Utopian Function,* pp. xxxii–xxxiii.

10. In his essay "Plato and Isaiah," Martin Buber discusses this link between the two philosophers. In *Israel and the World: Essays in a Time of Crisis* (New York: Schocken Books, 1948), pp. 103–4, 111–12.

11. This is a paraphrase of Buber's perspective in "Plato and Isaiah," adapted in relation to the artist.

12. Marcuse, *Aesthetic Dimension,* p. 73.

13. Ruth Levitas, *The Concept of Utopia* (New York: Philip Allan, 1990), pp. 191, 199. Levitas defines utopia as centered not on hope but on desire; in fact, the function of utopia, for her, is the education of desire itself. Her book provides an excellent survey of utopian thinkers working out of the Marxist tradition, including Ernst Bloch, William Morris, and Herbert Marcuse.

14. These reflections about forgiveness and promises are based on Hannah Arendt, *Human Condition,* pp. 237–47.

15. Sylvere Lotringer and Paul Virilio, *Pure War,* trans. Mark Polizotti (New York: Semiotexte, 1983), quoted in Lovejoy, *Postmodern Currents,* p. 263.

16. Arendt, *Human Condition,* p. 247.

17. Bloch, *Utopian Function,* p. 17.

18. Belting, *Likeness and Presence,* p. 10.

19. Gabriel Marcel, "Sketch of a Phenomenology and Metaphysic of Hope," in *Homo Viator: Introduction to a Metaphysic of Hope,* trans. Emma Craufurd (Chicago: Henry Regnery Co., 1951), pp. 33–4.

20. Ibid., p. 52.

21. Ibid., p. 53.

22. Ibid., p. 67.

23. Ibid., p. 61.

24. Becker, *Subversive Imagination,* p. 118. Cf. Kearney, *Dialogues,* p. 81.

25. Becker, *Subversive Imagination,* p. 119.

26. This is a summary of Marcuse's ideas in Becker, *Subversive Imagination,* p. 122.

27. Carol Becker develops these ideas about audience in "The Education of Young Artists and the Issue of Audience," in Henry A. Giroux and Peter McLaren, eds., *Between Borders: Pedagogy and the Politics of Cultural Studies* (New York: Routledge, 1994), pp. 101–12, esp. pp. 109, 111.

28. Becker, "Education," p. 17.

29. These ideas have been articulated by Antonio Gramsci, Michel Foucault, and Julia Kristeva, respectively. See Antonio Gramsci, "The Formation of Intellectuals," in *The Modern Prince and Other Writings* (New York: International Publishers, 1957); Michel Foucault's essays in *Power/Knowledge: Selected Interviews and Other Writings, 1972–1977,* ed. Colin Gordon, trans. Colin Gordon et al. (New York: Pantheon Books, 1980), and in *Language, Counter-Memory, Practice: Selected Essays and Interviews,* ed. Donald F. Bouchard, trans. Donald F. Bouchard and Sherry Simon (Ithaca, NY: Cornell University Press, 1977); and Julia Kristeva, "New Type of Intellectual," in *The Kristeva Reader,* ed. Toril Moi (New York: Columbia University Press, 1986). A discussion of the nature of the intelligentsia from a sociological perspective

may be found in Karl Mannheim, *Essays on the Sociology of Culture*, ed. Ernest Manheim (London: Routledge and Kegan Paul, 1956).

30. Raymond Williams, *Keywords*, p. 170. Cf. differing interpretations in James H. Billington, *The Icon and the Axe: An Interpretive History of Russian Culture* (New York: Random House, 1966), esp. pp. 233, 388–90; and Arnold Hauser, *The Sociology of Art*, trans. Kenneth J. Northcott (Chicago: University of Chicago Press, 1982), pp. 169–80. I strongly disagree with Hauser's assertion that the artist cannot be an intellectual unless "he" is a writer, as is evident above.

31. Poggioli, *Theory of the Avant-Garde*, p. 87. Mikhailovsky coined the term *raznochinets* for those who belonged to no particular social strata. Some have claimed that the intelligentsia was the public for avant-garde art, though Poggioli says that we must not confuse the intelligentsia with the intellectual elite, who *were* the public.

32. Mannheim, *Essays*, pp. 123–42.

33. Gramsci, "Formation of Intellectuals," p. 121.

34. He has developed this idea in numerous essays, especially "Truth and Power" and "Power and Strategies" in *Power/Knowledge*, pp. 109–45, and "Intellectuals and Power," in *Language, Counter-Memory, Practice*, pp. 205–17.

35. Foucault, "Truth and Power," p. 129. I have purposely left the male pronoun here, for it seems to me that such access to power is commonly the domain of men in patriarchal societies.

36. Kristeva, "New Type of Intellectual," pp. 292–300.

37. Kristeva's early essays especially show this debt to writings of the Bakhtin circle. See *Desire in Language: A Semiotic Approach to Literature and Art*, ed. Leon S. Roudiez, trans. Thomas Gora, Alice Jardine, and Leon S. Roudiez (New York: Columbia University Press, 1980); and *The Kristeva Reader*.

38. In my opinion Kristeva's otherwise useful formulations become problematic here, for she suggests that "real female innovation (in whatever social field) will only come about when maternity, female creation and the link between them are better understood."

39. For example, Mikhail Bakhtin, writing in the early 1920s, insisted that truth had a certain autonomy that could not be destroyed by acknowledging the specificity and hence the relativity of all deeds in the world. Indeed, "the multitude of value centers should lead us to doubt our values and to make our commitment to them provisional. But we do not end up with moral relativism. On the contrary, we arrive at a view that makes us continually and personally responsible for our actions and for assessing our moral responses." In Morson and Emerson, "Introduction," *Rethinking Bakhtin*, p. 20. For Bakhtin's own discussion of this, see "K filosofii postupka," pp. 120–30, and *Problems of Dostoevsky's Poetics*, p. 69. A similar position has been expressed in contemporary philosophy by writers such as Richard Bernstein and Barbara Herrnstein Smith. Cf. Richard J. Bernstein, *Beyond Objectivism and Relativism: Science, Hermeneutics, and Praxis* (Philadelphia: University of Pennsylvania Press, 1985); and Barbara Herrnstein Smith, *Contingencies of Value: Alternative Perspectives for Critical Theory* (Cambridge, MA: Harvard University Press, 1988). "If," as Barbara Herrnstein Smith put it, "there can be no total and final eradication of disparity, variance, opposition, and conflict, and also neither perfect knowledge nor pure charity, then the general optimum might well be that set of conditions that permits and encourages . . . *evaluation*: that is, the local figuring and working out, as well as we, heterogeneously, can, of what seems to work better than worse." In *Contingencies of Value*, p. 179.

40. Kearney, *Wake of Imagination*, p. 361.
41. This connection is made explicitly in Susan Sterling's essay "Signifying, Photographs and Text in the Work of Carrie Mae Weems," in *Carrie Mae Weems*, pp. 31–2.
42. Mannheim, *Essays*, pp. 159–62.
43. These ideas are an extended paraphrase of Mannheim's ideas in *Essays*, pp. 95, 118, 165, 170.
44. James Baldwin, *Nobody Knows My Name: More Notes of a Native Son* (New York: Dial Press, 1961), esp. pp. 153–4.
45. Heschel, *The Prophets*, pp. xvi–ii.

## CHAPTER 12. A FINAL IMAGE

1. These are described in detail in David Aune, *Prophecy*, pp. 327–33.
2. Malcolm Godwin develops this theme in *Angels: An Endangered Species* (New York: Simon and Schuster, 1990), p. 45. More details can be found in Gustav Davidson, *A Dictionary of Angels, Including the Fallen Angels* (New York: Free Press, 1967), pp. 117–19.
3. Seyyed Hossein Nasr, *Three Muslim Sages: Avicenna-Suhrawardi-Ibn 'Arabi* (Cambridge, MA: Harvard University Press, 1964), pp. 28–9.
4. Nasr, *Three Muslim Sages*, p. 39.
5. Cocking, *Imagination*, pp. 105, 114.
6. Nasr, *Three Muslim Sages*, p. 78. For more on Suhrawardi, see Henry Corbin, *History of Islamic Philosophy*, trans. Liadain Sherrard (London: Kegan Paul International, 1993), esp. Chapter VII, "Al-Suhrawardi and the Philosophy of Light," pp. 205–20.

# Works Cited

Abeles, Kim. *Encyclopedia Persona A–Z*. Los Angeles: Fellows of Contemporary Art, 1993.

Abrams, M. H. *The Mirror and the Lamp: Romantic Theory and Critical Tradition*. New York: Oxford, 1953.

Ackerman, Diane. *A Natural History of the Senses*. New York: Vintage Books, 1990.

*Ad Reinhardt*. Exhibition catalogue. New York: Rizzoli, 1991.

Adams, Marie Jeanne. "The Harriet Powers Pictorial Quilts." *Black Art* 3 (1979): 12–28.

Alpatov, M. *Color in Early Russian Icon Painting*. Moscow: Isobrazitelnoye Iskusstvo, 1974.

Alpers, Svetlana. *The Art of Describing: Dutch Art in the Seventeenth Century*. Chicago: University of Chicago Press, 1983.

Althaus, Paul. *The Ethics of Martin Luther*. Translated by Robert C. Schultz. Philadelphia: Fortress Press, 1972.

Anderson, Laurie. *Stories from the Nerve Bible: A Retrospective, 1972–1992*. New York: HarperPerennial, 1994.

Angus, S. *The Mystery Religions: A Study in the Religious Background of Early Christianity*. New York: Dover, 1975. Reprint of *The Mystery Religions and Christianity*. London: John Murray, 1925.

Arendt, Hannah. *The Human Condition*. Chicago: University of Chicago Press, 1958.

Aristotle. *On the Soul. Parva Naturalia. On Breath*. Translated by W. S. Hett. Cambridge, MA: Harvard University Press, 1935.

Augustine, Saint. *Saint Augustine Confessions*. Translated by R. S. Pine-Coffin. New York: Penguin Books, 1961.

Aune, David E. *Prophecy in Early Christianity and the Ancient Mediterranean World*. Grand Rapids, MI: William B. Eerdmans Publishing Company, 1983.

Auping, Michael. *Jenny Holzer*. New York: Universe, 1992.

Baggley, John. *Doors of Perception: Icons and Their Spiritual Significance*. Crestwood, NY: St. Vladimir's Seminary Press, 1988.

Bakhtin, Mikhail M. *Art and Answerability: Early Philosophical Essays by M. M. Bakhtin*. Translated by Vadim Liapunov and Kenneth Brostrom. Edited by Michael Holquist. Austin: University of Texas Press, 1990.

———. *The Dialogic Imagination: Four Essays by M. M. Bakhtin*. Translated by Caryl Emerson and Michael Holquist. Edited by Michael Holquist. Austin: University of Texas Press, 1981.

———. "K filosofii postupka." [Toward a philosophy of the act]. In *Filosofiia i sotsiologiia nauki i tekhniki*. Moscow: Nauka, 1986.

———. *Literaturno-kriticheskie stat'i.* Edited by S. G. Bocharov and V. V. Kozhinov. Moscow: Khudozhestvennaia literatura, 1986.

———. *Problems of Dostoevsky's Poetics.* Edited and translated by Caryl Emerson. Minneapolis: University of Minnesota Press, 1984.

———. *Speech Genres and Other Late Essays.* Translated by Vern W. McGee. Edited by Caryl Emerson and Michael Holquist. Austin: University of Texas Press, 1986.

Baldwin, James. *Nobody Knows My Name: More Notes of a Native Son.* New York: Dial Press, 1961.

Barasch, Moshe. *Modern Theories of Art from Winckelmann to Baudelaire.* New York: New York University Press, 1990.

———. *Theories of Art from Plato to Winckelmann.* New York: New York University Press, 1985.

Barnard, L. W. *The Graeco-Roman and Oriental Background of the Iconoclastic Controversy.* Leiden: Brill, 1974.

Barrow, Terence. *Maori Art of New Zealand.* Paris: Unesco Press, 1978.

Battersby, Christine. *Gender and Genius: Towards a Feminist Aesthetics.* Bloomington: Indiana University Press, 1989.

Baxandall, Michael. *Giotto and the Orators.* Oxford: Clarendon Press, 1971.

Bazin, Germain. *Le Crépuscule des images.* Paris: Gallimard, 1946.

Becker, Carol. "The Education of Young Artists and the Issue of Audience." In *Between Borders: Pedagogy and the Politics of Cultural Studies,* edited by Henry A. Giroux and Peter McLaren. New York: Routledge, 1994.

Becker, Carol, ed. *The Subversive Imagination: Artists, Society, and Social Responsibility.* New York: Routledge, 1994.

Behrendt, Stephe C. "The Consequence of High Powers: Blake, Shelley, and Prophecy's Public Dimension." *Papers on Language and Literature* 22 (Summer 1986): 254–75.

Belting, Hans. *The End of the History of Art?* Translated by Christopher S. Wood. Chicago: University of Chicago Press, 1987.

———. *Likeness and Presence: A History of the Image before the Era of Art.* Translated by Edmund Jephcott. Chicago: University of Chicago Press, 1994.

Bender, Gretchen, and Timothy Druckrey, eds. *Culture on the Brink: Ideologies of Technology.* Seattle: Bay Press, 1994.

Benjamin, Walter. *Illuminations.* Edited with an introduction by Hannah Arendt. Translated by Harry Zohn. New York: Schocken Books, 1969.

Bermingham, Ann. *Landscape and Ideology: The English Rustic Tradition, 1740–1860.* Berkeley: University of California Press, 1986.

Bernstein, Richard J. *Beyond Objectivism and Relativism: Science, Hermeneutics, and Praxis.* Philadelphia: University of Pennsylvania Press, 1985.

Berry, Wendell. *Home Economics.* San Francisco: North Point Press, 1987.

Bevan, Edwyn. *Holy Images: An Inquiry into Idolatry and Image Worship in Ancient Paganism and in Christianity.* London: George Allen and Unwin, 1940.

Bihalji-Merin, Oto. *Masters of Naive Art: A History and Worldwide Survey.* Translated by Russell M. Stockman. New York: McGraw Hill, 1971.

*Bill Viola: Survey of a Decade.* Exhibition catalogue. Houston: Contemporary Arts Museum, 1988.

Billington, James H. *The Icon and the Axe: An Interpretive History of Russian Culture.* New York: Random House, 1966.

Bisanz, Rudolf M. *German Romanticism and Philipp Otto Runge: A Study in Nineteenth-Century Art Theory and Iconography.* DeKalb: Northern Illinois University Press, 1970.

Blenkensopp, Joseph. *A History of Prophecy in Israel.* London: SPCK, 1984.

Bloch, Ernst. *The Utopian Function of Art and Literature: Selected Essays.* Translated by Jack Zipes and Frank Mecklenburg. Cambridge, MA: MIT Press, 1988.

Bonaventura, Saint. *Saint Bonaventura: The Soul's Journey to God.* Translated by Ewert Cousins. New York: Paulist Press, 1978.

Bottomore, Tom, ed. *A Dictionary of Marxist Thought.* Cambridge, MA: Harvard University Press, 1983.

Boyce, Mary. *A History of Zoroastrianism.* 2 vols. Leiden: E. J. Brill, 1975 and 1982.

———. *Textual Sources for the Study of Zoroastrianism.* Totowa, NJ: Barnes and Noble, 1984.

Boyer, Paul. *When Time Shall Be No More: Prophecy Belief in Modern American Culture.* Cambridge, MA: Harvard University Press, 1992.

Brodski, Bella, and Celeste Schenck, eds. *Life/Lines: Theorizing Women's Autobiography.* Ithaca, NY: Cornell University Press, 1988.

Broude, Norma, and Mary D. Garrard, eds. *The Power of Feminist Art: The American Movement of the 1970s, History and Impact.* New York: Harry N. Abrams, 1994.

Brown, Frank Burch. *Religious Aesthetics: A Theological Study of Making and Meaning.* Princeton, NJ: Princeton University Press, 1989.

Brown, Julia, ed. *Occluded Front: James Turrell.* Los Angeles: Lapis Press, 1985.

Brown, Marilyn R. *Gypsies and Other Bohemians: The Myth of the Artist in Nineteenth-Century France.* Ann Arbor, MI: UMI Research Press, 1985.

Brueggemann, Walter. *The Prophetic Imagination.* Philadelphia: Fortress Press, 1978.

Brumfield, William, and Milos M. Velimirovic. *Christianity and the Arts in Russia.* New York: Cambridge University Press, 1991.

Brummett, Barry. *Contemporary Apocalyptic Rhetoric.* New York: Praeger, 1991.

Bryer, Anthony, and Judith Herrin, eds. *Iconoclasm: Papers Given at the Ninth Spring Symposium of Byzantine Studies.* Birmingham, England: Centre for Byzantine Studies, 1977.

Bryson, Norman. *Vision and Painting: The Logic of the Gaze.* New Haven, CT: Yale University Press, 1983.

Buber, Martin. *Israel and the World: Essays in a Time of Crisis.* New York: Schocken Books, 1948.

———. *Pointing the Way: Collected Essays.* Translated and edited by Maurice Friedman. London: Routledge and Kegan Paul, 1957.

———. *The Prophetic Faith.* Translated by Carlyle Witton-Davies. New York: Macmillan, 1949.

Buchloh, Benjamin. "Theorizing the Avant-Garde." *Art in America* 72 (November 1984): 19–21.

Buhler, Stephen M. "Marsilio Ficino's *De stella magorum* and Renaissance Views of the Magi." *Renaissance Quarterly* 43 (Summer 1990): 348–71.

Bukatman, Scott. *Terminal Identity: The Virtual Subject in Postmodern Science Fiction.* Durham, NC: Duke University Press, 1993.

Bunt, Cyril G. E. *Russian Art, from Scyths to Soviets.* London: Studio, 1946.

Bürger, Peter. *Theory of the Avant-Garde.* Translated by Michael Shaw. Minneapolis: University of Minnesota Press, 1984.

Burkert, Walter. *Greek Religions.* Cambridge, MA: Harvard University Press, 1985.

Burkirk, Martha. "Interviews with Sherrie Levine, Louise Lawler, and Fred Wilson." *October* 70 (Fall 1994): 99–112.

Butler, Judith. "Sexual Ideology and Phenomenological Description: A Feminist Critique of Merleau-Ponty's *Phenomenology of Perception.*" In *The Thinking Muse: Feminism in Modern French Philosophy,* edited by Jeffner Allen and Iris Marion Young. Bloomington: Indiana University Press, 1989.

Calinescu, Matei. *Faces of Modernity: Avant-Garde, Decadence, Kitsch.* Bloomington: Indiana University Press, 1977.

Calvin, John. *Institutes of the Christian Religion.* 2 vols. Library of Christian Classics, Vol. 20. Edited by John T. McNeill. Translated by Ford Lewis Battles. Philadelphia: Westminster Press, 1960.

Cammann, Schuyler. "Suggested Origin of the Tibetan Mandala Paintings." *The Art Quarterly* (Spring 1950): 107–19.

Campagnon, Antoine. *The Five Paradoxes of Modernity.* Translated by Franklin Philip. New York: Columbia University Press, 1994.

Carlyle, Thomas. *Past and Present.* New York: New York University Press, 1965.

Carman, John, and Mark Juergensmeyer, eds. *A Bibliographic Guide to the Comparative Study of Ethics.* Cambridge: Cambridge University Press, 1991.

*Catalog of the Tibetan Collection and Other Lamaist Material in the Newark Museum.* Vol. 3. Newark, NJ: Newark Museum, 1971.

Cavarnos, Constantine. *Orthodox Iconography.* Belmont, MA: Institute for Byzantine and Modern Greek Studies, 1977.

Chadwick, N. Kershaw. *Poetry and Prophecy.* Cambridge: Cambridge University Press, 1942.

Chandra, Lokesh. *Buddhist Iconography of Tibet.* 2 vols. Kyoto: Rinsen Book Company, 1986.

Chave, Anna C. *Constantin Brancusi: Shifting the Bases of Art.* New Haven, CT: Yale University Press, 1994.

Christensen, Carl C. *Art and the Reformation in Germany.* Athens: Ohio University Press, 1979.

Christian, Barbara. "The Race for Theory." *Feminist Studies* 14 (Spring 1988): 67–80.

Cixous, Hélène. *Coming to Writing and Other Essays.* Edited by Deborah Jenson. Translated by Sarah Cornell et al. Cambridge, MA: Harvard University Press, 1991.

Clark, T. J. "Painting in the Year Two." *Representations* 47 (Summer 1994): 13–63.

———. *The Painting of Modern Life: Paris in the Art of Manet and His Followers.* Princeton, NJ: Princeton University Press, 1984.

Coates, Ross. "Interview with the Bricoleur." *Universe* 8 (Spring 1995): 2–5.

Cocking, J. M. *Imagination: A Study in the History of Ideas.* New York: Routledge, 1991.

Coggins, R., A. Phillips, and M. Knibb, eds. *Israel's Prophetic Traditions.* Cambridge: Cambridge University Press, 1982.

Cole, Susan Guettel. *Theoi Megaloi: The Cult of the Great Gods at Samothrace.* Leiden: E. J. Brill, 1984.

Coleridge, Samuel Taylor. *Biographia Literaria.* 2 vols. Edited by J. Shawcross. 1817. Reprint, London: Oxford University Press, 1965.

Collingwood, R. G. *The Principles of Art.* Oxford: Clarendon Press, 1938.

Collins, Adela Yarbro. *Combat Myths in the Book of Revelation.* Missoula, MT: Scholar's Press, 1976.

Collins, John J. *The Apocalyptic Imagination: An Introduction to the Jewish Matrix of Christianity.* New York: Crossroad, 1984.

Corbin, Henry. *Avicenna and the Visionary Recital.* Translated by Willard R. Trask. New York: Bollingen Foundation, 1960.

———. *History of Islamic Philosophy.* Translated by Liadain Sherrard. London: Kegan Paul International, 1993.

Cork, Richard. *A Bitter Truth: Avant-Garde Art and the Great War.* New Haven, CT: Yale University Press, 1994.

Corn, Joseph J., ed. *Imagining Tomorrow: History, Technology and the American Future.* Cambridge, MA: MIT Press, 1986.

Cotton, Bob, and Richard Oliver, eds. *The Cyberspace Lexicon: An Illustrated Dictionary of Terms from Multimedia to Virtual Reality.* London: Phaidon, 1994.

Crumlin, Rosemary, ed. *Aboriginal Art and Spirituality.* North Blackburn, Victoria: Collins Dove, 1991.

Dabrowski, Magdalena. *Kandinsky Compositions.* New York: Museum of Modern Art, 1995.

Dagyab, Loden Sherap. *Tibetan Religious Art.* Wiesbaden: Otto Harrassowitz, 1977.

Daly, Mary. *Beyond God the Father: Toward a Philosophy of Women's Liberation.* Boston: Beacon Press, 1973.

———. *Gyn/Ecology: The Metaethics of Radical Feminism.* Boston: Beacon Press, 1978.

———. *Webster's First New Intergalactic Wickedary of the English Language.* Boston: Beacon Press, 1987.

Darrow, William R. "Zoroaster Amalgamated: Notes on Iranian Prophetology." *History of Religions* 27 (November 1987): 109–32.

Daumal, René. *Mount Analogue: Authentic Narrative.* Translated by Roger Shattuck. San Francisco: City Lights, 1972.

Davidson, Gustav. *A Dictionary of Angels, Including the Fallen Angels.* New York: Free Press, 1967.

Derrida, Jacques. *Memoirs of the Blind: The Self-Portrait and Other Ruins.* Chicago: University of Chicago Press, 1993.

Dewey, John. *Art as Experience.* New York: Minton, Balch and Company, 1934.

Diderot, Denis. *Essais sur la peinture, Salons de 1759, 1761, 1763.* Paris: Hermann, 1984.

Dissanayake, Ellen. *Homo Aestheticus: Where Art Comes From and Why.* New York: Free Press, 1992.

Dodds, E. R. *The Greeks and the Irrational.* Berkeley: University of California Press, 1956.

———. *Pagan and Christian in an Age of Anxiety: Some Aspects of Religious Experience from Marcus Aurelius to Constantine.* New York: Cambridge University Press, 1965.

Dorra, Henri. *Symbolist Art Theories: A Critical Anthology.* Berkeley: University of California Press, 1994.

Douglas, Charlotte. "Beyond Reason: Malevich, Matiushin, and Their Circles." In *The Spiritual in Art: Abstract Painting, 1890–1985.* New York: Abbeville Press, 1986.

———. *Malevich.* New York: Harry N. Abrams, 1994.

Druckrey, Timothy, ed. *Iterations: The New Image.* Cambridge, MA: MIT Press, 1993.

Druick, Douglas W., et al. *Odilon Redon, Prince of Dreams, 1840–1916.* Chicago: Art Institute of Chicago, 1994.

Eagleton, Terry. *The Function of Criticism: From the Spectator to Post-Structuralism*. London: Verso, 1984.

Edelson, Mary Beth. *Firsthand: Photographs by Mary Beth Edelson, 1973–1993, and Shooter Series*. New York, 1993.

———. *Seven Cycles: Public Rituals*. New York: A.I.R. Gallery, 1980.

———. *Seven Sites: Painting on the Wall*. New York: Mary Beth Edelson, 1988.

Egbert, Donald Drew. "The Idea of the 'Avant-Garde' in Art and Politics." *American Historical Review* 73 (1967): 339–66.

Ehrenfeld, David. "The Roots of Prophecy: Orwell and Nature." *The Hudson Review* 38 (Summer 1985): 193–213.

Eliade, Mircea. *Yoga, Immortality and Freedom*. Translated by Willard R. Trask. Princeton, NJ: Princeton University Press, 1958.

Ellul, Jacques. *The Humiliation of the Word*. Translated by Joyce Main Hanks. Grand Rapids, MI: Eerdman's, 1985.

Engell, James. *The Creative Imagination*. Cambridge, MA: Harvard University Press, 1981.

Feldman, Edmund Burke. *The Artist*. Englewood Cliffs, NJ: Prentice-Hall, 1982.

Ferguson, Margaret, and Jennifer Wicke. "Introduction." *boundary* 2 19 (Summer 1992): 1–9.

Florenskii, Archpriest Pavel. "On the Icon." *Eastern Churches Review* 8/1 (1976): 11–37.

———. "Stat'i po iskusstvu" [Articles on art]. In *Sobranie Sochinenii I*, pp. 33–352. Paris: YMCA Press, 1985.

Foster, Hal, ed. *The Anti-Aesthetic: Essays on Postmodern Culture*. Port Townsend, WA: Bay Press, 1983.

———. "What's Neo about the Neo-Avant-Garde?" *October* 70 (Fall 1994): 5–32.

Foucault, Michel. *Discipline and Punish: The Birth of the Prison*. Translated by Alan Sheridan. New York: Vintage Press, 1979.

———. *Language, Counter-Memory, Practice: Selected Essays and Interviews*. Edited by Donald F. Bouchard. Translated by Donald F. Bouchard and Sherry Simon. Ithaca, NY: Cornell University Press, 1977.

———. *Power/Knowledge: Selected Interviews and Other Writings, 1972–1977*. Edited by Colin Gordon. Translated by Colin Gordon et al. New York: Pantheon Books, 1980.

Fox, Matthew. *The Reinvention of Work: A New Vision of Livelihood for Our Time*. San Francisco: HarperSan Francisco, 1994.

Freedberg, David. *The Power of Images: Studies in the History and Theory of Response*. Chicago: University of Chicago Press, 1989.

Freeman, Mark. *Finding the Muse: A Sociopsychological Inquiry into the Conditions of Artistic Creativity*. New York: Cambridge University Press, 1994.

Freud, Sigmund. *Civilization and Its Discontents*. Translated by James Strachey. New York: W.W. Norton and Co., 1961.

Friedländer, Saul, et al. *Visions of Apocalypse: End or Rebirth?* New York: Holmes and Meier, 1985.

Fromm, Erich. *Marx's Concept of Man*. New York: Frederick Ungar Publishing Co., 1961.

Fusco, Coco. "The Couple in the Cage: A Guatinaui Odyssey." *The Drama Review* 38 (Spring 1994): 143–67.

Fyodorov-Davydov, A. A. *Isaac Ilyich Levitan: His Life and His Work, 1860–1900*. Moscow: Iskusstvo, 1976.

Gablik, Suzi. *The Reenchantment of Art*. New York: Thames and Hudson, 1991.

Galavaris, George. *The Icon in the Life of the Church*. Leiden: Brill, 1981.

———. *Icons from the Elvehjem Art Center*. Madison: University of Wisconsin Press, 1973.

Gay, Peter. *The Enlightenment: An Interpretation*. 2 vols. New York: Alfred A. Knopf, 1966.

Gerhard, H. P. *The World of Icons*. New York: Harper and Row, 1957.

Geuss, Raymond. *The Idea of a Critical Theory: Habermas and the Frankfurt School*. Cambridge: Cambridge University Press, 1981.

Gill, Eric. *A Holy Tradition of Working: Passages from the Writings of Eric Gill*. Ipswich, England: Golgonooza Press, 1983.

Gill, Susan. "Painting from the Heart." *Art News* 86 (April 1987): 128–35.

Gilman, Richard. "The Idea of the Avant-Garde." *Partisan Review* 39 (1972): 382–96.

Gimpel, Jean. *Against Art and Artists*. Edinburgh: Polygon, 1991.

Godwin, Malcolm. *Angels: An Endangered Species*. New York: Simon and Schuster, 1990.

Goethals, M. Gregor. *The TV Ritual: Worship at the Video Altar*. Boston: Beacon Press, 1981.

Gómez-Peña, Guillermo. "The New World Border: Prophecies for the End of the Century." *The Drama Review* 38 (Spring 1994): 119–42.

Gordimer, Nadine. *The Essential Gesture: Writing, Politics and Places*. Edited by Stephen Clingman. London: Jonathan Cape, 1988.

Goswamy, P. N., and A. L. Dahmen-Dallapiccola. *An Early Document of Indian Art*. New Delhi: Manohar Book Service, 1976.

Gouma-Peterson, Thalia. " 'Collaboration' and Personal Identity in Miriam Schapiro's Art." In *Miriam Schapiro*. Exhibition catalogue. New York: Steinbaum Krauss Gallery, 1994.

Govinda, Lama Anagarika. *Foundations of Tibetan Mysticism*. York Beach, ME: Samuel Weiser, 1969.

Gramsci, Antonio. *The Modern Prince and Other Writings*. New York: International Publishers, 1957.

Greenberg, Clement. *The Collected Essays and Criticism*. 4 vols. Edited by John O'Brian. Chicago: University of Chicago Press, 1986–93.

Greenspahn, Frederick E. "Why Prophecy Ceased." *Journal of Biblical Literature* 108 (1989): 37–49.

Grimal, Pierre. *The Dictionary of Classical Mythology*. Translated by A. R. Maxwell-Hyslop. Oxford: Basil Blackwell, 1985.

Guerman, Mikhail. *Mikhail Vrubel*. Translated by John Greenfield and Valery Kereviaghin. Leningrad: Aurora Art Publishers, 1985.

Gorky, Maxim. *Autobiography of Maxim Gorky*. Translated by Isidor Schneider. London: Elek Books, 1953.

Guillaume, Alfred. *Prophecy and Divination Among the Hebrews and Other Semites*. London: Hodder and Stoughton, 1938.

Gunn, Giles. *The Culture of Criticism and the Criticism of Culture*. New York: Oxford University Press, 1987.

Gutmann, Joseph, ed. *The Image and the Word: Confrontations in Judaism, Christianity and Islam*. Missoula, MT: Scholar's Press, 1977.

Habel, N. "The Form and Significance of the Call Narrative." *Zeitschrift Altestamentliche Wissenschaft* 77 (1965): 297–323.

Hall, Donald. *Lifework*. Boston: Beacon Press, 1993.

Halliday, W. R. *Greek Divination: A Study of Its Methods and Principles*. London: Macmillan and Company, 1913.

Hanson, Paul D. *The Dawn of Apocalyptic.* Philadelphia: Fortress Press, 1975.
———, ed. *Visionaries and Their Apocalypses.* Philadelphia: Fortress Press, 1983.
Haraway, Donna. *Primate Visions: Gender, Race, and Nature in the World of Modern Science.* New York: Routledge, 1989.
———. *Simians, Cyborgs, and Women.* New York: Routledge, 1989.
Harris, Clare. "Desperately Seeking the Dalai Lama." In *Disrupted Borders: An Intervention in Definitions of Boundaries,* edited by Sunil Gupta. London: Rivers Oram Press, 1993.
Harris, Mary Emma. *The Arts at Black Mountain College.* Cambridge, MA: MIT Press, 1987.
Harrison, Jane Ellen. *Prolegemona to the Study of Greek Religion.* New York: Arno Press, 1975. Reprint ed. Cambridge: Cambridge University Press, 1903.
Haskell, Francis. *History and Its Images: Art and the Interpretation of the Past.* New Haven, CT: Yale University Press, 1993.
Haughton, Rosemary. "Prophecy in Exile." *Cross Currents* 39 (Winter 1989–90): 420–30.
Hauser, Arnold. *The Sociology of Art.* Translated by Kenneth J. Northcott. Chicago: University of Chicago Press, 1982.
Haynes, Deborah J. *Bakhtin and the Visual Arts.* New York: Cambridge University Press, 1995.
———. "Gender Ambiguity and Religious Meaning in the Art of Remedios Varo." *Woman's Art Journal* 16 (Spring–Summer 1995): 26–32.
———. "Nuclear Bower." *Artweek* (November 14, 1991): 14.
———. "Ultimate Questions: Bill Viola at the Donald Young Gallery." *Artweek* (May 21, 1992): 5.
Heidegger, Martin. *What Is Called Thinking?* Translated by Fred D. Wieck and J. Glenn Gray. New York: Harper and Row, 1968.
Heiferman, Marvin, and Lisa Phillips. *Image World: Art and Media Culture.* New York: Whitney Museum of Art, 1989.
Hein, Hilde, and Carolyn Korsmeyer. *Aesthetics in Feminist Perspective.* Bloomington: Indiana University Press, 1993.
Henderson, Linda Dalrymple. *The Fourth Dimension and Non-Euclidean Geometry in Modern Art.* Princeton, NJ: Princeton University Press, 1983.
Herrera, Hayden. *Joan Snyder: Seven Years of Her Work.* Purchase, NY: Neuberger Museum, 1978.
Heschel, Abraham Joshua. *The Prophets.* New York: Harper and Row, 1962.
Heschel, Susannah, ed. *On Being a Jewish Feminist: A Reader.* New York: Schocken Books, 1995.
Hickey, Dave. *Invisible Dragon: Four Essays on Beauty.* Los Angeles: Art Issues, 1994.
Hill, David. *New Testament Prophecy.* London: Marshall, Morgan and Scott, 1979.
Hobson, Stephen. "Manual: Et in Arcadia Ego." *Perspektief Magazine* 47/48 (June 1994): 72–82.
Hoffman, Helmut. "Early and Medieval Tibet." In *The Cambridge History of Early Inner Asia,* edited by Denis Sinor. Cambridge: Cambridge University Press, 1990.
Holl, Karl. "Die Geschichte des Worts Beruf." In *Gesammelte Aufsatze zur Kirchengeschichte,* Vol. 3, pp. 189–219. Tübingen: Verlag von J. C. B. Mohr (Paul Siebeck), 1928.
Huyssen, Andreas. *After the Great Divide: Modernism, Mass Culture, Postmodernism.* Bloomington: Indiana University Press, 1986.

Hyde, Lewis. *The Gift: Imagination and the Erotic Life of Property*. New York: Random House, 1983.

Isdebsky-Pritchard, Aline. *The Art of Mikhail Vrubel (1856–1910)*. Ann Arbor, MI: UMI Research Press, 1982.

Iskin, Ruth. "Toward a Feminist Imperative: The Art of Joan Snyder." *Chrysalis* 1 (1977): 101–15.

Jackson, David P., and Janice A. Jackson. *Tibetan Thangka Painting: Methods and Materials*. London: Serindia Publications, 1984.

James, William. *A Pluralistic Universe*. Cambridge, MA: Harvard University Press, 1977.

Jameson, Fredric. *Postmodernism, or the Cultural Logic of Late Capitalism*. Durham, NC: Duke University Press, 1991.

Jay, Martin. *Downcast Eyes: The Denigration of Vision in Twentieth-Century French Thought*. Berkeley: University of California Press, 1993.

———. *Force Fields: Between Intellectual History and Cultural Critique*. New York: Routledge, 1993.

Jencks, Charles, ed. *The Post-Modern Reader*. New York: St. Martin's Press, 1992.

Jennings, Theodore, ed. *The Vocation of the Theologian*. Philadelphia: Fortress Press, 1985.

Jigmei, Ngapo Ngawang, et al. *Tibet*. New York: McGraw-Hill, 1981.

John of Damascus, Saint. *On the Divine Images*. Translated by David Anderson. Crestwood, NY: St. Vladimir's Seminary Press, 1980.

———. *Orthodox Faith*. In *Saint John of Damascus: Writings*. Translated by Frederic H. Chase, Jr. New York: Fathers of the Church, 1958.

Jonas, Hans. "The Nobility of Sight: A Study in the Phenomenology of the Senses." In *Philosophy of the Body*, edited by S. Spicker. Chicago: Quadrangle, 1970.

Jones, Bill. "Joan Snyder." *Arts Magazine* 64 (Summer 1990): 76.

Jones, Suzanne W., ed. *Writing the Woman Artist: Essays on Poetics, Politics, and Portraiture*. Philadelphia: University of Pennsylvania Press, 1991.

Kahn, Douglas, and Diane Neumaier, eds. *Cultures in Contention*. Seattle: Real Comet Press, 1985.

Kallin, Jane. *The Folk Art Tradition: Naive Painting in Europe and the United States*. New York: Viking Press, 1982.

Kant, Immanuel. *Critique of Judgment*. Translated by J. C. Meredith. Oxford: Clarendon Press, 1952.

———. *The Critique of Pure Reason*. Translated by Norman Kemp Smith. London: Macmillan, 1958.

Kaplan, Janet. *Unexpected Journeys: The Art and Life of Remedios Varo*. New York: Abbeville Press, 1988.

Kappeler, Susanne. *The Pornography of Representation*. Minneapolis: University of Minnesota Press, 1986.

Kaprow, Allan. *Essays on the Blurring of Art and Life*. Edited by Jeff Kelley. Berkeley: University of California Press, 1993.

Kapsner, Mathew. "Thanka Painting." In *Chö Yang: The Voice of Tibetan Religion and Culture* 3. Edited by Pedron Yeshi. New Delhi: Indraprastha Press, n.d.

Karnos, David D., and Robert G. Shoemaker. *Falling in Love with Wisdom: American Philosophers Talk about Their Calling*. New York and Oxford: Oxford University Press, 1993.

Kaufman, Gordon. *In Face of Mystery: A Constructive Theology*. Cambridge, MA: Harvard University Press, 1993.

———. *The Theological Imagination*. Philadelphia: Westminster, 1981.

———. *Theology in a Nuclear Age*. Philadelphia: Westminster, 1985.

Kearney Richard, *Dialogues with Contemporary Continental Thinkers: The Phe-nomenological Heritage.* Manchester, England: Manchester University Press, 1984.

———. *Poetics of Imagining, from Husserl to Lyotard.* London: HarperCollins, 1991.

———. *The Wake of Imagination: Toward a Postmodern Culture.* Minneapolis: University of Minnesota Press, 1988.

Kempers, Bram. *Painting, Power and Patronage: The Rise of the Professional Artist in the Italian Renaissance.* Translated by Beverley Jackson. London: Penguin, 1993.

Kinsley, David. *Hindu Goddesses: Visions of the Divine Feminine in the Hindu Religious Tradition.* Berkeley: University of California Press, 1986.

Kirsh, Andrea, and Susan Fisher Sterling. *Carrie Mae Weems.* Washington, DC: National Museum of Women in the Arts, 1993.

Kitzinger, Ernst. *The Cult of Images in the Age Before Iconoclasm.* Cambridge, MA: Harvard University Press, 1954.

Kline, Katy, and Helaine Posmer, eds. *Leon Golub and Nancy Spero: War and Memory.* Cambridge: MIT List Visual Arts Center, 1994.

Koch, Klaus. *The Prophets.* Vol. 1, *The Assyrian Period.* Translated by Margaret Kohl. Philadelphia: Fortress Press, 1983.

Koerner, Joseph Leo. *The Moment of Self-Portraiture in German Renaissance Art.* Chicago: University of Chicago Press, 1993.

Kostelanetz, Richard, et al. *Dictionary of the Avant-Gardes.* Chicago: A Cappella Books, 1993.

Krauss, Rosalind E. *The Originality of the Avant-Garde and Other Modernist Myths.* Cambridge, MA: MIT Press, 1985.

Kris, Ernst, and Otto Kurz. *Legend, Myth, and Magic in the Image of the Artist.* Vienna: Krystall Verlag, 1934. Reprint. New Haven, CT: Yale University Press, 1979.

Kristeller, Paul Oskar. *The Philosophy of Marsilio Ficino.* Translated by Virginia Conant. Gloucester, MA: Peter Smith, 1943.

Kristeva, Julia. *Desire in Language: A Semiotic Approach to Literature and Art.* Edited by Leon S. Roudiez. Translated by Thomas Gora, Alice Jardine, and Leon S. Roudiez. New York: Columbia University Press, 1980.

———. *The Kristeva Reader.* Edited by Toril Moi. New York: Columbia University Press, 1986.

Kuhn, Annette. *The Power of the Image: Essays on Representation and Sexuality.* London: Routledge and Kegan Paul, 1985.

Kuspit, Donald. "Bill Viola: The Passing." *Artforum* 32 (September 1993): 144–5+.

———. *The Cult of the Avant-Garde Artist.* New York: Cambridge University Press, 1993.

———. *Signs of Psyche in Modern and Postmodern Art.* New York: Cambridge University Press, 1993.

Lacy, Suzanne. "In Mourning and In Rage (with Analysis Aforethought)." In *Fem-icide: The Politics of Woman Killing.* Edited by Jill Radford and H. Diane Russell. New York: Twayne/Maxwell Macmillan International, 1992.

Laeuchli, Samuel. *Religion and Art in Conflict: Introduction to a Cross-Disciplinary Task.* Philadelphia: Fortress Press, 1980.

Lama, Gega. *Principles of Tibetan Art: Illustrations and Explanations of Buddhist Iconography and Iconometry According to the Karma Gardri School.* 2 vols. Darjeeling: Jamyang Singe, 1983.

Langer, Susanne K. "The Cultural Importance of Art." In *Philosophical Sketches.* Baltimore: Johns Hopkins Press, 1962.

Leaman, Oliver. "Maimonides: Imagination and the Objectivity of Prophecy." *Religion* 18 (January 1988): 69–80.

Lehmann, Karl. *Samothrace: A Guide to the Excavations and the Museum.* 5th ed. New York: Institute of Fine Arts, 1983.

Lessing, Gotthold. *Laocoön: An Essay upon the Limits of Poetry and Painting.* Translated by Ellen Frothingham. New York: Noonday Press, 1957.

Levin, David Michael. *The Opening of Vision: Nihilism and the Postmodern Situation.* New York: Routledge, 1988.

———, ed. *Modernity and the Hegemony of Vision.* Berkeley: University of California Press, 1993.

Levitan, Isaac. *Levitan: Pis'ma, dokumenti, vospominaniia.* Moscow: Iskusstvo, 1956.

Levitas, Ruth. *The Concept of Utopia.* New York: Philip Allan, 1990.

Lewis, James R. "Shamans and Prophets: Continuities and Discontinuities in Native American New Religions." *American Indian Quarterly* 12 (Summer 1988): 221–8.

Lewis, Naphtali. *Samothrace: The Ancient Literary Inscriptions.* Vol. 1. New York: Institute of Fine Arts, 1958.

Limburg, James. "The Prophets in Recent Study: 1967–77." *Interpretation* 32 (October 1978): 56–68.

Lindblom, J. *Prophecy in Ancient Israel.* Reprint ed. Philadelphia: Fortress Press, 1965.

Lippard, Lucy R. "First Strike for Peace." *Heresies* 20 (1985): 12–15.

———. *From the Center: Feminist Essays on Women's Art.* New York: Dutton, 1976.

———. "Trojan Horses: Activist Art and Power." In *Art After Modernism: Rethinking Representation.* Edited by Brian Wallis. New York: New Museum of Contemporary Art, 1984.

———, ed. *Six Years: The Dematerialization of the Art Object from 1966 to 1972.* New York: Praeger, 1973.

Lipsey, Roger. *An Art of Our Own: The Spiritual in Twentieth Century Art.* Boston: Shambhala, 1989.

Lizhong, Liu. *Buddhist Art of the Tibetan Plateau.* Edited and translated by Ralph Kiggell. San Francisco: China Books and Periodicals, 1988.

Lloyd, G. E. R., and G. E. L. Owen, eds. *Aristotle on Mind and the Senses.* Cambridge: Cambridge University Press, 1978.

Long, Richard, and Herman Lelie. *Richard Long: Walking in Circles.* London: South Bank Center, 1991.

Lotringer, Sylvere, and Paul Virilio. *Pure War.* Translated by Mark Polizotti. New York: Semiotexte, 1983.

Lovejoy, Margot. *Postmodern Currents: Art and Artists in the Age of Electronic Media.* 2nd ed. Upper Saddle River, NJ: Prentice Hall, 1997.

Luther, Martin. *Luther's Works.* 55 vols. Edited by Jaroslav Pelikan. St. Louis: Concordia Publishing House, 1955–86.

Lyotard, Jean-François. *The Postmodern Condition: A Report on Knowledge.* Translated by Geoff Bennington and Brian Massumi. Minneapolis: University of Minnesota Press, 1984.

Macdonald, A., and A. V. Stahl. *Newar Art: Nepalese Art During the Malla Period.* Warminster, England: Aris and Phillips, 1979.

MacKenzie, David, and Michael W. Curran. *A History of Russia, the Soviet Union, and Beyond.* Belmont, CA: Wadsworth Publishing, 1993.

Maguire, Henry. *Art and Eloquence in Byzantium.* Princeton, NJ: Princeton University Press, 1981.

Maimonides, Moses. *The Guide to the Perplexed.* Translated by Shlomo Pines. Chicago: University of Chicago Press, 1963.

Malevich, Kasimir. *The Artist, Infinity, Suprematism: Unpublished Writings, 1913–1933. Essays on Art,* Vol. 4. Translated by Xenia Hoffman. Edited by Troels Andersen. Copenhagen: Borgens Forlag, 1978.

———. "The Question of Imitative Art." *Essays on Art,* Vol. 1. Translated by Xenia Glowacki-Prus and Arnold McMillin. Edited by Troels Anderson. Copenhagen: Borgens Forlag, 1968.

Mandel, Ernest. *Late Capitalism.* Translated by Joris De Bres. London: NLB, 1975.

Mann, Paul. *The Theory-Death of the Avant-Garde.* Bloomington: Indiana University Press, 1991.

Mannheim, Karl. *Essays on the Sociology of Culture.* London: Routledge and Kegan Paul, 1956.

Marcel, Gabriel. *Homo Viator: Introduction to a Metaphysic of Hope.* Translated by Emma Craufurd. Chicago: Henry Regnery Company, 1951.

Marcus, Greil. *Lipstick Traces: A Secret History of the Twentieth Century.* Cambridge, MA: Harvard University Press, 1989.

Marcuse, Herbert. *The Aesthetic Dimension.* Boston: Beacon Press, 1968.

Maritain, Jacques. *The Responsibility of the Artist.* New York: Gordian Press, 1960.

Martin, E. J. *A History of the Iconoclastic Controversy.* 1930. Reprint. New York: Macmillan, 1978.

Martindale, Andrew. *The Rise of the Artist in the Middle Ages and Early Renaissance.* New York: McGraw Hill, 1972.

Marty, Martin E., and R. Scott Appleby. *Accounting for Fundamentalisms: The Dynamic Character of Movements.* Chicago: University of Chicago Press, 1994.

Marx, Karl. *Karl Marx: A Reader.* Edited by Jon Elster. Cambridge: Cambridge University Press, 1986.

McEvilley, Thomas. *The Exile's Return: Toward a Redefinition of Painting for the Post-modern Era.* New York: Cambridge University Press, 1993.

McFague, Sallie. *Models of God: Theology for an Ecological, Nuclear Age.* Philadelphia: Fortress Press, 1987.

Merezhkovsky, Dmitri. "On the Reasons for the Decline, and the New Currents, in Contemporary Russian Literature." In *The Russian Symbolists: An Anthology of Critical and Theoretical Writings,* edited and translated by Ronald E. Peterson. Ann Arbor, MI: Ardis, 1986.

Merleau-Ponty, Maurice. *Phenomenology of Perception.* Translated by Colin Smith. London: Routledge, 1962.

———. *Sense and Non-Sense.* Translated and edited by Hubert L. Dreyfus and Patricia A. Dreyfus. Evanston, IL: Northwestern University Press, 1964.

———. *The Visible and the Invisible.* Edited by Claude Lefort. Translated by Alphonso Lingis. Evanston, IL: Northwestern University Press, 1968.

Miles, Margaret R. *Carnal Knowing: Female Nakedness and Religious Meaning in the Christian West.* Boston: Beacon Press, 1989.

———. *Desire and Delight: A New Reading of Augustine's Confessions.* New York: Crossroad, 1992.

———. *Image as Insight: Visual Understanding in Western Christianity and Secular Culture.* Boston: Beacon Press, 1985.

Miller, Nancy K., ed. *The Poetics of Gender.* New York: Columbia University Press, 1986.

Mitchell, W. J. T. *Iconology: Image, Text, Ideology.* Chicago: University of Chicago Press, 1986.

Monas, Sidney. "Modern Russian Poetry and the Prophetic Tradition." *World Literature Today* 59 (Winter 1985): 190–3.

Morris, William. *The Collected Works of William Morris.* 1910–15. Reprint. London: Routledge and Thoemmes Press, 1992.

Morson, Gary Saul, and Caryl Emerson. *Mikhail Bakhtin: Creation of a Prosaics.* Stanford, CA: Stanford University Press, 1990.

Moses, L. G. "The Father Tells Me So! Wovoka: The Ghost Dance Prophet." *American Indian Quarterly* 9 (Summer 1985): 335–51.

Murdoch, Iris. *Metaphysics as a Guide to Morals.* London: Chatto and Windus, 1992.

Nash, Paul. *Outline: An Autobiography and Other Writings.* London: Faber and Faber, 1949.

Nasr, Seyyed Hossein. *Three Muslim Sages: Avicenna-Suhrawardi-Ibn'Arabi.* Cambridge, MA: Harvard University Press, 1964.

Nattier, Jan. *Once Upon a Future Time: Studies in a Buddhist Prophecy of Decline.* Berkeley, CA: Asian Humanities Press, 1991.

Newman, Barnett. "The Sublime Is Now." In *Theories of Modern Art: A Source Book by Artists and Critics,* edited by Herschel B. Chipp. Berkeley: University of California Press, 1968.

Newsome, James D., Jr. *The Hebrew Prophets.* Atlanta: John Knox Press, 1984.

Niccoli, Ottavia. "The End of Prophecy." *The Journal of Modern History* 61 (December 1989): 667–82.

Nicholson, Linda. "Feminism and the Politics of Postmodernism." *boundary 2* 19 (Summer 1992): 53–69.

Nietzsche, Friedrich. *The Joyful Wisdom.* In *The Complete Works of Friedrich Nietzsche,* Vol 10. Edited by Oscar Levy. Translated by Thomas Common. New York: Russell and Russell, 1964.

Nin, Anaïs. *The Diary of Anaïs Nin, 1939–44.* Edited by Gunther Stuhlmann. New York: Harcourt, Brace and World, 1969.

Nochlin, Linda. *The Politics of Vision: Essays on Nineteenth-Century Art and Society.* New York: Harper and Row, 1989.

Novitz, David. *The Boundaries of Art.* Philadelphia: Temple University Press, 1992.

O'Brien, Mark, and Craig Little, eds. *Reimaging America: The Arts of Social Change.* Philadelphia: New Society Publishers, 1990.

Olander, William. *The Art of Memory, The Loss of History.* New York: New Museum of Contemporary Art, 1985.

Olschak, Blanche Christine, with Geshé Thupten Wangyal. *Mystic Art of Tibet.* Boston: Shambhala, 1987.

Olson, E. "The Wheel of Existence." *Oriental Art* 9 (1963): 2–7.

Onasch, Kurt. *Icons.* New York: A. S. Barnes, 1963.

Ouspensky, P. D. *Tertium Organum: A Key to the Enigmas of the World.* Translated by Nicholas Bessaraboff and Claude Bragdon. 2nd ed. New York: Alfred A. Knopf, 1922.

Overholt, Thomas. *Channels of Prophecy: The Social Dynamics of Prophetic Activity.* Minneapolis, MN: Fortress Press, 1989.

———. *Prophecy in Cross-Cultural Perspective: A Sourcebook for Biblical Researchers*. Atlanta: Scholars Press, 1986.

Owens, Craig. *Beyond Recognition: Representation, Power, and Culture*. Berkeley: University of California Press, 1992.

———. "Representation, Appropriation and Power." *Art in America* 70 (May 1982): 9–21.

Pal, Pratapaditya. *Art of Tibet: A Catalogue of the Los Angeles County Museum of Art Collection*. Berkeley: University of California Press, 1983.

Pal, Pratapaditya, and Hsien-ch'i Tseng. *Lamaist Art: The Aesthetics of Harmony*. Boston: Museum of Fine Arts, 1969.

Pallis, Marco. *Peaks and Lamas*. London: Cassell, 1939.

Parks, Addison. "Into the Garden: The Paintings of Porfirio DiDonna." *Arts Magazine* 63 (January 1989): 28–31.

Pathak, S. K. *The Album of the Tibetan Art Collections*. Patna, India: Kashi Prasad Jayaswal Research Institute, 1986.

Pelikan, Jaroslav, Joseph Kitagawa, and Seyyed Hossein Nasr. *Comparative Work Ethics: Judeo-Christian, Islamic, and Eastern*. Washington, DC: Library of Congress, 1985.

Perl, Jed. "Mixed Media." *The New Criterion* 8 (April 1990): 49–55.

Petersen, David L. *Prophecy in Israel: Search for an Identity*. Philadelphia: Fortress Press, 1987.

———. *The Roles of Israel's Prophets*. Sheffield, England: JSOT Press, 1981.

Peterson, Ronald E., ed. *The Russian Symbolists: An Anthology of Critical and Theoretical Writings*. Ann Arbor, MI: Ardis, 1986.

Philbin, Marianne, ed. *Ribbon: A Celebration of Life*. Asheville, NC: Lark Books, 1985.

Pickover, Clifford A., ed. *Visions of the Future: Art, Technology and Computing in the Twenty-First Century*. New York: St. Martin's Press, 1992.

Plaskow, Judith. *Standing Again at Sinai: Rethinking Judaism from a Feminist Perspective*. San Francisco: Harper and Row, 1990.

Plato. *The Republic*. 2 vols. Cambridge, MA: Harvard University Press, 1930.

Poggioli, Renato. *The Theory of the Avant-Garde*. Cambridge, MA: Harvard University Press, 1968.

Pollard, John. *Seers, Shrines and Sirens: The Greek Religious Revolution in the Sixth Century, B.C.* London: George Allen and Unwin, 1965.

Pollock, Griselda. *Vision and Difference: Feminity, Feminism and the Histories of Art*. London: Routledge, 1988.

Polumbaum, Nyna Brael, ed. *Save Life on Earth*. Berlin: Elefanten Press, 1986.

Postan, M. M., E. E. Rich, and Edward Miller, eds. *Economic Organization and Policies in the Middle Ages*. Vol. 3, *The Cambridge Economic History of Europe*. Cambridge: Cambridge University Press, 1963.

Pott, P. H. *Introduction to the Tibetan Collection of the National Museum of Ethnology, Leiden*. Leiden: E. J. Brill, 1951.

Pratt, Sarah. *Russian Metaphysical Romanticism: The Poetry of Tiutchev and Boratynskii*. Stanford, CA: Stanford University Press, 1984.

Pushkin, Aleksandr Sergeevich. *Stikhotvoreniia, 1820–1826*. Vol. 2. Moscow: Izdatel'stvo, 1949.

Rahman, F. *Avicenna's Psychology: An English Translation of 'Kitab Al-Najat,' Book II, Chapter VI with Historico-Philosophical Notes and Textual Improvements on the Cairo Edition*. 1952. Reprint. Westport, CT: Hyperion Press, 1981.

———. *Prophecy in Islam: Philosophy and Orthodoxy*. London: George Allen and Unwin, 1958.

Read, Herbert. *Art and Society*. New York: Schocken Books, 1966.

Reddish, Mitchell G., ed. *Apocalyptic Literature: A Reader*. Nashville, TN: Abingdon Press, 1990.

Reiling, J. *Hermas and Christian Prophecy: A Study of the Eleventh Mandate*. Leiden: E. J. Brill, 1973.

Reuther, Rosemary Radford. *Gaia and God: An Ecofeminist Theology of Earth Healing*. San Francisco: HarperSan Francisco, 1992.

Reynolds, Robert, and Thomas Zummer, eds. *Crash: Nostalgia for the Absence of Cyberspace*. New York: Thread Waxing Space, 1994.

Rhie, Marylin M., and Robert A. F. Thurman. *Wisdom and Compassion: The Sacred Art of Tibet*. New York: Harry N. Abrams, 1991.

Riasanovsky, Nicholas V. *The Emergence of Romanticism*. New York: Oxford University Press, 1992.

Rice, Tamara Talbot. *Russian Icons*. London: Spring Books, 1963.

Rich, E. E., and C. H. Wilson, eds. *The Economic Organization of Early Modern Europe*. Vol. 5, *The Cambridge Economic History of Europe*. Cambridge: Cambridge University Press, 1977.

Richards, Mary Caroline. *Centering in Pottery, Poetry, and the Person*. Middleton, CT: Wesleyan University Press, 1964.

Rimbaud, Arthur. *Complete Works*. Translated by Paul Schmidt. New York: Harper and Row, 1976.

Roerich, George. *Tibetan Paintings*. Paris: Librairie Orientaliste, 1925.

Rorty, Richard. "The historiography of philosophy: four genres." In *Philosophy in History: Essays on the Historiography of Philosophy*, edited by Richard Rorty, J. B. Schneewind, and Quentin Skinner. Cambridge: Cambridge University Press, 1984.

Roth, Michael S. "We Are What We Remember (and Forget)." *Tikkun* 9 (November–December 1994): 41–2+.

Rowley, H. H. *Prophecy and Religion in Ancient China and Israel*. New York: Harper and Brothers, 1956.

Sadler, Michael. *Modern Art and Revolution*. London: L. and Virginia Woolf at the Hogarth Press, 1932.

Saint-Simon, Henri. *Henri Saint-Simon (1760–1825): Selected Writings on Science, Industry and Social Organisation*. Translated and edited by Keith Taylor. London: Croom Helm, 1975.

———. *Oeuvres de Saint-Simon et d'Enfantin*. Paris: E. Dentu, 1865.

———. *Opinions littéraires, philosophiques et industrielles*. Paris: Galerie de Bossange pére, 1825.

Schechner, Richard. "The Decline and Fall of the (American) Avant-Garde, Part I." *Performing Arts Journal* 14 (1981): 48–63.

———. "The Decline and Fall of the (American) Avant-Garde, Part II." *Performing Arts Journal* 15 (1981): 9–19.

———. *The End of Humanism*. New York: Performing Arts Journal, 1982.

Scheler, Max. *Ressentiment*. New York: Free Press, 1961.

Schnapper, Antoine, ed. *Jacques-Louis David, 1748–1825*. Paris: Editions de la Réunion des Musées Nationaux, 1989.

Schopenhauer, Arthur. *Complete Essays of Schopenhauer*. Translated by T. Bailey Saunders. New York: Willey Book Company, 1942.

Schussler-Fiorenza, Elisabeth. *The Book of Revelation: Justice and Judgment*. Philadelphia: Fortress Press, 1985.

Schuyler, Philip. "Profiles (James L. Acord, Jr. – Parts I and II)." *The New Yorker,* October 14, 1991, 59–96, and October 21, 1991, 62–107.

**311**

Schwartz, Hillel. *Century's End: A Cultural History of the Fin de Siècle from the 990s to the 1990s.* New York: Doubleday, 1990.

Schwehn, Mark R. *Exiles from Eden: Religion and the Academic Vocation in America.* New York: Oxford University Press, 1993.

Sembach, Klaus-Jürgen. *Henry Van de Velde.* New York: Rizzoli, 1989.

Seznec, Jean, and Jean Adhémar, eds. *Salons.* 3 vols. Oxford: Clarendon Press, 1957–63.

Shroder, Maurice Z. *Icarus: The Image of the Artist in French Romanticism.* Cambridge, MA: Harvard University Press, 1961.

Siebers, Tobin, ed. *Heterotopia: Postmodern Utopia and the Body Politic.* Ann Arbor: University of Michigan Press, 1994.

Simon, Joan, gen. ed., with Janet Jenkins and Toby Kamps. *Bruce Nauman.* Minneapolis, MN: Walker Art Center, 1994.

Sims, Patterson. *The Museum: Mixed Metaphors.* Seattle: Seattle Art Museum, 1993.

Sirat, Colette. *A History of Jewish Philosophy in the Middle Ages.* Cambridge: Cambridge University Press, 1985.

Skulsky, Susan. "The Sibyl's Rage and the Marpessan Rock." *American Journal of Philology* 108 (No. 1): 56–80.

Smith, Adam. *An Inquiry into the Nature and Causes of the Wealth of Nations.* Edited by Edwin Cannan. Chicago: University of Chicago Press, 1976.

Smith, Barbara Herrnstein. *Contingencies of Value: Alternative Perspectives for Critical Theory.* Cambridge, MA: Harvard University Press, 1988.

Smith, Bernard. *The Death of the Artist as Hero: Essays in History and Culture.* Melbourne: Oxford University Press, 1988.

Snellgrove, David, and Hugh Richardson. *A Cultural History of Tibet.* New York: Frederick A. Praeger, 1968.

Soelle, Dorothee, with Shirley A. Cloyes. *To Work and To Love: A Theology of Creation.* Philadelphia: Fortress Press, 1984.

Stafford, Barbara. *Body Criticism: Imaging the Unseen in Enlightenment Art and Medicine.* Cambridge, MA: MIT Press, 1991.

Stanley, Liz. *The Auto/Biographical I: The Theory and Practice of Feminist Auto/Biography.* Manchester, England: Manchester University Press, 1992.

Stanton, Domna, ed. *The Female Autograph: Theory and Practice of Autobiography from the Tenth to the Twentieth Century.* Chicago: University of Chicago Press, 1984.

Stroumsa, Sarah. "The Signs of Prophecy: The Emergence and Early Development of a Theme in Arabic Theological Literature." *Harvard Theological Review* 78 (January–April 1985): 101–14.

Strozier, Charles B. *Apocalypse: On the Psychology of Fundamentalism in America.* Boston: Beacon Press, 1994.

Stuart, John. *Ikons.* London: Faber and Faber, 1975.

Tatarkiewicz, Wladyslaw. *A History of Six Ideas: An Essay in Aesthetics.* The Hague: Martinus Nijhoff, 1980.

Tatic-Djuric, Mirjana. *Image of the Angels.* Translated by George H. Genzel and Hans Rosenwald. Vaduz, Liechtenstein: Catholic Book Art Guild, 1964.

Taylor, Joshua, ed. *Nineteenth-Century Theories of Art.* Berkeley: University of California Press, 1987.

Teilhet, Jehanne. "The Role of Women Artists in Polynesia and Melanesia." In *Art and Artists of Oceania,* edited by Sidney Mead and Bernie Kernet. Mill Valley, CA: Ethnographic Arts Publications, 1983.

Teitelbaum, Matthew, ed. *Montage and Modern Life, 1919–1942.* Cambridge, MA: MIT Press, 1992.

Terkel, Studs. *Working: People Talk About What They Do All Day and How They Feel About What They Do.* New York: Pantheon Books, 1972.

Thompson, William Irwin, ed. *Gaia, A Way of Knowing: Political Implications of the New Biology.* Great Barrington, MA: Lindisfarne Press, 1987.

Todd, William Mills III. *Fiction and Society in the Age of Pushkin: Ideology, Institutions, and Narrative.* Cambridge, MA: Harvard University Press, 1986.

Tucci, G. *Tibetan Painted Scrolls.* 3 vols. Rome: La Libreria Dello Strato, 1949.

Turrell, James. "Open Space for Perception." *Flash Art* 24 (January–February 1991): 110–13.

Uspensky, Boris. *The Semiotics of the Russian Icon.* Edited by Stephen Rudy. Lisse, The Netherlands: Peter de Ridder Press, 1976.

Vattimo, Gianni. *The Transparent Society.* Translated by David Webb. Cambridge: Polity Press, 1992.

Vico, Giambattista. *The New Science.* Ithaca, NY: Cornell University Press, 1970.

Viola, Bill. *Reasons for Knocking at an Empty House: Writings, 1973–94.* Cambridge, MA: MIT Press, 1995.

Volf, Miroslav. *Work in the Spirit: Toward a Theology of Work.* New York: Oxford University Press, 1991.

Von Rad, Gerhard. *Old Testament Theology.* Translated by D. M. G. Stalker. New York: Harper, 1965.

Vorobyev, Nikolai A. *History and Art of the Russian Icon, from the Tenth to the Twentieth Centuries.* Translated by Boris M. Meerovich. Edited by Lucy Maxym. Manhasset, NY: Siamese Imports, 1986.

Vrubel, Mikhail. *Vrubel, Perepiska – Vospominaniia o Khudozhnike.* Moscow: Iskusstvo, 1963.

Walsor, Martin. "A Beautiful Life: A Sermon on the Occasion of the 25th Anniversary of the Death of Bertolt Brecht." Translated by Gitta Honegger. *Performing Arts Journal* 17 (1982): 37–45.

Walton, Kendall. *Mimesis as Make Believe.* Cambridge, MA: Harvard University Press, 1990.

Walzer, Michael. *Interpretation and Social Criticism.* Cambridge, MA: Harvard University Press, 1987.

Ware, Timothy. *The Orthodox Church.* Reprint ed. New York: Penguin, 1993.

Warnke, Martin. *The Court Artist: On the Ancestry of the Modern Artist.* Translated by David McLintock. Cambridge: Cambridge University Press, 1993.

Weber, Max. *The Protestant Ethic and the Spirit of Capitalism.* Translated by Talcott Parsons. New York: Charles Scribner's Sons, 1958.

———. *The Sociology of Religion.* Translated by Ephraim Fischoff. Boston: Beacon Press, 1964.

Wei, Lilly. "Making Art, Making Money." *Art in America* 78 (July 1990): 133–41+.

Welch, Sharon. *Communities of Resistance and Solidarity: A Feminist Theology of Liberation.* Maryknoll, NY: Orbis Press, 1985.

———. *A Feminist Ethic of Risk.* Minneapolis, MN: Fortress Press, 1990.

Welch, Stuart Cary. *Room for Wonder.* New York: American Federation of Arts, 1978.

West, Cornel. *Prophesy Deliverance.* Philadelphia: Westminster Press, 1982.

———. *Prophetic Reflections: Notes on Race and Power in America.* Monroe, ME: Common Courage Press, 1993.

————. *Prophetic Thought in Postmodern Times.* Monroe, ME: Common Courage Press, 1993.

Westermann, Claus. *Basic Forms of Prophetic Speech.* Translated by Hugh Clayton White. Philadelphia: Westminster Press, 1967.

White, Alan. *The Language of Imagination.* New York: Oxford University Press, 1990.

White, Sidnie Ann. "The All Souls Deuteronomy and the Decalogue." *Journal of Biblical Literature* 109 (Summer 1990): 193–206.

Wicks, Stephen. *Forest of Visions.* Knoxville, TN: Knoxville Museum of Art, 1993.

Wiesner-Hanks, Merry E. "Artisans." In *Encyclopedia of Social History.* Edited by Peter N. Stearns. New York: Garland Publishing, 1994.

Wilde, Oscar. *Selected Essays and Poems.* London: Penguin, 1954.

Williams, Raymond. *The Country and the City.* New York: Oxford University Press, 1973.

————. *Keywords: A Vocabulary of Culture and Society.* 2nd ed. New York: Oxford University Press, 1983.

Wilson, Peter L. *Angels.* New York: Pantheon Books, 1980.

Wilson, Robert C. *Prophecy and Society in Ancient Israel.* Philadelphia: Fortress Press, 1980.

Winward, Stephen F. *A Guide to the Prophets.* London: Hodder and Stoughton, 1968.

Wittgenstein, Ludwig. *Culture and Value.* Edited by G. H. von Wright. Translated by Peter Winch. Chicago: University of Chicago Press, 1980.

————. *Philosophical Investigations: The English Text of the Third Edition.* Translated by G. E. M. Anscombe. New York: Macmillan, 1968.

Wittkower, Rudolf, and Margot Wittkower. *Born under Saturn: The Character and Conduct of Artists.* 1963. Reprint. New York: Norton, 1969.

Witzling, Mara R., ed. *Voicing Our Visions: Writings by Women Artists.* New York: Universe, 1991.

Wolff, Hans Walter. "Prophecy from the Eighth through the Fifth Century." *Interpretation* 32 (1978): 17–30.

Wolfson, Harry Austryn. *Philo: Foundations of Religious Philosophy in Judaism, Christianity and Islam.* Cambridge, MA: Harvard University Press, 1962.

Wolin, Richard, ed. *The Heidegger Controversy.* Cambridge, MA: MIT Press, 1993.

Yates, Wilson. *The Arts in Theological Education: New Possibilities for Integration.* Atlanta: Scholars Press, 1987.

Yau, John, ed. "A Tribute to Porfirio DiDonna (1942–1986): Testimonials by Friends and Reproductions of DiDonna's Work." *Sulfur* 19 (Spring 1987): 50–63.

Ziegesar, Peter von. "Bill Viola at the Parrish Art Museum." *Art in America* 82 (November 1994): 135.

Zimmer, Heinrich. *Artistic Form and Yoga in the Sacred Images of India.* Translated by Gerald Chapple and James B. Lawson. Princeton, NJ: Princeton University Press, 1984.

# Index